POP DESIGN: MODERNISM TO MOD

NIGEL WHITELEY

THE
DESIGN
COUNCIL

Pop Design: From Modernism to Mod

First published in the United Kingdom in 1987 by
The Design Council
28 Haymarket
London SW1Y 4SU

Typeset by Colset Private Limited, Singapore

Printed by Biddles, Guildford

Designed by Mike McCarthy

British Library Cataloguing in Publication Data

Whiteley, Nigel
 Pop design — from modernism to mod: pop
 theory and design in Britain 1952–72.
 1. Design——Great Britain——History——
 20th century
 I. Title
 745.4'4941 NK928

ISBN 0 85072 159 8

CONTENTS

ACKNOWLEDGEMENTS

I would like to acknowledge the contributions of those who, in one way or another, have generously given their valuable time — in particular Deborah Allen, P Reyner Banham, Geoffrey Beard, Paul Clark, Peter Cook, Robin Day, Michael English, Ken Garland, Richard Hamilton, Bernard Holdaway, Magda McHale, George Melly, Ginny Pepper, Cedric Price, Peter Smithson, David Vaughan and Jon Wealleans. Many thanks to Zoë Wilcock who has typed more about Pop than she wishes to remember: and to Jony Russell and Sylvia Katz at the Design Council for their patience and steadfastness. My wife, Diane Hill, is due the deepest gratitude for her constant support, ceaseless encouragement, and incisive critical comments.

INTRODUCTION

Hardly a day goes by without the 1960s being revisited, revived or reviled. The revisiting is part of the daily fare of the media. On television 'The Avengers' wreak their revenge and the 'Star Trek' crew avert another intergalactic disaster; on Radio One the 'jocks' raid the sound-vaults of yesteryear and on Radio Two Keith Fordyce dredges up yet more 'Sounds of the 60s'. 'Sixties revivals adorn the glossy pages of the fashion monthlies although the clothes often seem reluctant to leave the image of the page for the reality of the street. Purple paisley kaftans, for example, and the Sassoon bob cut have cropped up in magazines several times, but, as yet, are as little worn in the Kings Road as they are in King's Lynn. The mini, though, has transcended its decade and become a sort of everyday fashion type-form.

The reviving of the 'sixties has become increasingly frequent among politicians of the Right. They proclaim the decisions, attitudes and values of the permissive and irresponsible 1960s, to be the cause of today's moral and social decay. The 'sixties was the decade when do-gooders encouraged a reliance on the state that sapped moral fibre and undermined traditional British independence, and the young sought the selfish gratifications of free loving and easy living.

The relevance of the 1960s and their influence on today is not surprising: in chronological terms the decade is recent and well remembered. However, the spirit and mood of the 1960s now seem so distant that they feel as much a part of the past as the Second World War. But the one thing that everyone agrees is that the 1960s was a decade of seminal importance in British social and cultural history: a time when attitudes, values, standards and opinions were transformed. And its importance was recognised at the time, especially by those who were optimistic about the future.

Social and economic changes — most of which occurred at an ever-increasing pace — had been underway throughout the 1950s: the gains in private affluence, the growth of consumerism, the rise of commercial television, longer education, greater job opportunity and increased social mobility. The effect of these changes on the expectations and aspirations of the population was substantial. Among the young, three new 'Rs' were apparent — *resentment* at inflexible and rigid divisions of class, *reaction* to authority and establishments of all kinds, and a mood of *rebelliousness*. They were the signs of a new assertiveness that grew in proportion to youth's financial well-being. The same climate accounted for the incipient youth culture — rock'n'roll music, coffee bars and youth-orientated fashions — that I term 'Early Pop'.

The year 1962 has been described as the year the 1950s ended: the new-found affluence of the young combined with the maturing of the post-war baby boom to result in an explosive discovery of young identity — a 'Youthquake'.[1] From the Beatles to Mary Quant, from the Kings Road to Carnaby Street, Britain swung to the accompaniment of Pop music, fashion and design.

It was less than a decade from the end of rationing to the rise of Beatlemania but it seemed like a century. Britain was shaking off the last

[1] Lewis 1978, p 177.

5

remnants of the 1950s. The 1960s was going to be the beginning of an exciting new age in which the only constant would be change. The young believed in progress with no compromises. The 'generation gap' between young and old suddenly seemed absolute. Many of the traditional attitudes to sex, marriage, the family, work, authority, one's country, the future and the past were rejected by the young to the consternation and anger of the old.

The optimists hoped political changes would echo the social changes. The Conservative party, which had been in office since 1951, appeared to represent everything that was typical of the old Britain: class divisions, privilege, pomposity and complacency. During the run-up to the 1964 General Election, the Labour party buried its traditional 'cloth-cap' working-class image and presented itself as the party of modernisation. Youthful-looking Labour leader Harold Wilson (that is in relation to the Conservative's Lord Home) conjured up a vision of the new Britain that he prophesied would be forged in the white heat of a scientific revolution. These were heady days as Labour, victors by a slender majority, promised a progressive and classless Britain.

Pop was part of this new confidence and it both reflected and expressed the outlook of the young. Pop centred around music and fashion but, during the 'High Pop' period of 1962 to 1966, it also branched out to include furniture and furnishings. 'High Pop' was available in a plethora of permutations, including the mini-dress of ever-shortening length and adorned with a variety of patterns in colourful combinations, silver polyvinyl chloride clothing influenced by the space race, throwaway paper furniture with a life-span of six months at the most, posters paying homage to pop groups and boutiques, and cheap mugs emblazoned with the Union Jack or the Stars and Stripes. Established principles of good design were an anachronism: Pop had to be fashionable, not functional. Until the '60s design had been modelled on the traditional 'mother' art, architecture. But what mattered now was the ever-changing appearance and disappearance of fashionable items. Change and consequent expendability were part of the Pop way of life.

Pop relied on making a large initial impact; its inevitable corollary was small sustaining power. Bright colour, fashionable patterns, bold designs, eccentric, even anti-ergonomic shapes — were all used to capture attention and announce the owner's up-to-dateness.

Affluence and consumerism were pre-requisites of Pop but they do not invalidate the movement's authenticity. Unlike some previous design movements, Pop was not foisted on an unwilling public by professionals and cultural critics divorced from popular taste and confident of their own infallibility. Pop was *genuinely* popular with the young and satisfied their needs and desires. Its success lay in its appeal to the young: it was fashionable, young, expendable and often humorous, gimmicky and sexy.

Pop was a way of life for the young with its own attitudes, values and standards. It was against traditional standards and old age: a rejection of 'wine culture' for 'coke culture'.[2] This book is about the great divide that was Pop, its theory and history in Britain. In recalling some typically exuberant or outlandish aspects of Pop, this book will jog the memories of those who experienced the 1960s. It may even rekindle the anger of those traditionalists and Modernists who saw Pop as a powerful threat to the principles of design that they cherished. What this book is *not*, however, is a celebration of Pop, a nostalgic look back to the 'swinging sixties' or a personal account full of

[2] David Sylvester 'Art in a Coke Climate' *Sunday Times Colour Supplement* 26 January 1964, p 14.

memories or anecdote. It *is* a book about social and cultural changes, and how such changes are manifested in design. *Pop Design — From Modernism to Mod* is concerned with attitudes, values and standards in design. It is an attempt to understand Pop as a cultural phenomenon, and place it in the historical contexts of politics, social change, culture and Modernist design. Pop as a movement flourished for only a few years, but the attitude to design it represents is still relevant and raises many issues about the nature of design in society. *Pop Design — From Modernism to Mod* analyses Pop's legacy and looks at the implications of Pop for current design theory.

This is the first book to *seriously* examine Pop design as a cultural phenomenon. The reason why other attempts have not been forthcoming is, I suspect, largely because of the suspicion with which most academics regard Pop. The very word connotes triviality and decidedly *un*academic pursuits.

Today the word *pop* is used loosely to refer to youth-directed top-twenty commercial music. However, it has had several meanings. In the 1950s pop was short for *popular* and was most frequently used in connection with *popular culture*. *Pop culture* referred to the output of the mass media including film, television and high-circulation glossy magazines. The growth of the mass media in the post-war years and its importation into Britain from America at an ever-increasing rate generated considerable argument about the effects of pop culture on people, communities and traditional concepts of culture. At this time the infrequently heard phrase *pop design* implied the popular taste on view at the annual 'Ideal Home' exhibition.

The first change in the common usage of 'pop' came in the early 1960s with the emergence of young artists on both sides of the Atlantic who incorporated the graphic imagery of popular culture, such as juke boxes and pin-ups of film stars, into their work. These artists soon became media celebrities and part of the 'swinging sixties' scene. Youth was numerous and affluent enough to be recognised as a distinct group with its own attitudes, desires and needs. Just as *Pop music* (different to *popular music*, which implies an appeal to people ranging from eight to 80), expressed and reinforced youth's identity, so *Pop design* answered its need for fashions and artefacts that caught the energy of the time and the spirit of youthfulness.

By the mid 1960s *Pop* could refer to art, music or design and the label was applied frequently and liberally to become as much a catchword of the time as 'swinging'. In the late 1960s — the period of 'Late' and 'Post' Pop — youth culture began to diversify and fragment and the word 'Pop' was replaced by more specialist terminology. Pop music, for example, became 'middle of the road', 'progressive', 'folk rock' or 'psychedelic' and so on. Pop could no longer claim to be a united movement or mood of the time, let alone a *Zeitgeist*. In spite of the fact that it has been used before and since, Pop belongs essentially to the 1960s.

Pop produced few theoretical statements. Indeed, some writers have remarked on Pop's anti-articulate and often anti-literate character. George Melly noted the bias in Pop towards the visual and musical and described the 'deliberate impoverishment of vocabulary' in spoken and written utterances.[3] Mick Farren wrote about Pop's '. . . non-literal culture dependent on style, mannerisms and emotional response for its expression . . .'.[4] And Theodore Roszak in *The Making of a Counter Culture* (1969) claimed that much that is best in Pop culture:

[3] Melly 1970, p 205.

[4] Farren 1972, p 31.

5 Roszak 1969, p 291.

'. . . does not find its way into literate expression One is apt to find out more about their [youth's] ways, by paying attention to posters, buttons, fashions of dress and dance — and especially to the pop music, which now knits together the whole thirteen to thirty age group.'[5]

Much of Pop was non-literate; attitude and the visually orientated Pop included in this book existed on different levels of consciousness and with different degrees of intention. There were three main categories: intellectual Pop, conscious Pop, and unselfconscious Pop.

Intellectual Pop began in the early 1950s and prepared the way for both Pop art and Pop design. While it is irrefutable that Pop would have occurred had the intellectuals of Pop never existed, their importance is not to be diminished, for they sought to analyse and understand the conditions of the new age of mass media, and re-evaluate accordingly their notions of the role and position of the fine arts in society and, important in the current context, Pop's implications for the theory of design. Were it not for these thinkers, Pop culture and design would have been dismissed as debased, trivial or exploitative. The 'prophets of Pop' have helped us to understand Pop and made us more aware of the intellectual conditions of the society in which we live.

Conscious Pop encompasses the objects, artefacts and images of Pop such as clothes, record covers and furniture that were produced commercially to answer the needs and desires of youth. This was by far the largest of the three categories. Some designers were supplying whatever would sell to make a 'killing' in a new and lucrative market. Other designers emerged from the grass roots of youth culture itself, and their taste was essentially the same as the group for whom they were designing. They were actively and emotionally immersed in Pop culture and living it by the day. Most of them had been to art school and either acquired a professional training in fashion or graphics, or a liberal fine-art education. Generally, conscious Pop designers were not aware of intellectual Pop, which is unusual. In conventional professional design there is a close relation between the theoretician and the practitioner. In many cases — the Bauhaus for example — the two roles are taken on by the same person. This was rarely the case in Pop.

Unselfconscious Pop was largely the 'do-Pop-yourself' category. It comprised objects and environments created by and for the same person, who would probably be unaware of any theoretical issues or wider implications of the activity. The unselfconscious Pop 'designer' was simply responding to what was fashionable or what appealed.

The intellectuals of Pop could be counted on the fingers of two hands. The public was not aware of any theory of Pop, and it is doubtful whether any more than one in a hundred designers and consumers of Pop ever considered that their thoughts or actions had significance for the future of design. The era of instant historical analysis and the action replay, of mental detachment and stylistic self-consciousness had not yet usurped the simplicity and optimism of the here-and-now and a belief in tomorrow. The young were too busy living today's life to the full to think of their place in tomorrow's history. The theory of Pop is derived from the small number of statements and articles by the intellectuals of Pop, the relatively few comments from the professionals of

conscious Pop, and an interpretation of the actions and artefacts produced by and for the Pop young. The theory of Pop was not codified but inferred.

This does not make Pop less important than a historically recognised design movement. In a movement like Pop, which is a mass movement and commercially based, any theory is the outcome of experience and observation. In a 'professional' design movement, practice is often forced to fit theoretical constructs in advance of practice — and people invariably suffer. The very fact that Pop did not rely on sponsorship, grants, educated taste or informed opinion guarantees it a certain validity. The manufacturer of Pop had to know what consumers wanted otherwise he or she courted financial disaster. Therefore, Pop culture must reflect a popular spirit of the age more accurately than the output of a minority cultural élite, divorced from the conditions of the mass marketplace.

Pop has now passed into history but the arguments about taste, standards and values in design continue. At a time when the 1960s are being revisited, it is fitting that Pop design should be re-evaluated and our interpretations revised.

BRITISH SOCIETY AND CHANGE

1

Pop came into being in a British society that had changed drastically in its outlook over the previous 20 years. The appropriate economic conditions may have been a pre-requisite for Pop, but a forward-looking, anti-traditional, youthful, and even brash confidence was also essential before Pop could be launched and consumed. How had these changes come about and what had been their causes?

The Social Structure Between the Wars

British society between the two World Wars had retained a rigid class structure. Economic prosperity or depression had had little effect on a socially unequal structure that was accepted — either through choice or resignation — by higher and lower classes alike. In spite of a number of serious strikes, social unrest and political action, the class system remained intact with predominantly conformist values, standards, attitudes and mores. In those pre-television days of the wireless, the Reithian moral tone of the BBC epitomised the belief that the ruling class knew what was good for the uneducated and uncultured masses; there was a correct way of doing everything, be it speaking English or courting a partner. Those in power dispensed justice, truth and wisdom to uphold all that was great about Britain, as well as, coincidentally, their own unchallenged position as moral, material and cultural guardians. The holders of power and office were, with few exceptions, recruited from the ranks of those with upper class backgrounds and/or public school education. Those who recall the halcyon days of order when authority was respected — at least according to the newsreels — seldom acknowledge the price that was paid in terms of intolerance of unorthodox views or lifestyles and the lack of social mobility which, although it can be exaggerated, is still a real possibility for a large proportion of the population.

The Second World War

Britain's self-image undoubtedly contributed to the success of its war effort. The dark days of selfless struggle and ceaseless toil demanded the restrictions on personal freedom and expression, the resignation to one's situation, the unquestioning acceptance and carrying out of orders and the belief in one's leaders that were an extension of society's pre-war code of conduct.

The Second World War had many social effects.[1] The 'We're all in it together' attitude and the so-called 'Dunkirk spirit' reinforced and consolidated the image of a Great Britain that would be united in peace as it had been in war. And yet aspirations and expectations were beginning to change, partly as a result of Allied propaganda, as enthusiastically received as it was skilfully deployed, promising a better Britain of health, wealth and happiness for all. The morale of the nation was kept high by plans for full employment and social welfare, universal education, a national health service, replanned and

[1] see Marwick 1984, pp 105-28.

11

modernised towns and cities, well-designed and sanitary housing, and national parks belonging to the people. In the First World War the promise had been 'homes fit for heroes': in the Second World War it was nothing less than a *new Britain* fit for heroes, the reward for the sacrifice and suffering.

Another cause of changing attitudes, which was not as easy to predict, was the breaking down of social barriers necessitated by hostilities. For both men in the forces and women, who, having been conditioned to think that their place was in the home, were suddenly expected to work in factories manufacturing arms and supplies, it was the first time they had mixed, or shared their lives, with people from outside their own geographical region, let alone their own social class. It contributed to a lessening of the awe felt for one's 'social betters'. Although the circumstances had been less than favourable journeying abroad and meeting people from different nations also had a broadening effect on many men who, normally, would have not travelled overseas.

Britain had been changed by the War; the mood for social reform grew and the resolve to bring it about gathered momentum.

Social Idealism and the Welfare State

[2] An excellent introduction to the 1945 to 1951 period is Addison 1985.

It is not surprising that this movement towards reform was realised in a resounding victory for Labour at the 1945 General Election.[2] The first plans for social reform had been proposed as early as 1942 by Sir William Beveridge and his committee in one of the major progressive achievements of the time. And R.A. Butler's Education Act, providing secondary education for all, had become an Act of Parliament in 1944. Labour, however, firmly nailed its colours to the mast of social reform, and in its 1945 election manifesto *Let Us Face the Future* promised, 'The establishment of a Socialist Commonwealth of Great Britain — freely democratic, efficient, progressive, public-spirited, its material resources organised in the service of the British people.'

Labour's plans included a wide-ranging nationalisation programme with the establishment of a National Coal Board, a British Railways Board, an Electricity Board, a Gas Board and the creation of a National Health Service. Much of the programme extended and made permanent the nationalisation of resources that had been essential in the War years; but Labour turned wartime necessity to peacetime policy. Britain had neither the financial organisation nor the skilled resources to implement the Welfare State immediately and fully. Many industries had been enfeebled, the economy was weak and the scarcity of daily provisions was as severe as it had been during the War. Basic foodstuffs and fruit, chocolate, sweets and clothing were all rationed until 1948 and, in many cases, until 1950. The last controls were lifted only in 1954.

1951 and a New Beginning

A turning point in the mood of the country occurred in 1951. After six years of war and six further years of rationing with 'make do and mend', social idealism can become threadbare. In the 1950 General Election, Labour's majority of 149 seats was slashed to nine. The Labour leadership struggled on for only a few more months before a second General Election was called. Labour polled more votes but, owing to the vagaries of the British electoral system, the Conserva-

tives, under the leadership of Winston Churchill, won with a majority of twenty seats. Although it was not a crushing victory, it did signify a change of mood. The Tories' successful election slogan had been, significantly, *Set the People Free*. It was the appeal of a government which promised to interfere less in people's lives, the appeal of no longer being told what one was allowed to eat and wear, the appeal of being able to begin to feather one's own nest that returned the Conservatives to office in 1951. Symbolically, if not materially, the consumer society had arrived in Britain.

Consumerism

1951 signified the public moment when the balance shifted from social idealism to consumerism, from the old age to the new. The trend towards a consumerist society was an inexorable fact of the 1950s and it was predictable that the Conservatives would win the General Elections of 1955 (under Sir Anthony Eden) and 1959 (under Harold Macmillan), on both occasions with an increased majority. Furthermore private affluence increased substantially for the vast majority of the population. People's aspirations changed as affluence increased; they wanted and *expected* to own the goods and services the pre-War generations would have associated with only the wealthiest sectors of society. For example, car ownership rose by 250% between 1951 and 1961, with the greatest increase after the middle of the decade. Between 1955 and 1960 weekly wages rose by 25% but, if overtime is taken into account, average weekly earnings rose by 34%. In the same period retail prices rose by only 15% but the cost of almost all of the technological consumer items, from washing machines and televisions to motorbikes, was much less in real terms, and for some items actually less in money terms, than it had been at the beginning of the 1950s. Harold Macmillan's remark, 'You've never had it so good', was an evident truth for the vast majority of the population.

People were encouraged to buy and to be good consumers. By the late 1950s, the Consumer Council and the Association for Consumer Research Ltd felt that the growing number of goods and the increasing complexity of the marketplace justified the publication of magazines to help the consumer: *Shoppers' Guide* and *Which?* came into existence. That the consumer would continue to buy was beyond question — he or she simply needed 'more guidance'.[3]

[3] Elizabeth Gundrey 'Guidance for Shoppers' *Design* November 1957, p 62.

Social Mobility

Most economic historians agree that the reasons for Britain's prosperity in the 1950s had less to do with planning and efficiency, than a worldwide trend of increased trading following the resumption of full manufacturing capacity and subsequent full employment after the War. In the present context, the *effect* of prosperity and consumerism — *social mobility*, particularly among the young, is more important. Many young adult couples craved the social status of owning their own homes and the material dreams — a car, washing machine, refrigerator, television, radio, record player and tape-recorder — that money could buy. Careful saving was too slow for those who wanted immediate gratification: hire purchase (HP) provided a welcome alternative. It has been

[4] see Ruth Adam 'A Guide to Never Never Land' *New Statesman* 25 June 1963, pp 111-14.

calculated that over half the television sets bought in the late 1950s were bought on HP. The HP debt in the New Towns, with their predominantly young aspiring middle-class populations, was disproportionately high. By the end of the decade, precipitated by the lifting of restrictions in 1958, the pre-war national HP debt of £100 million had increased ten-fold.[4]

The 1944 Education Act had also boosted social mobility. Secondary education had been made available to all with the State provision of grammar schools (for the more educationally able) and secondary modern schools. Public schools catered for the social and financial élite. Although the British educational system largely conformed to class divisions, a sizeable minority of working-class children who were academic achievers gained places at grammar schools and some carried on to university. A meritocracy was being established.

In *The Uses of Literacy*, published in 1957, Richard Hoggart writes sympathetically of the dislocating effect on a working-class youth who, by means of a grammar school and university education, is a-culturalised into middle-class habits of thought and neither belongs to the social class of his university friends, nor the class he grew up in. Others, however, were only too happy to escape the prejudices and narrowness of their backgrounds to 'better' themselves. And young adults who would previously have been expected to retain the aspirations and roles of their parents were genuinely able to break with convention. By the mid 1950s, only one man in three had the same social status (by occupation) as his father, and only one son in four of an unskilled labourer remain unskilled.

The Impact of the Media

Habits were changing too, and in particular those of leisure which were transformed by the expansion and character of television. The Second World War had put a temporary halt on the BBC's television service; by 1951 only 6% of households owned a television set. A decade later this figure had increased to 75%. Private affluence was the most obvious reason for the expansion of television ownership, but the change in character (in parallel with the changes in society) was also important. The BBC's monopoly was broken by the Television Act of 1954 which cleared the way for the introduction of commerical television in September 1955. The BBC's Reithian tone was immediately criticised in the leader of the first *TV Times*: 'So far television in this country . . . has been restricted by a lofty attitude towards the wishes of viewers by those in control.' The Independent Television Company (ITV) professed to know what the public wanted and presented programmes of a different tone; they imported slickly made and fast-moving series, such as 'Dragnet' and 'I Love Lucy', as alternatives to the BBC's home-grown ex-music hall stars. The viewing figures (ITV 75%, BBC 25%) confirmed ITV's belief that they understood popular taste. By 1959, up to 60% of British adults were tuning in to television for an average of five hours every evening in the winter, and three and a half in the summer. These figures testify to the impact television had on the way of life of most people.

The impact of television was also qualitative. Optimists argued that television opened people's minds to a wealth of experiences and information about current affairs, science, the arts, other nations and races, as well as making individuals visually more sophisticated. Pessimists argued that television not only reduced once-interactive family groups to passive and isolated individuals, but

that it also fuelled materialism by creating false desires for new, bigger and supposedly better consumer goods.

Television also affected other mass media. For example, the pre-eminence of television as a leisure pursuit in the 1950s was detrimental to the cinema. The number of cinemagoers declined throughout the decade, and the number of films registered in Britain and abroad dropped by 25% during the same period. Bigger and better technology was seen as a way of wooing back patrons, and a seemingly endless progression of 'technological breakthroughs' was proclaimed including *Cinerama* (1952), *Cinemascope* (1953), *Superscope* (1954), *Vistavision* (1954), *Todd-AO* (1955), *Naturama* (1956), *Cosmoscope* (1956), *Cinemascope 55* (1956), *Widevision* (1956), *Technirama* (1957), and *Panavision* (1957).

Reading habits changed too as cheaply produced colour magazines, such as *Life*, *Colliers* and *National Geographic*, and detective and science-fiction magazines and comics, began to arrive in ever-increasing numbers from America. British counterparts were produced (*Tit-Bits* and *Everybody's*, for example) which, although they could not match their American rivals for colour (or products advertised), became the staple diet of the British reading public.

The interrelation between affluence, consumerism, technology and the mass media is important, and it reveals much about society in the 1950s. Private affluence fuelled materialism which created a boom in consumer goods sales. Prosperity also made possible an expansion of the mass media which, because they were privately owned in America and Britain (with the exception of the BBC), reinforced consumerist attitudes. The more desirable and advanced consumer goods, such as portable or light-weight radios, tape recorders, and long-playing records with high quality performance, and the more exciting and impressive mass media (slicker television programmes, glossier magazines and epic films) were hailed by many as examples of how technology could enhance the lives of ordinary people in a democratic and free capitalist society. From the newest refrigerator to the latest 'A' or 'H' bombs experiment, technology and science were highly regarded as progressive and optimistic key components of the modern nuclear age.

Such attitudes were most apparent in America. America was the country where consumerism was realised most comprehensively. It was the richest nation in the world and it was in an advanced state of untrammelled capitalism. America's unconditional optimism for technology distinguished it from Britain. In relation to America's total commitment to personal gain, Britain retained a balance between private affluence and public responsibility — capitalism with a social conscience. But it was incontrovertible that (whether for good or bad) Britain was losing its traditional character and becoming Americanised.

The Effects of Change

The changes in British society in the 1950s brought about by affluence, mobility and the mass media were substantial. Unlike America, where the post-war condition was a logical progression towards the eternal American dream, Britain changed both in structure and ultimate goals. The old order was replaced, and with it went social stability. The health of Britain in the new Elizabethan age was vigorously debated.

[5] Hartley 'The Intellectuals of England' *The Spectator* 4 May 1962, p 580.

In a decade dominated by the Conservative Party it was hardly surprising that the Left felt society was crumbling. The thesis put forward by the Left, according to Anthony Hartley, was that '. . . the affluent society brought in by the Tories . . . with its refrigerators, motor cars and washing machines, had corrupted the British people into self-seeking vulgarity.'[5] The catch-phrase 'private affluence and public squalor' described what many on the Left felt the situation to be and this, they argued, had undermined the Welfare State; greed had replaced altruism. One Labour MP went so far as to state that Labour had lost elections because his party's '. . . ethical reach was beyond the mental grasp of the average person'.[6] Hartley remarked on the difference between the attitudes of the contemporary working class and the outlook of the *proletkult* of the 1930s, although he concluded that the old-fashioned 'correctly' valued proletariat may have been mythical and an invention of nostalgia.

[6] ibid, p 580.

The contrast of a contented, organically bonded community and the contemporary alienated and corrupted society was a central theme in the writings of Richard Hoggart and Raymond Williams. Hoggart and Williams were continuing the British tradition of cultural criticism (as opposed to analytical or sociological investigation) which can be traced back through FR Leavis' *Mass Civilisation and Minority Culture* (1930) to Matthew Arnold's *Culture and Anarchy* (1869). In *The Uses of Literacy* Hoggart bemoaned the loss of what he considered to be the good values and balanced lifestyle of the working class with the advent of magazines, cinema and television. Raymond Williams in *Culture and Society* (1958) and *The Long Revolution* (1961) was of a similar opinion:

> 'We should be much clearer about these cultural questions if we
> saw them as a consequence of a basically capitalist organisation and
> I at least know no better reason for capitalism to be ended.'[7]

[7] ibid, p 580.

The cultural critics were horrified by the Americanisation of society: a rapidly multiplying cancer of depersonalised mass-media entertainment and inauthentic processed culture. The mass media were seen as symptoms of capitalism and causes of corruption. In Britain there was little disinterested discussion and few serious attempts to understand the mass media. Hoggart's and Williams' central thesis — the corruption of the working classes by the purveyors of mass entertainment and mass consumption — was the commonly held view. The Marxist historian EJ Hobsbawn described the mass-media revolution as '. . . the most appalling thing which has happened in the twentieth century.'[8] The mass media were repeatedly attacked for providing popular culture which was considered to be debased, trivial or exploitative.

[8] see National Union of Teachers 1960, p 124.

Actions and Reactions

Starved of political power for nine years of the decade, the Left — from Fabian Socialists to the 'New Left' of the mid 1950s — took every opportunity to decry a society moving rapidly away from Socialism. And other, less overtly political, groups were also launching bitter attacks on a society they despised for its complacency and corruption. Some of the most passionate outbursts against Britain's self-satisfied mood came from the 'Angry Young Men', a loose grouping of writers and critics that included John Osborne, Kenneth Tynan,

John Wain, Lindsay Anderson and Colin Wilson. Most of them had been born in the 1920s (and so were not young by today's standard). Their youth had been interrupted by the Second World War which undoubtedly contributed to their feelings of frustration and sense of outrage. A collection of essays published in 1957 under the title *Declaration* outlined some of their grievances, such as the lack of a national theatre, and too much publicity being given to the Royal Family, which were more interesting for their common tone, described as 'furious irration', than their subject matter. Complacency, the maintenance of the status quo, and the plight of the individual trapped by rank and background against the insidious power of unyielding establishments were common themes in the so-called 'kitchen sink' literature and plays of the time. John Osborne's *Look Back in Anger* (1956), John Braine's *Room at the Top* (1957), and Alan Sillitoe's *Saturday Night and Sunday Morning* (1958) all received considerable critical acclaim, and a wider audience when they were translated into moody and evocative films at the end of the decade. Anti-establishmentarianism had arrived to reach its peak in the satire explosion of the early 1960s.

An alternative and unorthodox commentary on 1950s Britain was 'The Goon Show', christened in 1952 (having run for a year as 'Crazy People') it ran until 1960. Many episodes were centred around British National Service (abolished only in 1960) at the time of the 'H' bomb when defence was being geared towards nuclear retaliation. The threat of the bomb was an uneasy bedfellow for the absurdity of daily army life which included polishing boot studs and painting coal black. On the other hand, it was a ready source for the bizarre and surreal comedy created by Spike Milligan, Harry Secombe and Peter Sellers. Milligan was also a founder member of the Direct Action Committee Against the Bomb which led to the founding of the Campaign for Nuclear Disarmament (CND) in 1958. This largely middle-class movement rapidly gained support and, by 1960, the number of protesters on the annual Aldermaston march had increased tenfold from the initial 10 000 in 1958.

A substantial part of CND's membership comprised the under-35s, and protest of all kinds came from what can loosely be described as the youth of the country. Many theories have been put forward for the post-war connection between youthfulness and revolt, they range from the greater affluence which increased confidence and therefore outspokenness, to the psychologically disturbing effects of war and of being (in many cases) uprooted. Certainly — as in the case of the Angry Young Men — the intervention of war was likely to have a marked effect on a child's adolescent years which could easily turn to resentment and bitterness later in life. From 1955 criminality increased dramatically among the young. But generally the youthful revolt of the 1950s was no more than an extension and intensification of the unrest felt by society as a whole. However, the manifestation of youth sub-groups and gangs with their own identities in clothing and their own taste in music and young entrepreneurial designers brought the first stage of Pop into being.

The different kinds of protest were not without effect and significant liberalisation of society occurred in the late 1950s. In 1957, the Wolfenden Report recommended legalising homosexuality between consenting adults and reforming the law on prostitution — reforms that were put into practice in the 1960s. The 1959 Obscene Publications Act was also a step towards greater tolerance. The verdict of not guilty of obscenity at the test trial of D.H.

Lawrence's *Lady Chatterley's Lover* in 1960 surprised many and horrified a few but it was a sign of more open-minded times. Nevertheless when compared with the 'permissive 'sixties', Britain in the 1950s was still relatively repressive, intolerant and complacent. In spite of the Suez débâcle in 1956, the Right continued to act as if Britain was a world power commanding the prestige it had held during the War. Britain remained chauvinistic, and the class system was much in evidence; every institution — politics, the Armed Forces, universities, the BBC, publishing — seemed to have 'establishment' men at its apex and in the upper supporting layers.

Summary

During the 1950s Britain became a relatively affluent consumer society in which limited social mobility was a reality. Expectations and aspirations were changing drastically and the mass media — chiefly television — radically altered the nation's leisure habits and outlook. Most Britons were optimistic about the future and looked forward to a progressive age of science and technology that would bring about greater material gains. The old social order from the pre-war and wartime days had crumbled but so too had society's stability. Britain in the 1950s was, for the vast majority of the population, a more comfortable, more tolerant and more democratic place to live than pre-war Britain but it was also — and this must have seemed paradoxical to some — more discordant and divided. No longer were people passively accepting their lot; discontentment and protest were common features of the daily news in the later years of the decade. Affluence and a changing outlook were two of the main characteristics of late 1950s Britain. They were also the matrices in which Pop in Britain developed.

BRITISH DESIGN AND MODERNISM

2

Like British society, design in the post-war age was undergoing major change, and a reaction against the old order established in the inter-war years was taking place. In some ways this reaction paralleled the changes in society; the effect of consumerism was marked and the feeling of restlessness and rebellion spurred the young to action. The use of this parallel might give the impression that the respective old orders were fundamentally similar, which is certainly not true, yet the commonality of post-war reactions against the respective authorities of the old orders reveals that a belief in a new age was widespread within a culture that had been disturbed by the upheavals of war.

The Modern Movement

The established order in design of the inter-war years is now described as Modernism or the Modern Movement. Modernism is a cultural construct whose meaning defies precise definition and varies from discipline to discipline, and even from critic to critic. In architecture and design, one of the first outlines of the meaning of Modernism was provided by Nikolaus Pevsner, an art historian who emigrated to England because of the political climate in Germany in the mid 1930s. Pevsner brought first-hand knowledge of recent innovatory architecture and design on the continent, which he made use of in his book *Pioneers of the Modern Movement* published in 1936. Subtitled 'From William Morris to Walter Gropius', *Pioneers* traced the developments in 19th and early 20th century art, design and architecture that led to the rise of the Modern Movement. These developments included, as the book's subtitle suggests, the influence of William Morris who, along with other reformers, had attempted to counter the 'atrocities'[1] that mass production without design principles had brought about in the 19th century. Other tributaries outlined by Pevsner were the rejection of historicism that was heralded by Art Nouveau, the development of rational planning and simple constructional methods by Voysey and other late 19th century architects, and the exploitation of new materials and techniques of production by 19th century engineers, such as Telford, Brunel and Eiffel.

[1] Pevsner 1936, p 49.

The final chapter of *Pioneers* was concerned with the years leading up to 1914: the technical and aesthetic advances made by European architects in the use of undisguised concrete; the constructional and spatial sophistication of Louis Sullivan and Frank Lloyd Wright in America; the industrial aesthetic of Peter Behrens and Hans Poelzig in Germany; and, finally and triumphantly, the fully fledged Modernism of Walter Gropius' model factory for the *Deutscher Werkbund* Cologne exhibition of 1914. Here was the rational but masterly synthesis of technological innovation and aesthetic daring appropriate to the modern age.

Pevsner and other Modernists argued that there was an 'indissoluble unity of the art of an age and its social system'.[2] Art, design and architecture expressed the spirit of the age — the *zeitgeist*; and the over-riding charac-

[2] ibid, p 56.

teristics of the age shaped the artist's way of thinking and feeling. No artists were able to deny the determinants of their own consciousness. The Modern Movement was not, therefore, a stylistic option, or even just a consistent style, it was the only true and valid expression of the 20th century in architecture and design.

Architects and designers in the first quarter of the 20th century had undoubtedly felt they were helping to shape a new and progressive age. 'A great epoch has begun', proclaimed Le Corbusier in 1923, 'there exists a new spirit.'[3] The 20th century was to be an enlightened age of communal responsibility and collectivism that turned its back on the individualism and inequalities of the Victorian era. In the new age, man's creative energies were going to be harnessed: science and reason were the keys to progress. Modern design, declared *Bauhausler* Marcel Breuer in 1927, should consist of '. . . clear and logical forms, based on rational principles.'[4] The artist Amédée Ozenfant spoke for a whole school of progressive designers when he admitted that '. . . all inexactitude troubles us.'[5] Even a work of art should provoke a '. . . sensation of mathematical order.'[6]

[3] Le Corbusier 1927, p 9.

[4] Breuer 'Metal Furniture' 1927 in Benton 1975, p 226.

[5] Ozenfant 1952, p 222.

[6] ibid, p 117.

Standardisation, Simplicity and Impersonality

A useful introduction to the characteristics of the new architecture and design is an article by JM Richards which appeared in a 1935 issue of the *Architectural Review*, where Richards was their editor. Richards was, at that time, committed to the notion of Modernism as expounded by Pevsner and his article is entitled — significantly — 'Towards a Rational Aesthetic'. In the new age, Richards wrote, '. . . the appeal of vagueness and of the picturesque gives place to the aesthetic satisfaction of the mathematical equation'.[7] Richards pinpointed three necessary and major characteristics of Modern design: standardisation, simplicity and impersonality.

[7] JM Richards 'Towards a Rational Aesthetic' *Architectural Review* December 1935, p 139.

Standardisation was a corollary of mass production. If design was to be for the common man, then mass production was inevitable otherwise the trap in which William Morris had found himself would be repeated. Richards argued that standardisation did not mean monotony or sameness, rather '. . . a liberation of objects with certain intrinsic formal characteristics from accumulations of the ephemeral and the inessential.'[8] In other words standardisation would provide an underlying logic and order which ensured that items produced separately had shared characteristics. Decorative and ornamented Victorian design epitomised mass production that neglected the Modernists' formal characteristics and lacked the aesthetic coherency that rigorous standardisation could bring. Standardisation for the Modernist implied not only consistency and order but an increase in intrinsic quality. Although standardisation reduced diversity and variety, Richards wrote of the '. . . delight taken in the regularity of sheer repetition'[9]: the new age found aesthetic virtue in regimentation and sameness. This 'virtue' was typical of the optimism for the machine age and was a celebration of mechanisation, mass production and the machine aesthetic. If superficially similar to Andy Warhol's statements in the 1960s about his love of mechanical repetition, the Modernists' appreciation was fundamentally different in its wholehearted, if naive, optimism. The sense of irony and love of banality underlying Warhol's utterances were absent: the Modernist resided in *heroic* times.

[8] ibid, p 138.

[9] ibid, p 138.

Simplicity, the second major characteristic of Modern design, was not, according to Richards, merely an aesthetic preference in reaction to the elaborate forms of the 19th century. Simplicity was nothing less than the logical outcome of machine production. The growing complexity of the modern age meant an increase in sensory bombardment and a proliferation of material forms. Design should not add to the clutter by clamouring for visual attention but should assume a modest position in the background. Simplicity was the means to this end.

A further argument for simplicity was the sophisticated aesthetic satisfaction to be derived from unadorned surfaces. Not only were simple surfaces easier to manufacture and more convenient to maintain than ornamented ones, but they possessed greater 'integrity'[10] (this was presuming that one material was not employed to simulate another). The issue of simplicity — like many issues for the Modernist — was an aesthetico-moral one. In other words a visual decision was determined by ethical principles relating to 'truth' (such as 'truth to materials'), 'integrity' (such as 'integrity of surface') and so on. These aesthetico-moral issues were later to become a battleground as Pop designers rejected all these guiding principles.

The final and most important argument for simplicity was that it was a characteristic of machine production. No longer was it necessary for the worker to express technical virtuosity by producing elaborate detail. It was Richards' belief that,

> 'With emphasis transferred from the worker to the work done the urge to virtuosity disappears. The machine has destroyed the belief that a thing is more beautiful because more expertly made or because more difficult to make. . . . It has liberated the craftsman from the routine of production, and transferred his special qualities from the process to the object.'[11]

Although Richards' conclusion that Modernism was object-based is incontrovertible, his reasoning why it should be so is based more on value judgement and belief than fact or evidence. Are human beings *so* rational that they have no psychological need for 'virtuosity' or non-functional behaviour? Does simplicity satisfy complicated emotional needs? The Modernist's answers to these questions were very different to those of the Pop designers in the 1960s.

Impersonality was Richards' third major characteristic of Modern design and, for future designers, the most contentious and objectionable. Because machines were impersonal, Modernists argued that it was logical that their products should be so: 'The *machine* has rejected ornament', declared Herbert Read (a contemporary of Richards and another leading British Modernist), as though the machine was detached from human control.[12] However, the compelling reason for impersonality, wrote Richards, was because

> 'Modern design concerns itself with generic types rather than ad hoc products. The search for the standard or type-form is the paramount task of the modern designer.'[13]

The concept of the type-form was important because it was intimately related to the Modernists' aesthetics.

[10] ibid, p 137.

[11] ibid, p 137.

[12] Read 1934, p 56.

[13] Richards op cit p 137.

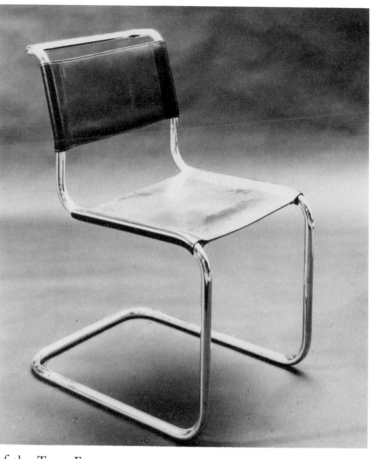

*Mart Stam, S33 tubular steel chair, 1926.
Standardisation, simplicity and impersonality are
combined to create a Modernist type-form.*

The Concept of the Type-Form

The type-form for a particular functional object is reached, it was argued, at the end of a process of mechanical evolution in which the object becomes increasingly better suited to its primary task. All that is inefficient or inessential is progressively eradicated until a form is derived that cannot be improved upon. Richards saw this as a worthy task for the modern designer. A particular type-form would be redundant only if a significant change came about in the function of the object (which was unlikely), its materials of manufacture, or method of production; only then should the type-form change. One example of a legitimate type-form change during the 1920s was the chair: the new possibilities introduced by tubular steel and the cantilever structure led to a type-form that replaced the old type-form which had arisen from the structural and constructional requirements of wood. Function and ergonomics may have remained constant, but technology brought about a change in materials/structure and the method of production.

The link with aesthetics was the belief that type-forms were always composed of primary or pure shapes — sphere, cylinder, cone, cube and pyramid — and that primary forms were intrinsically beautiful, not just to the 20th-century sensibility, but to those of all civilisations in all eras.

The belief that primary shapes bypassed conscious or cultural responses and appealed directly to the innate aesthetic sensibility in every human being

was not new. Plato, in a quotation much cited by Modernists in the 1930s, declared,

> 'By beauty of shapes . . . I mean straight lines and circles, and shapes, plane or solid, made from them by lathe, ruler or square. These are not, like other things, beautiful relatively, but always and absolutely.'[14]

14 quoted by Richards op cit p 131.

In more recent times, the idea of the absolute beauty of primary forms had travelled from Cézanne, via the 'significant form' theory of Clive Bell, to the Purists, including Le Corbusier, the major figure who strides both art and architecture.

The Purist Aesthetic

The Purist school of painting, founded by Le Corbusier and Amédée Ozenfant in the early 1920s, lasted for only a few years but had a decisive impact on the formulation of Le Corbusier's aesthetic ideas, which were highly influential within Modernism. Like Plato, the Purists believed that there were forms which were 'constants', eternally beautiful and beyond the whims of taste and fashion. The Purists contrasted primary forms with what they called secondary forms, which were non-geometric and impure. A secondary shape such as a zigzag or a whiplash curve '. . . satisfies only a passing need and then wears itself out.'[15] A work of art comprising one or more primary forms was eternally and universally beautiful. It did not matter whether a work of art was figurative or abstract as long as it was based on primary forms. This is why Purists considered the Parthenon, an ancient Egyptian statue or a painting by Piero della Francesca worthy of the epithet 'great'.

15 Ozenfant 1952, p 44.

The Purists painted figurative works in which the subject matter consisted of mass-produced, unemotive objects, such as briar pipes, bottles, glasses, jugs and occasionally a violin: objects that were anonymous or 'invisible' in daily life but exhibited primary forms, whether produced by hand or machine. The forms of these objects had evolved in some cases over centuries, until they had arrived at their most perfect (ie most functional) configuration: the typeform.

From depicting objects displaying primary forms, Le Corbusier turned to selecting and designing them. His 1925 *Pavillon de l'esprit nouveau*, with all its contents mass produced and 'off the peg' was the visual manifesto of Purist architecture and design. Many of the contents and furnishings of the house — the factory catalogue stairs for example — had not been designed for domestic settings but for industrial use. Unlike fashionable products with their self-conscious artiness or stylistic eccentricities, these simple objects had been

> '. . . determined by the evolution of forms between the ideal of maximum utility, and the satisfaction of the necessities of economical manufacture, which conform inevitably to the law of nature.'[16]

16 Ozenfant quoted in Banham 1960, p 211.

Le Corbusier denied that he was concerned with style in the sense of stylisation, a claim echoed by leading Modernists. Indeed, Gropius went so far as to assert

[17] Gropius 1935, p 92.

[18] ibid, p 92.

[19] Le Corbusier 1927, p 7.

that a recognisable style at the Bauhaus would have been '. . . a confession of failure.'[17] When appearance was divorced from principles to create a fashionable Modern *style*, Gropius was outraged. He dismissed *Moderne* and Modernistic designers as '. . . imitators who prostituted our fundamental precepts into modish trivialities'[18] — a comment that reveals the serious purpose behind the Modernists' work.

The Purists postulated that a design methodology incorporating functional requirements and the laws of production would produce rational, precise and pleasing design. Although they praised the engineer for creating precise and impersonal forms, the Purists did not believe that the engineer produced absolute beauty. They believed that only the artist, through superior sensibility, was able to create an order that, in the words of Le Corbusier, '. . . affects our senses to an acute degree and provokes plastic emotions . . .'.[19] The lofty status of the artist was thus ensured.

The *Sachlichkeit* Style

The Purists' ideas about aesthetics and design underlie the values of many Modernist designers and critics. They informed the thinking of J.M. Richards, and led him to define the characteristics of Modern design in the way that he did. But standardisation, simplicity and impersonality are not the inevitable attributes of design in the 20th century; they are the result of aesthetic and methodological preferences. They are how the Modernist believed modern design *should* appear.

Form had to be precise and rational, and the mood sober. Colour, like ornamentation, was deemed inessential or emotional and so tended to be

Marcel Breuer, dining room in the Piscator apartment, Berlin 1927. Breuer's work in this period epitomises sachlichkeit *Modernism's emotional austerity and non-referential nature.*

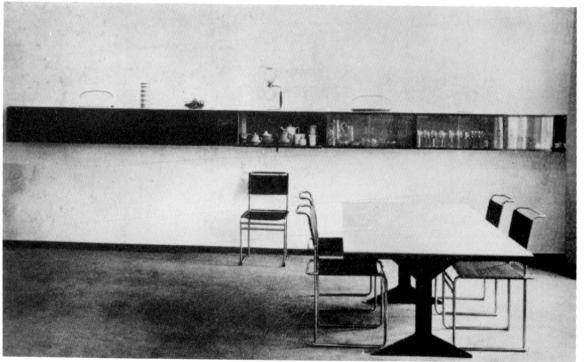

MUSEUM OF MODERN ART, NEW YORK

eliminated. Even when colour was used by architects and designers, the black-and-white illustrations in magazines and journals gave the impression of non-colour and became associated with this type of Modernism. These visually austere characteristics were described as *sachlichkeit*, a word that refers to a matter-of-factness or 'objectiveness' of appearance. When the post-war reaction eventually occurred, it overturned two of the main corollaries of *sachlichkeit* design: its reductivism and its absence of reference to a world beyond itself. The reductivist aspect derived from the search for the essential and rejection of all that was inessential, such as ornament and colour. Walter Gropius spoke of the desire to 'get rid of everything which masks [an object's] absolute form.'[20] For the *sachlichkeit* Modernist, less was more. The design was non-referential because the objects did not refer to any symbolic language or social order beyond the world of factory production. It was inward looking, revealing only '. . . its purpose and the construction necessary therefore.'[21] Any hint of popular taste or human association was banished.

This emotional austerity, the seriousness of purpose, and moral correctness felt by many Modernists in the 1920s and 1930s led them to make value judgements which they believed could or should not be questioned, and to rewrite history in a way that gave their cause deterministic inevitability.

LUND HUMPHRIES

Alexander Rodchenko, cover design for a collection of Mayakovesky's poems, 1927. Sachlichkeit graphics for the machine age.

Modernist History and Expressionism

Critics and historians, including Richards and Pevsner, were not attempting to provide a detached and critical analysis of Modernism and its sources but, because they were disciples, were seeking primarily to convert. This was not usually done in a sermonising or evangelical way but by presenting an interpretation of events as if only one was possible historically, socially and aesthetically. Sometimes value judgements were stated overtly. Pevsner, for example, rails against the aesthete who accepts '. . . the dangerous tenet of art for art's sake',[22] and he rejects the 'inherent fault'[23] of individual inventiveness. But more often these judgements were covert. History is tidied up and given the character of a relentless and unstoppable march of progress towards an inevitable goal. In *Pioneers of the Modern Movement* designers and movements were summarily dismissed, relegated to the footnotes, or excluded from the text because they did not subscribe to *sachlichkeit* Modernism. This included non-conformists like Antonio Gaudi, machine-age romantics including Sant' Elia and the Futurists, and visionaries and Utopians, such as Paul Scheebart, Bruno Taut, Hans Scharoun and Hermann Finsterlin.

Architects and designers primarily interested in sculptural, symbolic or expressive form, and sharing a dislike of *sachlichkeit* building, were, perhaps because it is easier to attack an identifiable enemy, given the umbrella term 'Expressionists'. For a short time around the years of the First World War, Expressionism prospered in architecture, and even *sachlichkeit* heroes, such as Gropius, Mies van der Rohe and Erich Mendelsohn, were — albeit temporarily — seduced by its formal possibilities.

Pevsner had ended his *Pioneers of the Modern Movement* in a way that led the reader to suppose that the authority of his type of Modernism was beyond question and its influence all pervasive. There was no hint that Expressionism was about to become the dominant force for a short but explosive

[20] Gropius *International Architecture* 1935, p 4 translated and included in Tim Benton *Images* A305 Open University, 1975.

[21] Breuer *'das neue frankfurt'* January 1928, p 11 in Stuttgart 1975, p 103.

[22] Pevsner 1960, p 112.

[23] Pevsner 1936, p 110.

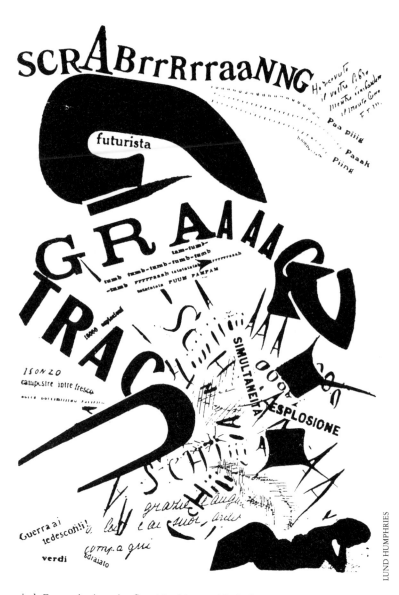

FT Marinetti, *Les mots en liberté futuristes, 1919.*
An example of Marinetti's commitment to
'Imagination without strings — words in freedom'.

LUND HUMPHRIES

24 Stern 'Avant-garde Graphics in Poland
Between the Two World Wars' *Typographica*
number 9 1964, p 5.

period. Expressionism also flourished in graphic design. Early Bauhaus graphic design, such as the cover for the Bauhaus manifesto in 1919 by Lyonel Feininger, was markedly Expressionist in character, and Peter Röhl's design for a 1921 Bauhaus programme featured Art Nouveau-influenced letters which anticipated hippy lettering of 1966/67. A consciously anti-rational stance was taken by the Polish graphic designers Anatol Stern and Alexander Wat in their 1920 *Manifesto to the Nations of the World* in which the authors dismissed rationality and logic '. . . as a limitation and cowardice of the mind.'[24] And FT Marinetti, in the Futurist manifesto *Destruction of Syntax — Imagination without strings — words in freedom* (1913), had tried to free the shapes and sounds of words from their conventional meanings.

Modernist critics, such as Pevsner, were dismissive of what they described as the Expressionist 'interlude', and in the revised 1960 edition of *Pioneers* Pevsner recalled:

'When I wrote this book the architecture of reason and functional-ism was in full swing in many countries, while it had just started a hopeful course in others. There was no question that Wright, Garnier, Loos, Behrens, Gropius were the initiators of the style of the century and that Gaudi and Sant' Elia were freaks and their inventions fantastical rantings.'[25]

25 Pevsner 1960, p 17.

In other words, there was a *true* tradition that was rational and responsible: the Expressionists were a group of irrational, even anti-rational subversives. Despite such attempts to negate them, alternative value systems and approaches to design did exist during that artistically varied and complex period between the early years of the 20th century and the Second World War, but it was not until the 1950s that they were re-evaluated.

Sachlichkeit Modernism encompassed an aesthetic and a set of values which made it highly selective in its view of history. It exaggerated its own status and authority, and created its own myth. But a myth can be potent and Modern-ism established itself as the legitimate order in design in the inter-war years. Like a faith, its followers were often devout to the point of intolerance of other creeds. To be a wholehearted Functionalist demanded the belief that, not only was your creed the true one, but that it was the *only* true one. If you were not for it, you were against it and any work of approach to design which did not accord with the creed was dismissed as 'decadent' (if there was any historical reference, eg Neo-Classicism), 'reactionary' (if there was any naturalistic reference, eg Victorian design), 'trivial' (if primarily decorative, eg Art Deco), 'sentimental' (if popular with the masses, eg the coal-effect electric fire), 'misguided' (a lack of understanding of design principles, eg streamlining), 'self-indulgent' (if the designer's or client's personality was apparent, eg Expressionism), or, simply, 'wrong' (if it was not *true* Modernism).

Modernists were of the opinion that their Purist sensibility, '. . . superior to individual fashions of feeling, thinking and acting . . .'[26] was not merely an alternative among several aesthetic philosophies, but a 'supra-aesthetic',[27] superior to all others and timelessly valid. This attitude of mind gave Modernists the confidence — some would say arrogance — to inflict their values and judgements in matters of design and taste on the mass of the popula-tion. That their taste was alien to most of the population did not stimulate them into either questioning the basis of their judgements or re-evaluating their criteria. The Modernists' assumption of moral authority with its attendant superiority was a particular bone of contention for the younger generation of designers in the 1950s and 1960s. When it eventually occurred, the rebellion was not merely against an aesthetic, but against an attitude of mind and approach to design.

26 Ozenfant 1952, p 20.

27 ibid, p 20.

The Modern Movement in Britain: Read and Pevsner

Modernism established itself in Britain in the early to mid 1930s. If its success and influence had been gauged by the small number of houses and luxury flats erected for wealthy patrons, its achievements would have been modest. But the instability and political pressures of the 1930s brought internationally acclaimed architects, designers and artists to Britain. Nikolaus Pevsner had arrived in 1933, Walter Gropius came a year later, followed by fellow

Bauhauslern Marcel Breuer and Laszlo Moholy-Nagy. By the end of 1936 Erich Mendelsohn, Serge Chermayeff, Berthold Lubetkin and Naum Gabo were also living in Britain. There was great optimism that Britain would become the driving force of the Modern Movement. The *Architectural Review*, following Richards' appointment as deputy editor in 1935, became a mouthpiece for the Modernists. The ideas of the Bauhaus were available to the English-reading audience for the first time in Walter Gropius' *The New Architecture and the Bauhaus* (1935): Pevsner published his *Pioneers of the Modern Movement* in 1936; and the BBC started to broadcast talks on Modern design. For a short while the British art and design scene assumed an international flavour. The 1937 publication of the Circle Group, for example, included contributions from Gropius, Le Corbusier, Moholy-Nagy, Breuer, Piet Mondrian and Jan Tschichold as well as Henry Moore and the influential and respected British critic, Herbert Read.

Read's *Art and Industry*, first published in 1934 and reprinted six times before the end of the 1950s, was orthodox, if not high church, Modernism: his declared aim was supporting and propagating the ideals of Gropius. Read sought a machine aesthetic of mathematical precision because, in keeping with advanced European thinking, '. . . precision implies economy of material and utmost clarity — two essentials of a work of art.'[28] There was an underlying Purist viewpoint in *Art and Industry* and two of the four parts of the book were concerned with the formal elements of art and design. Read's theory hinged on

[28] Read 1934, p 34.

Sven Markelius, sitting room exhibited at the Stockholm International Exhibition of 1930. Contemporary Swedish design, with its synthesis of traditionalism and progressivism, appealed greatly to some British designers.

ARCHITECTURAL PRESS

Gordon Russell, oak dining room furniture, c. 1936. Russell's work was soundly made with traditional materials and combined conservatism with the aesthetic restraint of Modernism.

his distinction between 'humanistic' and 'abstract' art: humanistic art was concerned with the expression of human feelings, whether noble or sentimental; abstract art appealed directly to the aesthetic sensibility through the intrinsic beauty of pure forms. 'Humanistic' and 'abstract' paralleled the Purists' 'secondary' and 'primary' forms: the one relying on meaning and confined to time and place; the other eternal and universal.

Yet Herbert Read did not simply regurgitate received ideas. He and other British Modernists did not give total support to the European version of Modernism and maintained a slight aloofness because of the 'relentless logic in its utter inhumanity' of what design writer John Gloag referred to as 'The Robot Modernist School'.[29] Even Richards spoke out against what he saw as the rather puritanical and extreme phase of European Modernism.[30] Herbert Read's popularity with the British was in no small part due to his tempering of *sachlichkeit* aesthetics. European Modernism, such as the Bauhaus, he argued, was too starkly functional, and '. . . functional thinking is like functional machinery — cold, precise, imageless, repetitive, bloodless, nerveless, dead.'[31]

Read and other British Modernists felt Swedish design combined the integrity of Modernism with a more sympathetic aesthetic. The Stockholm International Exhibition of 1930 had been a revelation to many British designers: the Swedes presented a Modern style that did not succumb to visual austerity. Swedish design made much use of natural materials and there was a high level of craftsmanship that could be appreciated by the traditionalist. For the generation or more of British designers who thought of William Morris and

[29] Gloag 'Wood or Metal?' 1929 in Benton 1975, p 231.

[30] JM Richards 'Towards a Rational Aesthetic' op cit p 137.

[31] Read 1934, p 14.

the Arts and Crafts movement as their spiritual and aesthetic heritage, Swedish design provided the solution to a design ethic and aesthetic that belonged to the modern age but had its roots in the past. The designer whose work epitomised this combination was Gordon Russell. Russell's work was soundly constructed of traditional materials, capable of mass production, modern without proclaiming its modernity and had a balance of plainness and decoration suited to either a modern or traditional setting. Depending on your point of view, Russell's design was either a masterly synthesis, or a typically British watered-down version of intoxicating ideas. Russell's attitude towards public taste and its improvement was undeniably British: 'I am never for forcing the pace. Limited advance and consolidate is a sound motto.'[32]

[32] Russell 'National Furniture Production' *Architectural Review* December 1946, p 183.

The advances of Modernism in Britain — albeit in a small number of progressive design circles that had the *Architectural Review* as their mouthpiece — were such that a 'Modern Architecture in England' exhibition was held at the Museum of Modern Art in New York in 1937. In the catalogue, the organiser claimed that '. . . it is not altogether an exaggeration to say that England leads the world in modern architectural activity'[33] and this, after England had barely been represented in an exhibition of international architecture at the same museum five years earlier. The emigration of Gropius and Breuer to America in 1937 may have signalled that the international phase of Modernism in Britain was over but its influence had been absorbed.

[33] Hitchcock 1937, p 25.

The effect of the European-influenced Modern Movement accounted, as Pevsner calculated in *An Enquiry Into Industrial Art in England* (1937), for a very small percentage of the total number of goods produced but, far from discouraging the British Modernists, it inspired them '. . . to fight against the shoddy design of . . . [the] goods by which most of our fellow men are surrounded . . .'.[34] According to Pevsner, this became the Modernist's 'moral duty'. In the 1930s, this duty was nothing less than a crusade — many architects and designers were deeply traditional. Sir Reginald Blomfield, the epitome of traditionalism, virulently attacked the Modern Movement in 1933 as

[34] Pevsner 1937, p 11.

'. . . essentially continental in its origin and inspiration, and it claims as a merit that it is cosmopolitan. As an Englishman and proud of his country, I detest and despise cosmopolitanism.'[35]

[35] Blomfield 'Is Modern Architecture on the Right Track?' *The Listener* 26 July 1933, p 124.

Blomfield's chauvinism discloses the insular outlook and intolerant attitudes prevalent in Britain during the inter-war years. Against a background of such sentiments, Modernism must have seemed — at least to those with broadly Left sympathies — to represent a new democratic, classless and scientifically progressive age of universal brotherhood. Modernism was part of the inevitable march of international Socialism that would slay the old orders of nationalistic pride and class divisions. The architect and the designer were going to be at the forefront of the battle for the new society.

Necessity and Utility

The Modernist battle for the new society was taken over but not extinguished by the battle for survival that was World War Two. The Modernists' optimistic outlook for a brighter future was entirely appropriate to the War effort and a number of individuals attained positions that enabled them to shape design

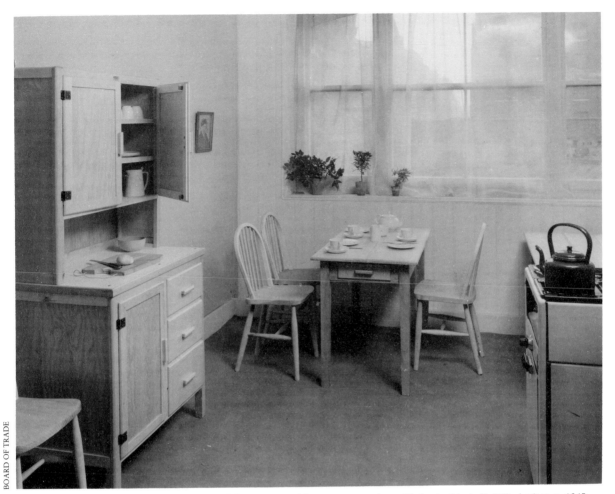

policy with regard to Modernist principles. The most notable success was the Utility Furniture Committee, set up by the Board of Trade to optimise the use of scarce resources. The task of the design subcommittee, under the chairmanship of Gordon Russell, was to prepare designs for a limited range of items to which firms were compelled to conform. Thirty pieces of committee-approved furniture know as 'Cotswold' (available from 1943), and 'Chiltern' (available from 1945) were manufactured. Economic necessity was turned to advantage by the Committee; the opportunity to manufacture well-designed pieces along Modernist lines was, according to one pro-Modernist critic, a '. . . step forward in the education of the manufacturer and the consumer.'[36] Russell was aware of the irony that '. . . Wartime conditions had given us a unique opportunity of making an advance.'[37]

The Committee's attitude to the taste of the masses is instructive and is encapsulated in Russell's statement that the aim of the new designs was to give the people '. . . something better than they might be expected to demand.'[38] They hoped that once the masses had been exposed to good design they would see the error of their ways. The public's reaction proved otherwise. The unpopularity of the designs was reputedly such that a black-market developed for decorating the Utility furniture with elaborate carving. A return to cottage-style and period reproduction furniture followed the removal of the regulations

Kitchen furnished with Utility furniture, c. 1945. British Modernists believed the War had provided an opportunity for '. . . a step forward in the education of the manufacturer and consumer.'

[36] Farr 1955, p 5.

[37] Russell quoted in MacCarthy 1979, p 69.

[38] Russell 'National Furniture Production' op cit p 184.

[39] Farr 1955, p 6.

controlling the appearance of furniture in 1948. One critic reluctantly admitted that a 'crushing reaction' had taken place.[39] This reaction was a foretaste of things to come.

The Council of Industrial Design

Just as the emergency nationalisation of resources during the War provided the basis for the setting up of the Welfare State, so governmental wartime concern with design (and art) set the scene for state involvement in the arts during the post-war period. Two major state bodies were formed during or shortly after the War: the Arts Council of Great Britain (which grew out of the Wartime Council for the Encouragement of Music and the Arts) and the Council of Industrial Design (CoID). Both bodies were centrally funded and exemplified the belief in Government intervention, control and planning that resulted in a Labour victory at the 1946 election.

The CoID was established in 1944 to '. . . promote by all practicable means the improvement of design in the products of British industry.' To this end the Council organised exhibitions and showcases at venues ranging from the Victoria and Albert Museum (the 'Britain Can Make It' exhibition, 1946) to railway stations and schools. *Design* magazine was introduced in January 1949 to publicise good Modern design and raise the design consciousness of manufacturers and consumers. The opening article in the first issue set the tone: Gordon Russell asked 'What is Good Design?'[40] The answer, good working order combined with an aesthetically pleasing appearance, would have satisfied the growing band of British Modernists.

[40] Russell 'What is Good Design?' *Design* January 1949, pp 2–5.

The main emphasis in *Design* up to the mid 1950s was an understanding and acceptance of Modern design principles undertaken at an elementary level. Russell thought it necessary to point out to manufacturers and public that good design is not '. . . precious, arty or high falutin', nor is it something that can be added to a product nearing its completion.'[41] The CoID attempted to induce manufacturers to improve the standard of their designs by convincing them that 'good design is good business'. Many manufacturers were suspicious of this argument and saw it as an attempt to impose an alien style. Some even spread the rumour that a CoID seal of approval was the commercial kiss of death. In a tone once described by Reyner Banham as 'all Montgomery and soda water'[42], and in language that harked back to a not too distant past, the editor of *Design* implored manufacturers to raise the standard of their designs because '. . . the fight against the shoddy design of those goods by which most of our fellow-men are surrounded has become a duty.'[43] If commercial gain could not tempt manufacturers, they might be shamed into improving their designs. This was the age of personal responsibility and public good.

[41] ibid, p 3.

[42] Reyner Banham on 'A Tonic to the Nation' BBC Radio 4, 29 November 1976.

[43] Farr 1955, p xxxvi.

Modernism in the Age of Consumerism

The intention of the CoID and other pro-Modernist bodies, such as the Design and Industries Association (DIA), in the post-war years was historically understandable and entirely honourable. They were fighting a campaign against functionally inadequate design and moribund 'Tudorbethan' taste, while extolling the virtues of clean-cut Modern design and those timeless aesthetico-moral principles, such as 'truth to materials', 'integrity of surface' and 'form

follows function', derived from the Arts and Crafts movement and European Modernism. But the rejection of this campaign by the Pop intellectuals and the first generation of Pop youth in the mid to late 1950s was also historically understandable, albeit dishonourable in Modernist terms. By then terms like 'honour', 'duty' and 'authority' had the ring of the old order that the young found unpalatable.

The reasons for the rejection of Modernism were twofold. First, its aesthetic predilections for plainness and restraint were out of keeping with the mass media, consumerist age. The standardisation, simplicity, and impersonality of Modernist design, however tempered the British version, were still essentially reductivist and non-referential and did not adequately fulfil the social role of design whereby objects manifest the aspirations, tastes and fantasies of consumers.

Second, the Modernist attitude of dictating the public's taste seemed patronising and élitist in the confident new age of meritocratic democracy. The Modernists' feelings about the public were encapsulated by the editor of *Design* who referred to the 'docile and uncritical public';[44] and Herbert Read who castigated the 'mob', that '. . . dull and indifferent public [who are] incapable of appreciating design . . .'.[45] As far as Modernists were concerned, popular taste was uneducated — it was vulgar, crude and escapist. It worried them not that the public found Modern design '. . . chill and bleak or plain and simple . . .'[46]: Modernists were the educated minority whose superior judgements meant they could dictate design and taste. While few would argue that a public uneducated in design, or uneducated in anything, is often going to transcend the prejudices of its own ignorance, to reject wholly those prejudices shows a lack of interest in a deeper psychological understanding of what and why people choose that indicates a contemptuous disrespect for the mass of the population. For the Modernist, standards were beyond discussion and the attitude of 'officers and men' seemed entrenched. However, social attitudes, especially with respect to authority, were beginning to change.

The Festival of Britain

The reaction to Modernism, like the shift towards the consumer society, took a number of years. But, not only was 1951 a politically symbolic year in that the Conservatives, with their commitment to private prosperity, were returned to power — it was also a significant year in British design history. That year marked the culmination of British Modernism, the highpoint of the old order — 1951 was the year of the Festival of Britain.

The story of the Festival has been recounted elsewhere.[47] It commemorates the popular successes of the South Bank theme pavilions and, in design terms, the architectural successes which included the Dome of Discovery, the Sea and Ships Pavilion, the Transport Pavilion and the Skylon. The layout and landscaping too, while receiving little attention from either visitors or critics at the time, made a major contribution to crowd control and the general ambience: instead of fences blocking access or signs announcing 'Keep Off', there were changes of floorscape from smooth to rough or from path to moat that discouraged or prevented access prettily and without offence. Good design, that is good British Modern design, was not confined to a pavilion, it was all around in the architecture, the interior design, the furniture and furnishings,

44 ibid, p 52.

45 Read speaking at NUT 1960, p 155.

46 Paul Reilly 'The Changing Face of Modern Design' *Design* August 1952, p 15.

47 see M Banham and Hillier (eds) 1976.

DESIGN COUNCIL

The Homes and Gardens pavilion at the South Bank site of the Festival of Britain, 1951, showing the often fussy face of British Modernism in the 1950s.

and in the spaces outside and the street furniture. Many of the British public were brought into contact with Modern design for the first time. The organisers saw the Festival as a national morale booster in the midst of austerity and shortages. But the designers saw it as something more: a vision of society physically transformed by Modern design. As one enthusiast declared: '. . . what a country we shall live in, what a Britain we shall have!'[48]

[48] Marghanita Laski quoted in Howell 1975, p 204.

In retrospect, we can see that this vision was part of an age that was at its end. The South Bank Festival of Britain was the design equivalent of the Welfare State: a controlled and ordered yet humanistic environment for the benefit of the wider population. But, despite the continuing crusades of the design reformers, design was being moved away from the collectivist ideals of the 1920s and 1930s towards the consumerist dreams of the 1950s.

The impact of the Festival of Britain on designers was, however, far from insignificant, and some of the first and second generations of Pop designers recount visiting the Festival as young adults or with school parties. In many cases it was the Festival that awoke their interest in design, and at least one major Pop figure has remarked that the Pop idea of the environment as a zone of fun or playground was, for him, first glimpsed at the South Bank site.[49]

[49] Peter Cook of Archigram in conversation with the author, 20 June 1977.

Modernism and the 'Contemporary' Style

Spurred on by the success of the Festival, Modernists continued to promote Modern or 'contemporary' design as it became popularly known. The CoID had implemented a stock list for the Festival from which the organisers could choose well-designed items, and subsequently this became a permanent 'Index'. These objects conformed to broadly Modernist principles while exhibiting the 'softer touches' — the use of the two or more woods or surfaces, and the decorative inlays and patterns — that supposedly 'humanised' the European version. In

1952, Paul Reilly in *Design* compared designs of the 1920s and 1930s with contemporary designs: Le Corbusier's 'Basculant' chair of 1928 with a Scandinavian chair of 1946; a Pel tubular steel cantilever chair (based on Mart Stam's 1926 chair) with Ernest Race's 'Antelope' chair of 1951; textiles, light-fittings, and typography were also compared. In each case the 'humanising' in contemporary British design, by which Reilly meant that the artefacts were lighter, more elegant, more decorative, more detailed, and less austere, was discernible. British 1950s design was better than European 1920s design because the contemporary British designer '. . . uses his heart as well as his head.'[50] Three of the most distinguished British Modernists — Read, Pevsner and Richards — agreed with Reilly's diagnosis.

[50] Reilly 'The Changing Face of Modern Design' op cit p 18.

Herbert Read, in the preface to the 1956 edition of his highly influential *Art and Industry*, wrote of the '. . . justifiable dissatisfaction with the bleakness of a pioneering functionalism'[51] and sought a lead from Modern British designers, such as Gordon Russell and Ernest Race. Nikolaus Pevsner, in the postscript to Michael Farr's 1955 *Design in British Industry* (a book that updated his own *An Enquiry into Industrial Art in England* of 1937) criticised the 'dictatorial quality' of 1930s Modernism which had come about as a necessary reaction to the excesses of Victorian historicism and over-elaboration. Now, in the 1950s, Pevsner believed, the Modern Movement had matured and was 'less puritanical, less exclusive'.[52]

[51] Read 1934 (1956 edition) p 7.

[52] Pevsner in Farr 1955, p 314.

The Re-evaluation of Victoriana

In what appeared to be a complete volte-face, bearing in mind his championing of the Modern Movement in the 1930s, Pevsner made a case for a re-evaluation of Victorian design. Victorian design had been anathema to Modernists in the 1920s and 1930s who were united by what they interpreted as the negation of the eternal and universal principles of design. Pevsner argued that Victorian design offered the long-overlooked qualities of contrast and surprise. He felt modern British design was close to achieving a synthesis of the intellectual rigour of Modernism and the emotional appeal of Victoriana. The Festival of Britain had shown just what could be achieved and he described the design there as 'excellent'.[53] Pevsner's intentions were summarised in a statement about Victorian graphic design elements in the revamped visual format of the *Architectural Review*. The inclusion of such graphics, he was at pains to point out, was

[53] ibid, p 319.

'. . . not a recommendation to cook *à la Victorienne* but rather a recommendation to spice with Victorian ingredients. It is . . . entirely a question of display faces, it is not a question of Victorian *mise en page*, that is we use Victorian materials in undeniably 20th century layouts.'[54]

[54] Pevsner 'Modern Architecture and the Historian or the Return of Historicism' *RIBA Journal* April 1961, p 235.

But Pevsner's recommendation was rejected by some and ignored by others.

For the younger architects and designers who were to feel some affinity with Pop, Pevsner's notion of a synthesis of Modernism and Victoriana was no more than a further dilution of Modernism that left it pitifully insipid. Although the young believed that Modernism was outmoded, many of them acknowledged the austere nobility and heroic single mindedness that had

characterised the work of Le Corbusier and others in the 1920s and 1930s. But British Modernism had reached a point at which it was degenerating into a trival compromise of finnicky and fussy details. Modernism in Britain was a spent force and the young rejected its new guise.

Pevsner's 'synthesis' was ignored by those who wanted to see the death of Modernism and the revival of Victoriana and popular traditionalism, especially those interested in graphic design. The 1950s witnessed a second revival of Victorian typography and layout. The first revival, contemporaneous with the European 'new typography' of the '20s and '30s, had been championed by John Betjeman and Nicolette Gray. Betjeman's interest lay in Victorian architecture and design generally, but Gray was more concerned with the character and nature of Victorian typefaces. She illustrated over two hundred from the decorated to the pictographic in her book *XIXth Century Ornamented Types and Title Pages* (1938). Gray's book was reprinted in 1951 and her conclusion seemed to fit the conditions of the developing mass-media age:

> 'The aim of both the founders and printers was continuously to supply the public with novelties which would attract and please; to succeed in this they had to keep in exact touch with the mood of the moment. Their business being purely commercial, considerations of scholarship, individual personality or typographical principle do not blur the contact. The result is a commercial art as pure as that of any primitive society.'[55]

Gray's influence was considerable in the 1950s. From 1952 onwards she published articles in the *Architectural Review* on the characteristics, qualities and appropriateness of various typefaces, as well as occasionally discussing wider subjects such as 'Expressionism in Lettering'.[56] Gray was not the only proponent of Victoriana in the *Architectural Review*. A regular column called 'Lettering' ran throughout the 1950s and played an important role in maintaining the decorative tradition in graphic design. The 'vitality' and 'robustness' of public house lettering were praised, and designers were urged to use it as a source of inspiration.

The Festival of Britain was a turning point in the revival of Victorian design and taste. The graphics at the Festival revealed more than a hint of Victorian revivalism, and *Design* exclaimed that '. . . every Victorian extravagance has been revived . . .'.[57] It was not only stylistically, however, that the Festival used the Victorian age. By 1951 the Victorian age was sufficiently far away to be seen as appealing or mildly humorous, and part of the Great British heritage. Emotive appeals to heritage and tradition had been part of the morale-boosting exercises of the War, and, at the Festival, there was no shortage of Victorian worthies and eccentrics in the jingoistic 'Lion and Unicorn' pavilion.

A number of studies of Victorian architecture and design appeared in the early 1950s, among them Pevsner's *High Victorian Design* (1951), and in 1952 the Victoria and Albert Museum mounted an exhibition of 'Victorian and Edwardian Decorative Arts'. Interest increased throughout the 1950s, and in 1958 the Victorian Society was formed. It is doubtful whether this new-found interest was due to anything as profound as an empathy felt by the new consumerist age for the old laissez-faire — it was another quarter of a century

[55] Gray 1938, p 9.

[56] Gray 'Expressionism in Lettering' *Architectural Review* April 1959, pp 272-76.

[57] Noel Carrington 'Legibility' *Design* July 1951, p 28.

Interior of the Lion and Unicorn pavilion at the South bank site of the Festival of Britain, 1951 showing the decorative and ornamented style, much influenced by Victorian design, which was apparent at the Festival.

before a prime minister called for a return to Victorian values — but the taste for Victorian design was symptomatic of an important change in aesthetic sensibility that was taking place.

The Popular Arts Tradition

Related and in many ways overlapping with the enthusiasm for Victorian design was the interest in the country's popular arts. Two books published in 1946 — Noel Carrington's *Popular English Art* and Margaret Lambert and Enid Marx's *English Popular and Traditional Art* — emphasised the popular arts as part of Britain's heritage. For these authors, the popular arts meant the hand-crafted folk arts. They agreed with Herbert Read that '. . . no popular art survived the Great Exhibition . . .',[58] that popular art could not be mass-produced. This traditionalist view was not shared by the designer and popular-art aficionado Barbara Jones who believed that the popular arts were a vital force in contemporary Britain and could be found in children's comics, cottage teapots and fairground decoration. At the Festival of Britain, the 'Lion and Unicorn' pavilion displayed examples of folk art and craft and, in the Battersea

[58] Read quoted in Jones 1951, p 7.

Tile fireplace in the form of an Airedale dog. This unusual item was on display at the 'Black Eyes and Lemonade' exhibition of the contemporary popular arts, 1951.

Pleasure Gardens, Rowland Emett's self-consciously picturesque railway was an attempt at modern-day popular-art whimsicality. However the most convincing display of the popular arts was an exhibition organised by Barbara Jones called 'Black Eyes and Lemonade' held at the Whitechapel Art Gallery. The exhibits included numerous contemporary examples of popular design, such as a thatched cottage tea service, a pair of black cow milk-jugs and a teapot with a handle in the shape of a parrot. In her book *The Unsophisticated Arts*, published in 1951 Jones described the contemporary popular arts as harder, cruder, brighter and less tasteful than the pre-industrial popular arts. Their essential attributes were, however, unchanged, and she argued that their energy, vitality and authenticity far outweighed the tastefulness, restraint and superior technical accomplishments of Modern design.

The taste for Victorian and popular art together with the revival of interest in 'bad taste' items from the 1930s, such as electric heaters in the shape of yachts and drinks cabinets disguised as grandmother clocks, were part of the growing desire, symptomatic of an increasingly consumerist society, for goods with varied, distinctive and unconventional forms.

The CoID and Consumer Associations

In spite of the changing state of society and the type of design it demanded in the mid to late 1950s the CoID remained intransigent in its outlook. The products selected by the CoID as exemplifying good design changed very little between the opening of the Design Centre in Haymarket in 1956 and the mid 1960s. In 1957 the Council introduced annual design awards, known as 'Designs of the Year'. The title was changed in 1960 to 'Design Centre Award', and from 1959 the Duke of Edinburgh presented his own prize for 'elegant' design. Simple forms, tastefully decorated surface, traditional materials and 'honest' techniques characterised the award winners. The CoID justified the fact that the designs looked alike by maintaining that they all expressed the spirit of the age, or were manufactured by the same techniques or composed of

the same materials. But the suspicion grew that the designs were similar because they had to conform to a functional *look*. In his speech to the Society of Industrial Artists in 1958, Stephen Spender's criticism of the designs selected by the CoID voiced this suspicion:

> 'In some cases . . . the aim seems to be to look functional rather, perhaps, than to be it. The concept of function translates itself into bareness, simplicity, squareness or roundness, solidity, seriousness. Above all, everything is impersonal.'[59]

[59] Spender quoted in Blake 1969, p 133.

Moreover, tests carried out by the consumer societies seemed, indirectly, to confirm this suspicion.

The Consumers' Association had been formally constituted in March 1957. It had grown out of the 1955 Consumer Advisory Council whose function was to advise the British Standards Institution (BSI) on basic standards of quality for consumer goods. The BSI had no powers to enforce their standards but manufacturers who *did* conform to them were allowed to use the BSI 'Kitemark' which guaranteed their standards had been found satisfactory. The *Shopper's Guide* was a short-lived magazine published by the Advisory Council, but *Which?* magazine, launched in October 1957, imparting factual information about consumer products, lasted the course. Its standard procedure was to compare a number of like products and criticise them objectively. Tests were rigorous and random samples were rechecked at varying intervals. Unlike magazines that relied on advertising for their income and could not risk offending any manufacturer, *Which?* was independently financed and did not include advertisements. *Which?* did not comment on appearance, only performance, and any product that looked functional but performed badly was criticised.

With efficient working order as its first principle of good design, one might have supposed that the CoID would have welcomed the rigorous approach of *Which?* Yet the CoID's attitude to the consumer movement was

Robert Heritage, sideboard for Archie Shine Ltd, 1957. The sideboard, which won a CoID award in 1958, was typical of the tasteful and elegant design that appealed to the CoID in the later 1950s.

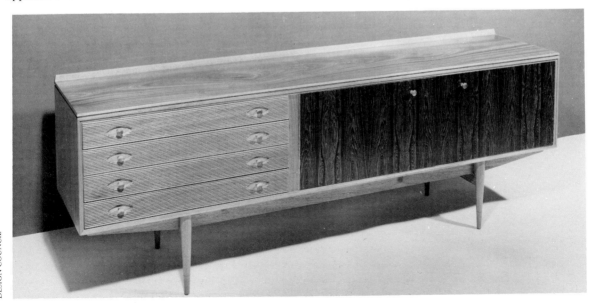

DESIGN COUNCIL

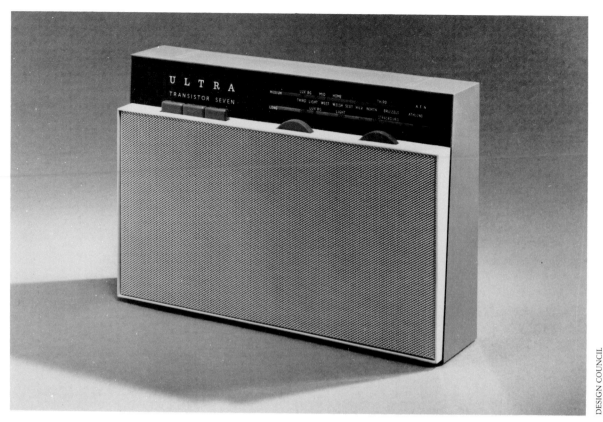

DESIGN COUNCIL

Ultra Rio (model TR 70) transistor radio, 1960. The Rio won The Duke of Edinburgh's Prize for Elegant Design in 1961 but was berated by some design critics for its poor performance.

[60] Editor 'The Basis of Choice' *Design* August 1962, p 23.

[61] Blake 'The Case for Criticism' *Design* June 1961, p 43.

less than enthusiastic. Fears were expressed in *Design* that appearance had almost become a 'dirty' word, and there was a warning that '. . . there is almost a danger that mugging up statistics may become a substitute for wider and more discriminating assessments.'[60] J.E. Blake trod on dangerous ground when in 1961 he asserted in *Design* that the CoID's intention '. . . is less to provide a guide to what is best on the market than to suggest, through a close study of individual products, what are the things that really matter in design . . .'.[61]

It does not imply an excess of cynicism to suppose that the 'more discriminating assessments' and the 'things that really matter in design' are nothing more than superior taste manifested in a certain refined and functional look. When it came to form and function some Modernists were prepared to sacrifice function before form. Although they asserted that 'form follows function', they were reversing the slogan and naïvely assuming that mechanical efficiency is a corollary of good form. But if naïvety did not underlie the assumption, a belief in the unquestioned authority of a certain kind of taste did. Could it be that principles were summoned to justify a style?

The CoID — 'H.M. Fashion House'

This was certainly the suspicion of Reyner Banham, the architectural historian and design writer who was to become one of the major figures in the British Pop movement. In an article entitled, quite scathingly, 'H.M. Fashion House', Banham claimed that the CoID '. . . approves of rubbish'.[62] To justify his statement, Banham cited a suitcase included in the Design Index but that had been

[62] Banham 'H.M. Fashion House' *New Statesman* 27 January 1961, p 151.

singled out by the Consumer Advisory Council as an example of extremely poor design: the handle broke off easily; it was far from water-proof; the fittings rusted; the lining came out; and it scuffed quickly. This was not an isolated example, there were others: the Ultra TR70 transistor radio, which won the Duke of Edinburgh's 'Award for Elegant Design' in 1961 was an ergonomically poor design and its performance was only average; the award-winning Milward electric razor found by Consumer Association testers to have several serious performance defects. The inconsistency between function and appearance was the result of the CoID's lack of proper testing. Banham predicted and answered the Council's objection that

> '. . . quality-testing is not the Council's business, and that it was formed to raised the level of public taste. But tasteful rubbish is still rubbish, and lack of confidence in the Council's qualitative standards will undermine its influence with the public it is supposed to be improving.'[63]

63 ibid, p 151.

He went on to expose the CoID's tendency to recite slogans without thinking about the meaning: their

> '. . . belief that there is some kind of necessary relationship between the appearance of an object and its performance and quality. Unfortunately not. "Form follows function" is a slogan, not a statement of fact.'[64]

64 ibid, p 151.

All this indicated that the CoID displayed 'narrow middle-class' taste. It was not only Banham who criticised the CoID for their parochialism. Misha Black, a designer whose work was close to the mainstream Modern Movement, blasted the CoID for adopting '. . . a position of moral self-righteousness no different from that of the sermonising total abstainer.'[65] Banham was also offended by the CoID's patronising attitude:

65 Misha Black 'Taste, Style and Industrial Design' *Motif* number 4 1960, p 63.

> 'The concept of good design as a form of aesthetic charity done on the labouring poor from a great height is incompatible with democracy as I see it.'[66]

66 Banham 'The End of Insolence' *New Statesman* 29 November 1960, p 646.

The times were changing: Banham's tone sounded similar to that of his literary counterparts; he belonged to same generation for whom disillusionment with the old order was growing. Jimmy Porter, the hero of John Osborne's 'Look Back in Anger' may have bemoaned the paucity of worthwhile causes, but those who felt that Modernism had become bastardised while the guardians of culture had grown complacent, had no doubt about *their* worthwhile causes.

New Towns and New Humanism

In architecture, there had been no shortage of causes or social idealism immediately after the War. A number of schemes — the most famous of which was the London County Council's Roehampton development of 1952-59 — showed the influence of pioneering Modernist, Le Corbusier, and a social commitment to the high-rise concept.

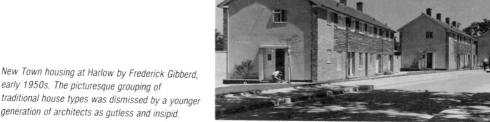

New Town housing at Harlow by Frederick Gibberd, early 1950s. The picturesque grouping of traditional house types was dismissed by a younger generation of architects as gutless and insipid.

ARCHITECTURAL PRESS

More typical of public-sector housing, however, were the low and mid-rise developments in rebuilt cities, such as Coventry, and the New Towns, including Harlow and Stevenage, which were the result of another aspect of the 'planned future' — the New Towns Act of 1946. Most politically and socially committed architects believed that the village-green groupings of traditional housetypes with pitched roofs, brick or rendered walls, window boxes and coloured paintwork expressed the spirit of the post-war Socialist society far better than any Modernist-inspired high-rise *idea* in which the individual was lost in a sea of concrete and glass.

The 'new' architecture was termed 'New Empiricism' or 'New Humanism' and its sources were recent Swedish architecture and the Garden City movements with a nod in the direction of the Ideal Home. It was championed by that erstwhile proponent of Modernism, the *Architectural Review*, and it is interesting to chart the change of course of both the journal and its assistant editor, JM Richards, who, from pioneering prophet of Modernism in the 1930s, became an apologist for picturesque suburbia in the 1950s. Only six years separated the publication of Richards' widely read Modernist text *An Introduction to Modern Architecture* (1940) and *The Castles on the Ground*, a celebration of middle-class speculative suburban housing, but they represented different architectural worlds. Richards settled into his new cause but some younger architects were appalled at what they interpreted as another symptom of British cultural complacency, the '. . . accommodating, neo-accommodating architecture of the immediately post-war phase'.[67]

[67] Banham in Pevsner 'Modern Architecture and the Historian or the Return of Historicism' op cit p 238.

New Brutalism and the Smithsons

An alternative to this 'weak-kneed' liberalism was provided by 'New Brutalism'. The first New Brutalist building was a school at Hunstanton in Norfolk designed in 1950 and completed in 1954 by a couple in their early twenties, Peter and Alison Smithson. The critical reaction to the building, described by the *Architectural Review* as 'the most truly modern building in Britain', centred around the 'honest' use of materials which were undisguised and used 'as found'.[68] There was little cosmetic treatment or covering up of structural materials, nor were the services (wiring, pipes etc) hidden. On the other hand, the services were not particularly emphasised; the resulting appearance owed its greatest debt to Mies van der Rohe.

Nevertheless, the school was described as New Brutalist, a term the Smithsons themselves coined, they explained,

[68] anon. 'School in Hunstanton, Norfolk' *Architectural Review* September 1954, p 78.

'. . . on sight of a newspaper paragraph heading which called (by poor translation of Beton Brut?) the Marseilles Unité "Brutalism in architecture" — that was for us: "New", because we came after Le Corbusier, and in response to the growing literary style of the Architectural Review which — at the start of the 'fifties was running articles on . . . the New Empiricism, the New Senti-mentality, and so on.'[69]

[69] A and P Smithson 1972, p 2.

Above all else the New Brutalists were committed to being

'. . . objective about "reality" — the cultural objectives of society, its urges, its techniques, and so on. Brutalism tries to face up to a mass production society, and drag a rough poetry out of the confused and powerful forces which are at work. . . . Brutalism has been discussed stylistically whereas its essence is ethical.'[70]

[70] Banham 1966, p 66.

British architecture was changing and the New Brutalists, like the Angry Young Men, were in revolt against the established order of society. But the New Brutalists went further and sought new forms to express the new order: they promised to break with conventional architecture and abandon concepts of composition, symmetry, module, proportion and literacy of plan. These were radical ideas indeed — although not the only contribution the Smithsons made to the new architectural thinking.

Neo-Expressionism

Far from being an isolated phenomenon, New Brutalism was but one reaction to *sachlich* Modernism in the 1950s. Some critics, notably Pevsner, saw New Brutalism as part of a worldwide Neo-Expressionist reaction which included Le Corbusier's chapel at Ronchamp in France (1950–54), Frank Lloyd Wright's Guggenheim Museum (1943–59) and Eero Saarinen's TWA Building (1956–62), both in New York. What these buildings were supposed to share was a preference for sculptural forms over functional anonymity.

Alison and Peter Smithson, school at Hunstanton, 1950–4. This Mies-influenced building was dubbed 'New Brutalist' and hailed as '. . . the most truly modern building in Britain.'

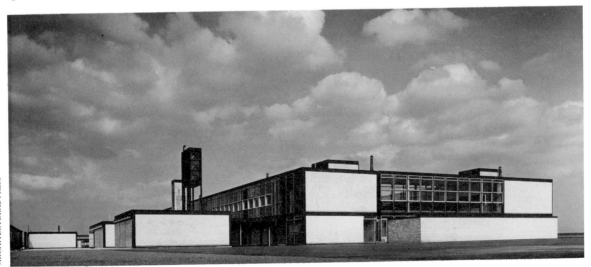

ARCHITECTURAL PRESS

Architectural Expressionism from the years around the First World War was, concurrently with Neo-Expressionism, undergoing critical re-evaluation internationally. Architects and movements that had been forgotten for years were discussed in the architectural press, and books and exhibitions re-assessed what had been thought of as lost causes or culs-de-sac. In the *Architectural Review* in the mid to late 1950s, Banham wrote a series of articles about Expressionist architects of the First World War and the 1914 Futurist manifesto of architecture. In 1960 the publication of Banham's seminal *Theory and Design in the First Machine Age* exposed the hollowness of much of the Modern Movement dogma, revealed *sachlich* Modernism as '. . . poverty-stricken symbolically',[71] and re-evaluated the importance of the Futurists and Expressionists. The re-assessment was an international phenomenon. In Germany in 1960 Ulrich Conrads and Hans G. Sperlich published *Phantastische Architektur*, a historical survey of 1910s and 1920s Expressionism; and in New York in 1960 the Museum of Modern Art mounted an exhibition entitled 'Visionary Architecture' which featured the work of architects such as Taut and Finsterlin. In Italy the controversial Neo-Liberty style was interpreted as an Art Nouveau revival — the first (loosely based) historical revival of the Modern Movement.

71 Banham 1960, p 320.

'Post Modern Anti-Rationalism' and Young Rebels

72 Pevsner 'Modern Architecture and the Historian or the Return of Historicism' op cit p 236.

73 ibid, p 230.

74 ibid, p 235.

75 Pevsner 1960, p 18.

Pevsner described the recent architectural and critical trend as 'post modern anti-rationalism'.[72] In his view it was an '. . . alarming recent phenomenon'.[73] He was concerned that the revised edition of *Pioneers of the Modern Movement* (as *Pioneers of Modern Design* in 1960) would be misunderstood '. . . as an encouragement to the new historicism.'[74] Pevsner remained '. . . convinced that the style of the Fagus Works and the Cologne model factory is still valid . . .'.[75]

But ideas were changing radically. Just as Modernism had been a new challenge to the old guard, the tendencies of the later 1950s were sparked off by the need to break with an order that had become an orthodoxy with (according to those in revolt) conventions that had become outmoded and moribund. The change in attitude was even more marked, especially among the young. It was the angry young professionals and intellectuals of the generation born in the 1920s who were the leaders of the rebellion, most vocal in their condemnation of the status quo, and who despised the attitude of moral superiority they attributed to their elders. Although few were politically right wing at the time, they felt more at home in the post-war consumer society with its changed expectations and aspirations, easing of social conventions, optimistic outlook and love of mass-media extravaganzas. Pop was a natural outcome of this consumerist society, and many of the rebels were drawn to it. Pop would have happened whether the rebels existed or not, but what they did contribute was an understanding of the conditions of mass-media society and its implications for art, architecture and design. Indeed it was the Pop professionals and intellectuals who most fully realised the fundamental nature of the changes in British society in the post-war era.

THE INDEPENDENT GROUP

3

The overwhelming majority of British intellectuals in the 1950s were hostile to what they interpreted as the Americanisation of their society. Hollywood movies, commercial television, glossy magazines and consumer goods were interpreted as symptoms of cultural degeneration and material greed. Thinkers from all the main political persuasions began to look back with nostalgia to either an ordered, respectful and supposedly content society or a society in which working-class humanity triumphed over the adversity of poverty. It was against this intellectual conservatism and cultural parochialism that a small group of artists and critics rebelled. If their statements and views occasionally revealed wishful thinking tending towards an uncritical optimism, the hostility towards their interests and enthusiasms made their exaggerated stance understandable and, indeed, necessary. Without their energetic contribution, British intellectual thought would have been that much more stuffy, self-opinionated and complacent. And more importantly, Pop would have not had a serious body of thought to underpin it.

The Founding Fathers

The Independent Group, as it was called, was a loosely knit discussion group comprising a range of individuals with diverse views and opinions. There was, however, a faction within it which shared an interest in technology and post-war Americana. It was this faction which made the major contribution to our understanding of the conditions of popular culture. Henceforward, I shall refer to this faction — the individuals connected centrally or their sympathisers on the edge of the group — as the Independent Group (IG). In practice, there was neither an official nor unofficial IG point of view but, for the sake of simplicity, the individual views of members of the relevant faction will be expressed in terms of a general IG viewpoint. Although this tends to exaggerate group identity at the cost of individual opinions and has — in the view of some[1] — fuelled a myth about the historical importance of the group, it does help to underline the commonly held feelings, attitudes and values of the most significant strand of the IG.[2] In fact, far from an overestimation of the importance of the IG, there has been, in my view, a serious underestimation of the IG's contribution to cultural thought in the post-war period.

The IG held their first meeting in 1952 at the Institute of Contemporary Arts (ICA) then in Dover Street, London. The intention as the name implied, was to assert their independence of the ICA's view of art, which the IG saw as symptomatic of the British art establishment. They believed that British art was parochial, complacent and did not encourage or value the work of non-establishment artists. They felt that the ICA was a microcosm of all that was wrong with the British ruling class. The young and angry IG were going to shake things up.

For the IG, the British art establishment was personified by the Modernist writer and critic Herbert Read, president of the ICA. 'If', declared the painter Richard Hamilton, 'there was one binding spirit amongst the people at

[1] see for example Penny Sparke and Anne Massey 'The Myth of the Independent Group' *Block* number 10 1985, pp 48-56.

[2] For fuller accounts of the IG see Frank Whitford 'Paolozzi and the Independent Group' in *Eduardo Paolozzi* Exhibition catalogue, Tate Gallery 1971, pp 44-48; and *Fathers of Pop* film/video, Miranda Films, London 1979.

[3] Hamilton on *Fathers of Pop* op cit.

the Independent Group, it was a distaste for Herbert Read's attitudes.'[3] Lawrence Alloway, then a lecturer at the National Gallery, added that Read was disliked less for his theories than the terms in which he discussed art and design. Read believed the artist was a leader in society, aware of eternal truths and detached from the lower order of daily existence. Read as a person was liked by the group, and Hamilton and Alloway admit to a certain embarrassment at their attacks, but, as Alloway explained, there was no one else to attack at the time, no one else in Britain had worked out an all embracing theory of art and design. Read had been the major figure in British art and design since the mid 1930s, and books such as *Art and Industry* had been revered by generations. Reyner Banham wrote how his generation had '. . . grown up under the marble shadow of Sir Herbert Read's Abstract-Left-Freudian aesthetics and suddenly, about 1952, [were] on strike against it.'[4]

[4] Banham 'Futurism for Keeps' *Arts* December 1960, p 33.

'Bunk' and *Art Autre*

At the initial meeting, the IG decided to hold a series of seminars based on common interests, with admission by invitation only. These seminars were arranged for 1952 and Banham became convener soon after they began. The programme Banham devised centred on science and technology, and included talks on helicopter design, proteins and (by Banham himself) the machine aesthetic. The first talk of the season was by the sculptor Eduardo Paolozzi. It was entitled *Bunk* after one of his collages based on the images of popular culture, and it was the forerunner of the IG's interest in mass media and popular culture. Paolozzi talked little in the lecture, but using an epidiascope he projected a large collection of advertisements and photographs culled from the American popular magazines without explanation. Images of science-fiction car adverts, robots, food, consumer goods and hardware were shown in random juxtaposition to create the impression of a constantly changing collage.

From the time of his stay in Paris between 1947 and 1949, Paolozzi had amassed a vast collection of images from magazines and packaging which he collaged together or stuck unretouched in scrapbooks. Paolozzi was influenced by Dada and Surrealism — he had met Arp and Tzara, and seen Duchamp's work — but had been particularly impressed by Jean Dubuffet whom he had also met in Paris. Dubuffet rejected all conventional notions of 'culture' and 'art' with their connotations of establishment approval and claims to worthiness, and had set about looking for and making *art brut* (raw art). In this alternative art, all talk of aesthetics, formal preconceptions and classical ideals were banished in favour of authenticity, spontaneity and a-formality which, in conventional terms, could be extremmly ugly and sometimes disturbing. Graffiti and the scribblings of children, criminals, degenerates and mental patients were held in high esteem by Dubuffet whose own work showed their influence. That *art brut* is not an isolated tendency in the art of the later 1940s and early 1950s is affirmed by Michel Tapié's book *Un art autre*, published in 1952, which contained a number of individuals (including Jackson Pollock for the a-formality of his drip paintings) whose work was considered to be in opposition to established conventions.

At this time, Paolozzi's sculpture was inspired by Dubuffet. But Paolozzi's collages show a wider Surrealist influence, and anticipate Pop in the use of the imagery of popular culture.

Eduardo Paolozzi, Bunk collage. The assemblage of random images in this collage paralleled Paolozzi's Independent Group lecture.

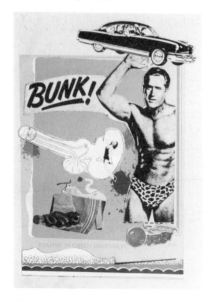

'Parallel of Life and Art', 1953

In 1953 there were no IG talks but some of the IG members worked on the 'Parallel of Life and Art' exhibition held at the ICA. 'Parallel of Life and Art' contained 122 large, grainy-textured photographs of machines, slow-motion studies, X-rays, high speed and stress structures, anthropology and children's art. These images were displayed from the walls, ceiling and floor, and the

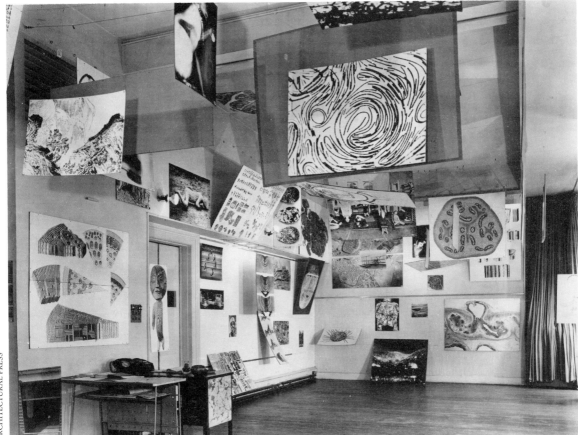

subject-matter was presented, in accordance with the *art autre* tendency of the time, in a non-hierarchic way. The only 'art' imagery was a photograph of Jackson Pollock at work. Paolozzi, the photographer Nigel Henderson, and the New Brutalist architects, Peter and Alison Smithson, organised the exhibition which was conceived as an extension of their personal scrapbooks. Paolozzi's scrapbooks were well known among the group, and the Smithsons had also been collecting advertisements and images from popular culture, scientific and technical journals.

Parallel of Life and Art exhibition, 1953. The organisers, who included members of the Independent Group, arranged the eclectic mixture of images in an environmental and consciously non-hierarchic way.

New Recruits

To counter accusations of exclusiveness, in 1953 the ICA organised a series of seminars, which were open to subscribers, entitled 'Seminars in the Aesthetic Problems of Contemporary Art' and chaired by the art critic, Robert Melville.

Contemporary art movements, such as Abstract Expressionism, usually dismissed by the conservative British art establishment, were discussed. The IG gained several new members from the seminars including the critic Lawrence Alloway, artist John McHale, and the Cordells — musician Frank and artist Magda.

The new recruits became stalwarts of the second and final IG series of seminars which took place in the winter of 1954–55. McHale and Alloway became joint conveners and the emphasis of the meetings shifted from technology to communications, art and popular culture (or 'pop' as the IG members often referred to it). Topics included Richard Hamilton's current exhibition, communications theory, fashion (by Toni del Renzio); pop music (by Frank 'the man behind Alma Cogan' Cordell), American advertisements and architecture (by the Smithsons), consumer goods (by Hamilton), and the symbolism of Detroit car styling (by Banham). And continuing the interest in anti-art and alternatives to logical order, Alloway and Edward Wright addressed the question: 'Were the Dadaists Non-Aristotelean?' The presenters argued that the Dadaists subverted normal hierarchical forms of categorisation by recontextualising or re-ordering objects in new relationships, an idea influenced by AE van Vogt's 1948 *The World of Null-A* — Null-A meaning non-Aristotelian — which had appeared in serial form in *Astounding Science Fiction* in the early 1940s.

It was only when pet subjects were aired that IG members became aware of their shared interests and enthusiasms. Lawrence Alloway recalls that a section of the IG suddenly realised that they

> '. . . had in common a vernacular culture that persisted beyond any special interest or skills in art, architecture, design, or art criticism that any of us might possess. The area of contact was mass-produced urban culture: movies, advertising, science-fiction, Pop music. We felt none of the dislike of commercial culture standards amongst most intellectuals, but accepted it as fact, discussed it in detail, and consumed it enthusiastically. One result of our discussion was to take Pop culture out of the realm of 'escapism', 'sheer entertainment', 'relaxation' and to treat it with the seriousness of art. These interests put us in opposition both to the supporters of indigenous folk art and to the anti-American opinion in Britain.'[5]

[5] Alloway 'The Development of British Pop' in Lippard 1966, pp 31–32.

The isolation of the IG intellectually and aesthetically, remembering the climate in Britain at that time, was not exaggerated by Alloway. The role the two series of IG seminars played was major, providing both an intellectually supportive environment and an opportunity to test out ideas.

The Mass Media Age

British intellectuals and cultural critics could not believe that anyone should take popular culture seriously and accused the IG of sophisticated meddling with unsophisticated tastes. The group denied the accusation and pointed out that popular culture was a natural part of their backgrounds. Banham explained that they were:

'. . . all brought up in the Pop belt somewhere. American films and magazines were the only live culture we knew as kids — I have a crystal clear memory of myself, aged sixteen [1938] reading a copy of *Fantastic Stories* while waiting to go on in the school play, which was Fielding's *Tom Thumb the Great*, and deriving equal pleasure from the *recherché* literature I should shortly be performing, and the equally far out pulp in my mind. We returned to Pop in the early 'fifties like Behans going to Dublin or Thomases to Llaregub, back to our native literature, our native arts.'[6]

Alloway agreed: 'the mass media were established as a natural environment by the time we could see them.'[7] This immersion in popular culture was genuine; not all of the IG had backgrounds typical of academics or cultural critics. Banham was born in 1922 and had gone to the Courtauld Institute after the war but originally had left school early to go into industry; Hamilton, also born in 1922, had been a jig and tool draughtsman at EMI; Paolozzi was born in 1924 in Edinburgh of Italian parents, an ice-cream family. For Banham the retention of a 'common touch' had mean that, unlike the cultural critics, the IG were not '. . . isolated from humanity by the Humanities . . .'.[8]

The IG and the cultural critics were in fundamental disagreement about the desirability of the mass-media age. Whereas the cultural critics wanted a return to the halcyon days of cultural stability, the IG embraced the new age. The explosion of the mass media meant that the information, knowledge, news and imagery that for centuries had been the preserve of a few became available to the majority of citizens in the industrialised world. 'Ordinary' people were as likely to know about world events, the latest technological advances and artistic achievements as the privileged few, the traditional holders of power. Technology had made this possible; it was transforming the existences of ordinary people. Reyner Banham cited a telling example:

'Even a man who does not possess an electric razor is likely . . . to dispense some previously inconceivable product, such as an aerosol shaving cream, from an equally unprecedented pressurised container, and accept with equanimity the fact that he can afford to throw away, regularly, cutting-edges that previous generations would have nursed for years.'[9]

When such examples were multiplied across the spectrum of daily living it was clear to Banham that '. . . science and technology . . . have powerfully affected human life, and opened up new paths of choice in the ordering of our collective destiny.'[10]

6 Banham 'Who is this Pop?' *Motif* number 10 1962/63, p 13.

7 Alloway 'Personal Statement' *Ark* number 19 1957, p 28.

8 Banham 'Pop and the Body Critical' *New Society* 16 December 1965, p 25.

9 Banham 1960, p 9.

10 ibid, p 9.

Homo Ludens and Specialist Leisure

For the IG and other technological progressivists, there was a logical development from the elimination of drudgery to the attainment of nirvana. It was only a matter of time before man would be freed from the anxiety of survival, primary needs or the constraints of work to exploit his creative potential. This concept of *Homo ludens* was outlined by John Huizinga in his book of the same

title first published in 1944. Huizinga studied the element of play in culture and found it to be necessary, constant and inherent in man. The rapid technological progress and marked increase in personal wealth in America after the war were seen as portents for the change in man from *Homo sapiens* to *Homo ludens*. Society was shifting from an organisation and structure based on work, to one predominantly based on leisure. Accordingly, the concept of leisure had to be redefined: no longer should it be seen as time left over from work; it had to be treated as an important part of daily life. Alloway gave an example of the enhanced status of leisure:

> 'Once detective fiction . . . was read for relaxation; now leisure occupations, reading, music, movie-going, dressing, are brought up into the same dimensions of skills as work which once stood alone as serious activity.'[11]

[11] Alloway 'Notes on Abstract Art and the Mass Media' *Art* 27 February/12 March 1960, p 3.

Education for leisure was as important as education for work and eventually it would be reflected in the school curriculum. Technology was to thank for the conquering of work and the provision of the adult playground. The political implications of a high-technology society — especially the issue of ownership and control within a capitalist system — were largely ignored by the IG.

The cultural critics feared that the depersonalisation perpetrated by the mass media would dull the public's sensibility and receptiveness, leaving it emotionally and aesthetically lifeless and ripe for exploitation. The IG were dismissive of this attitude; the public was neither mindless nor gullible. Banham emphatically claimed the public could not be manipulated against its will:

> 'That there is commercial exploitation in pop culture nobody in his right mind would deny, but there has to be something else underneath, some sub-stratum of genuine feeling, a genuine desire for the thing, which has to be touched off before the market will really move.'[12]

[12] Banham 'The Atavism of the Short-Distance Mini-Cyclist' *Living Arts* number 3 1964, p 93.

Nor was the public the unwilling or uncritical recipient of technology, consumerism and the mass media:

> 'When something is so largely consumed with such enthusiasm and such passion as many aspects of pop culture are, then I don't think any social critic in his right mind should simply reject it as being a load of rubbish or even the opium of the people.'[13]

[13] ibid, p 95.

Indeed, alienation did not seem to be common (except among cultural critics), largely because the mass media were not as impersonal as the critics suggested. This supposed 'impersonality', the IG believed, was an emotive reaction to the word 'mass'. Once the mass media were scrutinised they sub-divided into innumerable specialised interests that encouraged individual differences: 'The audience today', Alloway wrote, 'is numerically dense but highly specialised . . . by age, sex, hobby, occupation, mobility, contacts, etc.'[14] Even within a specialism there were different emphases: for example, *Astounding Science Fiction* was for scientifically and technically minded readers, whereas *Galaxy Science Fiction* tended towards a dramatic storyline.[15] This diversity, it was

[14] Alloway 'The Long Front of Culture' *Cambridge Opinion* number 17 1959, p 25.

[15] McHale 'The Expendable Ikon — 1' *Architectural Design* February 1959, p 82.

argued, could not happen in a folk-orientated culture or a pre-mass media culture:

> 'It is not the hand-craft culture which offers a wide choice of goods and services to everybody (teenagers, Mrs Exeter, voyeurs, cyclists), but the industrialised one. As the market gets bigger consumer choice increases: shopping in London is more diverse than in Rome; shopping in New York more diverse than in London. General Motors mass-produced cars according to individual selections of extras and colours.'[16]

16 Alloway 'The Long Front of Culture' op cit p 25.

This argument ignored the danger of monopolistic power and the criticism of the illusionary freedom of capitalist choice.

Criticisms of the IG

The IG was accused of naïvety because its enthusiasm for technology and the mass media did not take into account the social and political conditions in which they were produced. A further accusation was that the group was uncritically pro-American. The two accusations were closely connected. But the IG members were neither naïve nor extreme right wingers. They realised that the American mass media and consumer goods were part of a system and power structure uncompromisingly capitalist. In the late 1960s Banham recalled the problem the IG had of reconciling their '. . . admiration for the immense competence, resourcefulness and creative power of American commercial design with the equally unavoidable disgust at the system that was producing it . . .'.[17]

This led to divided loyalties: '. . . we had this American leaning and yet most of us are in some way Left-orientated, even protest-orientated.'[18] The IG had a dilemma and Banham remembers John McHale saying to Magda Cordell: 'If we go on voting Labour like this we shall destroy our own livelihood!'[19] Of the pre-eminence of American popular culture in their discussions Alloway explained:

17 Banham 'Representations in Protest' *New Society* 8 May 1969, p 718.

18 Banham 'The Ativism of the Short-Distance Mini-Cyclist' op cit p 92.

19 ibid, p 92.

> 'It is not a nostalgia for the US. It is simply that American pop art is a maximum development of a form of communication that is common to all urban people. British pop art is the product of less money, less research, less talent, and it shows.'[20]

20 Alloway 'Notes on Abstract Art and the Mass Media' op cit p 3.

America was the wealthiest and technically most advanced country and as such the natural focus for the IG's attention. But Banham admitted it was not only because of the better popular culture that the IG turned to America, it was also that the

> '. . . gusto and professionalism of wide-screen movies or Detroit car styling was a constant reproach to the Moore-ish yokelry of British sculpture or the affected Piperish gloom of British painting.'[21]

21 Banham 'The Ativism of the Short-Distance Mini-Cyclist' op cit p 22.

This discontentment with what the IG interpreted as British cultural complacency was a sign of the times.

Nevertheless, the IG were accused of romanticising America and its popular culture because it was distant and, in a sense, exotic. That many commodities were still scarce in Britain in the mid 1950s, and that by 1958 only John McHale (of the Alloway, Banham etc strand of the IG) had visited America, reinforced this criticism. The America as viewed by Britons was the America of magazines, advertisements, films, consumer products and television. The imagery *became* America in a way that imagery (or propaganda) of Britain never could because it was always tempered by the reality of living here. Alloway admitted that the IG's perspective was different because of distance:

'We are (a) far enough away from Madison Avenue and Hollywood not to feel threatened (as American intellectuals often do), and (b) near enough (owing to language similarity and consumption rates) to have no ideological block against the content of US popular culture.'[22]

[22] Alloway 'Notes on Abstract Art and the Mass Media' op cit p 3.

The cultural critics may have found Alloway's reasoning somewhat unconvincing. On the other hand, Alloway wondered whether he had '. . . lost more by my taste for the American mass media (which are better than anyone else's) than have those older writers who look to the Mediterranean as the "cradle of civilisation"?'[23]

[23] Alloway 'Personal Statement' op cit p 28.

Alloway was implying that much of the criticism directed at the IG arose because of the intellectual distaste for anything American. Had a European country been the focus of the IG's attention, criticisms would still have been made, but they may not have been as vituperative. For British intellectuals in the 1950s America and culture were mutually exclusive.

A more valid criticism of the IG would have been that the popular culture they discussed — car styling, science fiction, fashion and films — was the best (ie the liveliest and most vital) popular culture of the day, and not necessarily the most typical. Certain areas of conservative popular culture such as 'Coronation Street', cottage-style and neo-Georgian furniture, and romantic novels were ignored. Alloway could make an impressive case for the study of science-fiction illustration on the ground that the currency of the symbols used in magazines

'. . . is an index of the acceptance of technological change by the public in the United States. Science fiction alone does not orientate its readers in a technological and fast-moving culture but it is important among the attitude-forming channels.'[24]

[24] Alloway 'Technology and Sex in Science Fiction' *Ark* number 17 1956, p 20.

He would have found it difficult to make a similar case for soap operas. The American popular culture chosen by the IG illustrated their belief that images and symbolism helped the spectator come to terms with technological change, but, the majority of popular culture was not progressive — it was backward-looking and nostalgic.

Although some of these accusations made about the IG were valid, the critics failed to acknowledge the IG's efforts to understand and evaluate popular culture in a mass-media society. The cultural critics' own evaluations of popular culture were based on immutable *a priori* moral judgements about the society producing it, or pre-mass media criteria that were no longer relevant.

New Criteria for the New Age

Valid judgements about the qualities of popular culture required a suspension of moral judgement on the society that was producing it and a willingness to reconsider evaluative criteria. But these were things that the cultural critics and the design theorists were not prepared to do partly because, wrote Alloway, accustomed to setting moral and aesthetic standards, they

> '. . . no longer possess the power to dominate all aspects of art. . . . It is impossible to see . . . [the mass media] clearly within a code of aesthetics associated with pastoral and upperclass ideas because mass art is urban and democratic.'[25]

25 Alloway 'The Arts and the Mass Media' op cit p 84.

New conditions and artefacts required new criteria. Alloway realised it was futile to ask a conventional music critic for a relevant opinion on Elvis Presley, a literary critic for one on science fiction, or a theatre critic for one on a Hollywood film since the appeal of, for example, Presley was only in small part musical. It was far more to do with gestures expressing a set of attitudes which had to be taken into account.

Each IG member had their own view of what were appropriate criteria with which to judge popular culture. Richard Hamilton analysed the characteristics of Americanised popular culture as:

> 'Popular (designed for a mass audience)
> Transient (short-term solution)
> Expendable (easily forgotten)
> Low Cost
> Mass Produced
> Young (aimed at Youth)
> Witty
> Sexy
> Gimmicky
> Glamorous
> Big Business'[26]

26 Hamilton in a letter to the Smithsons dated 16 January 1957 and included in Hamilton 1983, p 28.

According to this definition, popular culture had nothing in common with the values of 'high' art and design. A theory based on the values of popular culture would have to be radically different from any that had gone before.

Expendability

Banham articulated the problem as he saw it in 1955:

> '. . . we are still making do with Plato because in aesthetics, as in most other things, we still have no formulated intellectual attitudes for living in a throwaway economy. We eagerly consume noisy ephemeridae, here with a bang today, gone without a wimper tomorrow — movies, beach-wear, pulp magazines, this morning's headlines and tomorrow's TV programmes — yet we insist on aesthetic and moral standards hitched to permanency, durability and perennity.'[27]

27 Banham 'Vehicles of Desire' Art number 1, September 1955, p 3.

This pinpointed the main stumbling block for conventional critics of popular culture: the concept of expendability. Banham was resolute in his belief that

'The addition of the word *expendable* to the vocabulary of criticism was essential before Pop art could be faced honestly, since this is the first quality of an object to be consumed.'[28]

[28] Banham 'Who is this Pop?' op cit p 12.

Expendability was widespread in popular culture. The content of the mass media — the plethora of images shown on television and cinema screens and in mass circulation magazines — became almost instantly out of date, as relevant as yesterday's newspaper. The structure behind the novelties may have remained fairly constant (eg a television comedy programme at a certain time each evening; a human interest story each day in the newspaper) but the rapid turnover of images implied, so John McHale believed in 1959, that on the surface of things, '. . . the only real constant is change.'[29] Museums contained rare and precious objects preserved for posterity; popular culture boasted a 'here today, gone tomorrow' attitude.

[29] McHale 'The Expendable Ikon — 1' op cit p 83.

America owed its post-war prosperity to a system based on material expendability, more commonly known as planned obsolescence. The implications for design were major. Every consumer item was designed to last for only a limited period of time. When the item reached the end of its life-span it was thrown away and replaced by an updated model which was equally if not more expendable. It was thought that planned obsolescence, by encouraging consumerism, stimulated trade, expanded the economy, created jobs and increased prosperity. As far as product design was concerned, the result was anti-Modernist in principles, methodology and aesthetics.

Good working order — supposedly the first principle of Modernist design — was not compatible with planned obsolescence. At most, good working order was a short-term attribute that lasted only until the appearance of an updated model or the end of the after-sales guarantee.

The Modernists' design methodology whereby form followed function was also flouted. The form of American consumerist design was seldom the logical outgrowth of functional and utilitarian factors; it was primarily determined by the perceived psychological requirements of the consumer. This resulted in products that were visually extravagant in ornament and decoration, and aesthetically as far from the Modernist virtues of standardisation, simplicity and impersonality as could be imagined.

The American System of Design

The sort of American products Banham and other members of the IG were writing about relied on, in Banham's phrase, '. . . massive impact and small sustaining power . . .'.[30] Manufactured goods designed, styled or packaged in this way made great use of novelties, features, gimmicks, gadgets, extras, and bright colours, which played on emotional, psychological or associational factors (the 'tertiary' function) to increase sales appeal.

[30] Banham 'Who is this Pop?' op cit p 12.

Sales appeal had been the driving force behind American design since the late 1920s. It was during the Depression that manufacturers had begun to realise that appearance could improve sales. This strategy had also led to the beginnings of industrial design.[31] There was no American equivalent to the

[31] see Meikle 1979; and Pulos 1983 chapters 6 and 7.

THE INDEPENDENT GROUP

European tradition of aesthetico-moral reform; the growth of industrial design had resulted from the increase in competition among middle-to-large producers. Books, articles and statements by the first generation of American industrial designers, such as Raymond Loewy, Norman Bel Geddes, Henry Dreyfuss and Walter Dorwin Teague, justified their activities in terms of creating a better world by making products more efficient, easier to operate and more appealing to contemporary taste.

At their worst, they were thinly disguised attempts to increase sales indirectly by reassuring the consumer of the enlightened purpose of the industrial designer and the altruism of the manufacturer. When it came to the issue of abstract aesthetics (which it seldom did) the American designer was outspoken and honest. In a letter to *The Times* in 1945 Loewy outlined his simple but powerful '. . . conception of aesthetics [which] consists of a beautiful sales curve shooting upwards.'[32]

Without the ethical concerns that dictated the European Modernist's design solutions, the American designer's main constraint was that his design had to appeal to the public. To achieve this the American designer took as a starting point symbols that were understood — and enjoyed — by the consumer. In the 1930s those symbols were derived from speed and dynamism, hence the vogue for streamlining.

Streamlining did have some functional justifications. As speeds increased in air, sea, rail and automobile travel, increased efficiency was gained by shaping the container to produce an aerodynamically superior form. The conventional box shape was inefficient because it presented a front buffer that caused turbulence behind. Wind-tunnel tests revealed that a tear-shape with the larger end at the front provided the optimum shape for motion. The streamlining of aeroplanes, boats, trams, and some cars in the 1930s was partly the result of improved efficiency, and partly because it connoted modernity. Streamlining was the catchword and concept of 1930s America. Consumers were promised that streamlining would increase the efficiency of bureaucratic procedures, decrease the delay in bringing goods to consumers, and provide better value for money. The advantage to manufacturers was pinpointed by an astute businessman: '. . . streamlining a product and its method of merchandising is bound to propel it quicker and more profitably through the channels of sales resistance.'[33]

The craze stimulated a wealth of streamlined products for which the style was functionally unnecessary or even wildly inappropriate: radios, electric heaters, vacuum cleaners, irons, toasters, jugs, pans, light-fittings, cash registers, even stapler guns and — a *cause célèbre* — a pencil sharpener.

32 Raymond Loewy in a letter to *The Times* 19 November 1945.

33 William Acker quoted in Meikle 1979, p 72.

Car Styling and Planned Obsolescence

Sales appeal had also been given priority in car design. Before the mid 1920s, styling had been confined to custom cars hand-made for celebrities, but from 1927 General Motors (GM) began to style their mass-produced cars. Harley J Earl was responsible for these visual changes; he had been tempted from a Los Angeles custom-body garage by GM early in 1926. Having arrived in Detroit as a consultant to the Cadillac division, Earl created the 1927 La Salle 'with a new concept in mind: that of unifying the various parts of the car from the standpoint of appearance, of rounding off sharp corners, and of lowering the

55

Raymond Loewy, streamlined pencil sharpener, 1934. Streamlining was applied inappropriately and — as far as Modernists were concerned — immorally to a range of products.

LOEWY INTERNATIONAL

[34] Alfred P Sloan Jnr quoted in Meikle 1979, p 12.

[35] JF McCullough 'Design Review — Cars '59' *Industrial Design* February 1959, p 79.

[36] ibid, p 79.

silhouette.' According to GM's president, the result was 'a production automobile that was as beautiful as the custom cars of the period.'[34] The car sold well and Earl was made director of the new Art and Colour section of GM. Earl had, in effect, a roving commission for the styling of the five GM lines: Cadillac, Pontiac, Buick, Oldsmobile and Chevrolet. In accordance with the idea of product styling and the growth of the industrial design profession in the 1930s, GM renamed their Art and Colour section the Styling Section in 1937.

Early in its history, the car in America had become a commodity to own with pride rather than just a service to use. It was a potent symbol for Americans, and as post-Second World War affluence enabled widespread ownership, the symbolic importance of the car increased; it became the *objet sans pareil* of American consumerism. The big and powerful cars of the 1950s were a manifestation of America's super-power status and worldly confidence '. . . an accurate image', according to one writer, 'of post-war value immortalised in chrome and steel.'[35]

Although Americans were united by a shared pride in their country's international standing, they were (true to their capitalist system) deeply competitive and vied with one another for prestige and status. A gleaming new car may have been a sign of financial success, but the make and model of the car was what really mattered — this announced the owner's position on the social ladder. The American magazine *Industrial Design* summed it up neatly, describing the 1950s car as a '. . . kind of motorised magic carpet on which social egos could ascend.'[36] In the GM stable, the range was spread between Cadillac at the top end and Chevrolet at the bottom. The other three makes — Pontiac, Oldsmobile and Buick — were mid-market. Social mobility was expressed by the make of car you owned and, if you were as status-conscious as society encouraged, you would be satisfied with no less than a Cadillac. In order that this system could be strictly observed and your place on the social ladder unequivocally communicated to others, each make had its own

identity — expressed through styling features — so it could be immediately recognised.

An integral part of the system was the idea of the model change. At regular intervals — and the frequency decreased from three years to two as the decade rolled on — a new model was introduced. The reason for this was economic. In 1955, Earl unashamedly pronounced that, 'Our big job is to hasten obsolescence. In 1934 the average car ownership span was five years; now it is two years. When it is one year, we will have a perfect score.'[37] A model change was an incentive for the consumer to buy a new car even though the existing one might be mechanically sound. This kept market turnover high, companies profitable and ensured full employment and the private prosperity that enabled individuals to afford their new car. Americans were convinced it was their public duty to be good consumers.

[37] ibid, p 79.

The model change made use of both technical and visual features. An abundance of gadgets, all claimed as important innovations, were introduced throughout the 1950s. These ranged from air-conditioning and softer suspension to electric windows and automatic light dimming. However, it was new visual features that ensured sales because they could be *seen* not only by the owner but all the envious would-be owners. These visual changes frequently had their own logic based on evolutionary development. For example, a broad trend in the 1950s was for cars to become lower and longer; regardless of

Cadillac convertible, 1954. The symbolically-loaded American automobile of the 1950s was described as a '. . . kind of motorised magic carpet on which social eggs could ascend.'

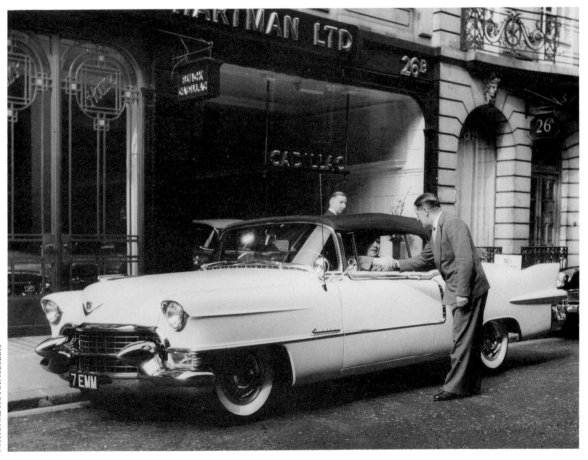

ergonomic considerations, the average car height dropped ten inches between 1950 and 1959. But the pace of evolutionary change was crucial: if it was too slow differences between the last model and the next would not be perceptible (and hence there would be less incentive to buy); if it was too rapid the manufacturer would run the risk of alienating the customers by offering something too novel for their taste and of using in a year or two evolutionary changes that could be spread over a decade. The changes had to be such that the consumer was dissatisfied with last year's model, but not disgraced or embarrassed by it.

Finally, the imagery and symbolism of the car designs, in this decade of American pre-eminence, referred back to power and technology. Jet and space travel were the high technology fantasies of the day and they provided a direct and popular source of styling for the 1950s cars by way of bomb- or breast-shaped chrome protuberances on the grille, giant jet fins at the end of the car, 'ventiports' (hot air extractor holes) on the side of the engine, wrap-around cockpit-like windscreens and science fiction-influenced dashboard and interior displays.

Critics of American Design — Pro and Con

Such styling features filled Banham with admiration and praise:

> 'Unlike European architecture, US car styling seemed to have tapped an inexhaustible supply of new forms and new symbols of speed and power, the sheer aesthetic inventiveness displayed by Detroit designers . . . was a constant reproach to the faltering imagination of European architects and the industrial designers they appeared to admire.'[38]

[38] Banham 1966, p 63.

In his talk on American car styling at the 1954–55 IG session and in a subsequent article, Banham argued that the car stylists of Detroit produced a more popular and democratic type of design than any Modernist could achieve. He anticipated the criticism that designers such as Harley Earl were only stylists rather than 'total' designers by arguing that technology had become so advanced that it was no longer possible for one person to design satisfactorily a complex product. Designers had to specialise and work together in teams, one member of which should be a stylist or 'appearance designer'. This arrangement was more likely to produce design that the public would enjoy and eagerly consume. Certainly neither the Detroit manufacturers nor the public shared the Modernists' aesthetic preference for standardised repetition; by 1954, because of the many colour options and varied trim patterns, it was possible to have each unit of a particular model different from the next. Banham argued that this was not a deceptive choice, but proof that mass production need not *necessarily* lead to Modernist anonymity.

Modernist design critics were horrified that Banham was not only analysing Detroit car design and American popular culture in general, but praising it. In his postscript to Michael Farr's 1955 *Design in British Industry*, Pevsner wrote about three quintessentially American and 'three equally objectionable modes of expression: streamlining, the mouth-organ radiator fronts of motor cars, and multicoloured printed ties.'[39] Pevsner acknowledged that streamlining was '. . . emphatically representative of a certain quality of this

[39] Pevsner in Farr 1955, p 317.

machine age'[40] but he dismissed its non-functional manifestations as an abuse of principles. His objection to the post-war car was that '. . . it symbolises riches and power . . . grossly.'[41] A dubious compliment follows: 'That sort of noisy show comes off in the United States where it is at least in accordance with its people.' A similar objection is raised against multicoloured ties: the ' . . . perfect counterparts to the modern American's middle-class car.'[42] Pevsner's animosity towards these three symbols of American civilisation was because '. . . they are in contradiction to qualities of the British character. To be gross and flamboyant has never been typical of British art and design.'[43]

Pevsner's final observation was right: to those inbred with the traditions of British art and design, and even of European art and design, American consumerist design was alien and a threat to civilised behaviour. The only critic the IG respected when it came to consumer design was an American called Deborah Allen. From its first year of publication, in 1954, to 1959, she annually reviewed the new Detroit models for *Industrial Design*. Allen could not be accused of naïve eulogy; in 1957, for example, she maintained that the new models were '. . . as expensive, fuel-hungry, space-consuming, inconvenient, liable to damage, and subject to speedy obsolescence as they ever have been.'[44] Nor did she reject them out of hand like the British critics. She took the role of what Alloway described as the 'knowing consumer'[45] who accepted Detroit styling in principle and criticised it accordingly, pointing out when it was relatively good or bad. Her belief was that '. . . the automobile designer is deeply and boldly concerned with form as a means of expression — as he should be.'[46] In 1955 Allen described how

'. . . the modern car is designed to look as though it were exploding into space. The visual centre of gravity is no longer at the centre of the car, but at the engine, which means that everything behind the front part must appear to trail off into space. The old streamlined rumps were a fairly literal translation of aerodynamics; today's cars do not try to withstand the effects of speed; they disintegrate, and the cant is a definitive expression of disintegration.'[47]

In the same article she explained that, in the case of the 1955 Plymouth,

'Direction is implied with the familiar devices — higher wheel openings at the front that the rear, the sharp line of the front post, the curved line of the rear post, an emphatic line at the front fender, a slightly raised rear fender, a jagged line at the tail.'[48]

The IG had spotted Allen's writings and were full of praise. Banham, for whom Detroit cars were the '. . . breathless, but unverbalisable consequence to the live culture of the Technological Century',[49] hailed her criticism as

'. . . the stuff of which the aesthetics of expendability will eventually be made. It carried the sense and the dynamism of that extraordinary continuum of emotional-engineering-by-public consent which enables the automobile industry to create vehicles of palpably fulfilled desire.'[50]

40 ibid, p 317.

41 ibid, p 317.

42 ibid, p 318.

43 ibid, p 318.

44 Allen 'Design Review '57' *Industrial Design* number 1 1957, p 103.

45 Alloway 'Artists as Consumers' *Image* number 3, 1961, p 18.

46 Allen 'Design Review '57' op cit p 103.

47 Allen 'Design Review '55' *Industrial Design* number 1 1955, p 85.

48 ibid, p 88.

49 Banham 'Vehicles of Desire' op cit p 3.

50 ibid, p 3.

Banham, in his analyses of American design, had discovered that expendability not only related to the physical properties of an object, but could also refer to its functional, social, stylistic or symbolic aspects. Many American products incorporated two or more of these forms. A new car, for example, had a limited life-span before it broke down or rusted, it might be technologically superseded within a year or two, or it could become 'down-market', visually 'old-fashioned', or outmoded in styling (the symbolism might change from space travel to underwater travel).

Banham and a Theory for Expendability

But Banham's interest in expendability was not confined to his diagnosis of it as the essence of American design. What really intrigued Banham was the continuing relation between expendability and technology. Banham suggested that the attitude towards technology of the vast majority of people — including Modernists — was ill-informed. People needed to realise that expendability was not an evil inflicted upon the masses by conniving manufacturers, but a fact of 20th-century existence.

Banham's theoretical justification for an acceptance of expendability and of design based on popular culture was contained in an article entitled 'Machine Aesthetic' which appeared in the *Architectural Review* in 1955. The author's target was the Purist type-form and the belief that the closer an object is to its most functional shape, the more it exhibits primary forms and, consequently, the cheaper it is to produce. This, Banham asserted, was not necessarily true and in many cases demonstrably untrue:

> '. . . utility is a complex affair which, in certain products for certain markets, may require the addition of ornament for ostentation or social prestige. Similarly, the demands of economic production do not, as the authors of the model supposed, follow the laws of nature, but those of economics, and in fields where the prime factor in costing is the length of the production-run, simplicity, such as would render a handicraft product cheaper, might render a mass-produced one more expensive if it were less saleable than a more complex form.'[51]

[51] Banham 'Machine Aesthetic' *Architectural Review* April 1955, p 255.

Banham was postulating that the Purist characteristics were conditional attributes and not consequences of machine production. The nub of his argument was the relevance of 'primary' and 'secondary' forms. The Purists and Herbert Read had argued that primary (or abstract) forms communicated to everyone, irrespective of culture, race or creed: they were universal and timeless. However, secondary (or humanistic) forms were bounded by time, place and people. Primary forms were absolute, secondary forms were relative. Banham refuted the Modernists' belief in the abstract communicative force of primary forms and argued that the meaningful forms for each society or group were those that embodied the cultural and social milieu: for example the Detroit car in America in the 1950s.

This led Banham to the controversial issue of expendability, which he considered to be a characteristic of contemporary popular culture and the mass media, and at the heart of technology itself. Technology was in a state of continual change as modifications, improvements and inventions occurred.

Furthermore the rate of technological change in the 20th century was constantly accelerating. Expendability of hardware was a consequence of technological progress. Modernists, in seeking to embrace technology and establish a machine aesthetic, had mistaken the technological manifestations of a particular age for the essence of technology. (With the Modernists' interest in Plato it was ironic that they confused the shadow for the reality of technology.) Order, stability, permanence and timelessness are the attributes of a classical aesthetic, not 20th century technology. Modernists could be accused of forcing technology into an established aesthetic mould while claiming they were conjuring up a new aesthetic from the machine.

The 'First Machine Age' and Futurism

The visual and historical coincidences that linked technological products such as motor cars with Phileban solids and the Parthenon in the 1920s had passed by the mid-1930s. In the conclusion to his book *Theory and Design in the First Machine Age*, first published in 1960, Banham continued the theme of his 1955 article:

> 'As soon as performance made it necessary to pack the components of a vehicle into a compact streamlined shell, the visual link between the International Style and technology was broken. . . . Though there was no particular reason why architecture should take note of these developments in another field or necessarily transform itself in step with vehicle technology, one might have expected an art that appeared so emotionally entangled with technology to show some signs of this upheaval.'[52]

[52] Banham 1960, p 328.

The Modernists' lack of understanding had arisen because they identified intellectually, not emotionally with technology. In the light of this premise Banham was, in the 1950s, re-assessing the assumptions and value system underlying Modernism.

Theory and Design in the First Machine Age was a reworking of the doctorate Banham had started in the mid 1950s. The book caused a controversy (so did the doctorate — Pevsner was his tutor) because it confronted the issue of technology and expendability. In so doing, Banham exposed the simplistic and selective story of the development of Modernism as narrated by critics such as Pevsner and Richards. Banham presented a non-conformist view of design in the 'first machine age', a view his detractors claimed had a Futurist bias.

Modernist critics had either ignored or denigrated Futurism. In the original edition of *Pioneers* (1936), Pevsner gave Futurism no more than a footnote. In Sigfried Giedion's 900 page *Space, Time and Architecture* (published in 1941 with three reprintings by the early 1960s) Futurism was allotted four pages of text and two of illustrations (compared with over 70 pages on Le Corbusier); and in *Art and Technics* (1952 and frequently reprinted) Lewis Mumford dismissed Futurism as '. . . a little ridiculous, if not repulsive.'[53] With its celebratory approach to technology and its positive acceptance of change and expendability, Futurism was, if not the documented source, the undoubted spiritual forebear of American 1950s consumerist design and, subsequently, Pop.

[53] Mumford 1952, p 54.

54 F T Marinetti 'The Founding and Manifesto of Futurism' 1909 in Apollonio 1973, p 22.

Futurism dates back to 1909 when FT Marinetti, the founder and chief protagonist of the movement, delivered a series of outspoken and uncompromising manifestos to provoke a reaction in the Italian art world and free, as Marinetti described it, '. . . this land from its smelly gangrene of professors, archaeologists, *ciceroni* and antiquarians.'[54] Like many other artists at that

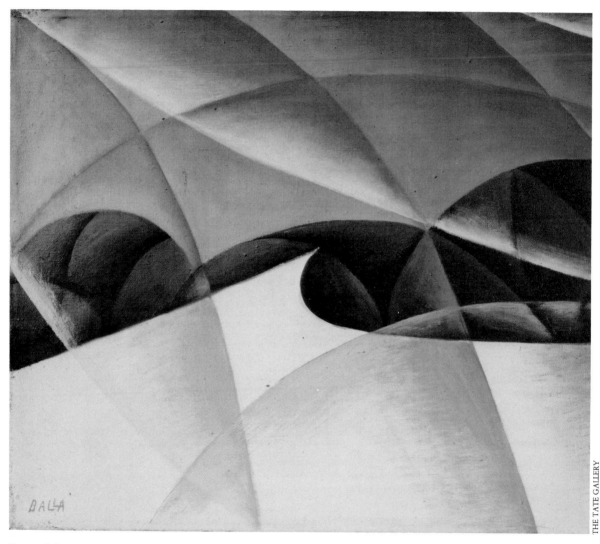

THE TATE GALLERY

Giacomo Balla, Abstract Speed — The Car has Passed, *1913. The Futurists responded emotionally to the machine age and celebrated the experience and sensations provided by machines such as the car.*

time, the Futurists believed they were witnessing the dawning of a millennium. They looked at the machines around them and saw no lessons inherent in the precision of machinery, no mathematical order nor classical harmony, but power, dynamism and excitement of the new technology which should not be observed with the detached air of an academic, but experienced for all its compulsive sensations. Jettisoning the aesthetic and cultural conventions of the past, the Futurists embraced the radically *new* beauty of the 20th century,

'. . . the beauty of speed. A racing car whose hood is adorned with great pipes, like serpents of explosive breath — a roaring car that

seems to ride on grapeshot is more beautiful than the *Victory of Samothrace*.'[55]

[55] ibid, p 21.

The car was held in particularly high regard because it epitomised all that was new and dynamic in 20th-century technology. When driving a car the individual was in control of a powerful and terrifying machine. Marinetti likened it to a wild animal: the '. . . famished roar of automobiles',[56] and described the experience of driving dangerously — and eventually crashing — at speed. The Purists' detached contemplation of a standardised and impersonal machine is transformed into a Nietzschian drama of power and experience.

[56] ibid, p 21.

The more sublime the experience of machines and technology, the more it appealed to the Futurists. Their emotional response is encapsulated in the language and images of the following passage from the 1909 Manifesto:

'We will sing of great crowds excited by work, by pleasure, and by riot; we will sing of the multicoloured, polyphonic tides of revolution in the modern capitals; we will sing of the vibrant nightly fervour of arsenals and shipyards blazing with violent electric moons; greedy railway stations that devour smoke-plumed serpents; factories hung on clouds by the crooked lines of their smoke; bridges that stride the rivers like gymnasts, flashing in the sun with a glitter of knives; adventurous steamers that sniff the horizon; deep chested locomotives whose wheels paw the tracks like the hooves of enormous steel horses bridled by tubing; and the sleek flight of planes whose propellers chatter in the wind like banners and seem to cheer like an enthusiastic crowd.'[57]

[57] ibid, p 22.

This celebratory and romantic spirit infused all the Futurists' outpourings: on painting, sculpture, photography ('photodynamism'), music ('art of noises'), theatre, cinema, and even lust, men's clothing, and the 'Reconstruction of the Universe'. There was no manifesto on design, but the 'Manifesto of Futurist architecture', published in 1914, contained some pertinent remarks on expendability. The manifesto was a reworking by Marinetti of the Foreword to a catalogue for an exhibition of visionary drawings by Antonio Sant' Elia and Mario Chiattone called the 'New City'. The tone of the manifesto echoed that of previous Futurist pronouncements. The 'New City' was urgently needed because the current city belonged to the past:

'As though we — the accumulators and generators of movement, with our mechanical extensions, with the noise and speed of our life — could live in the same streets built for their own needs, by the men of four, five, six centuries ago.'[58]

[58] Sant'Elia 'Manifesto of Futurist Architecture' 1974 in Apollonio 1973, p 34.

A Futurist could no more live in a city built in a bygone age than wear the clothes of yesteryear. The 'kaleidoscope appearance and disappearance of forms'[59] in the machine age required a dynamic approach to building:

[59] ibid, p 34.

'We must invent and rebuild the Futurist city: it must be like an immense, tumultuous, lively, noble work site, dynamic in all its parts; and the Futurist house must be like an enormous machine.

The lifts must not hide like lonely worms in the stair wells; the stairs, become useless, must be done away with and the lifts must climb like serpents of iron and glass up the housefronts. The house of concrete, glass and iron, *without painting* and without sculpture, enriched solely by the innate beauty of its lines and projections, extremely 'ugly' in its mechanical simplicity, high and wide . . . must rise on the edge of a tumultuous abyss: the street . . . will descend into the earth on several levels, will receive the metropolitan traffic and will be linked, for the necessary passage from one to the other, by metal walkways and immensely fast escalators.'[60]

[60] ibid, p 36.

The image of the Futurist city was principally one of movement and excitement. There was no mention of order, only of expressive and dynamic forms: the city is a dynamic work site in a state of flux. The new sensibility expressed itself in a '. . . taste for the light . . . the ephemeral and the swift.'[61] This led to the most radical statement in the manifesto:

[61] ibid, p 36.

'. . . the fundamental charactersitics of Futurist architecture will be obsolescence and transience. Houses will last less long than we. Each generation will have to build its own city.'[62]

[62] ibid, p 38.

Obsolescence and transience had never been elevated to the position of essential characteristics before. The Futurists had squarely come to terms with the idea that technology is in a state of continual change. Sant'Elia's visions remained on paper: he died while on active service in 1916, two years after designing the 'New City'.

Banham tended to overlook Futurism's dubious social and political beliefs. In more recent times, Futurism has been attacked for its links with the Fascist movement and its attitude towards war and women particularly.[63] Such attacks are justified and highlight the values and implications of the darker if not the black-shirted side of Futurism. One historian has criticised Futurism's '. . . romantic and uninformed glorification of the machine (technology) in society . . .'[64]: an understandable view in the light of the rising consciousness about the politics of technology in recent years. Yet it is erroneous to dismiss Futurism's attitude to technology as '*uninformed* glorification', fascist and symptomatic of mindless male aggression. Although such attacks on the Futurists as a group and on Marinetti as an individual can be upheld, it is useful to examine the group's attitude to technological change in an advanced society as one that transcends its particular historical location. Indeed, this is what Banham attempted in the mid to late 1950s and, although Banham's predilections may have been determined by beliefs about technology we now consider to be naïve, the issues he raised made a major contribution to opening up a debate about the relation between cultural and technological habits of thought.

[63] see, eg, Caroline Tisdall and Angelo Bozzolla *Futurism* London, Thames and Hudson 1977.

[64] ibid, p 200.

'Man Machine and Motion', 1955

One of the most tangible influences of Futurism on the thinking of Banham and other members of the IG, notably Richard Hamilton, was the exhibition entitled 'Man Machine and Motion' which followed the second IG session of

1954–55. The exhibition, which was shown in Newcastle (where Hamilton taught at the University)ʹand at the ICA, was a collection of 200 large illustrations — mostly photographs — tracing man's relation with the machines he invented to increase movement and travel. Hamilton was largely responsible for planning the exhibition and Banham contributed to the catalogue.

The man–mechanical theme was a conscious reaction to the 'Growth and Form' exhibition staged by the ICA in 1951 as part of the Festival of Britain. Hamilton had worked on 'Growth and Form' which was concerned with the normally invisible forms of nature as revealed by the microscope. The large illustrations in that exhibition had not been labelled in order to draw attention to formal similarities behind seemingly diverse aspects of nature. The Modernist associations were emphasised by the contributions of Herbert Read who wrote the Foreword to the catalogue and Le Corbusier who opened the exhibition.

Four years later 'Man Machine and Motion' redressed the balance with not only a mechanistic emphasis, but a romantic-Futurist one. In his Introduction to the catalogue, Banham observed that images of early 20th-century technology can be viewed in two ways:

'A photograph of an early aeroplane standing unattended has a distinct and separate beauty: the elaborate geometry of it engages the eye. But when man gets into the machine he gives it quite another meaning. The look of it excites us in a different way, both more intimate, less abstract, and more unexpected.'[65]

[65] Banham 'Man Machine and Motion' exhibition catalogue, London, ICA 1955, np.

Banham went on to leave the reader in no doubt of the Futurist emphasis of the catalogue and exhibition. This new version of man and machines evoked

'Much that is heroic and much that is terrible . . . not only in the sky, but in every street where a boy joins magically with his motor-bicycle, his face whipped by the wind and stiffened by a passion for which we have no name.'[66]

[66] ibid, np.

These phrases are reminiscent of Marinetti's Futurist manifesto, and homage was indeed paid to the Futurists in Banham's Introduction.

A further but less obvious and more sophisticated influence of Futurism on the IG was a change in sensibility; Alloway described it as a shift from Clive Bell's concept of a '. . . disinterested aesthetic faculty, uninvolved with the rest of life, to a descriptive aesthetic which acts not as an ideal but as a commentary on one's experience in the world.'[67]

[67] Alloway quoted in Finch 1969, p 22.

The shift was apparent in the imagery of both 'Man Machine and Motion' and 'Parallel of Life and Art'. The images in these exhibitions were not meant to be mere illustrations of an idea, but emotionally powerful in their own right.

The word 'image' was frequently used by the IG in the mid 1950s, and referred to the evocative power of an illustration, whether figurative or abstract. Three books the IG found particularly stimulating for their images were Sigfried Giedion's *Mechanisation Takes Command* (1948), Amédée Ozenfant's *Foundations of Modern Art* (1931 and reprinted in 1952), and Moholy-Nagy's *The New Vision* (1932 and reprinted in 1946). Alloway recalled how,

'These books were being *read* by the British constructivists at the time (Victor Pasmore, for example), but the artists around the IG valued the illustrations more than the texts, which carried too many slogans about a "modern spirit" and "the integration of the arts" for their taste. It was the visual abundance of these books that was influential, illustrations that ranged freely across sources in art and science . . . I know that what I liked about these books . . . was their acceptance of science and the city, not on a utopian basis, but in terms of fact condensed in vivid imagery.'[68]

[68] Alloway 'The Development of British Pop' in Lippard 1966, p 32-33.

The original Purist bias of the books was discarded by the IG members who viewed them with a more subjective, Futurist bias.

The Futurist Sensibility and its Detractors

The reaction of Modernist critics to Futurism, technological change and expendability was predictable. The debate about the nature of technology was not taken seriously outside IG-influenced circles. The Futurist idea of shedding the cultural 'baggage' was viewed in the same light as a terrorist act; artists had a responsibility to uphold traditional standards, not undermine them. Many critics were more exercised by the attention given to popular culture and the mass media. In the revised edition of *Art and Industry* published in 1956, Herbert Read complained:

'. . . is it really necessary to make a virtue of this vulgar necessity? Such, however, is the affirmation of certain critics, who decry the purists and the traditionalists, and would have the artist and the industrial designer accept the taste of the masses as the expression of a new aesthetic, an art of the people. The supermarket and the bargain basement replace the museums and art galleries as repositories of taste, and any ideals of beauty or truth, refinement or restraint, are dismissed, in the language of the tribe, as "square".'[69]

[69] Read 1934 (1956 edition) p 17.

That this was an attack on IG thinking, was confirmed by a further statement:

'. . . never before our time has this [vulgarism] been presented as a philosophical theory, never before defended by writers clever enough to rationalise the blind instincts of the mob. To such a tendency I suggest that we should oppose and maintain certain principles which can never be abrogated so long as we believe in the dignity of work, the future of civilisation, the worth of life.'[70]

[70] ibid, p 17.

[71] Read speaking at National Union of Teachers 1960, p 155.

According to Read, the mob — that '. . . dull and indifferent public'[71] — were seduced and corrupted by materialism. Such sentiments were detested by the IG for their tone of moral superiority, and underlined that it was not just an aesthetic or approach to design that were at issue, but an attitude to people. For those like Read, however, whose design ideal was the classical calm of timeless Phileban solids, the flamboyant excesses of popular culture were the harbingers of a world of eternal damnation.

The Standards and Values Debate

The essence of the debate was aesthetic standards and values. A Modernist acknowledged only one set of aesthetic values that were universal and absolute: a Detroit car was subject to the same aesthetic laws as a Bauhaus chair. For Banham and the IG, on the other hand, aesthetic values were relative: a Detroit car would be judged by one set of values, a Bauhaus chair by another. As Banham wrote of Detroit car styling in 1955:

> 'It is a design language which can be used badly or well, but the good and the bad are not identified by applying to it tests which are not germane to it, and to set up an exclusive standard, which is what any universal criterion of taste like the Machine Aesthetic must eventually become, is simply to deny ourselves the enriched experience which a variety of product aesthetics can offer . . .'.[72]

[72] Banham 'New Look in Cruiserweights' *Ark* number 16, February 1956, pp 44-47.

But the acceptance of different value sets did not satisfy the IG; of crucial importance was the ordering of these sets within an overall value system. The Modernist might claim to accept two (or more) sets, but these would be strictly ordered in a hierarchical structure with the 'high' art set at the top and the 'low' art set at the bottom. The high art set would be classed as serious and worthwhile, the low art set trivial and of no real value. The radical implication of the IG's thinking was the rejection of ordering value sets in a hierarchical structure.

The IG were not in agreement on the structure to replace the hierarchy. Alloway proposed a '. . . unifying but tolerant aesthetic . . .': a continuum.[73] 'Tolerant' because it included high culture at one end and popular culture at the other; 'unifying' because it treated all culture in sociological terms of meaning, content and symbol. Hamilton suggested a structure in which '. . . each of society's members accepts the convenience of different values for different groups and different occasions'[74], in other words, appropriateness for a particular group at a particular time in a particular place. This conclusion was significantly different from the 'tolerant aesthetic' of Alloway's continuum. The relativity of the 'appropriateness' theory implied several hierarchies, one for fine art, one for popular culture, one for folk, and so on. Each of the several hierarchies was equal in status and so, as McHale pointed out,

[73] Alloway 'Personal Statement' op cit p 28.

[74] Hamilton speaking at National Union of Teachers 1960, p 136.

> '. . . there is no inherent value contradiction implied in enjoying Bach and the Beatles. The situation is characteristically "*both/ and*" rather than "*either/or*".'[75]

[75] McHale 'The Plastic Parthenon' in Dorfles 1969, p 101.

Although none of the IG used the term, Hamilton was proposing a 'plurality of hierarchies'. The conceptual framework in which the Pop movement flourished in the 1960s was now established. Important as this outcome was, the IG's deliberations did not lead only to a conceptual framework for Pop. Ideas were generated which shaped or affected artistic practice in both art and architecture.

The Smithsons and 'Architecture as a Consumer Product'

In the case of Peter and Alison Smithson, the IG's interest in advanced technology, Americana and advertising led to an investigation of architecture as a consumer product. In 1956 they wrote:

[76] A and P Smithson 'But Today We Collect Ads' *Ark* November 1956, p 49.

'Gropius wrote a book on grain silos, Le Corbusier one on aeroplanes, and Charlotte Perriand brought a new object to the office every morning; but today we collect ads.'[76]

In other words, the 1950s equivalent to 1920s 'noble source' engineering was advertisements. In the 1954–55 IG season, the Smithsons had given a lecture on the gulf between consumer ideals and conventional architectural solutions in which they claimed

'Mass production advertising is establishing our whole pattern of life — principles, morals, aims, aspirations and standard of living. We must somehow get the measure of this intervention if we are to match its powerful and exciting impulses with our own.'[77]

[77] ibid, p 50.

According to the Smithsons,

'As far as architecture was concerned, the mass production industries had already revolutionised half the house — the kitchen, bathroom, laundry, garage — without the intervention of the architect, and the curtain wall and the modular pre-fabricated building were causing us to revise our attitude to the relationship between architect and industrial production.'[78]

[78] A and P Smithson 1973, p 12.

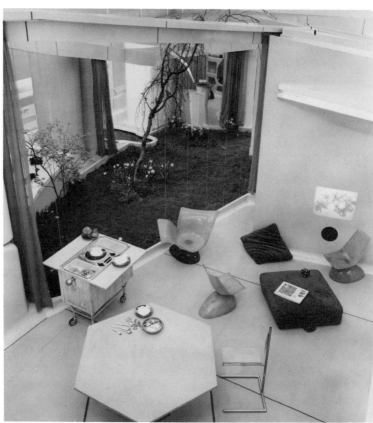

Alison and Peter Smithson, House of the Future, 1956. The idea of a house as a fashionably styled and carefully packaged consumer product reflected the Smithsons' involvement with popular culture.

DESIGN COUNCIL

Their 'House of the Future', commissioned for the 1956 Ideal Home Exhibition, grew from these ideas and was an ingenious mixture of building industrialisation and Detroit-influenced car styling. The components that comprised the 'House' were mass-produced but, as with car production, each component was used only once in each unit (house). This solved the problem of industrialisation leading to repetition and standardisation — visual dullness. With the Smithsons' approach, there was the possibility for an annual model change and even customisation from a kit of parts. The structure of the 'House' was a smooth plastic shell moulded in the minimum number of parts that could be easily transported. There were no external windows, so that house units could be grouped densely together, but windows around the inner wall of the 'House' looked on to an enclosed garden-patio to maintain privacy. Within the building was a range of up-to-date services, technical equipment, and space-age gadgets including an 'Electro-static dust collector' and an adjustable height table which could be raised out of, and returned flush with the floor. The services included a kitchen module with some built-in cooking equipment, and a bathroom module. Most of the technical equipment was mobile and included cooking equipment (pans with a built-in heating element) and a service trolley (housing television and radio).

The lay-out of the building was radically affected by the sophisticated technology. New and synthetic materials made the provision of specialist work surfaces unnecessary, and pre-cooked, deep-frozen foods did not require a large preparation area in the kitchen module. This resulted in '. . . a total shift away from "room" fixation.'[79] Spaces were flexible and multi-purpose. Apart from the service cores, anything could happen anywhere. The styling of the 'House' was designed with the consumer in mind, and features were included — for example, a chrome strip on the exterior of the building (which recalled car styling) — to make the product fashionable and desirable.

The 'House of the Future' reflected the two interlocking interests of the IG: up-to-date technology and popular culture. The Smithsons were designing a building in response to the potential of modern technology which, as they had argued in their 1954–55 IG lecture, was revolutionising architecture. Furthermore, the appearance of the 'House of the Future' was as fashion-conscious as a well-styled industrial product and acknowledged consumer expectations.

The Smithsons continued their research into technology and architecture with two 'Appliance Houses', which could be mass produced by advanced technological means, capable of dense grouping, and 'contain a glamour factor'[80] to ensure their appeal to consumers. The 'Snowball' house would be a mass-produced and expendable building; the 'Strip' house would be built of individual components (bricks, baths, etc) that could be mass-produced and combined with individually selected or custom-made extras. The interrelation of technology and popular culture was not the Smithsons' sole concern at this time. Their interest in New Brutalism, although related to their Pop architecture in so much as both were attempts at understanding the reality of people's aspirations, did eventually take them in a different direction.

[79] A and P Smithson 'The Future of Furniture' *Architectural Design* April 1958, p 176.

[80] ibid, p 177.

'This Is Tomorrow', 1956

The shift from the slickness of technology and popular culture to a sometimes rather 'folksy' version of Brutalism was highlighted at the celebrated 1956 exhi-

bition 'This Is Tomorow', held at the Whitechapel Art Gallery. The original idea for the exhibition came from *La Group Espace* in Paris who were in favour of an integration of the arts similar to that of the Bauhaus. However, the English artists and architects, as Alloway stated in the Introduction to the exhibition catalogue, '. . . do not agree on any universal design principle [and] would not submit to the dogmatic ideas of synthesis held by La Groupe Espace.'[81] Their idea of collaboration, he believed, was derived from a fiction of the Middle Ages. In its place Alloway suggested 'antagonistic co-operation'[82] — a collaboration maintaining diversity, discord, excitement and 'rough edges' akin to the bustle of Futurist life.

Twelve groups of three members, a painter, sculptor, and an architect, were formed, and each designed an environmental exhibit inside the gallery. The results ranged widely. A number of groups, including the Kenneth and Mary Martin team, designed sculptural architecture in a Constructivist style in sympathy with the original proposal by *La Group Espace*. But two of the exhibits departed significantly from conventional notions. Eduardo Paolozzi, Nigel Henderson and the Smithsons constructed a 'Patio and Pavilion' which, inspired by the way people use their backyard sheds for a diversity of leisure pursuits, was a copy of the shed in Henderson's backyard in Bethnal Green. Objects, including a bicycle tyre, tools, pin-ups and rocks — the debris of daily life — were scattered around the exhibit. 'Patio and Pavilion' was intended as a symbolic display of basic needs that were everyday and unheroic. This commonplace exhibit revealed a Brutalist attitude.

The exhibit that has become most closely associated with 'This Is Tomorrow' was the environment constructed by Richard Hamilton, John McHale and architect John Voelcker. The space was divided into two sections and incorporated two themes: visual effects and popular images. The flat plane of a wall on the left of the space was contradicted by black and white undulating patterns (influenced by Josef Albers), and the spectator moved towards several Duchamp 'rotorelief' discs in motion which further confused perception. To the right of the environment was a collection of popular imagery ranging from an American juke box which played contemporary hits, to a sixteen-foot robot with flashing eyes, named Robby, who was carrying off an unconscious about-to-be-ravished young woman. Robby had starred in the science-fiction film 'The Forbidden Planet' (US 1956), and the cardboard cut-out had been used as a publicity attraction outside the London Pavilion cinema. There was a life-size photograph of Marilyn Monroe with her skirt blown upwards — a famous moment from 'The Seven Year Itch' (US 1955) — and a six-foot-high close-up of spaghetti, which reflected John McHale's interest in the imagery of food. An enclosed section included a large photograph of a face on which the senses were labelled. The spectator then entered an inner space — a small 'total environment' where the senses were bombarded by cinema projections, scents, a simulated science-fiction space capsule with monsters peering through the windows, a floor of dribbled fluorescent paint seen in black light, and varying floor textures. These visual ambiguities and the facets of popular culture anticipated the two main art movements of the following decade, Op and Pop.

Many visitors assumed the exhibit to be neo-Dada, ironic and provocative. The real intention, according to Hamilton, was a '. . . concentration of the sensory effects of the [current] environment.'[83] Hamilton expressed the opinion that,

[81] Alloway 'This Is Tomorrow' Whitechapel Gallery Catalogue 1956, np.

[82] ibid, np.

[83] Hamilton in 'This Is Tomorrow' catalogue op cit np.

'We reject the notion that "tomorrow" can be expressed through the presentation of rigid formal concepts. Tomorrow can only extend the range of the present body of visual experience. What is needed is not a definition of meaningful imagery but the development of our perceptive potentialities to accept and utilise the continual enrichment of visual material.'[84]

84 ibid, np.

Their exhibit was not a programme, but a sample of the sensory bombardment that was the reality of modern life.

Hamilton and Pop Art

'This Is Tomorrow' is remembered in the art history books as the exhibition where the study of popular culture ceased to be an avant-garde activity. It is also where, in the form of Hamilton's collage *Just what is it that makes todays home so different, so appealing?*, Pop Art began.

Each team in the exhibition was asked to design a poster to reflect their stance. *Just what is it* . . . illustrated what Hamilton felt were the essential ingredients of American popular culture in 1956. His method was to draw up a list of categories — man, woman, food, history, newspapers, cinemas, domestic appliances, cars, space, comics, television, and information — and then find images in American magazines typical of each (the title for the piece was found during this process). There was no shortage of source material; John McHale, who had won a Yale Fellowship and had spent some of 1955 and 1956 in America, had brought back a trunk full of American popular magazines. McHale made his own series of collages which were Dubuffet-influenced figures composed of miscellaneous gadgets, food advertisements and machinery updating Arcimboldo's 16th-century figures composed of fruit and vegetables. The success of the collage indicated a way in which popular culture could be used by the fine artist. Paolozzi had used much the same technique in his collages from 1947 onwards, but *Just what is it* . . . made a greater impression on historians and critics because Hamilton (somewhat ironically given the IG's call for emotional involvement and a rejection of aesthetic detachment) worked in a more systematic way and was willing to detail his aims and methods carefully. Furthermore, Paolozzi's work lacked the context 'This Is Tomorrow' provided for Hamilton's collage.

Hamilton produced a number of paintings following on from *Just what is it* . . ., which made use of American product styling, advertising imagery and advertising techniques. Hamilton looked upon these paintings not as a way of '. . . finding art forms but [as] an examination of values' — art as visual research.[85] *Hommage à Chrysler Corp* (1957–58) reveals a debt to the IG in general and Banham's investigations into car styling in particular. The painting was, Hamilton explained,

85 Hamilton quoted in Guggenheim 1973, p 24.

'. . . a compilation of themes derived from the glossies. The main motif, the vehicle, breaks down into an anthology of presentation techniques. One passage, for example, runs from a prim emulation of in-focus photographed gloss to an artist's representation of chrome to ad-mans sign meaning 'chrome'. Pieces are taken from Chrysler's Plymouth and Imperial ads, there is some General

Richard Hamilton, Just what is it that makes today's home so different, so appealing?, 1956. This small collage, used as a poster for the 'This is Tomorrow' exhibition, resulted from Hamilton's visual analysis of contemporary popular culture. It illustrates his notion of art as an '. . . examination of values.'

Motors material and a bit of Pontiac. The total effect of Bug Eyed Monster was encouraged in a patronising sort of way.'[86]

Typical of most car advertisements, a woman was represented in the painting '. . . engaged in a display of affection for the vehicle. She is constructed from two main elements — the Exquisite Form Bra diagram and Voluptua's lips.'[87] Other paintings researched and executed in a similar way — *Hers is a lush situation* (1957–58) and *$he* (1958) for example — were produced in the late 1950s.

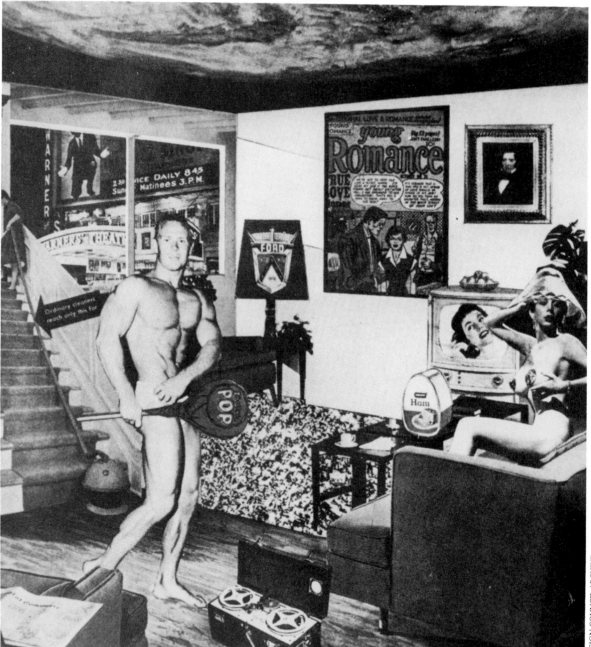

A full explanation of each painting was usually published in a sympathetic journal such as *Architectural Design*.

Many critics interpreted this series of paintings as satirical and felt they contained veiled criticisms. Some years later Hamilton emphasised that 'neither the titles nor the pictures were satirical. They are intended to be witty but not without a certain affection for the institutions and social mores they feed upon.'[88] Hamilton was playing the role of Alloway's 'knowing consumer'[89], which accorded with Hamilton's view that 'an ideal culture, in my terms, is one in which awareness of its condition is universal.'[90] In other words, consumers were not manipulated but able to 'read' and understand the objects and symbols of their culture.

Hamilton's carefully engineered pictures were clearly descended from the IG's discussions. Paolozzi's work in the late 1950s, however, became less concerned with popular culture and moved towards the fine-art equivalent of New Brutalism; his roughly hewn figures owed more to Dubuffet than science fiction, although his later work did return to popular culture roots.

The Contribution of the IG

The impact of the mass media on everyday life was such that many artists at the same time in places as far apart as America and Europe were responding to the new phenomena. This does not belittle the importance of the IG, rather it underlines the authenticity of Pop art as a movement. Nonetheless the direct influence of the IG on British Pop through the work and ideas of Richard Hamilton and, to a lesser extent, Eduardo Paolozzi cannot be denied. Hamilton's attitude towards and approach to subject matter was profoundly influenced by the IG's deliberations on popular culture. The IG's activities encouraged him to question nothing less than the role and position of fine art in a mass-media age (just as they stimulated the Smithsons to question architecture's role). In 1961 Hamilton wrote:

'It is the *Playboy* 'Playmate of the Month' pull-out pin-up which provides us with the closest contemporary equivalent of the odalisque in painting. Automobile body stylists have absorbed the symbolism of the space age more successfully than any artist. Social comment is left to comic strip and TV. Epic has become synonymous with a certain kind of film and the heroic archetype is now buried deep in movie lore. If the artist is not to lose much of his ancient purpose he may have to plunder the popular arts to recover the imagery which is his rightful inheritance.'[91]

This led Hamilton to use the imagery of popular culture as subject matter: to make, in the artist's words, '... fine art works about popular art phenomena'.[92] In that they are unique works of fine art, the paintings of Hamilton and Pop generally are ultimately closer to the Western tradition of high art than the expendable mass-produced ephemeras of popular culture. And yet their value is undiminished; Hamilton's works, like the discussions of the IG which so shaped them, are diagnostic and didactic, a step towards that ideal culture in which there is universal awareness of its conditions.

[86] Hamilton ' *Hommage à Chrysler Corp*' *Architectural Design* March 1958, pp 120-21.

[87] ibid, p 121.

[88] Hamilton quoted in Guggenheim 1973, p 45.

[89] Alloway 'Artists as Consumers' op cit p 18.

[90] Hamilton speaking at National Union of Teachers 1960, p 136.

[91] Hamilton 'For the Finest Art Try — POP' *Gazette* number 1 1961, p 148.

[92] Hamilton quoted in Guggenheim 1973, p 45.

The Growth of Pop

Hamilton's mode of Pop art was not the only one in currency by the end of the 1950s. Although he had no contact with the IG and never visited any of their exhibitions, Peter Blake was producing paintings and collages that could also be categorised as Pop. Whereas Hamilton continued to look towards American popular culture as his source, Blake showed a greater awareness of the incipient British Pop music scene with its teenage stars like Marty Wilde. Blake was not a Pop fan himself and, when asked about the latest idol Cliff Richard, he replied:

> 'I've never actually seen him in the flesh and don't particularly go for his type of music — I prefer modern jazz myself — but I'm a fan of the legend rather than of the person.'[93]

93 Blake quoted in Hamburg 1976, p 32.

However, Blake's subject matter does reflect the changes that were taking place in Britain: Pop culture had arrived and with it the teenager. Popular culture had become 'Early Pop'.

EARLY POP

Rebels From America

Early Pop was essentially American and many of its most salient characteristics were concentrated into a little under two hours — the running time of 'Rebel Without a Cause', the celebrated cult-movie that deified its star, James Dean. Although his first major film, 'East of Eden' (released in 1954), had established Dean's image as an ill-tempered adolescent rebel, its setting in a Californian farming valley in 1913 diminished its meaning and relevance for the young. But 'Rebel Without a Cause' (1955), set in the consumerist middle-class America of the mid 1950s, permitted the young full identification and empathy.

Dean was cast as Jim, the disillusioned and angry son of a comfortable and complacent family. Desperate to escape the deadening conformity of his home and parents, Jim tempts fate by getting on the wrong side of a local gang. The antagonism ends with the famous 'chicken run' sequence in which the gang leader and Jim challenge one another to test whose nerve will break first as they both drive towards a cliff's edge. 'Rebel Without a Cause' presented a glamorous lifestyle of driving fast and living dangerously, rebelliousness, taking chances and living for kicks. Here was youth as a way of living, a way of being.

Dean's looks and behaviour were perfect for this image. A contemporary American poet wrote of Dean's '. . . resentful hair . . . the deep eyes floating in lonesomeness, the bitter beat look [and] the scorn on the lip.[1] Dean's style had been shaped by the Actor's Studio in New York where he had learned 'whole body acting' — the use of body and gestures — to enhance the realism of characterisation. Where James Dean the actor ended and Jim the character began is blurred by a mixture of truth and myth. Dean's own behaviour and lifestyle — contempt for his elders, insults to his co-stars or his love of motor-racing and fast living — seemed no more than a magnification of Jim's rebelliousness and street-wise existence. Dean remains the personification of the 1950s American adolescent; his death at the age of 24, when his Porsche collided with another car on the way to a motor-racing meeting, ensured the preservation of his image. This death had not been premature but confirmation that the stance of anger and revolt belonged to the young. Growing old was a compromise, and Dean's death was as important to the incipient youth culture as his life. He was Pop's prologue.

Some aspects of 'Rebel Without a Cause' are typical of Pop: the opposition to parental and adult authority and the feeling of belonging to an emerging and urgent generation. Other aspects of the film reveal more about Early Pop: that it was primarily an American phenomenon — the adolescents in the film are 'spoilt' by contemporary British standards and affluent by any standards, helping themselves to their parents' cars and consumer goods to counteract the boredom of their increased leisure time.

[1] John don Passos quoted in Lewis 1978, p 125.

Teenage Affluence

Indeed, whether it was in America or Britain, never before had the young enjoyed the purchasing power to assert themselves in economic terms and it was

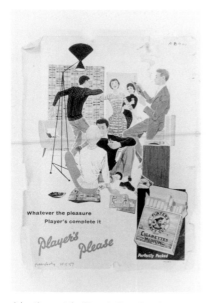

Advertisement for Player's Navy Cut cigarettes, 1957. Affluence led to the establishment of teenagers as a distinct group in Britain in the later 1950s, a group that advertising was quick to exploit.

[2] see Mark Abrams *Teenage Consumer Spending in London* 1961.

[3] Hoggart 1957 (1958 edition) p 340.

at this time that the term 'teenager' came into linguistic currency to describe this post-school but pre-responsibility age-group. A survey conducted in 1959 revealed that 80% of British teenagers were at work. But what was most significant was the disproportionate amount of money that teenagers had to spend on leisure and entertainment.[2] Because they were unlikely to have a family to support or a house to maintain, their money was largely their own, and collectively this amounted to approximately £830 000 000 in 1959. Consequently, teenagers could lavish money on clothes, cigarettes, drink, cosmetics, personal transport, and records.

Teenage affluence was a symptom of full employment. The average real wage of an adult worker increased by 25% between 1938 and 1958, whereas the average real wage of a teenager increased by 50%. Unlike previous generations of youngsters, the new young did not have to donate their earnings to help keep their families above the breadline because their parents were also relatively affluent. British teenagers of the late 1950s grew up in an atmosphere not of 1930s unemployment and poverty, nor of 1940s war and strife, but of the caring Welfare State and relative prosperity. What previous generations would have counted a privilege, teenagers thought of as their birthright. But, instead of expressing their gratitude, it seemed that teenagers wanted arrogantly to assert their ill-considered views.

This was the viewpoint put forward by Richard Hoggart who was alarmed that British youth was becoming like American youth, learning about American adolescent attitudes and opinions through such depersonalised and indoctrinating mass media as film with — in the case of 'Rebel Without a Cause' — its lush Warnercolour and seductive Cinemascope vision. Such debased entertainments, Hoggart warned, '. . . are full of a corrupt brightness, of improper appeals and moral evasions.'[3] Hoggart could have intended his warning to apply to either the medium of film or the content of 'Rebel Without a Cause': either way British youth were deaf to his message.

James Dean had given youth an attitude, a stance that became a kind of *Weltanschauung*. And what that *Weltanschauung* lacked in substance it made up for in style. Now that teenagers had rebelled against their elders they wanted their own culture they could find refuge in, their *own* tastes that *belonged* to them. In Early Pop that culture resided in music and clothes.

Rock 'n' Roll

Rock 'n' roll music fitted youth's new mood perfectly. The first major rock 'n' roll hit was Bill Haley's 'Rock Around the Clock'. It entered the American top twenty in May 1955 and stayed there for 22 weeks, eight of which were at number one. A few months later it entered the British top twenty for 17 weeks, with five of those at number one. To capitalise on the enormous success of the group and its sound, a film was hastily released in 1956. Neither Bill Haley nor any of his Comets had the looks, let alone the charisma of James Dean, but the combination of the energetic beat, raucous saxophone and shouted lyrics of their music, and the 'zany' behaviour and loud tartan jackets of Haley's band was inflammatory. Wildly enthusiastic audiences occasionally followed dancing in the aisles with the slashing and, in some cases, ripping out of cinema seats. Sixty youths were charged with rioting, and 12 towns banned the film. The popular press declared that teenagers had gone too far.

From 1955 to 1957, records and appearances from singers such as Chuck Berry, Jerry Lee Lewis, Little Richard, Gene Vincent and Elvis Presley confirmed the adult public's fear and loathing. And following the mid 1950s Skiffle craze, popularised by Lonnie Donegan, came British rock 'n' roll. Cliff Richard, Adam Faith, and Tommy Steele were the first British Pop stars on whom numerous 'discoveries' were modelled, most conforming to a stereotype with a name that combined the boy-next-door appeal with a sexually descriptive surname: hence Marty Wilde, Johnnie Gentle, Tommy Quickly, Billy Fury, Rory Storm, and Vince Eager.

British television and radio first acknowledged the new teenage music in 1957 with '6.5 Special' (BBC) and what eventually became 'Saturday Club' (Light Programme). Other programmes directed at the teenage audience soon followed: 'Dig This' (1959), 'Drumbeat' (1959), and the long-running 'Juke Box Jury' (1959–67) on BBC; and 'Cool for Cats' (1957–59), 'Oh Boy!' (1958–59), and 'Boy Meets Girl' (1959–60) on commercial television.

But because Rock 'n' roll has strong visual appeal, it was best seen live. Although the 'image' of the sound of rock 'n' roll was important, the content and delivery of the lyrics (including techniques like glossalalia — emphasising certain sounds for dramatic and/or emotional effect), and the singer's appearance, style, gestures, postures and movements were integral parts of the total appeal. For example, Elvis Presley's 'Hound Dog' (1956) comprises pro-youth lyrics (the verbal message), a fast tempo and rhythmic insistency conveying energy and immediacy (the musical message), and glossolalia (emotional expression). In live performance these were reinforced by Presley's appearance (tight-fitting trousers, unbuttoned shirt and Teddy Boy quiff), movements (such as hip gyrations), gestures and expressions (the Presley 'sneer').

Record Cover Design

The cover of Presley's first long-playing (LP) record attempted to capture the essence of the singer's performance and marked a new departure in record-cover design. LP covers for most classical or popular music were unimaginative, often portraying a musical instrument, a bust of the composer or a photograph of the conductor or singer. Record covers for jazz were more inventive and 'cool' in character like the music; they might employ a Paul Klee-inspired line drawing, assymetrical typographical layout or an artistic photograph. But the 1956 Presley LP cover was a dramatic action shot of the star delivering his lyrics '. . . his face and body distorted by excruciating passion', according to one writer.[4] Presley's name in large, rough-shaped letters of red and green added to this dynamic and exciting image.

The second Presley LP cover was a black-and-white photographic portrait against a bright orange background. Unlike conventional record-cover portraits, which tended to emphasise the artist's amiable personality, the Presley photograph focused on his notorious sneer. The typography was expressive of excitement and energy. Although most rock 'n' roll records were 'singles' and did not have picture covers, covers like Presley's expressed the aggressiveness and anti-establishment character of the music. They conveyed a stance and sold an image appealing directly and emotionally to the teenage group.

RCA/ARIOLA LTD

The cover design for Elvis Presley's first LP, 1956. This was the first cover to convey the energy and raucousness of rock'n'roll.

[4] Hipgnosis p 10.

The Teddy Boys

Teddy Boy, mid 1950s. The Teds were one of the first groups to understand the power of fashion in the 'war of the generations'.

The group most closely associated with rock 'n' roll was the Teddy Boys, although Teds pre-dated rock 'n' roll by a few years. The Teds were only a small minority of British, urban, usually working class and unskilled, young males. But the attention they attracted was sensationalist and revolved around their unruly behaviour, hooliganism, delinquency and crime that was supposed to be a mark of the Teds' lifestyle.

Crime perpetrated by the young, for reasons touched on in the first chapter, increased sharply during the 1950s, and more than doubled between the middle and the end of the decade. Indeed, once the public's image of Teds as lawless tough guys had been established, they were often happy to live down to expectations. But, whether they were lawless or not, the Teds *looked* deviant in the eyes of the public. They had discovered that clothing and image were a means of non-verbal communication and — of greatest importance to subsequent youth sub-groups — a way of announcing an identity in opposition to conventional adult standards and norms.

The basis of the Ted's appearance was the Edwardian suit which at that time was a Savile Row mode. It was worn, however, not in a style or way that connoted upper-class elegance but because it contributed to an image of the archetypal 'baddie' from Hollywood westerns. The Ted's greased hair, long sideburns, ornate waistcoat and bootlace tie reinforced this effect. Tight trousers ('drain-pipes'), crepe-soled shoes ('brothel creepers') and a DA ('duck's arse') hairstyle were the other components of the Teddy-Boy image — a conspicuous display of style and affluence, at odds with the less-affluent background from which the Teds came and an outspoken opposition to middle-class British conventions of decorum and restraint. In a society that had grown up with the belief that seriousness of mind was conveyed by sobriety of dress, youth soon realised the power of fashion to offend, shock, insult or horrify.

Bikers

Until a revival in the 1970s, Teddy Boy clothing belonged in the 1950s. However, the image of 'the Biker' is less historically specific. They wore leather jackets, denim or leather trousers, and heavy boots. Hair was greasy, usually long, and worn in a swept-back style. In contravention of safety and sense, Bikers wore their jackets and sleeves open and trousers were left to flap outside boots. The manner in which the garments were worn, or in the case of the helmet not worn, was important because it was not speed for its own sake (the fact of speed), but the experience of travelling fast (the sensation of speed) that appealed to the Bikers' Futurist sensibility. Paul Willis describes how 'The ensemble of bike, noise, rider, clothes *on the move* gave a formidable expression of identity to the culture and powerfully developed many of its central values.'[5] The visual impact of the Bikers came from a total image that clothes alone could not have portrayed.

The source of the Biker's style and behaviour had been Marlon Brando in *The Wild One*, an American film released in 1954. Brando played the part of the leader of a motor-cycle gang who create mayhem in a small and sleepy town by breaking into the local jail, taking a girl hostage and, accidentally, killing an old man. The level of violence and the lack of retribution led to the film being criticised for glamorising violence and it was banned at many British cinemas.

[5] Willis 1978, p 57.

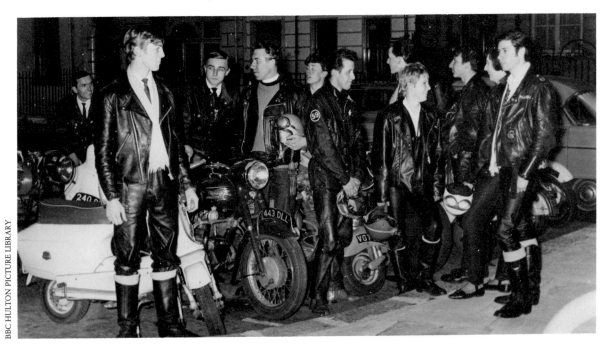

In the 1950s both Brando (born in 1924) and Dean (born in 1931) were portrayed as disaffiliated young anti-heroes, but their images had little other than rebellion in common. Dean was middle class and neatly dressed in smart clothes that were even conventionally acceptable. Brando had the physique, face and body language of a boxer and his rough-and-ready appearance gave no hint of any interest in fashion. These two images continued during the years of High and Late Pop: the first finding its apotheosis in androgynous Mod fashions; the second remaining in the macho and deviant images constructed by Rockers, Hell's Angels and a further generation of Bikers.

Bikers, mid 1950s. The Biker cultivated a deviant image and posed as an outlaw on the edge of society.

Beatniks and Beats

If the Biker's image was the fashion equivalent of a coarse insult and the Teddy Boy's look was syntactically crazy and semantically outrageous, the 'rave gear' worn by Beatniks, or the more extreme followers of traditional jazz was jibberish. 'Rave gear', the precursor of hippy clothing, was a bizarre assemblage, bringing together such items as a bowler hat (in homage to Acker Bilk), a potato sack, a cut-down fur coat, baggy trousers and army boots. Other Beatniks and Beats adopted the image of the poor and downtrodden prole and wore shapeless and frayed old clothes. They listened to Woody Guthrie and Pete Seeger and aspired to the rootless and nomadic condition described by Jack Kerouac in his novel, *On the Road* (1956). Their unwashed, unlaundered and straggly haired look was a protest against the clean-shaven and clean-cut image of the 'corporation man'. Other fashions also expressed a rejection of conventional values. An anti-fashion outfit of black jumper and jeans or slacks was associated, rather tentatively, with political protest, black humour, and existentialism. This look of protest against the bourgeoisie and their comfortable affluence was exemplified by the wide-eyed, serious-minded appearance of Juliette Greco.

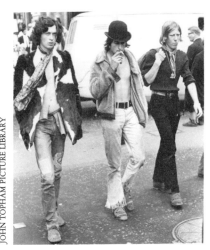

Beatniks, 1960, wearing 'rave gear' — the fashion equivalent of jibberish.

Teenage Fashions

The majority of teenagers were, however, content with their world and wanted to express nothing more than youthful high spirits. They wanted clothes that looked fashionable and up-to-date and, as the decade unfurled, they became more independent-minded. In the early 1950s, American and Italian fashions — loose-fitting cardigans and slacks — had brought a casual note to fashion that appealed to the young but, generally, young clothes of that period were scaled-down versions of adult fashions. Paris was the *haute couture* capital of the world, and one fashion historian has described the early 1950s as a time of 'tyrannical dictatorship', when women were expected to '. . . adopt an almost reverential approach towards the Olympian edict handed down from leading designers and fashion *couturiers*'.[6] Throughout the 1950s, the *haute couturiers* presented new and arbitrary looks which became the fashion for a season and were copied by manufacturers. 'Good taste' and fashion etiquette were not broken in polite society and conventions were adhered to concerning what should be worn on various social occasions. As late as 1959 *Vogue* published a feature for the teenager on 'Clothes for the Occasion' outlining what was proper to wear for a lunch date, a lunch party, a race meeting, a committee meeting, a garden party, cocktails, dinner, the theatre, a dance, and a wedding. The social occasions chosen by *Vogue* show how the establishment equated fashion with only one end of the social spectrum. In January 1953, *Vogue*, acknowledging the growing importance of youth, introduced their 'Young Idea' feature for the 17–25 age-group but, in spite of the promised 'independent fashion for the young', it illustrated little that was significantly different from adult norms.

Fashion began to change as teenagers grew in confidence and affluence. During the mid to late 1950s the sources of youth fashion began to change. No longer were the aristocracy or the Paris fashion houses providing the ideas: film and, especially, pop music stars became the trendsetters. Other ideas came from teenagers themselves. At the end of the 1950s *Vogue* announced the arrival of the 'art student' look for women: a casual look of 'donkey' jackets, loosely brushed hair, smock-length shirts and wicker-basket accessories. Its significance, according to the fashion historian Georgina Howell, was that it was one of the first fashions to begin '. . . in the street and work upwards.'[7] This was a sign of things to come in the 1960s.

[6] Howell 1975, p 204.

[7] ibid p 206.

Mary Quant

The time had come for individuals and companies to capitalise on teenagers' fashion needs. In November 1955 the first boutique opened in Kings Road, Chelsea, under the name of 'Bazaar'. It was owned by Archie NcNair, who provided the business acumen, Alexander Plunket Green, in charge of sales promotion and showmanship, and Mary Quant, who designed or bought the clothes. 'Bazaar' was an attempt to provide clothes for the young. Quant had realised that suitable clothes did not exist in any quantity and, in order to cater for this market, she decided to design them herself. Her early designs were much influenced by clothes of the 1920s and 1930s and tended towards simplicity. They included a short shift with box pleats which gave a tunic effect, a shirt with knickerbockers patterned with large polka dots, a cardigan dress with matching wool stockings, a grey and black striped pinafore dress slightly

DESIGN COUNCIL ARCHIVE

Invitation to the opening of Bazaar which sold a range of Quant designs for young women who sought young style.

gathered in with a belt in matching material, and a flared black dress with a white collar. Materials were often monochrome or restricted to bold shapes, sometimes widely mixed in scale. A characteristic Quant feature in the late 1950s and early 1960s was a dropped waistline which, in the cases of pinafore and sack dresses, was eliminated altogether. A novel idea of Quant's was a white plastic collar which could be attached to a dress to alter its appearance and give it a fresh lease of life. These collars sold for 2/6d (12½p) each. Spurred on by the sales success of these garments, Quant moved to a larger bedsitter where she employed a few machinists and went from strength to strength based on her realisation that the young women wanted their own style of clothing.

John Stephen

Nor was the young male ignored or confined to deviant sub-groups. In 1957 John Stephen opened his first shop in Carnaby Street. Stephen had come to London from Glasgow when he was 19 and had realised that men's clothes were like a uniform: '. . . staid, sober, and, above all, correct, advertising your precise rung on the social ladder and even your bank account.'[8] At that time the fashion for young men who wanted to be different from their elders (without becoming social outcasts) was the 'Italian look', a style derived from Savile Row but 'sharpened up' in the process. Stephen sold these and slightly more individual clothes, in which, according to a 17-year-old, '. . . you can express yourself

[8] Stephen quoted in John Crosby 'The Most Exciting City in the World' *Telegraph Colour Supplement* 16 April 1965, p 11.

. . . a nice dark red shirt with black verticals and a dark blue suit, a Perry Como and Italians.' Stephen's influence was considerable. By the mid 1960s he owned over half the boutiques in Carnaby Street, all catering for men's fashion. The growth of men's fashions — a sign of an affluent and anti-puritanical time — increased rapidly, and by the mid 1960s there were as many male as female boutiques in London.

Fashion was youth's major means of expression in the years around the turn of the decade. In 1959 *Vogue* commented that '. . . for millions of working teenagers now, clothes . . . are the biggest pastime in life: a symbol of independence, and the fraternity mark of an age group.' *Vogue* also noted that 'young' began to appear '. . . as the persuasive adjective for all fashions, hair-styles, and ways of life.' The young fashions offered by Quant, Stephen and others suited the mood of the time. Like the industrial design profession in America in the 1930s, many fashion designers in Britain in the late 1950s responded to economic conditions and consumer-group needs. They met those needs by capturing and expressing the mood of the time. Quant summed it up: 'The clothes I made happened to fit in exactly with the teenage trend, with pop records and espresso bars . . .'.[9]

Crisply-styled clothes by John Stephen. For those who wanted to look 'sharp' without being exhibitionist.

BBC HULTON PICTURE LIBRARY

[9] Quant 1966, p 74.

Coffee Bars

Most British teenagers were excluded from pubs by the legal age limit and the majority could not afford to go to clubs. Espresso or coffee bars sprung up in most towns to cater for teenagers, and they quickly became the focus of teenage life. Young people congregated to talk about sex, fashion, music, films and, for those whose parents were affluent enough to own one, television. The interior design of the coffee bars was a blend of the continental (usually Italian or

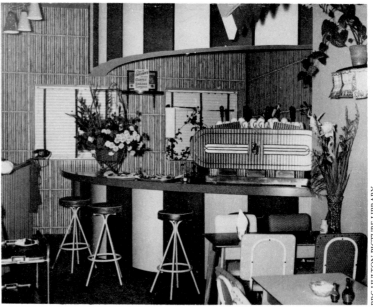

Coffee bar interior, mid 1950s: a romantic and theatrical mixture of Italy, France, the Alps and the Festival of Britain.

BBC HULTON PICTURE LIBRARY

Alpine) and the 'contemporary' look associated with the Festival of Britain: rough stone walls, wooden vertical slat screens, chairs or stools with tapering legs, wicker or bamboo baskets and magazine racks, and sub-Picasso or Modigliani prints. Two prominent features completed the ensemble: a coffee-machine and a juke-box.

The coffee-machine was more than likely to be Italian, and probably a Gaggia. The Gaggia coffee machine (the best-known of which was designed by Gio Ponti) was typical of Italian post-war design. On a visit to Italy in 1950, the American designer Walter Dorwin Teague had declared that Italian designers were '. . . frolicking like boys let out of school' in reaction to the pre-war stranglehold of Modernism.[10] Italian design was flamboyant, it had panache and, like American consumerist design, emphasised styling. Many Italian products were styled with the image-conscious teenager in mind. Advertising for the sculpturally conceived Vespa motor scooter, for example, emphasised the mobility and freedom that a scooter facilitated and the Italianness of the product, because Italian design meant style.[11] While most scooters were marketed as cheap and utilitarian machines, Vespas were sold as providers of pleasure.

[10] W D Teague 'An Italian Shopping Trip' *Interiors* November 1950, p 199.

[11] see Dick Hebdige 'Object as Image' *Block* number 5, 1981, pp 44-64.

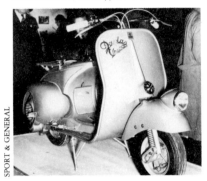

The Douglas 125cc Vespa, 1946. In the post-War years, Italian designers were '. . . frolicking like boys let out of school . . .'.

Juke Boxes

The juke box was an American invention of the 1920s, which was spectacularly successful. Wurlitzer, Seeburg, Rock-Ola and AMI (Automatic Musical Instrument Co) had become household names. They were first brought into Britain in 1955 when import restrictions on non-essential goods were relaxed. By the end of 1957, 8 000 had been imported and could be seen and heard in many coffee bars, cafes and clubs. The styling of juke boxes was all important and worthy of Pevsnerian declamations. Like American cars, juke boxes were regularly repackaged and restyled. Although a juke box's basic mechanism could last up to 20 years before it became technically obsolescent, the rate of *visual* obsolescence was swift. The curved and bulbous look, popular in the 1930s and 1940s was superseded by a sleeker and rectilinear image in the 1950s. The new styling was derived from recent Detroit cars; the juke box borrowed the car's vocabulary of wrap-around windscreens, tail-fins, elaborate dashboard and lighting displays and flamboyant chromium grilles. As cars were the leading status symbol of the day, they often became a source of symbolism. Furthermore, the car's associations of power, energy, science-fiction, sex and fashionableness were regarded as equally appropriate for juke boxes.

Teenagers instinctively took to juke boxes which became, according to John Krivine, a historian of juke boxes,

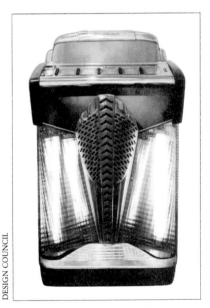

The Filben Maestro from the late 1940s, anticipating the influence of car styling on juke boxes in the 1950s.

'. . . both the vehicle and focus for a youth culture. It was a "place" away from the home environment, where kids could meet and listen to the music of their idols. It was the subject of songs, poems and films of the time, and had a meaning that went far beyond its function of mere music machine; it was a symbol of teenage independence.'[12]

[12] Krivine 1977, p 140.

The juke box's performance was as much visual as aural: it was an expression of the energy of the teenagers' lifestyle and the rock 'n' roll music which boomed

from its innards.

So rapidly did the juke-box become a symbol of teenage independence and outlook, that, as early as 1957, Richard Hoggart was using the phrase 'juke-box boys' to denote a large section of the teenage population. The 'juke-box boys' were those '. . . aged between 15 and 20, with drape suits, picture ties, and an American slouch.'[13] They congregated in coffee-bars (or 'milk-bars' as Hoggart referred to them) which

[13] Hoggart 1957 (1958 edition) p 248.

> '. . . indicate at once, in the nastiness of their modernistic knick-knacks, their glaring showiness, an aesthetic breakdown so complete that, in comparision with them, the layout of the living rooms in some of the poor homes from which the customers come seems to speak of a tradition as balanced and civilised as an eighteenth-century town house.'[14]

[14] ibid, pp 247-48.

Furthermore, it was *American* Pop songs, which made use of what Hoggart described as the 'hollow-cosmos effect', that 'blared out' from the juke-box.[15] But what horrified or angered the older generations delighted the young.

[15] ibid, p 248.

America and Britain

Major changes were under way in young people's taste and outlook in the mid to late 1950s. As Hoggart correctly observed, the new British pop culture was essentially American in style. But it was inevitable that America, the first, and wealthiest, society to have a youth culture, would provide the model. Britain was changing, and the signs of change could be seen in many high streets. Following a visit to America by a director in 1955, Lyons were converting their traditional tea shop to informal quick-service restaurants or 'fast food outlets'. An even more significant sign of the times — the first British Wimpey — opened its doors in 1955.

The British young may have identified with Jim in 'Rebel Without a Cause,' but the affluent home Jim lived in and the lifestyle he enjoyed were fantasies for most of the audience. It was true that, because of their own and their parents' relative affluence, youth had 'never had it so good' in the latter part of the 1950s, but the Britain most teenagers knew was that described in Alan Sillitoe's *Saturday Night and Sunday Morning* (1958) or Stan Barstow's *A Kind of Loving* (1960), novels that depicted a grimness reminiscent of the early 1950s. Even when both were released as evocative films in 1960 and 1962, they were not dismissed as anachronistic.

What was established in Britain in the Early Pop period was an outlook (an assertion of identity), a set of obsessions (principally music and fashion), and a tentative infrastructure (small companies run by people such as Mary Quant and John Stephens) which was ripe for development as soon as youth had the financial means. High Pop exploded in 1963 when youth financially came of age.

The pace of change in turn-of-the-decade Britain was accelerating. Following a small economic recession in 1960 and 1961, the economy started to recover in 1962. Individual prosperity and consumerism continued to grow and were being enjoyed by an ever-greater percentage of the population. The social mobility triggered by full employment and prosperity was being underpinned by a longer formal education and more educational opportunities. All of these factors encouraged a confidence throughout society. But the ways in which that confidence was manifested varied considerably among different social groups and contributed to the tensions underlying the now fragile surface of British society's outmoded social structure and outlook.

Satire

The kitchen-sink writers continued their theme and some young men were still angry, but a new generation turned to ridicule as the best way of challenging authority and undermining the status quo. Anti-establishmentarianism was the word and satire was the new style of abrasive and often cruel humour enjoyed by the young in the early 1960s. From undergraduate reviews at Oxbridge, satire travelled to the West End stage in 1961 with 'Beyond the Fringe' — the theatrical success of the year. With a fanfare of publicity The Establishment, describing itself as 'London's first satirical night club', opened and its membership topped 11 000 within a year. The first issue of *Private Eye* came off the press in October 1961 and 'That Was The Week That Was' (TW3) was launched on television at the peak of the satire boom. Many viewers were shocked that such disrespectful sentiments about politicians and institutions should be given exposure on a mass medium. But the new generation of humorists, like the new generation of youth, showed little respect for their 'elders and betters'. TW3 may have been controversial, but its success was incontestible. When it began in late 1962 the viewing figures were roughly three million; by the end of February 1963 they had risen to 12 million.

Changes in Politics and Outlook

Satire thrived because the old order, misguidedly confident in its own authority, provided an apparently endless series of easy targets. (Even *The Times* was of the opinion that 'Eleven years of Conservative rule have brought the nation psychologically and spiritually to a low ebb.') In 1963, the Profumo affair (involving a cabinet minister and a call girl who also enjoyed liaisons with a Russian agent) rocked the Conservative party. Reactions ranged from anger to scorn and the satirists had a field day. The health of the increasingly tottery Prime Minister, Macmillan, by then 69, declined and in October 1963 the Earl of Home was chosen as his successor. In order to take his place in the House of Commons, the new prime minister had to renounce his hereditary peerage. But Sir Alec Douglas-Home (as he became) could not renounce his appearance and

image. Whatever his policies, Home looked and sounded like a frail and ageing British aristocrat, a god-sent subject for satirical cartoonists.

Meanwhile, in early 1963, Harold Wilson became leader of the Labour Party at the age of 47. Wilson was a supreme and charismatic communicator. He conjured a vision of a progressive and classless Britain that would leave behind the conservatism (in both senses) and class divisions of the past forever. The new Britain, Wilson prophesied at his party's annual conference in 1963, would be '. . . forged in the white heat of the scientific revolution . . .'.[1] In employing the imagery of scientific progress Wilson was exploiting a rich vein of popular enthusiasm. Increasingly, science and technology were seen as the keys to success. For Britain in the 1950s, advanced technology had only existed in science-fiction films and on the other side of the Atlantic. From the time the A-bomb exploded at Hiroshima, the Americans had had a monopoly — as members of the Independent Group would readily have testified — on frontier-pushing science and advancing technology. American films and maga-zines presented their scientists as leaders and popular heroes. And the romantic appeal of science had been given a major boost in the mid 1950s when the space-race was launched, which quickened dramatically in 1960 when the youthful new President of the United States JF Kennedy announced:

> 'I believe that this nation should commit itself to achieving the goal, before this decade is out, of landing a man on the moon and returning him safely to earth. No single project in this period will be more impressive to mankind. . . .'[2]

Not only did science and technology provide material wealth, but national prestige too.

In 1963, the Robbins Committee report on higher education, published under the Conservative government, heralded a big expansion of higher educa-tion including a marked increase in the provision for science and technology. But, just as Labour had been the party that aligned itself with the policy for the Welfare State at the end of the War, it was Labour under the leadership of Harold Wilson who expressed the spirit of the technological era. 'This is a time', Wilson declared,

> '. . . for a breakthrough to an exciting and wonderful period in our history, in which all can and must take part. Our young men and women, especially, have in their hands the power to change the world. We want the youth of Britain to storm the new frontiers of knowledge, to bring back to Britain that surging adventurous self-confidence and sturdy self-respect.'[3]

A General Election was called in 1964. To many it was a choice between a progressive Britain led by the young and ambitious, or a conservative Britain under the guidance of an ageing aristocrat.

Wilson's strategy since his election as leader was to present Labour as the party of modernisation and progress. To do this he broke with the party's tradi-tional cloth-cap image and working-class base because it tied Labour to an outmoded version of the class struggle — Wilson believed the social changes that had taken place since the War made the 'class struggle' anachronistic and a

[1] Wilson 'Labour and the Scientific Revolution' *Annual Conference Report* 1963, p 140.

[2] JF Kennedy quoted in Ryan *The Invasion of the Moon* 1977, pp 18-19.

[3] Wilson *Wilson's Speeches* London, Penguin 1964, p 10.

vote loser. Social mobility now meant that a large percentage of the lower paid were neither working class, in the old sense of the term, nor working class in outlook. Furthermore he realised that many voters, especially the young, were disillusioned with the Conservatives and what they stood for, and could be won over if Labour emphasised *classlessness* and a thoroughly modern outlook.

Wilson cleverly used his skill in reading the mood of the time and fought the election with *images* of the new Britain rather than detailed policies of how it might be brought about. He realised that the nation, and especially the young, wanted to *believe* in the new Britain. Politics in Britain was changing. According to a writer in *Harpers*, politics had ceased to be the preserve of the old and/or serious and had become fun: '. . . which [party] to choose is an exciting new responsibility.' Part of the nation responded to the 'Let's Go with Labour' call and Wilson's party was elected with a majority of four seats — evidently Britain was far from thinking as one country.

The 'Youthquake'

The growing importance of youth was a consequence of affluent economic conditions and changing attitudes and values. The power of youth (as they were now known — the word 'teenager' was no longer 'with it') was also a demographic fact. The post-war 'baby boom' had resulted in a large increase of 15–19-year-olds as a percentage of the total population, which rose from 6.5% in 1955 to a peak of just under 8.0% in 1963 and 1964 — the largest for over a century — and settled at around 7.0% in the late 1960s and 1970s. The economic and social conditions were perfect for an '. . . explosive discovery of young identity — a Youthquake.' The '. . . first children of the Age of Mass-Communication' had come of age.[4]

In 1963 the media became almost obsessed with youth values, trends, and idols. But youth made its greatest impact in fine art, fashion and music. By 1966, this artistic expansion had made Britain the creative centre of youth culture, and London the 'most exciting city in the world'. *Time* proclaimed: 'In a decade dominated by youth, London had burst into bloom. It swings: it is the scene.' And the scene comprised those young celebrities — the fashion designers, models, photographers, hairdressers, artists, designers, pop stars, actors, sports stars, entrepreneurs, and restaurateurs — who were the proponents of Pop.

[4] anon 'Bulge Takes Over' *Town* September 1962, p 43.

'Coloursupps' and Lifestyles

The tastes of these celebrities were chronicled in that publishing symptom of the swinging 'sixties — the 'coloursupp'. The first — *The Sunday Times Colour Supplement* (later *Magazine*) — started in February 1962 and included features on young fashions (Mary Quant clothes), modelling (Jean Shrimpton), photography (by David Bailey), and a James Bond story. The *Telegraph Colour Supplement* appeared in 1964, and the *Observer Magazine* in 1965. All of them featured art, fashion, design, consumer goods, travel and adventure, subjects that complemented their glossy advertisements perfectly.

The colour supplements were obsessed with young 'lifestyles' (an archetypal 'sixties word) and carried regular design features that had a substantial effect on taste. *The Sunday Times Colour Supplement*'s 'Design for Living'

feature, for example, began in April 1962 with an attack on decorum and 'good taste':

> 'Poor design has become a target for anyone with a brick to throw: good design is treated as a sort of sacred cow. The attitude to function is racing to the same level of absurdity; testing is turning into an obsssession. There are times when one longs to buy something plumb ugly and utterly unfunctional.'[5]

[5] Janice Elliot 'Design + Function' *Sunday Times Colour Supplement* 15 April 1962, p 26.

This point of view undermined the basic premises that bodies like the CoID had been upholding since the War. Even contemporary Scandinavian design received criticism:

> 'For years Scandinavia has been the dominating influence on our furniture and furnishings. We have come to accept mass produced perfection in china, glass and furniture. . . . What we need is an unexpected touch of salt; something not off the conveyor belt.'[6]

[6] Arianne Carstaing 'Peasant Props, Glazes and Glitter' *Sunday Times Colour Supplement* 6 January 1963, p 17.

The colour supplements promoted anything colourful, novel or gimmicky, as long as it had impact. Their liberal peppering of features on consumer goods and seductive advertisements for desirable hardware helped to bring the idea of young taste and trendiness into currency.

Being up-to-date and fashionable was often more important than being functional, and certainly they became more important than the conventional 'good' taste of understatement and restraint. The split between young and old seemed absolute. Pop music, Pop fashions, Pop design and Pop art infuriated the old as much as they were cherished by the young. Even the liberally inclined of the 1950s found Pop difficult to accept, as attitudes to the Pop painting of the early 1960s reveal.

Pop Art: 'Second Generation'

After the 'first generation' of Pop artists — Hamilton, Paolozzi and Blake — a second generation emerged in the early 1960s, a group of artists which included Peter Phillips, Derek Boshier, David Hockney, Allen Jones, Ron Kitaj and Patrick Caulfield. Their breakthrough was made at the 1961 'Young Contemporaries' exhibition. These artists, many of whom were at the Royal College of Art, were aged between 22 and 24, 15–20 years younger than the IG. Hockney and Kitaj won prizes in John Moore's exhibition in 1961 and in 1962 Boshier, Hockney, Jones and Phillips featured in the 'Image of Progress' show at the Grabowski Gallery. In 1963 the same artists represented Britain in the Paris Biennale. Most of the 'second generation' painters also took part in the 'New Generation' exhibition at the Whitechapel Art Gallery in 1964, a show that received much acclaim and publicity. The term 'pop art' changed in meaning at this time from the shorthand for 'popular culture' and the mass arts, to refer to the artworks produced by the Pop painters.

The new Pop artists displayed a figurative emphasis in their work with subject matter taken from racing cars, motor bikes, spaceships, film and pop stars, sex symbols, pinball and juke-box imagery, and neon-style lettering. The imagery was usually painted in bold and bright colours which often clashed.

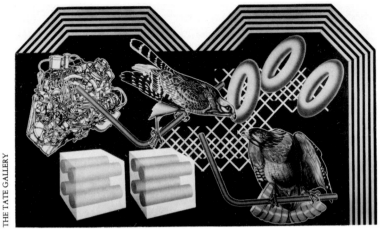

Peter Phillips, Random Illusion No. 4, *1968.*
Phillips' graphic style of Pop art was, according to
Alloway, superficial and of no lasting value.

Although the 'second generation' shared the same type of imagery as
Hamilton, Blake and Paolozzi (bearing in mind that source material was
updated), the use to which they put it was significantly different. Whereas
Hamilton had used imagery to make a sociologically inclined point, Blake to
suggest a 'folksy' atmosphere and Paolozzi to make a surreal juxtaposition, the
'second generation' painters used imagery in a more graphic, less didactic way.
When generalising about six artists a degree of oversimplification is inevitable,
but a difference did exist and IG stalwart Lawrence Alloway tried to pinpoint it.
Writing of Peter Phillips, he criticised the 23-year-old artist's lack of a

> '. . . sense of Pop art as the latest resonance of long iconographical
> traditions. He seems to use pop art literally, believing in it as
> teenagers believe in the 'top twenty'. In a sense, the appeal to
> common sources within a fine art context, one of the strongest
> original motives for using pop art has been lost. The new pop art
> painters use the mass media in the way that teenagers do, to assert,
> by their choice of style and goods, their difference from their elders
> and others.'[7]

7 Alloway 'Pop Art Since 1949' *The
Listener* 27 December 1962, p 1087.

Alloway's criticism was that of the father whose son was not fulfilling his wishes.
The IG's idea (and Hamilton's use) of fine art was one possible approach but
Alloway seemed to be claiming that it was *the* correct one — in view of the IG's
non-hierarchical beliefs, this was difficult to justify. The narrowness of
Alloway's view about Pop art is contained in his statement that 'first generation'
Pop was '. . . an episode, a thread in a general tradition of iconographical art
which has exploded since the 19th century . . .'.[8] Was 'first generation' Pop as
traditional and respectable as Alloway claimed, or was the revolt of the 1950s
being superseded by the revolt of the 1960s?

8 ibid, p 1087.

That a change of aesthetic intention had taken place is undeniable, but
whereas Alloway attributed it to a loss of purpose, Phillips saw it as
inevitable:

> 'My awareness of machines, advertising, and mass communica-
> tions is not probably in the same sense as an older generation that's
> been without these factors . . . I've lived with them ever since I can
> remember and so it's natural to use them without thinking.'[9]

9 Phillips: statement in Whitechapel 1964,
p 72.

What happened, although simple to grasp, was significant in outcome: the mass media had ceased to be a novelty. Hamilton had felt the need to analyse images but Phillips took the mass media for granted, part of everyday life. The 'second generation' could enjoy popular culture without the need to intellectualise, or any of the anxiety of the 'first generation'.

The Re-organisation of Art Education

Although the mass-media environment had affected the young in general, the young painters had been particularly influenced by the art colleges. The role of the art colleges in the development of Pop was crucial. It was not necessarily what the colleges taught — although in areas such as fashion design this should not be underestimated — but the atmosphere in which they taught.

Since the late 19th century, art education had become an increasingly difficult and controversial subject. As fine art in the 20th century had eschewed all established conventions of standards and criteria, art schools were faced with the dilemma of how to educate artists. In the 1950s, the British response to this dilemma, unlike responses in America and in parts of Europe, was to seek refuge in the traditions of British art. The art schools were largely conservative and provincial, emphasising craft-based techniques which bore little or no relation to mainstream art movements. But, symptomatic of the dissatisfaction with the status quo voiced in the late 1950s, art education was scrutinised and found to be in need of major surgery. The re-organisation began in 1959 when a National Advisory Council on Art Education was set up under the chairmanship of Sir William Coldstream. In 1961, the Council reported in favour of a new qualification, called the Diploma in Art and Design (DipAD): a pre-diploma year followed by a three-year diploma course. The diploma was divided into four subject areas: fine art, graphics, three-dimensional design, and textiles and fashion. All subject areas were to have a fine art core, which was an attempt to liberalise art education and shift it from the more vocational or technical associations of the old National Diploma in Design (NDD). There was opposition to a fine-art core on the grounds that fine art and design habits of enquiry and procedure are different: those in support of the fine-art core believed that all aspects of art and design are essentially visual and creative. But disagreements apart, art education was changing fundamentally.

The first of two significant changes was that design students (graphics, three-dimensional or textiles/fashion) were encouraged to adopt more of a fine art *attitude* to their work. There was a greater emphasis on creativity and originality, the outcome of which was evidence in a wide variety of fields throughout the decade.

The second change was in fine art itself. Courses became a microcosm of 20th century mainstream art. There was no longer a consensus, let alone observable criteria, about what was good or worthwhile. Experimental and extreme activities ranging from painting to performance and gesture, took place in an open-minded and permissive environment. The only shared belief was that art colleges saw their primary role as providing conditions conducive to innovative and creative work of any kind. All sorts of individuals — students and staff — were attracted to the art colleges. The DipAD requirements specified that entrants should normally have five 'O' levels, but a caveat permitted students without such qualifications to be admitted if their art was outstanding.

With so little agreement on standard, the definition of 'outstanding' could be applied liberally, and art colleges became an appealing alternative within higher and further education. During the 1960s, British art colleges acquired a reputation for being the most experimental public-funded educational institutions in the world. They became the focal points for those who sought change, excitement and an alternative culture. Far more than their teaching (at times in spite of it) their atmosphere produced the painters, fashion designers, poster artists, and even the Pop musicians who became the heroes and heroines of the High Pop years.

Pop Music and 'Beatlemania'

Pop music and fashion remained the central axes of the young in the High Pop years. Of the two, music enjoyed the greater affection: it was endlessly available and encapsulated youth's love of energy and excitement. Although the older generation disliked Pop fashions, they *loathed* Pop music which brought, in the memorable words of one critic, '. . . connotations of dinner music for a pack of hungry cannibals.'

Since the invasion of the rock'n'rollers in the mid 1950s, American singers had topped the British charts. Of 24 number-one hits in 1961, 15 were American. In the early years of the 1960s the upsurge of British creativity was reflected in the charts. In 1963, British Pop music exploded with 'Merseybeat' and the emergence of the so-called beat groups such as Gerry and The Pacemakers, The Searchers, Billy J Kramer and The Dakotas, Brian Poole and The Tremeloes and, most importantly, The Beatles, who had three number-one hits which stayed top for a total of 18 weeks. Their first LP, 'Please Please Me', was number one for six months and in the top-ten chart for a total of 61 weeks. The mass hysteria and Beatlemania made 1963 the year of The Beatles.

Liverpool's position as the top Pop city was challenged in 1964 with the rise of London groups including The Rolling Stones, whose unkempt and scruffy image made The Beatles seem to be models of neatness and convention. The appearance and loutish behaviour of The Rolling Stones signified to older generations a less acceptable youthful rebellion — a fact which was grasped by the groups and their fans. However, The Beatles remained unassailable with three number-one hit singles and two LPs, 'With the Beatles' and 'A Hard Day's Night', in the top-ten LP charts for 75 weeks. Their first film, 'A Hard Day's Night' (GB 1964), directed by Dick Lester, received both popular and critical acclaim for its surreal, fast-moving sequences. Lester declared, in true Pop spirit, that he went for maximum impact and was not concerned with creating an enduring artwork. The Beatles also undertook their first tour of America, inciting Beatlemania wherever they travelled. At one point in 1964 The Beatles held the top five places in the American singles chart and had 12 records in the top one hundred. Britain's position as the leader in Pop music and young fashion was indisputed.

In 1965 The Beatles released their second film, 'Help!', had three number-one single hits, two LP hits ('Beatles for Sale' and 'Help!') and were even awarded MBEs by Harold Wilson, (who realised that there may be a General Election soon). The Rolling Stones had three number-one hits, and The Who burst into the limelight. In 1966, American groups re-established themselves: The Beach Boys introduced the 'surfing' sound from California,

and Tamla Motown artists — such as The Supremes and The Four Tops — were popular. But British Pop groups were still the most successful, none more so than The Beatles who had three number-one hit singles and two number-one LPs.

Television and radio broadcast a number of regular Pop-music programmes between 1961 and 1966. The BBC introduced 'Top of the Pops' in 1964, and 'Thank Your Lucky Stars' ran on ITV for five years from 1961. But it was Redifusion's 'Ready! Steady! Go!' ('RSG'), running from 1963 to 1966, that best portrayed the fads and fashions in music and clothing during this period. The BBC's format for Pop radio programmes was less than satisfactory and commercial 'pirate' radio stations, the first of which was Radio Caroline in 1964, answered the need for a faster, more up-to-date style.

Throughout the 1960s Pop music was a tool of rebellion, a means of expressing identity. Innumerable records were released, most of which sank into obscurity. Even a successful record (excepting those by The Beatles) had a life span of only a few weeks. Pop music aspired to the condition of fashion in which change was the only constant. The young demanded, according to George Melly, '. . . music as transitory as a packet of cigarettes and expendable as a paper cup.'[10]

[10] Melly 'Pop World and Words' *New Society* 18 October 1962, p 32.

Expendable Subject Matter

There is certainly no doubt about the expendability of the souvenirs and mementos that were produced to exploit the commercial potential of Pop groups. The more popular the group, the greater the number of souvenirs. Within weeks of Beatlemania an enormous range of souvenirs appeared with Beatles' imagery or endorsement: posters, postcards, scrapbooks, calendars, booklets and magazines, paperweights, pencils and biros, T-shirts, handkerchiefs, socks, shoes, suits, dresses, skirts, knickers, pyjamas, belts, scarves, hats and wigs, bracelets, pendants, badges and rings, soap, bath-oil, shampoo, aftershave and 'talc', handbags, 'hold-alls', beachbags, shaving bags and satchels, umbrellas, plates, beakers, ashtrays, glasses, mugs, cups and saucers, paper cups, tea-towels, bedspreads, pillowcases, lampshades, wastepaper baskets, stools, keyrings, record-cases, wallpaper, dolls, plastic-model kits, toy guitars, and confectionery, including 'seaside' rock, bubblegum and even treacle records. Once the craze for a particular group subsided most of the souvenirs found their way into the dustbin, some to resurface 20 years later at Sothebys.

There are many types of expendability — physical, technical, stylistic or symbolic — and frequently one type was used to reinforce another. The most common modes of expendability in the High Pop years were subject matter, style and physical form. Quintessentially Pop artefacts combined at least two and sometimes all three modes.

Expendability of subject matter was the least visually successful or stimulating mode because it ignored appropriate form. Much of The Beatles' memorabilia was expendable only in subject matter. For example, The Beatles mug was produced blank in tens of thousands, and any image from pop groups to signs of the zodiac and football teams could be printed on it. Although the subject matter of The Beatles' mug was Pop, its form could have arisen from the Bauhaus.

BBC HULTON PICTURE LIBRARY

REX FEATURES LTD/HOFFMANN

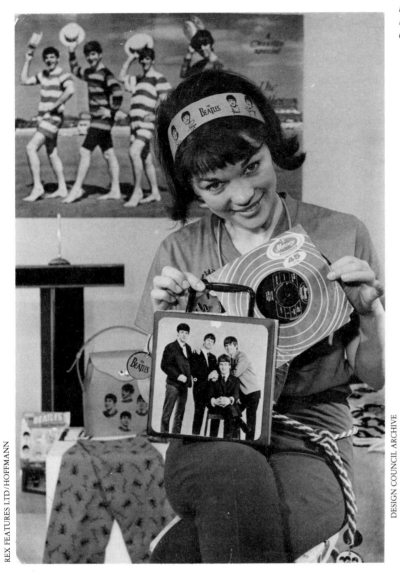

Souvenirs and Beatles mementoes, mid 1960s. Beatlemania gave rise to a bewildering array of items — all attempts to cash-in on the Beatles' enormous popularity.

DESIGN COUNCIL ARCHIVE

Transistor radio by Ferguson, 1960. The 'tranny' quickly became a popular symbol of teenage mobility — and an irritant to adults.

Stylistic Expendability and The Rise of Fashion

Indeed surprisingly few of the objects associated directly with Pop music had Pop characteristics. Juke boxes, so expressive of the frenzy of the 1950s became visually subdued and even tasteful: less of a focus, they became an invisible source of music (a trend that reached its zenith in the late 1970s). The transistor radio, or 'trannie' as it was known, became widely available in the 1960s, and was an integral part of the Pop lifestyle. Its essential portability meant that the Pop fan need never be away from the top twenty, need never be aurally isolated in an alien environment of nature or silence. The styling of transistor radios aimed at the young market borrowed the imagery of the 'walkie-talkie' or the army combat radio, imagery which was associated with movement and action.

SOTHEBY'S

Electric guitar, mid 1960s. Aggressive and virile in colour and shape, this was more a weapon than an instrument.

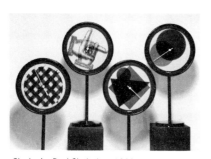

PAUL CLARK

Clocks by Paul Clark, late 1960s. Although these clocks date from late in the decade, they epitomise the stylistic expendability of Pop with its massive initial impact and small sustaining power. Ergonomics are sacrificed to fashionable imagery.

Injection-moulded coloured plastic casings enlivened the appearance of transistor radios but their form was almost invariably discreet and neutral.

A form that was determined as much by expressive needs as utilitarian ones was the electric guitar, the most visually important instrument of beat music. Three guitars (bass, rhythm, and lead) and drums was the line-up for most beat groups and both the appearance of the guitars and the way they were played were important aspects of a group's act. In 1965 a major manufacturer of guitars described how his designers experimented with numerous different shapes and colours until they arrived at a red, horned-end shape. Both colour and form were chosen for their associations: red because it was an 'aggressive, virile colour', and the horn-shape because, 'When a youth holds a guitar he is not playing an instrument, he is wielding a weapon. Watch him and you see he swings it around as if it were a machine gun.' Ergonomics were sacrificed to appearance. Although embellishment, customisation and novelties of finish and materials were common, the form of the electric guitar remained largely unaltered until the end of the 1970s.

Expendability of subject matter and expressive form were common characteristics of Pop. Add to these stylistic expendability, which in Pop is often a corollary of physical expendability, and you have High Pop.

Stylistic expendability can refer to the imagery and/or the form of two- and three-dimensional objects: a record cover using a particular graphic style, or a piece of furniture shaped in a certain way will fall out of fashion sooner or later. In the case of clothing, stylistic expendability was often underpinned by physical expendability.

At the beginning of the decade there was a need for clothing fashions that expressed youthful vitality and energy. One magazine called for '. . . space age clothes that can be launched to cram into suitcases, crush into narrow spaces for long journeys, and emerge at the end laboratory fresh.' Similarities were noted between the hectic pace of contemporary life and the social whirl of the 1920s:

> 'Then, as now, the clothes were for girls who wanted to look as though they were equipped to go anywhere, do anything. . . . Above all, the social mood is curiously in tune. People are determined to cram in a good time while they are still around to enjoy it.'[11]

There was an emphasis on youthfulness in the clothes of both periods but 1920s fashion had not been exclusive to the young. It was, according to Elizabeth Ewing '. . . *The* Fashion and it was a question of take it or leave it, whether you were 17 or 70.'[12] This was fundamentally different to Pop's specific appeal. A further difference was that in the 1920s fashions were available only to a relatively small, affluent group, in the 1960s the fashions were within the means of virtually all the young who wanted them. Clothes from the 1920s and 1930s were frequently revived in the 1960s. The 'lure' of the '20s and '30s was part of a widening of sources which were eclectic and often exotic.

Mary Quant's designs, however, moved away from the influence of earlier fashions and developed her own style. Quant had opened a second 'Bazaar' shop, in Knightsbridge, and in 1961 she decided to go wholesale. She had realised there was a huge market for the type of clothes she was designing: '. . . there was a real need for fashion accessories for young people chosen by

people of their own age. The young were tired of wearing essentially the same as their mothers.'[13] The young had money and could assert their tastes. One of the first large stores to stock Quant's mass-produced designs was 'Woolands' which opened a youth section called '21' in 1961. Typical of Quant's new designs was her 'mix and match' range: garments could be bought separately or co-ordinated with one another to produce the right image. The 'mix and match' range greatly increased the number of outfits available — all of the clothes were part of a total kit which provided the wearer with considerable flexibility. Quant's clothes enabled girls to create a fashion of their own.

Pop fashion became a topic of national interest and debate in 1963 — the year when '. . . legs never had it so good'. Although there had been a minor emphasis on boots and patterned tights the previous year; in 1963 the emphasis on legs was unmistakable: not only were striped football socks, heavy-ribbed knee socks, boldly coloured or patterned stockings, chunky Fair-Isle stockings, high boots and gumboots fashionable, but skirts were becoming increasingly short. In keeping with a life of activity, these skirts were flared or widely pleated for ease of movement. The mini had arrived. At this time, however, it was long enough to be worn by women of all ages.

Quant's next range of clothes — 'Ginger Group' — was an extension of the 'mix and match' idea, and she made use of simple but dramatic patterns and forms. The lack of fussiness and detail appealed to the young and it also had the major advantage of reducing production costs and thereby the retail cost. The image that Quant had originated was completed by a new hairstyle created by Vidal Sassoon which replaced the puff ball as worn by fashion models of the 1950s. Sassoon's thick chopped bob, cut high to the top of the neck at the back with a long straight fringe at the front brought women's hairstyles into the age of the mini. It had an enormous impact and 'the look' came into being. For Quant 'the look' was a total image:

'What a great many people still don't realise is that the look isn't just the garments you wear. It's the way you put your make-up on, the way you do your hair, the sort of stockings you choose, the way you walk and stand; even the way you smoke your fag. All these are part of the same "feeling".'[14]

[11] Drusilla Beyfus 'The Thirties Hits Town Again' *Queen* 16 January 1963, p 63.

[12] Ewing 1974, p 178.

[13] Quant 1966, p 41.

VIDAL SASSOON/DAVID MONTGOMERY

Vidal Sassoon, The Five Point hairstyle, 1964-5. This dramatic haircut was the inspiration for the crop of geometric cuts that followed.

[14] ibid, p 156.

Quant and the Designer's Role

Quant was highly successful. Her trip to America in 1962 established British leadership in young fashions. In 1963, *The Sunday Times* applauded her for 'Jolting England Out Of Her Conventional Attitude Towards Clothes'; critics claimed that she had changed the British approach to fashion. She was more modest about her achievement: 'We were in at the beginning of a tremendous renaissance in fashion. It was not happening because of us. It was simply that, as things turned out, we were part of it.'[15] Quant, and other fashion designers, had responded to a need. Unlike the Modernist designer who was willing to impose an alien taste on the public, Quant shared the tastes of the group for whom she catered. She described the designer's role thus:

'All a designer can do is to anticipate a mood before people realise that they are bored with what they have already got. It is simply a

[15] ibid, p 73.

[16] ibid, p 74.

question of who gets bored first. Fortunately I am apt to get bored pretty quickly. Perhaps this is the essence of designing.'[16]

Not only did the designer have to produce one novelty after another, but the novelties had to capture the mood of the time. Fashion, Quant believed, is related to and should reflect society:

[17] Quant 'A Personal Design for Living' *The Listener* 19/26 December 1974, p 816.

> '. . . this really was the first time that the emancipation of women became possible, and inevitably one produces the sort of things that reflect the way that one feels at the time. Everyone wanted to look as though they were very young, whether they were or they weren't.'[17]

Seeking to capture the excitement and sex appeal of youthfulness and the fun and energy of childhood, she saw no reason why '. . . childhood shouldn't last forever. I wanted everyone to retain the grace of a child and not to have to become stilted, confined, ugly beings. So I created clothes that worked and moved and allowed people to run, to jump, to leap, to retain this precious freedom.'[18]

[18] Quant quoted in Catherine Storr 'The Middle Age of Mrs Plunkett Greene' *Harpers and Queen* May 1973, p 118.

Bright Young Designers

This new spirit was also captured by other clothes designers including Zandra Rhodes, Bill Gibb, Ossie Clark, and Marion Foale and Sally Tuffin. Foale and Tuffin were typical of the new breed: they left the Royal College of Art in 1961 and declared 'We . . . don't want to be chic; we just want to be ridiculous.'[19] They were not dictating a new fashion from above but were themselves a part of it: '. . . we only design clothes that we want to wear.'[20] Although it could not be called a folk art, fashion of the kind designed by Foale and Tuffin was certainly coming up from a grass roots level. In early 1964 the trade journal the *Tailor and Cutter* acknowledged this new source of fashion: '. . . for the first time ever, many fashion influences are emanating from the under-25 group'. Production was not dominated by large manufacturers flooding the market with huge production runs, but by individuals who sold to manufacturers (who often produced the designs), or direct to stores. In the latter case, the retail cost was kept down by reducing the profit margin at each point of sale. In 1964, the International Fashion Council acknowledged the youth market as a 'style of fashion'. Fashion may have been breaking down barriers of class and nationality, but it was creating a new condition of membership: age.

[19] Foale and Tuffin quoted in Bernard 1978, p 16.

Two shops that became an integral part of swinging London opened their doors in 1964: 'Quorum' and 'Biba'. 'Quorum', run by ex-RCA students, Ossie Clark and Alice Pollock, catered for the wealthy end of the Pop world including Pop stars: but 'Biba', run by Barbara Hulanicki and her husband Stephen Fitzsimon, sold fashionable but cheap goods '. . . in a hypnotic atmosphere of pounding pop music and swinging short skirts and is tops for girls who want lots of new, cheap, not very well-made clothes . . .'. Biba started as a mail-order boutique — offering a gingham shift and scarf for 25/- (£1.25) — because Hulanicki was not able to buy the type of clothes she wanted. Biba's policy of selling cheap clothes was part of their 'knock-down, throw-away-and-buy-another philosophy'.[21] Hulanicki, in true Pop style, was

Marion Foale and Sally Tuffin, Double D dress, mid 1960s. Simplicity, youthfulness and fashionability: '. . . we only deisgn clothes that we want to wear.'

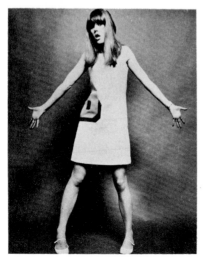

providing both stylistic and physical expendability. And the rate of change increased as Biba introduced new designs once or twice a week. Mass-production, cheapness and expendability were to the advantage of the consumer, Hulanicki argued, because they enabled the manufacturer to offer the consumers '. . . a far wider range of choice from which they can evolve their own taste'.[22]

By 1964, Pop fashion had almost fulfilled Richard Hamilton's 1950s definition of popular culture. Clothes were *popular*, *young* and highly fashionable and, therefore, were stylistically *expendable*, but also relatively *low cost* because they were either poorly made (acknowledging physical expendability) or *mass produced*. The fashion trade was booming: young fashion had become *Big Business*. And it was not long before Pop clothes became *sexy*, *witty* and *gimmicky*.

[20] Foale and Tuffin quoted in anon 'The Year of the Crunch — the Challengers' *Queen* 2 January 1963, p 6.

[21] Hulanicki quoted in Bernard 1978, p 148.

[22] Hulanicki quoted in Drusilla Beyfus 'Finding Your Style — Female' *Telegraph Colour Supplement* 6 June 1969, p 24.

Fashion, Sex Appeal and Gender Differentiation

Quant turned her attention to designing clothes that were *sexy*. Her 'baby doll' or 'little girl' look was: '. . . as sweet as sugar, but it is a sugar laced with the spice of sex appeal'. The pinnies, pantaloons and 'naughty knickerbockers' in pinks, blues and yellows were marketed as part of Quant's 'Ginger Group' range of co-ordinates. Femininity was at a premium and Quant wanted her

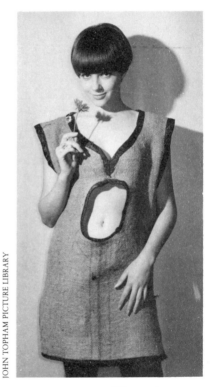

The 'little girl' look, mid 1960s, was '. . . as sweet as sugar . . .' but '. . . laced with the spice of sex appeal' — a widespread fashion with, in retrospect, alarming connotations.

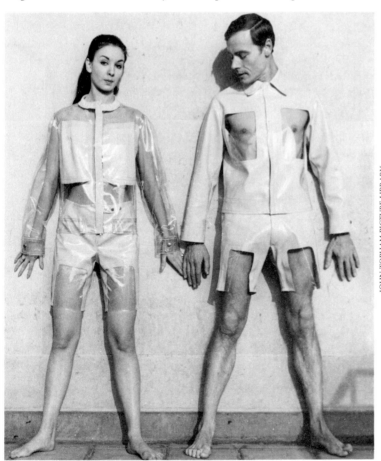

Cut-away clothes, mid 1960s. The vogue for cut-aways, usually in women's clothing, was part of an increasing male-orientated emphasis on sexuality and exhibitionism.

BBC HULTON PICTURE LIBRARY

JOHN TOPHAM PICTURE LIBRARY

[23] Quant 1966, p 152.

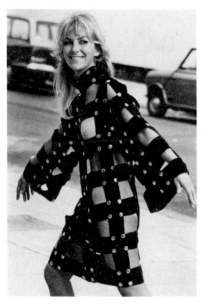

Sexually suggestive fashion, 1967. This dress, made from velvet ribbon and held together with metal fasteners, is modelled without the 'optional extra': underwear!

JOHN TOPHAM PICTURE LIBRARY

[24] ibid, p 93.

[25] Laver 1969, p 241ff.

[26] Storr 'The Middle Age of Mrs Plunkett Greene' op cit, p 119.

[27] Johnson 'Make Mine Topless' *New Statesman* 24 July 1964, p 116.

[28] Laver 1969, p 264.

clothes to say: 'Girls are nothing like boys. I'm a girl and isn't it super?'[23] The combination of childlike simplicity and sex appeal would have been unthinkable in the 1950s or early 1960s. Whatever the underlying psychology, the 'little girl' look was an example of sex appeal as a motivating force in young female fashion but its potential offensiveness was reduced by humour and *wit*. Quant's introduction of these qualities into fashion paralleled the use of humour and wit by the 'second generation' of Pop artists. The 'sixties was not the time for epic or heroic statements.

Another sexually manipulated female fashion was the 'topless' dress: designed by Rudi Gernreich in anticipation of fashion in 1970. Beach fashions have proved Gernreich right but whether the topless dress was serious or a publicity stunt (and merely *gimmicky*) is debatable: Gernreich did not put his design into production. However, some manufacturers did produce topless dresses that sold well, although one fashion editor commented on the rush to buy topless dresses and the reluctance to wear them. Several public wearings did lead to fines imposed by local magistrates. Dresses with cut-away parts or bikini dresses joined by mesh or netting which were sexually suggestive without being explicit were more acceptable. They invariably revealed less than first met the eye, and were often worn with a flesh-coloured bodystocking.

Clothes with sex appeal became central to Pop fashion. Many women would have denied that they chose their clothes with the intention of attracting the opposite sex, but Mary Quant was of the belief that, in female fashion, '. . . sex appeal has Number One priority'.[24] Quant's assertion supported the view expounded by the fashion historian and critic, James Laver, that the essence of women's fashion is sexual attraction. According to Laver, changes in women's clothing could be explained by the 'shifting erogenous zone' — women were made sexually attractive by shifting the emphasis from one erogenous zone to another.[25] The 'topless' fashion and the mini are examples of this theory.

A different interpretation of clothes with sex appeal was that they were symptoms of the emancipation of women. At the time, the swinging sixties were seen as a permissive age when a woman, liberated by the oral contraceptive pill, could enjoy sexual freedom. The critic, Catherine Storr, opined that the Pop fashion designers had given clothes '. . . a sexually attractive appeal which, by extension, heralded women's freedom, albeit sartorially . . . and by extension freed their sexuality and their emotions.[26] In the *New Statesman* Paul Johnson wrote that by choosing to assert herself: '. . . a girl who wears a topless dress in the streets of Coventry or Nottingham could be doing as much for her sex as any Mrs Pankhurst.'[27] We can now see the limitations of this naïve nascent feminism. Many sexy Pop clothes were designed to titilate men and reinforced the stereotype of the woman as an attractive young plaything. James Laver, in apparent contradiction of his earlier statement, believed that sexual differences in clothing are emphasised '. . . in periods of marked male domination.'[28] In retrospect, however, it is reasonable to conclude that sexually orientated fashion reflected woman's changing view of herself in the 1960s and as such was an early and tentative step towards female consciousness and autonomy.

Although some clothing emphasised the gender difference, other clothing minimised that difference. Much cross-fertilisation of ideas went on in male and female fashions. For example, the trouser suit, which had been available since the beginning of the decade, was described as the 'find of the year' in 1964. The increasing shortness of skirts meant that they had become restrictive,

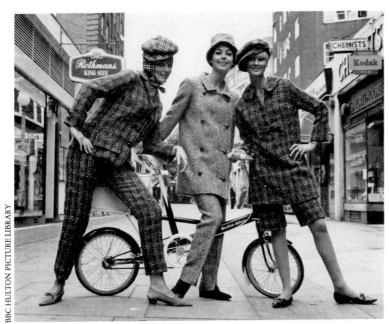

BBC HULTON PICTURE LIBRARY

Trouser suits were deemed suitable for the all-action life of the young, modern woman — whether she was speeding away to the country in a sports car or pedalling back from a Carnaby Street shopping spree on a new Moulton bicycle.

preventing the wearer from participating fully in her all-action life. The trouser suit was suitable '. . . for climbing in and out of cars, for racing around at weekends, or holidays — in short, made for the jumping, swaggering pace of 1964.' Prices for the trouser suit ranged from medium to high: *The Sunday Times Magazine* illustrated a plain suit for £6 16s (£6.80), and a fashionable 'fab suit' in floral print by Foale and Tuffin for 19 guineas (£19.95) available from Woolands. Unlike the mini and the topless, the trouser suit could be worn by young and old alike. It quickly became respectable and produced by the *haute couture* fashion houses for their wealthy clientele.

The turnover of fads and fashions seemed never-ending. By 1964, London was undisputedly the international centre of young fashion. According to the *Journal of the Society of Industrial Artists and Designers*:

> '. . . less than five years ago British women were among the drabbest, dullest and most boringly dressed people in the world . . . now . . . this has all changed . . . of all the branches of industrial design taught at art schools, fashion design has been the most successful in making our machine-made environment really enjoyable.'[29]

A similar although perhaps even more significant change was happening in male fashion.

[29] Editor: leader in *Journal of the Society of Industrial Artists and Designers* March 1964, p 1.

The Mods

Up to the time of Pop, male clothes were sombre and discreet, a direct descendant of puritan dress and an expression of seriousness of mind. Any extrovert display was taken as a snub at decorum and good taste. If a woman's clothing was supposed to make her attractive to the opposite sex, the motivation behind men's fashion was, conventionally, to denote status. The suspicion that only

Mod style, 1962. Marc Bolan, later to achieve stardom with the pop group T Rex, was a leading Mod — or Face — in 1962.

Mod

homosexual men were interested in fashion — a characteristic of the puritan tradition — was another reason for the sense of outrage caused by Pop fashions.

The first male fashion of the 1960s was that of the Mods or Faces, a small, exclusively male minority cult. Mods were 'dedicated followers of fashion', totally obsessed by style. They boasted that they changed their clothes five times a day, wore make-up, and completely rejected women and anybody over 25. Clothing was handmade by carefully selected tailors under directions from the wearer. One of the original Mods commented: '. . . we had our shoes hand-made for us . . . they were elfin, absolutely tiny, and they crippled you. They cost £5 a pair and fell apart in a fortnight but they were really beautiful.' The pursuit of style was all important; it was not eternal but changed by the week and for no reason. A particular garment might be worshipped one week and discarded the next. The Mods were wholehearted practitioners of expendability, but it was stylistic rather than just physical. The Mods' attitude to expendability was symptomatic of the times and in 1962 the editor of the *Tailor and Cutter* was forced to admit that 'styling has now become the mainspring of male fashion . . . mere "lasting" quality of clothes is no longer the prime motivation for their sales.'

The Mods could not have followed their dedication to fashion without money, which underlines the relative affluence of Britain at that time. It was possible, one Mod pointed out, to have a good life without working: 'A bit of dole; a bit of quiet thieving and an extra bit of handout from permissive parents was enough to keep anyone going . . .'. The Mods belonged to the first generation who did not remember the War, and subsequently did not feel guilty about their extravagant way of life.

In 1963, Mod became a mass youth group, and both the fashion itself and its role within the group changed. The single-minded dedication to clothes shown by the first wave of Mods was replaced by wider interests which included drugs, motor scooters and music. As the money available for clothes was relatively

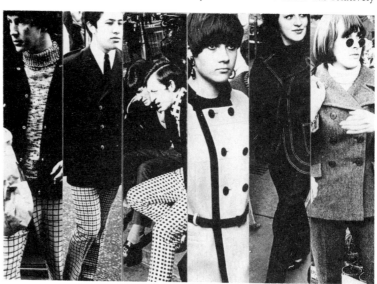

Mod fashions, mid 1960s, described in one magazine as '. . . visually kinky, colourful, uninhibited expressions of the androgynous male-female fashion . . .'.

reduced, coupled with a less exclusive approach, there was a need for cheaper, mass-produced clothes. In 1963 Mod became a blanket term for both male and female Pop fashions.

The main characteristic of male Mod fashion was brilliant colour: red denim trousers, purple shirts, green sweaters and even brightly coloured shoes were fashionable. Fashion magazines reported a wholesale plunder of ideas from female fashions. Some thought this made it difficult to tell the sexes apart. Men wore their hair long, women wore it short, and Pop groups, such as The Kinks, wore their hair in a style suited to either sex. A lot of clothes were sold as 'unisex' — they were 'Visually kinky, colourful, uninhibited expressions of the androgynous male–female fashion the Mod kids fall for.' Unisex hairstyles and clothes caused an outcry from older generations brought up to expect gender differentiation. One coloursupp feature entitled 'The Borderline Dispute' asked 'Has it all gone too far?', and received replies such as 'A man should look like a man', and '. . . those black suede shoes with purple velvet edging are really effeminate!' And the *Tailor and Cutter* added a characteristically stern caution: 'Adopting girls' hair styles may lead to adopting their clothes and there is legal danger in that.'

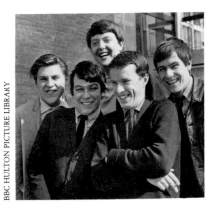

The Animals in 1964. Many pop groups cultivated a mod image of sharp stylishness.

Fashion as Expression and Communication

The shock of the new is a common phenomenon. Now it is hard to appreciate the sense of outrage that young fashions caused. Many of the male fashions, in particular, were basically conventional, departing from the norm only in details, colour or pattern. One example is the Beatle suit which was popular in

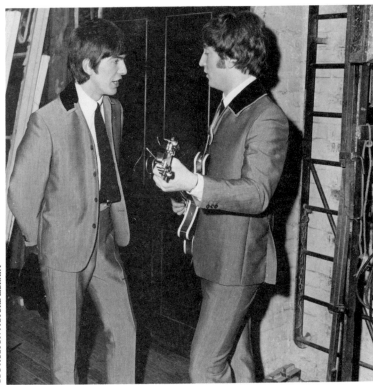

John Lennon and George Harrison wearing their specially designed Beatle suits: a combination of casualness and respectability calculated to appeal to the young without alienating the old.

1963 and 1964. The jacket differed from convention in that it was lapel- and collar-less, but the effect was not much different to that of a normal suit. At the time, however, the novelty of the styling made the jackets appear more different than they now seem.

The aim of the Beatle suit was to strike a balance between rebellion and respectability — rebelliousness to appeal to youth, respectability to soothe the parents — an aim that was successful. The importance of The Beatles' clothing style was discussed in an interview with their spokesman who, in the *Tailor and Cutter*, admitted that The Beatles '. . . prefer the looser casual style, not only for comfort, but to enable them to "get the message" over in their act.' The Pop groups and their promoters exploited the role of fashion as a form of social expression. Two groups who cultivated a scruffy appearance were The Rolling Stones and The Pretty Things. They also indulged in public acts of rebellion which gained them much publicity. Opposing the fashionable scruffiness, the *Tailor and Cutter* in 1965 stated: 'If you do not submit to some degree to the standards of society around you, you are deliberately sticking your tongue out at the world. And that, in effect, is what the majority of modern Pop groups are doing.' In 1965, the outrageousness of male fashions — pink trousers, Art Nouveau belts, orange corduroy shirts and flowered ties — was described as 'anarchistic'. The *Tailor and Cutter* regretted this '. . . new concentration on visual impact at the *complete expense* of quality (in its old connotation of durability).'

Futurism and Clothing

30 Balla 'Futurist Manifesto of Men's Clothing' 1913 in Apollonio 1973, p 132.

PHOTO GIUSEPPE SCHIAVINOTTO

Giacomo Balla, design for a man's suit, 1914. Balla, in his Futurist Manifesto of Men's Clothing *anticipated the visual impact and stylistic expendability of Pop.*

Indeed, Pop fashion for men in the mid 1960s was remarkably similar to the Futurists' notion of how men's clothes should look.[30] Giacomo Balla had written the 'Futurist Manifesto of Men's Clothing' in 1913:

'WE MUST DESTROY ALL PASSÉIST CLOTHES and everything about them which is . . . colourless, funereal, decadent, boring and unhygienic.'

to be replaced by:

'. . . hap-hap-hap-hap-happy clothes, daring clothes with brilliant colours and dynamic lines. . . . Use materials with forceful MUSCULAR colours — the reddest of reds, the most purple of purples, the greenest of greens, intense yellows, orange, vermilion. . . .'

Other adjectives used to described Futurist clothes — dynamic, aggressive, shocking, energetic, violent, flying, peppy, joyful, illuminating, phosphorescent — make it clear that their appearance would have been similar to that of Pop clothes. Furthermore, the motivating force behind Futurist clothes was that:

'. . . they must be made to last for a short time only in order to encourage industrial activity and to provide constant and novel enjoyment for our bodies.'

Planned obsolescence and a desire for visual stimulation were also essential not only to Pop fashion in particular, but Pop design in general.

An increasing number of men began to take fashion seriously, and in 1965 men's fashion sales rose by 15%. Hepworths, to mark the occasion of their centenary, presented the Royal College of Art with £20 000 a year in order to set up a menswear section. In February 1965 *Queen* started a regular feature, 'The Male Element', and in October the *Sunday Express* became the first national newspaper to employ a male fashion columnist. Reactions to male Pop fashion polarised: it was seen as either the symbol of national decline, or a positive expression of a new spirit. There were claims that fashion was helping to destroy class barriers but John Morgan considered that the male interest in fashion was neither good nor bad but merely reflected full employment and a relatively high level of income among the young.[31] But surplus wealth alone does not necessarily lead to a blossoming of creative talent. Drusilla Beyfus described the significance of fashion from youths' point of view:

> '. . . the last thing these customers want is a good thing to last. They need to be able to afford a new fashion, often. For a lot of these youngsters, the fact of snapping up high-heeled navy blue suede boots one week and buying a two-toned shirt the next is the finest proof they know that they have a lot of living to do.'[32]

In the High Pop years fashion assumed an absurd importance for many of the young, and seemed to provide a purpose in life.

[31] Morgan 'Males in Vogue' *New Statesman* 26 November 1965, p 820.

[32] Beyfus 'How to Tell a Boy From a Girl' op cit, p 47.

'Ready! Steady! Go!'

The undisputed guide to fashion for the Mod was 'Ready! Steady! Go!' (RSG) first shown in August 1963. RSG was immediate and full of visual impact; it showed the latest fashions in clothes, music, dance, slang and gesture every

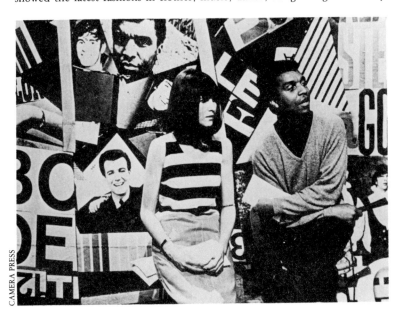

CAMERA PRESS

Cathy McGowan (with Kenny Lynch) on the set of *Ready! Steady! Go!* in 1965. The sets helped to convey the general atmosphere of spontaneity and excitement.

33 Twiggy 1976, p 16.

week (virtually eliminating the time lag between the capital and the provinces). The programme's early evening screening time on Friday meant that 'The Weekend Starts Here' slogan was the case for millions of viewers. The latest fashions were keenly observed and the following day the clothes were either sought in boutiques, or quickly 'run up' at home. The model, Twiggy, recounts that '. . . we had to make things ourselves, because they were never in fashion long enough for the fashion people to catch up.'[33] One of the comperes of the programme, Cathy McGowan, attributed RSG's success to its attitude in giving the young what they wanted: 'We show the kids what's new — they can pick it up if they like it.'[34]

34 McGowan quoted in anon 'Changing Faces' *Sunday Times Colour Supplement* 2 August 1964, p 16.

Pop television programmes also had a major influence on boutique interiors. The 'Orbit' boutique in Bristol was typical of the High Pop boutique. It was '. . . as far from the old time *soigné* salon as could be conceived. The decor doesn't casually seduce ''modom'': it hits her right between the eyes, like the kind of thing that goes on behind Cilla on ''Thank Your Lucky Stars''.' 'Orbit' was decorated with coloured Op art discs which neither respected the scale of the interior nor provided a neutral background to the clothes, but created a Pop atmosphere. Television sets and boutique interiors shared the same purpose — to give context and meaning to the 'goods' on display.

The Mini and Body Language

The mini continued its relentless rise to new heights. *Haute couture* fashion designers were said to disapprove, and Christian Dior is supposed to have found them ugly. But despite establishment disapproval, the mini survived: 'a victory for the girl in the street against the couturiers'. In 1965, when mini skirts had risen as far as mid-thigh level, tights were introduced by Dorothy Perkins to avoid the almost certain exposure of stocking tops and suspender elastic. The new mini length required a new way of sitting, which illustrates the relation between clothes and body expression. The fashionable posture was a mixture of modesty and exhibitionism: knees together facing slightly inwards and feet wide apart. The overall appearance — personified by Twiggy, the 17-year-old who was 1966 'Face of the Year' — resembled a gangling adolescent. This look became widely fashionable among the young in the mid 1960s. George Melly recorded his observations of five art students talking in a group, all of whom, male and female, stood in the same way:

> 'Heads craned forward, shoulders slightly raised, trunks off centre, but leaning either forward or to one side, never straight or backwards. Arms and legs were pushed out at angles so that there seemed no flow either singularly or as a group. When they moved, which was infrequently, everything seemed to jerk into new awkward angular shapes.'[35]

35 Melly 'Gesture Goes Classless' *New Society* 17 June 1965, p 26.

36 Quant 1966, p 46.

37 Bailey 1969, p 226.

38 Armstrong-Jones quoted in *Sunday Times Magazine* 9 December 1979, p 27.

39 Hall-Duncan 1979, p 161.

Similar body stances had been adopted by fashion models. Previously, models had been trained to look aloof with one toe pointed a little ahead of the other, but Quant selected models with high cheek bones, angular faces, Sassoon hairstyles and long legs. She insisted they stand '. . . in gawky poses with legs wide apart, one knee bent almost at right angles and one toe pointing upwards from a heel stuck arrogantly into the ground.[36] The fashion model as a sophisticated

but unobtainable clothes-horse was being replaced by the model as actress or purveyor of a lifestyle. As the photographer David Bailey put it, no longer were fashion models '. . . fairy-snowed, . . . but like birds we'd like to make.'[37]

Fashion Photography

Fashion photography changed accordingly. The neutral and formal fashion plates of the 1950s were replaced by the new photography which was grainy, contrasted, novel in camera angle, and informal, as though the photographer had stumbled across the scene. The first changes became apparent in the late 1950s. In 1959 *Vogue* employed Lord Snowdon (then Anthony Armstrong-Jones) and his 'action style' became a trademark. In his autobiography he describes how he made the models move and react '. . . either by putting them in incongruous situations or by having them perform unlikely and irresponsible feats. I made them run, dance, kiss — anything but stand still.'[38] To maximise visual impact, tricks were used to deceive the viewer's eye: nylon thread would be used to suspend a glass which looked as if it had been thrown; a model in an impossible position would have had her shoes nailed to the floor; a rope would suspend another model from the ceiling.

Snowdon, and the older generation of photographers — Richard Avedon, Irving Penn, Norman Parkinson and Helmut Newton — influenced the photographers who became famous in the 1960s: David Bailey, Bryan Duffy and Terence Donovan. Duffy's photographs appeared in *Vogue* from 1960, Bailey's from 1961 and Donovan's from 1963. Their work also appeared frequently in *Town*, *Harpers* and *Queen*. Professional and personal relationships between photographers and models overlapped. In Bailey's case the model was Jean Shrimpton, the 'Face of the Year' in 1963. Their partnership started in 1962 and reached its peak in 1964 when every issue of *Vogue* seemed to contain some of his photographs of her. In the *History of Fashion Photography* (1979), Nancy Hall-Duncan writes how

> '. . . the directness of the confrontation and the fascination of Shrimpton and Bailey's personal and professional relationship, particularly its sexual overtones, gave these pictures amazingly wide appeal. Bailey became a pop tastemaker and Shrimpton the symbol of swinging London; together their sexually — and socially — charged symbolism personified the myth of the sixties.'[39]

A cult of the 'photographer-hero' arose, and Antonioni's film 'Blow Up' (GB 1966) was loosely based on David Bailey's lifestyle.

More conservative art editors rejected the new fashion photography. For a trade journal such as the *Tailor and Cutter* the style was alien: 'The depicting of some garments seems to have become of secondary importance when measured against the photographer's chance to show off his artistic licence and his eccentric chic.' The criticism of the means becoming an end was valid. As Bryan Duffy said of Bailey's photographs of Shrimpton:

> '. . . he's always made Jean very leggy. I think he's done a lot to make people conscious of legs, even if the clothes were not any-

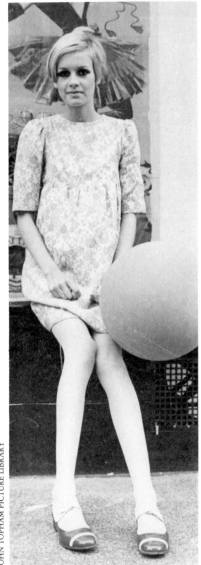

JOHN TOPHAM PICTURE LIBRARY

Twiggy in 1966 was the 'Face of the Year' and a stereotype of the anorexic woman: Twiggy's vital statistics were 32-22-32.

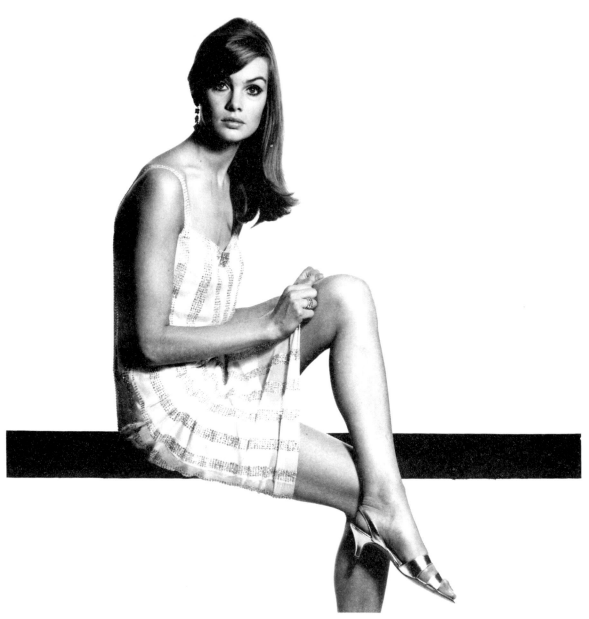

Photograph of Jean Shrimpton by David Bailey, mid
1960s. Shrimpton was cast as a symbol of
swinging London: Bailey was perceived as a Pop
tastemaker.

CAMERA EYE/DAVID BAILEY

thing to do with leggy things. Somehow he's made them look as I'm sure the person who designed the clothes had no intention of making them look. He just likes Jean's legs.'[40]

40 Duffy quoted in Francis Wyndham 'The Model Makers' *Sunday Times Colour Supplement* 10 May 1964, p 19.

But the way a fashion garment is depicted — its total image — is often *as* important as the garment itself. The new style of photography was less an illustration than the projection of a total image. Duffy argued they were '. . . imparting an attitude, a look, a stance, a way of expression of a body, which one hopes . . . people will adopt.'

'We'd spend an evening in the East End . . . watching Mods and Rockers . . . I wouldn't go down there consciously, thinking I'm going to observe them and then come back and do a fashion picture from their attitudes of standing, but one finds one does. . . . They're sort of inflexions or manners that you see about. . . . So you say to a girl: "Stand this way".'[41]

41 ibid, p 19.

The Pop photographers were aware that the image was more important than its individual parts which explains why their photographs caught the mood of the time. As any 'look' is transitory, Duffy felt the photograph should also be transient:

I think it would be marvellous to make your pictures out of date after six weeks . . . because the quicker you get them out of date, the more on the ball you are. I hate this thing "classical".'[42]

42 ibid, p 21.

The '60s photographers were willing to break with convention as long as their images looked fashionable. The driving force of photography had become stylistic expendability. Pop photography was exemplified by *Bailey's Box of Pin Ups* (1965), portraits of the models, pop singers, artists, hairdressers, tycoons, photographers and even criminals who comprised 'the Scene'.

Magazine Design

Magazines in which the photographs appeared were also revamped. In 1957, Jocelyn Stevens, then only 25 years of age, bought the society magazine *Queen*, '. . . an old-fashioned, stuffy magazine . . .', and transformed it. Mark Boxer was appointed art editor, and under their initiative *Queen* became visually dynamic and '. . . a cult thing'. It was no longer aimed at the society deb and her parents, but the Chelsea girl of 'swinging London'. *Queen* and *Vogue* used high-contrast photography with grainy textures and a layout of stark sans serif lettering which went to the edge of the page and of acceptability. Principles and conventions of borders and spacing were ignored for purposes of impact and ingenuity. This new style was acclaimed as the 'black and white revolution'.[43]

43 Banham 'Black and White Magazine Show' *New Statesman* 2 June 1961, p 889.

Improved printing technology permitted innovation. Photo-lithography gave designers greater freedom and facilitated the binding, stretching and twisting of letters for decorative or dramatic effect, which was seen across the spectrum of graphic design from television title credits and commercials to colour supplements, book jackets and record covers. Penguin books, for example, under the art editorship of Germano Facetti, departed from a strictly

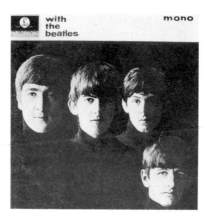 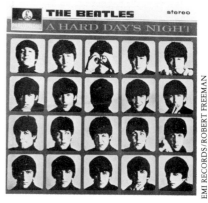

EMI RECORDS/ROBERT FREEMAN

'With the Beatles' and 'A Hard Day's Night', 1963 and 1964. The covers of the second and third LPs by the Beatles reflect graphic design trends of the early to mid 1960s.

typographical design for their covers and began using drawings, sketches, paintings, photographs and photomontages.

Record Cover Design

Record covers were also changing. While the sales of 'singles' remained fairly constant, at just over 50 million per year between 1960 and 1966, the sales of LPs almost doubled from marginally over 17 million to slightly under 34 million in the same period as affluence became widespread and the cost of stereo record players became relatively cheaper. The cover of The Beatles' first LP 'Please Please Me', issued in April 1963, was an unimaginative photograph of the group gazing down from a balcony at the record company headquarters, but their second LP 'With the Beatles' (November 1963), had a cover that made a massive impact. A stark black and white grainy photograph of the group taken by the fashion photographer Robert Freeman was used. The simplicity was startling. The faces were half in shadow but brightly highlighted; the typography, placed discreetly at the top of the cover, did not detract from the photograph. 'With the Beatles' was the first record cover to show the influence of the 'black and white' design of the fashion magazines. It was followed some months later (January 1965) by The Rolling Stones' second LP cover which was a low-key, colour, high-contrast, light-and-shade portrait of the group by David Bailey. 'A Hard Day's Night', The Beatles' next LP issued in July 1964, had a photographic cover with 20 small portraits, similar in style to their previous cover, arranged to suggest the repeated images of an Andy Warhol print. The LP covers of 'Beatles for Sale' (December 1964) and 'Help!' (August 1965) used Robert Freeman photographs, but neither brought in new graphic ideas or fashion. But 'Rubber Soul' (December 1965), with a photograph by Freeman, made use of a distorted image in a diagonal layout with the title of the record in red Pop-style rubbery lettering (to reinforce the title) at the top left of the cover. The impression the design created was of a dreamlike vision — reality viewed through the reflection of water. 'Rubber Soul' anticipated the psychedelic record covers of 1967.

There were other notable Pop LP covers in the early to mid 1960s, for example, Bob Dylan's 'The Times They Are A-Changin'' (July 1964), with its dramatic black-and-white high grain photograph of Dylan as an angry young man, and The Animals' 'Animal Tracks' (May 1965), with the group photo-

graphed as commandos resting during manoeuvres on a railway track. However, the majority of LP covers were straightforward portraits or figure photographs of the group. The record cover did not become a significant vehicle of Pop design until 1967.

Pop Art-Influenced Graphic Design

Surprisingly few of the many graphic design ephemeras associated with the Beat music boom had been Pop in anything but subject matter. The number of photographs of The Beatles that could be bought in books, magazines, on post-cards, calendars, and posters was incalculable, but rarely was the visual style of presentation itself Pop. The first major flowering of Pop graphic design appeared in the Royal College of Art's journal, *Ark*. Under the editorship of Roger Coleman between 1956 and 1958, *Ark* had shifted its ground from Modernism to Pop. The new style *Ark* had published articles by Independent Group members with entire issues devoted to IG interests including 'Americana'.[44] The change in editorial policy was accompanied by a change in presentation and format. Visual experimentation included text printed on brown sugar paper, a yellow transparent page containing the image of a figure in red, and a page of silver incorporating a transparent mystical symbol so the text on the next page — an article on religion — could be seen. The visual dexterity of *Ark* between 1956 and 1958 anticipated the graphic design of the underground magazines a decade later.

Ark returned to a more conventional format until 1962 when a new graphic inventiveness was apparent under the editorship of Bill James. The influence of the Pop painters was undeniable. Hockney, Boshier and Phillips had graduated from the RCA in 1962, Jones had left in 1960 and Kitaj in 1961. Richard Hamilton taught at the College from 1957 to 1961, and Eduardo Paolozzi gave guest lectures there. *Ark* number 32 was the highpoint of the Pop graphic style with its orange, blue, red and yellow cover depicting part of a slot machine, which incorporated images of Victorian moustaches and the 'Joker' from the 'Batman' comic strip.[45] Inside there was an orange and red transparent

44 *Ark* number 19, 1957.

45 *Ark* number 32, Summer 1962.

Page from booklet given away with *Ark* no. 32, 1962. The fine art and graphics departments at the Royal College of Art were major centres of Pop two-dimensional style.

Cover of *Town* magazine, May 1963. Pop art quickly became part of the visual currency of the day.

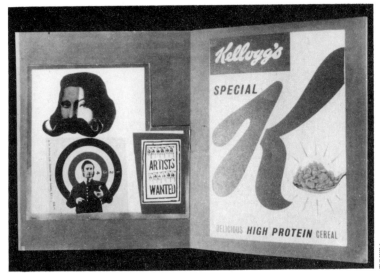

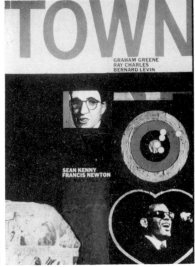

paper inlay, a series of grainy photographs of America by art editor Brian Haynes, and an article by Richard Smith which included illustrations of paintings by David Hockney, Derek Boshier and Peter Phillips. A 'kit of images', included as a free gift with the issue, was a veritable Pop *objet d'art* incorporating images of a target, a pinball machine, packaging and Americana. Issues 33 and 34 maintained this graphic style.[46]

[46] *Ark* number 33, Autumn 1962; number 34, Summer 1963.

The graphic style of *Ark* was influential and Pop graphics appeared increasingly from 1963 as the fashion spread. The colour supplements employed Pop artists as well as graphic designers to design covers and illustrations for articles. Peter Blake, for example, designed a cover for *The Sunday Times Colour Supplement* in October 1963 containing a feature on 'The Criminal Core'. In a similar style to his paintings of Pop stars, Blake's cover design was a set of boxes, and each box contained either a portrait or an object. The cover for *Town* magazine in May 1963 was an example of unrestrained Pop design: portraits painted in a Pop style of a contributor to and a pop star featured in the magazine were placed against a bright yellow background which included a fragment of a comic strip and a target; the magazine's bright red title was used as an integral part of the design. Pop art quickly became part of the visual currency of the day.

Two Pop art motifs that were very popular were the Union Jack flag and the target. From 1963 the Union Jack could be seen on mugs, trays, alarm clocks, plates, cushions, tea-caddies, table-cloths, bedspreads, carrier bags, tea-towels, aprons, handkerchiefs and clothes. Oliver Goldsmith introduced Union Jack sunglasses in the spring of 1966 and, in the summer of 1966 the emblem proliferated in the graphics and souvenirs associated with the World Cup which was held in England that year. By 1967 cheap souvenirs carrying the Union Jack had become the mainstay of Carnaby Street boutiques, one of the greatest Pop exports of the swinging sixties. The target motif also appeared on an extensive range of surfaces. The title sequence of 'Ready! Steady! Go!' included a target as

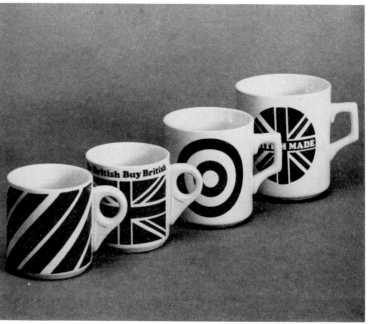

Paul Clark, souvenir mugs, 1965. Expendable subject matter in Pop graphic styles printed on anonymous forms.

DESIGN COUNCIL ARCHIVE

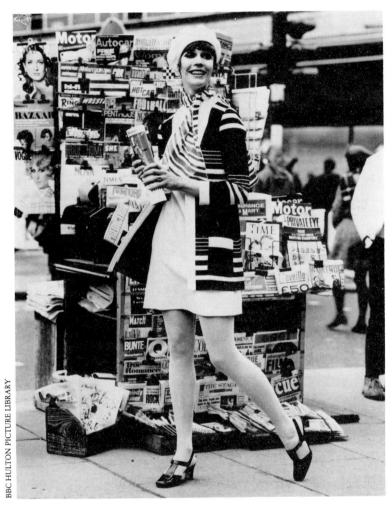

BBC HULTON PICTURE LIBRARY

Op clothes, mid 1960s: '. . . anti pretty but witty.'

part of a series of Pop objects, and target mugs and T-shirts were big sellers in 1965 and 1966.

A Pop art style that was frequently used on fashions and as graphic design was the comic-strip of Roy Lichtenstein, from the instruction leaflets in Mary Quant's cosmetic packs to the style of the American-made 'Batman' series on television (1966–67). In 1966 one of Lichtenstein's paintings — *Pistol* — was reproduced in black and white on a unisex T-shirt by Lee Cooper (without the knowledge or permission of the artist). It was a splendid example of High Pop — *popular*, *expendable*, *low-cost* (12/6d (63p)), *young*, *witty* and *gimmicky*.

Op Art-Influenced Graphic Design

The Op art of Bridget Riley had a short but significant impact in 1965 and early 1966. In autumn 1965, Op fashion was being hailed as a 'Positive new look. Very simple. Black and white in new proportions, new textures. And the only dash of colour is you.' Bold black and white checks and big black parallels swivelling into circles at the waist adorned dresses, skirts, shorts, trousers and

even pyjamas. Op clothes were '. . . full of surprises and jokes suddenly sporting great circles or squares or other geometrical shapes. . . . They're anti pretty but witty. . . .'

The popularity of Op fashion was ensured by the successful return of the television series 'The Avengers' in September 1965. The first series had starred Honor Blackman who usually dressed in black leather fighting-suits, part of the earlier 1960s fashion for leather boots and the 'kinky' look, but in the second series Blackman was replaced by Diana Rigg and a new image. John Bates of Jean Varon designed Rigg's clothes, which bore the influence of Op and Pop art, especially the large collection of furs and short skirts which were part of a wardrobe of 35 garments and complementary accessories. By the end of October 1965, Avenger-inspired clothes produced under licence were available in the shops.

The Op fashion craze lasted into 1966, but some critics objected to the incongruity of having a swirling Op pattern printed on a two-dimensional surface which was '. . . wrapped, pleated, draped and creased' on a three-dimensional form. Bridget Riley bitterly complained that the manufacturers and designers of the dresses did not understand

> '. . . the principles on which my images are based and [if they] applied them to dresss, they'd get something different and perhaps quite marvellous. But they must lift them wholesale, and on the most superficial level. So nothing has any unity. I've yet to see an op fabric which is wearable. I think they're ugly beyond belief.'[47]

John McConnell, Biba logos, 1965 and 1969. The Op-/Art Nouveau-influenced logo was replaced by one inspired by Art Deco at the end of the decade.

But conventional design principles such as 'integrity of surface' were irrelevant to Pop designers or consumers.

Op was also used extensively in graphic design, and two of the best known logos of the mid 1960s were Op-inspired: the 'Woolmark', a black stylised ball of wool; and that of the 'Biba' boutique, a mixture of Op and Art Nouveau. Op sets on 'Ready! Steady! Go!' and 'Top of the Pops' helped spread the fashion into countless high-street window displays and even films such as 'Modesty Blaise' (GB 1966). John Bannenberg's Op domestic interior for Mary Quant received much publicity and was described as

> '. . . an exercise in pure fashion — in today, expendable tomorrow and no tears shed. There is little in the room which is intended to hold its interest for a much longer period of time than the swinging dresses worn round the table. Neither associations with the past, nor an inheritance for the future have much place here.'[48]

The domestic interior was no longer a neutral background for gracious living, but as exciting, and as expendable, as a boutique interior.

The Art Nouveau Revival

There was an Art Nouveau revival which gathered momentum after the 1963 Alphonse Mucha exhibition at the Victoria & Albert Museum. The 'colour-

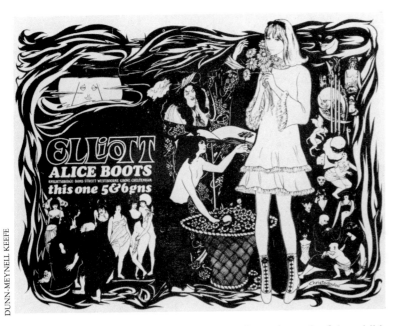

DUNN-MEYNELL KEEFE

Paul Christodoulou Elliott: Alice Boots, 1967. The 'rediscovery' of Beardsley, in 1966, had a major influence on graphic design.

47 Riley quoted in Prudence Fay 'Op-position' *Queen* 5 January 1966, p 9.

48 Drusilla Beyfus 'Op Art Rooms' *Telegraph Magazine* 17 September 1965, p 40.

supps' and magazines, eager to report new trends, made much of the exhibition. By 1964, *Queen* was describing 'Art Nouveau fever'. Liberty's revived a collection of Art Nouveau printed fabrics. And a Beardsley-influenced poster by Paul Christodoulou for Elliott's shoes, introduced in February 1964, was part of an Art Nouveau-style campaign which included window displays and interior designs. In 1966, the Beardsley exhibition at the V & A was a particular source of inspiration for graphic designers: the cover of The Beatles' seventh LP 'Revolver' (August 1966), and another poster by Christodoulou for Elliott's shoes in 1967 made direct references to Beardsley's work. Tiffany lampshades were revived in early 1967, and also a further collection of Art-Nouveau fabrics with designs '. . . as exciting now as they were in the late nineteenth century.' Biba's Kensington shop had a distinctive Art Nouveau decor of 19th-century furniture and Beardsley prints.

The 'naughty nineties' aspect of Art Nouveau, with its Symbolist imagery and languid *femmes fatales*, appealed greatly to the Pop designer. In 1964, *Design* wrote of the 'kinky' look of both Art Nouveau and Pop, which made Art Nouveau a relevant source of imagery for Pop.

Victoriana had always been an undercurrent in Pop graphic design, and some continuity with Victorian graphic design had been maintained with the revivals of the 1930s and 1950s. The 1960s revival extended from the use of Victorian 'camp' design, such as the original 'Your Country Needs You' poster, to Victorian typography, facilitated by the re-introduction of eight Victorian and Art Nouveau typefaces by Letraset.

Eclecticism

Eclectic sources were sometimes merged to create a hybrid. Nigel Quiney mixed Art Nouveau whiplash curves with bright Pop greens, reds, blues, and yellows in his non-seasonal wrapping paper. Cliff Richards designed cardboard gift

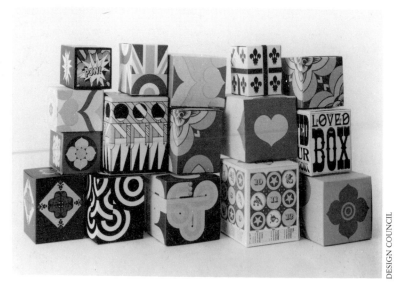

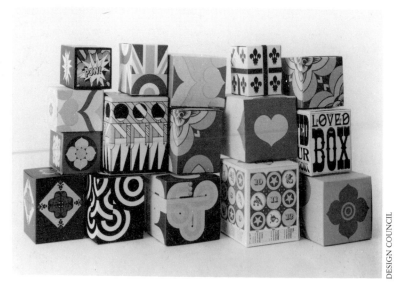

Cliff Richards cardboard gift boxes, 1966. Pop graphic design borrowed and stole from a multitude of sources from Victoriana to Pop Art.

DESIGN COUNCIL

boxes and made use of several motifs and styles of Pop graphic design: the Union Jack, a comic-strip style, Op art, Art Nouveau and Victoriana. Pop note-paper, introduced in 1966, was a combination of Art Nouveau swirls and Pop colours in pink, gold, blue, green and orange. These patterns and colours defied the primary need for a plain, neutral background but '. . . it doesn't matter. The papers are for fun and for communicating the up-to-dateness of the writer.' The medium, it seems, was the message. Pop eschewed Modernism's purity and would beg, steal or borrow from any source that had visual impact and appeal. By the time a Modernist had raised an objection about the appropriateness of a source, Pop had left it behind and moved on. The reason why a particular fad or craze caught on with Pop consumers is often impossible to explain rationally. Although visual novelty and impact were important, they did not guarantee popularity. Imagery or style had to be relevant and/or expressive of youthful-ness before it was popular. Pop and Op were popular because they had immediate impact, were visually dynamic and up-to-date; and Art Nouveau

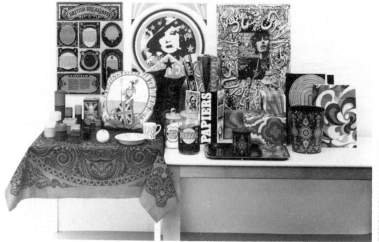

Posters, objects and souvenirs from Carnaby Street, 1967. 'One day "Carnaby Street" could rank with "Bauhaus" as a descriptive phrase for a design style . . .'

DESIGN COUNCIL ARCHIVE

had associations of the 'naughty nineties'. The meaning of symbols could also change. The Union Jack was transformed in the 1960s from a symbol of national pride, to that of the new and 'swinging' Britain. However, without the appeal of its design and bold colours, the Union Jack would not have been so popular.

49 Sally Jess quoted in Meriel McCooey 'Plastic Bombs' *Sunday Times Colour Supplement* 15 August 1965, p 27.

Space and Plastics

The 1960s was the decade of the space race. Inevitably the imagery of space percolated through Pop design. Boutiques had walls and ceilings of anodised or polished aluminium, and some — including the 'Just Looking' boutique in the Kings Road by Garnett, Cloughley, Blakemore and Associates — made use of stainless steel computer-lettering for their signs.

Most of the space-derived clothes were made in plasticised polyvinyl chloride (PVC), a soft and flexible material previously used for domestic items, such as shower-curtains. PVC made the fashion headlines in 1965 when it was described as the 'success of the season'; 'the explosion of the year'. According to one designer PVC was important because 'It's a material you can't work nostalgically, you have to make modern shapes.'[49] It had taken two years of research and experimentation before the difficulty of welding the seams was solved and the material could be used to make clothes. In the mid 1960s, PVC was manufactured in 'razzle dazzle bright colours', 'hygienic white' with flowered, striped or Op patterns, transparent or in silver. PVC accessories, such as 'hangman's helmets and face-protecting visors', Op art berets and earrings were also available. Some of the see-through designs were space-inspired, but it was silver, because of its association with a spacesuit, that became the colour of space fashion. As one excited fashion commentator exclaimed in 1965: silver clothing '. . . fits into current fashion like an astronaut into his capsule'.

Silver clothing was produced in a range of materials, some described as so 'magically soft, so weightless, they seem to have lost their gravity like the flim-

Harry Lans, silver paper suit, 1967. A disposable fashion for space-age living.

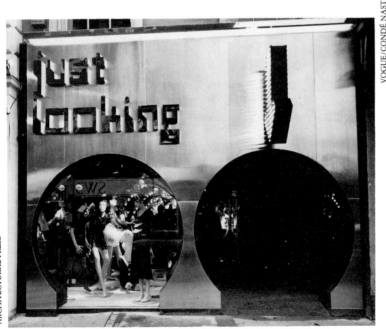

Space-age influenced boutique design. The interior scheme of a boutique was important in establishing the right atmosphere and mood for its modernistic and fashionable merchandise.

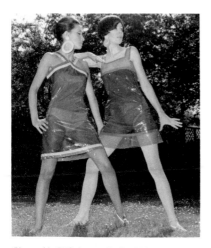

Disposable PVC dresses by Daniel Hechter, 1966. In the 1960s PVC was used as a disposable material. A major appeal was its futuristic character — it seemed to belong wholly to the space age.

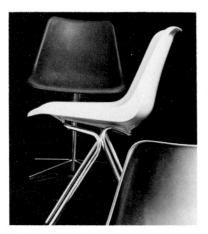

Robin Day, polypropylene chair, 1963. Although not Pop, the Polyprop was both multi-functional and cheap enough to be expendable. Over two million had been sold by 1970.

BBC HULTON PICTURE LIBRARY

HILLE INTERNATIONAL

siest tinfoil.' As early as 1964 Courrèges were offering fashionable if expensive 'moon girl' silver trousers, but by 1967 Incadinc were supplying a silver dress for only 16/- (80p). It was made of metal-covered plastic Melinex, which the manufacturer claimed would not rip, tear, flare, crack or scratch, and was sold in kit form. All the purchaser needed was a pair of scissors and sellotape. Its rather unusual drawback was that it was a 'noisy little dress'. Disposable silver clothing was deemed by one designer as perfect for our age: '. . . after all, who is going to do the laundry in space?'

The significance of the popularity of PVC and other plastics-based clothing arose not only from the appropriateness of its associations and imagery, but from the acceptance of undisguised plastic. Plastic had had overtones of inferiority and cheapness since the 1930s when plastic was often used to stimulate more popular or expensive materials. 'Bargain prices bought shoddy goods — faded colours, crazed mugs, cracked boxes and designs that came off in the wash', wrote Sylvia Katz. 'The whole industry was demeaned and the effects were felt all down the line from designer through producer to consumer.'[50] The rash of easily broken and sometimes dangerous plastic toys imported from Hong Kong in the 1950s had consolidated this prejudice. But by putting plastic to new uses and inventing fashionable and appealing forms, the Pop fashion designers transformed the image and status of the material.

From the mid 1960s until the sharp escalation in the price of oil during the energy crisis of 1972, there was major experimentation and innovation in the design of plastic chairs. Italy was foremost in plastics design. Joe Colombo's plastic stacking chair (1965), Vico Magistretti's 'Selene' chair (1968) in moulded glass fibre, Leonardi and Stagi's moulded glass fibre 'Dondolo' stacking chair (1967), and Motomi Kawakami's press moulded ABS plastics 'Fiorenza chair' (1968) were all manufactured in Italy and imported into Britain. Most of these chairs were relatively expensive: the cheapness of injection moulding was offset by the high cost of tooling, which, in the mid 1960s, could require an investment of over £100 000 before any chairs could be produced. Manufacturers would only make such an outlay if the design was likely to sell over a long period of time. Robin Day's 'Polyprop' chair, first produced in England in 1963, sold well; it was cheap and multi-functional. However it conformed to Modernist principles of design and aesthetic. The only plastics furniture cheap and fashionable enough to be described as Pop was that covered in plastic or kapok, such as 'Walters Whatsits', colourful multi-purpose items sold at just under £3 each (cheap enough to throw away).

Paper Products

One material that was unreservedly Pop was paper. Plastic may have been expressive of the space age and was, at times, cheap enough to be expendable, but paper products signified a complete commitment to stylistic *and* physical expendability. Paper goods were the embodiment of Pop values: *expendable* and transient, *popular* with the *young*, *witty*, *gimmicky* and sometimes *sexy*, *mass produced* and very *low cost*. 'Paperchase', which sold only paper items, including Pop carrier bags, non-seasonal wrapping paper, models and mobiles, opened on Fulham Road in 1967 and became *Big Business*.

Paper was used to describe a variety of paper-based products coated with a fire-resistant finish.[51] Paper products had always been acceptable for certain

[50] Katz 1978, pp 11.

[51] see Peter Murray 'Structural Paper Products' *Architectural Design* April 1970, p 211.

prescribed functions where disposability was justified by hygiene, cost or convenience, such as in hospitals, at children's parties or as underwear. But Pop designers were more interested in paper's potential as a cheap, disposable and fashionable material.

Paper clothes became generally available in early 1967 and the craze lasted until the following winter. A firm aptly named 'Dispo' intended to bring out a new design every month. Their colourful (including 'fluorescent lime and pink') dresses were priced between £1 2/9d and £1 5/- (£1.14½ to £1.25); the average cost of a cotton dress was £6. Zandra Rhodes designed a printed paper wedding dress (the neat answer to the one-off occasion) for £1 4/- (£1.20), and for £3 it was possible to buy a silver paper suit — 'the ultimate space-age adventure' — by Harry Lans at Biba.

The 'Jumpahead' boutique boasted a wide range of paper garments '. . . so long as they were "in" ', including 'striped strong orange, purple and yellow' paper bra and bikini pants for 21/- (£1.05). However, the 'Pop Poster' dress, manufactured by a firm called 'Poster Dresses' and on sale for about 32/- (£1.60), was most suited to Pop fashion design. Emblazoned across the dress was a bold or colourful photographic image of the pin-up of the week. After a few days, or even a couple of outings — whichever came sooner — the dress would be thrown into the wastepaper bin, the exhausted symbol of High Pop expendability.

Excitement, youthfulness, fun, disposability and constant change — these were the hallmarks of the High Pop lifestyle. Pop demanded a commitment to and consistency of lifestyle if it was to be lived to its fullest. After all, it was no good returning from the disco in your disposable paper clothing to a pad full of Tudorbethan taste or Finnish furniture. Paper furniture was the logical outcome of Pop applied to the home. The young needed furniture that not only

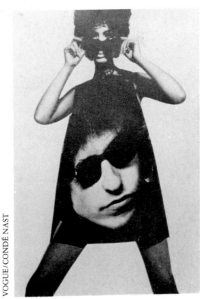

Pop Poster dress, 1967: the ultimate in fashionable Pop expendability.

VOGUE/CONDÉ NAST

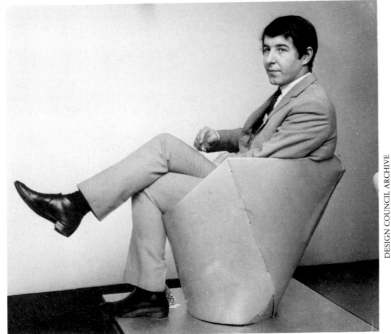

DESIGN COUNCIL ARCHIVE

David Bartlett, Tab paper chair, 1966. The designer, looking not wholly convinced, demonstrates the sturdiness and comfort of his chair.

Peter Murdoch, disposable paper chair, 1964. Although manufactured for children, Murdoch originally intended the chair for the adult market.

52 quoted in Ann Barr 'Max Clendinning' *House and Garden* November 1967, p 51.

expressed, but reflected their way of living: furniture that had arisen from and was an embodiment of Pop values. The furniture designer Max Clendinning remarked: 'Mini skirts should make a difference to chair design.'[52] From 1964 they did. It happened in two ways: the first was the application to furniture of the type of bold and decorative Pop patterns that were to be seen on minis; the second was a transference of the *attitude* towards Pop clothes, namely that furniture could be fashionable, fun and *disposable*.

The most successful example of Pop disposable furniture was Peter Murdoch's 1964 paper chair. It was composed of three different papers to make a board of five laminates, giving it a washable finish and relative rigidity able to stand prolonged wear for 3–6 months. The chair was stamped out as a piece of flat card at a rate of one per second, thus reducing the unit cost of production to a few pennies. Problems of storage in factories and shops were dispensed with: 800 chairs could be stacked into a pile 4 feet high. The chair was decorated in bright Op and Pop polka dots which were printed on at the same time as the card was pressed and scored. New patterns and colours could be introduced frequently without necessitating any modification to the form of the chair, which kept production costs low over a long period of time. By mid 1966 Murdoch's chair had received international recognition, but the designer was unable to find a British manufacturer who would produce it; they remained, characteristically, too conservative to see its potential. The International Paper Corporation in America backed Murdoch's idea, and subsequently the chair was imported into England where it sold for 30/- (£1.50).

Bernard Holdaway designed a range of tough, washable, reinforced cardboard furniture which was commissioned for a family room in the 'Ideal Home' exhibition of 1966. It was constructed of a series of tubes 14–36 inches in diameter, cut away and infilled with chipboard. Holdaway's aim was '. . . exciting designs at the lowest possible price: in fact, the idea is that the furniture

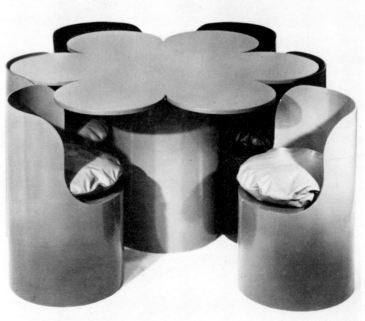

Bernard Holdaway, Tomotom furniture, 1966. Colourful, '. . . exciting designs at the lowest possible price . . .' for the young and fashion conscious.

KEYSTONE PRESS

should be cheap enough to be expendable.'[53] The chair retailed for about £2, and a 54-inch diameter table sold for £6 17/6d (£6.75). Bright colours (a choice of red, blue, yellow, green or purple) or strong contrasts gave the furniture its fashionable Pop or Op appearance and cushions in complementary colours were optional. The range, known as 'Tomotom', was featured in international design magazines and put into production by Hull Traders, a small firm who had previously marketed printed fabrics.

In January 1967 the Design Centre held an exhibition of prototype furniture by student and young designers, much of which was made of paper. Peter Murdoch showed a plastic-coated paper chair, and David Bartlett, who had recently left the RCA with a diploma in industrial glass design, exhibited a chair in polythene laminated fibreboard called the 'Tab'. The 'Tab' was produced as a flat board (on which were printed bright fashionable designs), which was scored lightly, then folded into shape and held together by interlocking the seams. In 1967 Thames Board Mills manufactured and retailed Bartlett's chair at a price of 45/- (£2.25). It received CoID approval and was featured in the 'Ideal Home' exhibition of 1967.

Paper furniture was the perfect solution for a generation which demanded visual impact and continual change. Fashionable paper products — a mix of stylistic and physical expendability often incorporating expendability of subject matter — were the apex of High Pop.

[53] *Design* April 1966, p 54.

Binder, Edwards and Vaughan, custom-painted piano for Paul McCartney, 1966. This fine art-educated group of designers also sold their work to Henry Moore.

Participation in Pop Design

Stylistic expendability and a rapid turnover of images could also be obtained by re-painting items: 'change the paint, change the fashion' as one of the colour supplements suggested. Dull or second-hand pieces of furniture were ideal for this treatment and a vogue occurred in 1965–66. Designs ranged from abstract coloured lines in 'bold and hard and bitter-sweet mixed' colours to the simplicity of traditional folk-art pieces and the elaborate fairground and canalboat-influenced designs of Binder, Edwards and Vaughan. This group of designers painted bright designs on furniture which sold for between £20 and £30. They also customised two cars: a Buick and a Cobra AC. The decorative scheme on both echoed the lines of the cars' bodywork to heighten their form. The Buick was predominantly covered with orange and blue lines of force; the Cobra, in bright red, blue, purple, green and orange, had more rounded lines. The nature of hand-customised items meant that they were expensive, but people were encouraged to do their own painting. *Ideal Home* believed that do-it-yourself Pop fell into the '. . . you-too-can-be-an-artist-like-me category. . . . What you *do* need is a plentiful supply of old magazines and newspapers, a basic skill with scissors and paste, with a sense of daring and a feeling of fun.' This sentiment was also expressed by *House and Garden*: 'The essence of this movement, mood, manner, call it what you will, is that it can be practised by anybody with half an imagination and half an eye.' *Mobilia* saw an ecological significance in repainting old objects and declared that '. . . it is now time to stop manufacturers and replace their economic and political motivations by aesthetic ones as we launch into this orgy of praise and embellishment of the things we have.' It was certainly true that manufacturers were not supportive of do-it-yourself Pop: anything which discouraged consumers from buying new products was obviously bad for trade.

A customised scooter, mid 1960s: the scooter as a mod cult symbol.

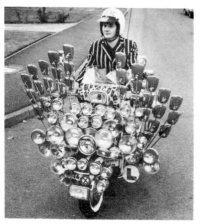

REX FEATURES/JIM SELBY

54 Barnes 1979, p 122.

The participatory aspect of Pop is important. Unlike a professional design movement such as Modernism, which was handed down by designers to the 'dull and indifferent' public, Pop was essentially a grass roots activity. And although Pop had its trendsetters, they tended to be part of the grass roots themselves or, at the very least, to come from the earth rather than the clouds. Furthermore, Pop designers often drew upon what they had seen on the streets or in the dancehalls. Participation ranged from selecting clothing from the kit of parts presented by the designer to re-painting objects and customising mass-produced products. For example, to the Mod, the scooter was not only a means of transport but a cult symbol that could be customised with colourful resprays or by adding extra lights and mirrors, horns, leopard skin seats, mud-flaps, long aerials, mascots and fur trim. In his book, *The Mods*, Richard Barnes describes one scooter which had '. . . 27 lamps, 4 Alpine horns, 6 chrome mascots, 4 mirrors and 2 badges. That lot cost him £75 in 1963. . . . When all the lights were on it was amazing, like rows of floodlights', and 'I heard of one scooter Mod who put coloured cellophane in his lamps. He had over 14 different colours when they were lit up.'[54]

The Pop Interior

55 Amaya 'The Style of the Sixties' *The Spectator* 14 July 1967, p 53.

Do-it-yourself Pop and individual inventiveness were at a premium in interior Design where accepted principles of design and taste were subjugated to the overall effect, which often resulted in an improvisational character. Mario Amaya understood the Pop approach to domestic design: 'With tins of bright enamel, aluminium foil and PVC at five shillings a yard, you can turn the most dismal one-room flat into a . . . haven of jazzy pop, op patterning . . .'.[55] The flat of the architectural student, Piers Gough, had walls covered from top to bottom with old enamelled advertising signs and shop display items. Most of the furniture had been acquired from a demolished hotel and a rubbish tip. Gough viewed interior design (in true Pop spirit) as expendable, and renewed it frequently: a spirit that was echoed in countless flats and bed-sits up and down the country. Barney Broadbent, an interior designer who had been influenced by films such as '2001', made his flat completely silver: he had slatted aluminium cladding on the walls, iron filing paint on the floor, and silver-sprayed glass domes that were placed randomly. The atmosphere of the room could be changed by using different lighting. Max Clendinning announced in an interview that he was about to repaint an all-white room:

56 quoted in Barr 'Max Clendinning' op cit, p 57.

> '. . . in near phosphorous colours . . . green and pinks. The light would then seem to come from the walls. One could change it completely with lights. I'd paint everything — walls and furniture — one colour, and then cover shapes in other colours over the whole thing as though applying camouflage — just like colours spreading in a pool of oil.'[56]

It is hard to imagine a greater contrast to the ordered background anonymity of the Modernist interior. The Pop domestic interior was theatrical, an environment in which to enact the Pop lifestyle of action, fun and change.

Similar signs of theatricality were evident in commercial interiors. In the early 1960s, the Swiss Cottage branch of the 'Golden Plaice' restaurant chain

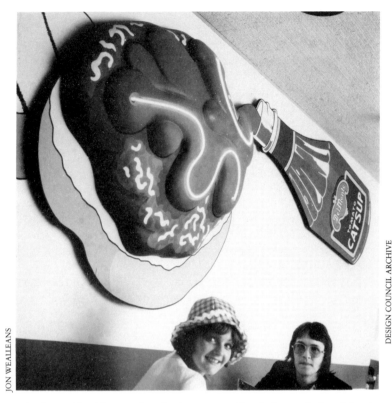

Interior details by (left) Jon Wealleans and (above) David Brookbank, showing the use of theatrical effects.

gained considerable notoriety for its treasure island theme designed by the company architect David Brockbank. The walls were made of polystyrene in the form of the side of a galleon complete with cannon and mock rigging. Plastic palm trees spread their branches across the ceiling and ultra-violet lighting illuminated the false treasure in a cave by the stairs. Under each glass table top there were a pair of pirate cutlasses and pistols. Other restaurants followed suit in the early to mid 1960s: the 'Tun of Port' had photographs of the exploits of Tom Jones covering every inch of the walls and ceiling; the 'Square Rigger' was decked out like the inside of a galleon, with background sound effects of breaking waves and crying seagulls; and 'Le Macabre' was in the mode of the fairground ghost train. Updated versions of the Victorian gin palace included 'Flanagans', with an interior of Victoriana including gas lamps, a penny-farthing bicycle and old advertisements, and '325 Kings' which was decorated using timber from a tax collector's office, an old cathedral organ with the grille as a lamp, and Victorian posters.

In 1965 Lyon's introduced their 'Chips with Everything' chain of restaurants aimed at the 16–30 age group of teenagers and young married couples. The concept was the result of research by Wolff, Olins and Partners: the press release promised a '. . . pop art interior, free juke box, record sleeve posters, and trouser-suited chippies.' High Pop for high tea.

Writers on interior design for conventional magazines toned down this visual experimentation to make Pop palatable to their readership. The 'Domestic World of Pop' (a 1965 *House and Garden* article) turned out to be little more than a conventional interior with the occasional Pop feature: a Warhol print or brightly coloured objects. However, this interior 'look' was

popular, fashionable and, in commercial terms successful, as the rise of 'Habitat' shows.

'Habitat'

In May 1964 Terence Conran opened his first Habitat shop at 77 Fulham Road. His involvement with design can be traced back to 1955 when he founded the Conran Design Group, and, a year later, Conran Fabrics Ltd. Habitat exploited the desire of young upwardly mobile professionals for moderately cheap, reasonably fashionable furniture and design displayed in a lively manner. Conran boasted Habitat was, 'a swinging shop for switched-on people selling not only our own furniture and textiles but other people's too. It's functional and beautiful.'[57] As well as the company's own designs, Habitat sold an eclectic mixture of styles and periods: bentwood furniture, chairs by Le Corbusier and Vico Magistretti, lighting equipment, toys, bright enamelled tinware, low lacquered tables, fabrics, pale-wood tables, kitchen utensils (especially of the 'French farmhouse' type), and general 'below stairs' Victoriana.

A Habitat style of interior decoration soon evolved: '. . . based upon taking a few pieces of really good modern furniture and putting them in really

[57] 'The Changing Idiom' *Ideal Home* June 1964, p 37.

Interior of Habitat, 1967. Habitat's eclectic mixture of styles and periods displayed clearly and imaginatively in a Modernist setting.

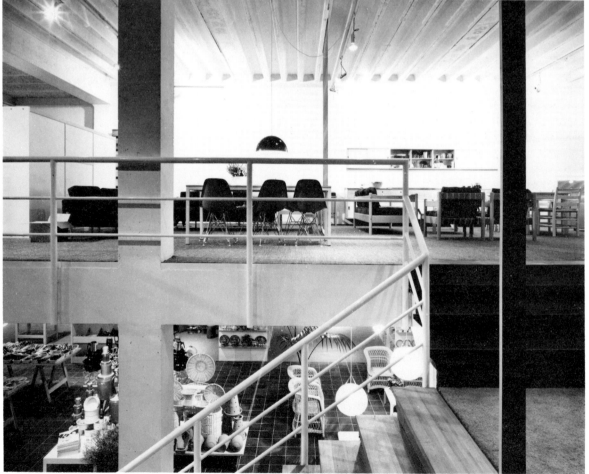

CONRAN DESIGN GROUP

RACE FURNITURE

RACE FURNITURE

Max Clendinning, items from the 'Maxima' range of furniture, 1965. The kit of parts approach to fashionable furniture meant that the consumer was presented with nearly 300 permutations from the 25 standard parts.

sharp juxtaposition with sharp-eyed finds from the junk shops, all set against no-nonsense backgrounds, whether of untreated brick or timber.' The junk-shop finds — old advertising signs, fairground ephemeras, scientific instruments, models of steam engines, apothecary jars and naïve paintings — added a personal touch to what was otherwise a standardised interior. The Habitat style appealed to the young and 'switched-on' because not only did it counter Scandinavian good taste and British repro bad taste, but also because '. . . it is an echo of their own attitude to clothes, for instance with expensive shirts worn with unpressed denims.' A second Habitat shop was opened in 1966 on Tottenham Court Road, and by the end of the decade there were five branches. Habitat also ran a mail-order service which, among other things, handled 'knockdown' ('KD') furniture.

'Knockdown' Furniture

The early to mid 1960s boom in public building (hospitals, universities and colleges) and private enterprise (hotels and offices) generated a need for furniture that was easy to manufacture, inexpensive, light and transportable. Knockdown furniture, described as a '. . . painless and sophisticated offshoot of the do-it-yourself philosophy . . .', was available to the domestic market from 1965. There was Nicholas Frewing's 'Flexible Chair' for Race furniture, bought as a kit of parts with no fixed joints, which could be assembled by the purchaser in a few minutes. But the knockdown technique did not radically alter the Scandinavian appearance of Frewing's chair. At this stage the advantage of 'knockdown' was on the side of the manufacturer (ease of production) and retailer (ease of storage), with only marginal benefits (slightly cheaper and quicker delivery) to the purchaser. In 1965 Jean Schofield and John Wright designed a knockdown chair that was described as '. . . transitional, at a stage between the

58 Corin Hughes-Stanton 'Furniture, Function and Comfort' *SIA Journal* March 1965, p 3.

59 Peter Collins 'Knockdown Furniture' *Sunday Times Colour Supplement* 13 March 1966, p 49.

60 John Vaughan 'Rethink' *Queen* 13 April 1966, p 46.

61 Mario Amaya 'Semi-works' *The Spectator* 18 August 1967, p 194.

62 Peter Collins 'Knockdown Furniture' op cit, p 49.

functional stuff and designs with a bit of wit and whimsy.'[58] The designers admitted starting with a preconceived idea of shape, an approach quite contrary to the established principles of design. Schofield and Wright accepted that the chair, with its dominant curves and strong colours (red, yellow, blue, cream, brown or black), would be seen as fashionable and they hoped it would 'catch on with the younger generation'. And although knockdown furniture was becoming Pop in its appeal to youth, it far from satisfied the Pop criteria of cheapness and expendability. The Schofield and Wright chair was hand-made and cost £45 10/- (£45.50).

An interesting development in Pop knockdown furniture was Max Clendinning's 'Maxima' range, manufactured in 1965 by Race. The rounded corners and jig-saw like pieces were mannered and eccentric and were likened by one critic to 'Mackintosh taking a trip'. The range was based on three sizes of plywood box on to which shaped sides, backs or legs could be bolted to make different chairs or tables. Nearly 300 pieces of 'transformation furniture' (as Clendinning dubbed it) could be assembled from the 25 standard parts which came in a number of lacquers. The range was aimed at the 'young, fashionable market' and those 'in touch', but it was generally high in price: a dining chair cost £17, an easy chair £85.[59] With the Maxima range, the knockdown construction partly determined its appearance, and the advantage was shifted towards consumers who, as in Quant's 'mix and match' and 'Ginger Group' ranges, got flexibility and a fashionable item for their money.

The nearest knockdown furniture came to true Pop design was a prototype by Carol Russell. Russell's aim was to '. . . design a range of furniture that could be produced more easily and sold more cheaply than any other range in existence.'[60] Cut from a single sheet of plywood, Russell's design folded into a rectangle and could be hung on a wall: an 'instant functional abstract painting'. Other prototype designs by Russell included a multi-coloured chair, each section of which was slotted and grooved to fit together without the need for screws, bolts or glue. The sections could be stamped out and the colour applied in the same manoeuvre. Tooling-up was uncomplicated because the shapes were simple and so prices could have been kept low enough to make the chair disposable. A large manufacturer was reported as 'very interested', but the conservative nature of the British furniture industry ensured the chair remained a prototype.

The description of Russell's chair as partly a functional object and partly an artwork was apt. Many young furniture designers were influenced by artists, such as Gerrit Rietveld of De Stijl whose own work was mid-way between art and furniture. The inventively shaped sculptures of Anthony Caro, Philip King and other 'New Generation' sculptors (including Gerald Laing, Michael Bolus and Tim Scott) and the acid or bright colours used by painters, such as Richard Smith, John Hoyland, Peter Sedgley, Allen Jones, and Paul Huxley, had a direct effect on the shapes and colours used by Russell, Clendinning, Schofield and Wright. According to one critic, the new furniture could become '. . . semi-works of art on a mass-produced level.'[61]

Some believed that Pop knockdown furniture would affect the way in which furniture was retailed. In 1966 Peter Collins wrote: 'This is the take-it-home-in-a-carton-and-assemble-it-yourself type of furniture which you ought to be able to buy in parts off the shelf like a can of baked beans.'[62] A similar claim was made for paper products: paper clothes would make a boutique like a

supermarket with garments '. . . packaged in tear off rolls, like sandwich bags, and sold for pennies'. Easily stored and fashionable paper furniture enabled the shopper to select a pattern and take the chair away immediately rather than having to wait for two months before the order could be filled. The anxiety of selecting products would be reduced if the purchasers knew they could be thrown away in six months' time. It seemed as though Pop's stylistic and physical expendability would bring about a transformation in the pattern of consumption.

Summary

Although Pop did not bring about the widespread and permanent changes its devotees would have wished, it did transform the habits and outlook of the great majority of the young in terms of design. High Pop realised Richard Hamilton's description of the characteristics of popular culture as '. . . popular, expendable, low-cost, mass-produced, young, witty, sexy, gimmicky, glamorous, and Big Business.' In the 1950s Reyner Banham had identified expendability as the most radical of those characteristics, and expendability became the most salient feature of High Pop. The intellectual structure of design theory had crumbled. Architecture, with its connotations of seriousness and permanence, no longer had the status of the master art. All the applied arts — and in many cases the fine arts — aspired to the condition of fashion. The essence of Pop, as a fashion journalist so accurately observed in 1965 was its '. . . enjoy-it-today-sling-it-tomorrow philosophy . . . uninterested in quality and workmanship as long as the design is witty and new'. In the *SIA Journal* in 1965, Michael Wolff

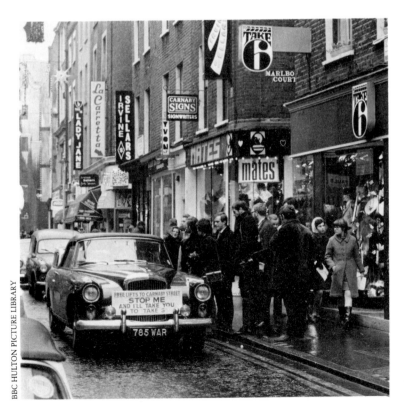

BBC HULTON PICTURE LIBRARY

Carnaby Street, 1966. The majority of shoppers and sightseers did not need such extra encouragement to visit Carnaby Street.

[63] Wolff 'Life Enhancing' *Society of Industrial Artists' Journal* January 1965, p 10.

[64] K and K Baynes 'Behind the Scene' *Design* August 1966, p 28.

The Who in 1965 claimed '. . . pop-art clothes, pop-art music and pop-art behaviour . . . We live pop art.'

had eagerly anticipated the day when '. . . cutlery and furniture design (to name but two) swing like the Supremes.'[63] By 1966 that day seemed to have indeed arrived.

Between 1963 and 1967 Carnaby Street, the fashion and commercial centre, became the focus of attention and popular symbol of 'Swinging London' and the High Pop style. The street's bright Pop art colours and fun imagery gelled in the mind to such an extent that, in the words of Ken and Kate Baynes in an article in *Design*, 'One day "Carnaby Street" could rank with "Bauhaus" as a descriptive phrase for a design style . . .'.[64] And yet High Pop was so much more than a mere style. It was, as we have seen, an attitude, a stance and a complete way of life in opposition to conventions and traditions. The Who's 'My Generation' single (1965) was an anthem to youth values and contained the ultimate in anti-old age, anti-parental sentiments: 'Hope I die before I get old.' With the release of their 'Anyway, Anyhow, Anywhere' single, The Who had been billed as a 'pop art group with a pop art sound'. Members of the group were pictured in typical High Pop garb: one wearing a T-shirt with a coloured target; one a jacket made from a Union Jack and another, a target T-shirt with a picture of Elvis Presley and the word 'POW' in imitation of a comic strip or Roy Lichtenstein painting. The Who claimed to be a total Pop experience: '. . . pop-art clothes, pop-art music and pop-art behaviour. . . . We live pop art. . . .' The self was a living artwork, its decisions and preferences based on aesthetic rather than ethical principles, its actions based on display and performance. But, as consciousness changed in the latter years of the decade, this amorality began to pall and eventually offend. Fashionableness and fun came to be seen as superficial and selfish. When youth yearned for meaning, they turned off Pop.

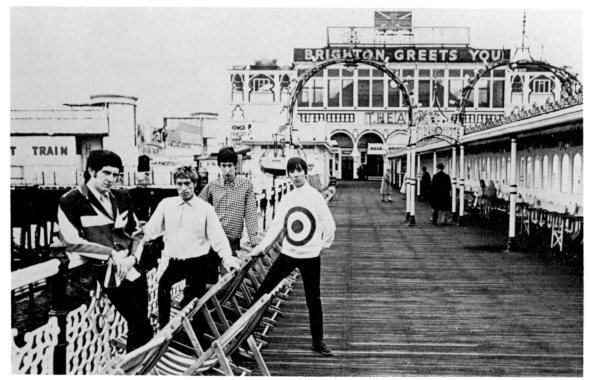

FABULOUS MAGAZINE

THE PROPHETS OF POP

In the 1950s, before Pop had made its entrance, the IG had enthusiastically discussed American popular culture. In the 1960s, the type and origins of popular culture (or pop as it had become) *and* the social and cultural environment of Britian were changing. Pop was no longer a minority cause but an everyday mass attraction. What was the effect on the members of the IG, and did they, as individuals, continue to contribute to the development of Pop?

Alloway and McHale

As his attitude to the 'second-generation' Pop painters revealed, Lawrence Alloway seemed to have become disillusioned. He left Britain for America in the mid 1960s and took up the post of curator of the Guggenheim Museum in New York. Mass culture hardly needed fighting for in America and Alloway, always a supporter of minority causes, diverted his energies elsewhere.[1] John McHale also went to America and became executive director and research associate of the World Resources Inventory at Southern Illinois University. Later he was appointed Director of the Center for Integrative Studies at the State University of New York. Throughout the 1960s and until his death in 1978, McHale remained passionately committed to experimental science and advanced technology. He wrote widely about futurology and the effect of new technologies on the patterns of our lives and modes of thought.[2] He retained an enthusiasm for popular culture but did not become involved in the debates about Pop.

[1] see Alloway 1984.

[2] see McHale 1984.

The Smithsons, Paolozzi, and Hamilton

Alison and Peter Smithson had begun to move away from technology and popular culture from the time of their 'Patio and Pavilion' exhibit at 'This is Tomorrow'.[3] By the mid 1960s they had renounced their involvement in Pop, along with Eduardo Paolozzi.[4] Richard Hamilton continued to work in what has been dubbed the 'mega-visual' mode, employing mass-media imagery and commercially produced artefacts as the basis for his work.[5] Although he maintained an active interest in popular culture, his written statements tended to be directed at fine art issues.

[3] see A and P Smithson 1973; A and P Smithson 1982.

[4] see Kirkpatrick 1970.

[5] see Hamilton 1983.

Banham as Theorist

Reyner Banham, on the staff of the *Architectural Review* from 1952 to 1964, published his major and controversial work about the Modern Movement in architecture, *Theory and Design in the First Machine Age*, in 1960. This was followed in 1962 by the *Guide to Modern Architecture*. Banham became a senior lecturer at University College, London, in 1964 where he progressed to reader (1967) and then professor (1969). Banham wrote two more books dealing with architectural history: a history of *The New Brutalism* and one about

Richard Hamilton, Towards a Definitive Statement on the Coming Trends in Men's Wear and Accessories (a): Together Let Us Explore the Stars, *1962. In the 1960s, Hamilton continued his visual — and often witty — analysis of popular culture.*

mechanical services in architecture, *The Architecture of the Well-Tempered Environment*, which were published in 1966 and 1969, respectively. Banham also contributed to numerous journals and magazines throughout the 1960s. In (principally) the *Architectural Review* Banham wrote about 20th-century architectural history and current architectural theory; while from 1958 to 1965 in the *New Statesman* and from 1965 (to the present) in *New Society*, he had a regular column dealing with not only current architecture, but also design, technology, the mass media and popular culture.

It was undoubtedly Banham who, in the 1960s, made the major contribution to the theory of Pop. Motivated by the idea of an *art autre*, which had travelled from Dubuffet and Tapié in Paris via Paolozzi, Banham sought an *architecture autre* that could be the basis of an alternative design. When New Brutalism and the Smithsons did not provide this foundation, Banham looked towards the radical use of technology. His research into the Modern Movement and the 'first machine age' had formed Banham's belief that the *Sachlichkeit* wing with its Purist, essentially Classical aesthetic had become the mainstream by denying the validity and vitality of the romantic, subjective and emotionally direct wing epitomised by Futurism. Whereas the *Sachlichkeit* architects made the new architecture and design conform to a timeless classical aesthetic, the Futurists attempted to establish a new sensibility based on the changed conditions of modern life and technological innovation. The Futurists' enthusiastic view of technology and acceptance of continual change appealed to Banham who saw the popular culture and mass media of the post-war years as developments of such an attitude. Thus technology and popular culture were interconnected: the products of popular culture that interested Banham required sophisticated technological expertise to produce them; and expendability was a fundamental characteristic of both. The essence of Futurist-derived technology was change; Pop was both expendable *and* symbolised expendability. This led Banham to the conclusion of the major importance to Pop theory that '. . . addition of the word expendable to the vocabulary of criticism was essential before Pop . . . could be faced honestly.'[6]

[6] Banham 'Who is this Pop?' *Motif* number 10 1962, p 12.

Banham also argued that there was a causal link between Pop imagery and technological change. Once the manufacturers of the American cars of the 1950s realised that the public would enthusiastically purchase styling novelties, they produced ever more fantastical designs. This had two major implications:

'Firstly it has precipitated a number of hidden technical changes required to make cars workable in their ever more fantastic shapes; secondly it has completely pulped all preconceptions about what a car should look like, and thus opened the way for yet more violent changes in appearance necessitated by major technical revisions as rear engines.'[7]

[7] Banham 'The End of Insolence' *New Statesman* 29 October 1960, p 644.

Changes in styling appeared to have been the forerunners of technical changes. According to Banham, it was not function that determined form, but fantasy.

This argument for fantasy contradicted the supposedly rational and scientific design procedure of many Modernists. Banham described his apparently carefree attitude to technological innovation as a way of playing '. . . science for kicks.' His description was guaranteed to infuriate Modernists and cultural critics alike. It was, he declared,

'. . . a way of using the mind for pleasure, or just the hell of it, in such a way that it flourishes, not vegetates. . . .The lesson . . . seems to be clear — to go on with our scientific surf-ride on which we are newly launched, to play it for all the kicks it can produce, and stay with it till it is exhausted.'[8]

[8] Banham 'Propositions' *Architectural Review* June 1960, p 388.

However flippant or irresponsible this attitude may appear, underlying it were serious intentions. Banham was trying to keep his mind open and not prejudge new events and manifestations with outmoded or irrelevant criteria. He believed the rigid set of values upheld by Modernists had caused them to reject the Futurists' attitude to technological change; a similar narrowness of mind lay behind the cultural critics' inability to establish criteria appropriate to the conditions of the mass-media age. Banham was a Futurist at heart: he wanted to shed the weight of his European cultural baggage and live in an eternal present of constant change.

Banham maintained that when designers played 'science for kicks' they were likely to produce

'. . . the kind of symbols by which we identify ourselves as members of the scientific adventure to which we are all committed in our smallest acts — such as reading this print, or turning on the light to make its reading easier.'[9]

[9] ibid, p 388.

He suggested that 'science for kicks' in its purest form was science fiction, a subject that should be taken seriously because, ultimately, our vision of the future is a self-fulfilling prophecy. This was a belief with which John McHale fully concurred. In a 1967 issue of *Architectural Design* devoted to futurology and entitled '2001', McHale stressed that his concern was not accurate prediction but ' "future-orientation" . . . as an intellectual and social attitude.'[10] McHale also argued that the imagery of technology '. . . may be as powerful an

[10] McHale '2000 +' *Architectural Design* February 1967, p 65.

[11] ibid, p 65.

[12] Banham 'The End of Insolence' op cit, p 645.

[13] ibid, p 646.

[14] Banham 'Propositions' op cit, p 382.

[15] Banham 'Stocktaking' *Architectural Review* February 1960, p 93.

agency of change as the rational understanding of its scientific and technical base.'[11] Banham and McHale's faith in technology was as great as their childlike enthusiasm for the latest technological goodies. They were, in the American slang of the day, 'technology freaks'.

Banham explored other areas in his quest for architecture and design *autres*. While at times he played 'science for kicks', at other times he argued for a design approach that ignored visual concerns — 'design as service'. Banham discussed this approach in a series of articles entitled 'Stocktaking' that appeared in the *Architectural Review* in 1960. One example of 'design as service' was the portable outboard motor for boats, which was essentially a power-pack that could be clipped on to provide a source of energy. Its visual form was the result of functional requirements, and it was not highly styled. The motor was an enabling service and its value was judged by its performance. Another example of 'design as service' was the air-conditioning plant, essential to comfortable existence yet, in visual terms, almost entirely self-effacing. If good design was '. . . the radical solution to the problems of consumer needs', then those needs might be satisfied by a visually insignificant service.[12] The designer was not a stylist, but a problem solver with an up-to-date knowledge of technology whose priorities were primary function and mechanical performance. 'Ergonomics is where good design begins' wrote Banham in 1961 — many products of popular design, especially Detroit cars, were often far from ergonomically efficient.[13]

Banham's thinking in the early 1960s had been affected by the principles of ergonomics and consumer testing, which were also exerting a strong influence on the systematic design methodology movement led by L Bruce Archer and J Christopher Jones. Banham and the design methodologists were united in their dissatisfaction with the thinking of Modernism, but the supposedly rational and orderly procedures sought by the methodologists did not appeal to Banham. He claimed they were wrong in their belief that design problems could be solved in a linear and sequentially developing way. A solution that might appear to be the logical deduction from an initial premise may be completely inadequate if the premise was stated incorrectly or presumed a certain type of solution: it is useless to pefect a paint brush if the solution is a spray-gun; it is misguided to design a town-car if a better solution is efficient public transport. Good design thinking was lateral and radical.

Banham also exposed the limitations of logical and conservative thought in architecture. The architect must keep an open mind to technology because '. . . technology will impinge increasingly on architecture in the next ten years, and . . . technological habits of thought are hostile to architectural habits of thought.'[14] Architectural habits of thought included the assumption that the architect was an artist creating monumental forms. Technological habits referred to the open-mindedness about technological change and innovation. Architectural habits were seen as conservative; technological habits were questioning and relevant to the age. Technology had the potential, Banham proposed, to make redundant '. . . "basic" ideas like house, city, building.'[15] For example, had not the American drive-in cinema already made the conventional cinema building an out-moded monument? Banham's enthusiasm for things American often derived from that country's positive acceptance of technology and change. America was not laden down by any cultural baggage: technological habits of thought and radical solutions were distinctly possible.

Buckminster Fuller

The American who exemplified this radical approach to technology was Buckminster Fuller (1895–1984) who became a major influence on, and even a guru to, the Pop generation of architects and designers. Fuller subscribed to the view that the chief characteristic of technology was the 'unhaltable trend to constantly accelerating change', and he had consistently questioned his attitude to technology since the heroic years of the 1920s.[16] Fuller pronounced that architecture should not be a question of form or style, but the solution to a need. The conventional concept of architecture was redundant.

Le Corbusier's maxim about the house being a machine for living in was extended by Fuller in 1927, when he designed the 'Dymaxion' house (dymaxion = dynamic plus maximum efficiency). A central mast of duralumin contained the services which comprised a lift, air-conditioning, and plumbing and water heating on top of a septic tank. Floors for the living quarters were suspended from the central mast. Equipment, such as a television, typewriter, microphone and an automatic laundry, was an integral part of the house. The building was prefabricated and simply assembled on site. Fuller saw it as temporary solution to the problem of lightweight prefabricated shelters, until technological advances provided a better one. The 1946 Wichita house updated the Dymaxion and could be flown to the site in a tube that weighed six thousand pounds. Services were pre-moulded and pre-installed.

Fuller's radical problem solving was not a series of isolated solutions, but part of a comprehensive system. The Dymaxion house was part of his:

[16] Fuller 'Influences on My Work' 1955 in Meller 1970, p 64.

Buckminster Fuller, Wichita house, 1946. Fuller's radical thinking and rejection of architectural formalism led to innovative designs which influenced three generations of theorists and architects.

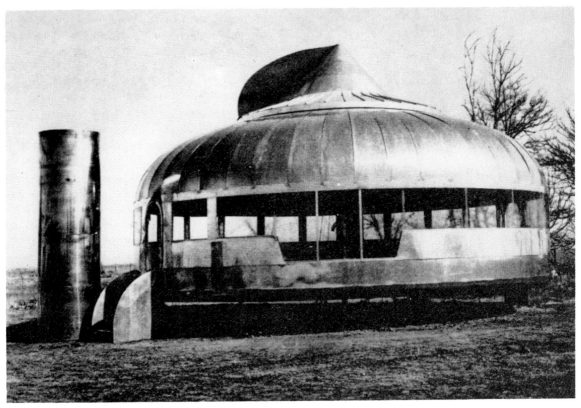

'. . . concept of air-deliverable, mass-produceable, world-around, human life protecting and nurturing scientific dwelling service industry as means of transforming high scientific capability from a weaponry to livingry focus, thereby to render successful all world's people instead of only a few, on the premise that a comprehensive anticipatory design service could, through increased technical efficiency and upping of overall performance per pounds of world resources, bring about physical success for humanity — never to be obtained on political reform — thereby eliminating fundamental causes of war.'[17]

[17] Fuller quoted in Meller 1970, p 30.

Fuller's architectural inventions were far removed from the concerns of Le Corbusier and Gropius. Indeed, his condemnation of Modernist architects for their superficial attitude to technology was savage yet hard to refute:

'. . . the Bauhaus international school used standard plumbing fixtures and only ventured so far as to persuade manufacturers to modify the surface of the valve handles and spigots, and the colour, size, and arrangements of the tiles. The international Bauhaus never went back of the wall surface to look at the plumbing . . . they never enquired into the overall problem of sanitary fittings themselves . . . In short they only looked at problems of modifications of the surface of end-products, which end-products where inherently sub-functions of a technically obsolete world.'[18]

[18] Fuller 'Influences on My Work' op cit, p 66.

Fuller made it clear which questions he thought the architect and designer should ask:

'Do any [Bauhaus designers] publish what their structures weigh and what their original minimum performance requirements must be, and later prove to be, in respect of velocities of winds, heights of floods, severity of earthquakes, fires, pestilence, epidemics etc. and what their shipping weights and volumes will be and what man hours of work are totally involved?'[19]

[19] ibid, p 66.

These were questions of a very different order from those asked by Modernists in their quest to find forms symbolising the 'machine age'. Contemptuous of the overly aesthetic basis of the architect's education, Fuller proposed a new syllabus comprising chemistry, physics, mathematics, biochemistry, psychology, economics and industrial technology.

Fuller believed that the world would change if society willed it. In 1961 (and with the air of a papal edict) he announced the 'Design Science Decade' which would take place between 1965 and 1975. Conventional approaches to architecture and design would be re-evaluated in the wake of a 'world design revolution'.[20] Attitudes would be radical but responsible and society would be transformed.

[20] Fuller quoted in Meller 1970, p 36.

Fuller's reputation in the late 1950s and 1960s was high amongst the young but low amongst the architectural establishment. Philip Johnson pleaded, 'Let Bucky Fuller put together the dymaxion dwellings of the people

so long as we architects can design their tombs and their monuments'[21] — a
sentiment echoed by the majority of architects. Nevertheless, Fuller was a major
influence on the Pop generation for several reasons: first, his pro-technology,
anti-formalist stance and acceptance of expendability; second, the imagery he
created, such as geodesic domes, despite his emphasis on solutions to problems
rather than formal ends; third, his independence of thought which made him a
rebel and guru; and fourth, his apolitical attitude. Fuller was a technological
determinist who thought that politics would cease to exist when the new civilisa-
tion created by technology came into being: The naïvety of his political view was
consistent but nonetheless astonishing. He wrote in the mid 1960s:

> 'It seems perfectly clear that when there is enough to go round
> man will not fight any more than he now fights for air. When man
> is successful in doing so much more with so much less that he can
> take care of everybody at a higher standard, then there will be no
> fundamental cause for war. . . . Within 10 years it.will be normal
> for man to be successful. Politics will become obsolete.'[22]

But by 1972 the oil crisis had heightened political tension and Fuller's optimism
seemed a symptom of the 'Swinging Sixties'.

Banham and Fuller

In the early 1960s, Banham was most strongly influenced by the technological
(as opposed to architectural) habits of thought exemplified by the work of
Fuller. But Banham admitted that he was unsure whether a genuine synthesis of
the two habits of thought were, if desirable, possible:

> 'What I can't be sure about is whether Bucky's rules and the rules
> which govern architecture as we know it are mutually
> exclusive. . . . I am currently in a half-and-half position: radical
> technology like Fuller's will *dis*place architecture even if it doesn't
> *re*place it.'[23]

He also realised that Fuller would never be:

> '. . . the kind of influence that Corb or Mies or Wright have been.
> Bucky isn't a formgiver and the only significant form he has given
> us is the geodesic dome, and what's significant about that is not
> the architectural shape but the radical thinking behind it.'[24]

Banham's own radical thoughts were presented in an article entitled 'A
home is not a house' in *Art in America* in 1965, and it was reprinted in English
journals in 1966 and 1969. In it he proposed the concept of the 'unhouse':

> '. . . when it contains so many services that the hardware
> could stand up by itself without any assistance from the house,
> why have a house to hold it up? When the cost of all this tackle
> is half of the total outlay what is the house doing except con-
> cealing your mechanical pudenda from the stares of folks on the
> sidewalks?'[25]

[21] Johnson 'Where We Are At' *Architectural Review* September 1960, p 175.

[22] Fuller 'Influences on My Work' op cit, p 66.

[23] Banham 'Home Thoughts From Abroad' *Industrial Design* August 1963, p 78.

[24] ibid, p 78.

[25] Banham 'A Home is Not a House' *Architectural Design* January 1969, p 45.

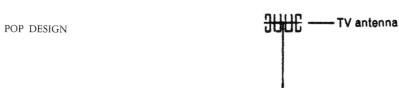
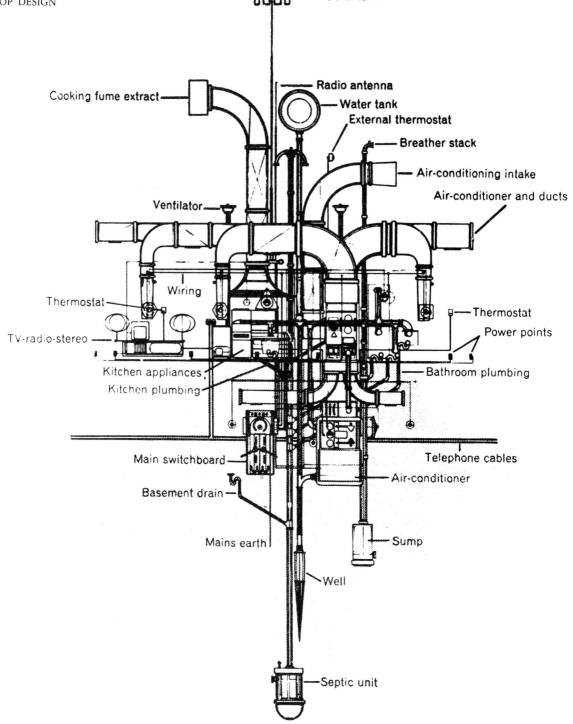

TV antenna

Cooking fume extract

Radio antenna
Water tank
External thermostat
Breather stack
Air-conditioning intake
Air-conditioner and ducts

Ventilator

Wiring

Thermostat

TV-radio-stereo

Thermostat
Power points

Kitchen appliances
Kitchen plumbing

Bathroom plumbing

Main switchboard

Telephone cables

Air-conditioner

Basement drain

Sump

Mains earth

Well

Septic unit

ARCHITECTURAL PRESS

*Reyner Banham, the Unhouse, 1965. These are the
services contained within a house, '... the junk [in
Banham's words] that keeps the pad swinging. The
house itself has been omitted from the drawing, but
if mechanical services continue to accumulate at
this rate it may in fact be possible to do away with
houses.'*

It was regrettable but architects felt a concern with services was beneath them
and threatened their status as 'form-givers'.

Banham's interest in mechanical services and technological habits of
thought culminated in *The Architecture of the Well-Tempered Environment*.
It was the first book to study seriously the history of mechanical services and
their relation to architectural form:

'. . . the history of architecture should cover the whole of the technological art of creating habitable environments, [but] the fact remains that the history of architecture found in books currently available still deals almost exclusively with the external forms of habitable volumes as revealed by the structures that enclose them.'[26]

[26] Banham 1969, p 12.

The book was intended to counterbalance the conventional view of architectural history. Banham praised Fuller for his '. . . willingness to abandon the reassurances and psychological supports of monumental structure', and hailed him as one of the major figures of this alternative tradition.[27]

[27] ibid, p 265.

Cedric Price

In Britain, the only architect consistently to question conventional preconceptions and propose radical solutions was Cedric Price (born 1934) whose projects were often reported and analysed in *Architectural Design*. An early scheme by Price was a transportable weekend house where variable volumetric demands were combined with maximum weekday security. The foundations were built on a rail-track-sleeper principle which enabled sliding and folding extensions to be added as required. Other schemes by Price showed a direct debt to Fuller, in particular his 1963 scheme for an auditorium for the American Museum at Claverton which made use of a 'radome'. Price constantly emphasised function over form and his projects often comprised written notes with only minimal visual suggestions. The form of the building did not interest Price, and the sketches for a project such as his 1963 portable circular cinema concentrate on the method of erection and the range of services and facilities. Functional expendability and the provision of flexibility and choice were Price's main pre-occupations.

Price's uncompromising approach is evident in his 'Pop-up Parliament' of 1965, a scheme which seriously questioned what was needed for a parliamentary building. The aims of the scheme were to give members '. . . as efficient a workshop as possible; and to make the building flexible for later needs and decisions.'[28] Price also hoped to demystify the parliamentary process and, in so doing, '. . . arouse people's serious involvement'. The architect envisaged the demolition of the old palaces of Westminster which would be replaced by the well-documented but visually undelineated 'efficient workshop'. Although formal considerations were deemed irrelevant, a certain amount of symbolism was admitted by implication — the reason, Price thought, why people had become attached to the old buildings was

[28] Price quoted in Paul Barker 'Pop-Up Parliament' *New Society* 29 July 1965, p 8.

'. . . historical: we associate them with order and permanence, churches and town halls. And permanence isn't the thing to symbolise in a era of throwaway Pentel pens and planned obsolescence.'[29]

[29] ibid, p 8.

Price welcomed the expendability so typical of the Pop age but on an actual rather than symbolic level. The creation of a functional, efficient and flexible workshop, not a stylistic or symbolic architectural form, was his aim. Form resulted from function.

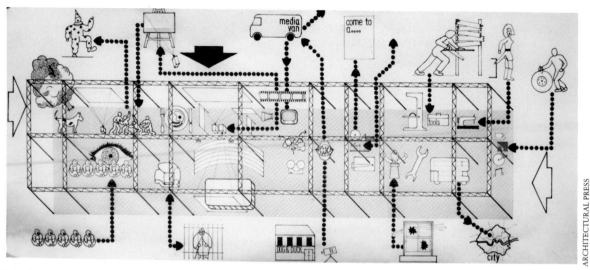

ARCHITECTURAL PRESS

Cedric Price, the Fun Palace project, 1962-7. A flexible environment which could respond to the particular needs and desires of its varied users.

The project that elevated Price to prophet status in the Pop architecture and design world was his 'Fun Palace' commissioned by avant-garde theatrical entrepreneur, Joan Littlewood. The 'Fun Palace' scheme occupied Price intermittently from the early to mid 1960s. Problems with local councils and sites meant the design was frequently modified, but the client's brief remained relatively unchanged. Price interpreted the brief as:

> 'A new attitude to the use of time and space. A springboard for the needs and objectives of the community A space to try new skills, waste time pleasurably, extend interests. . . . The project to be multilateral rather than comprehensive. Scientific gadgets, new systems, knowledge locked away in research stations can be brought to the street corner.'[30]

30 Price 'Fun Palace, Camden, London' *Architectural Design* November 1965, p 522.

31 ibid, p 522.

This sounded like the brief for an *architecture autre* and Price rose to the occasion. He proposed not a building — let alone 'architecture' — but, in his usual understated prose, a '. . . serviceable environment in which visitors may choose from and participate in varied activities.'[31] Sample activities suggested by Littlewood were: a fun arcade (an amusement arcade that made use of new technology); a music area where instruments could be borrowed and where impromptu jam sessions could take place; a dancing area; a theatrical area; a science-playground with learning activities and closed-circuit television; an art area; various workshops; and a meditation area. None of the activities were to be permanent which meant that spaces had to be flexible. Price envisaged a giant 855 × 375 feet space-frame, the scale of a shipyard, which incorporated five rows of 15 latticed-steel towers, each connected at the top by tracks to carry travelling gantry cranes for the transport of equipment to all parts of the site. The supporting towers would contain all the necessary services, but other parts of the building (ramps, walkways, escalators, walls, floors, ceilings and auditoria) were impermanent, movable and interchangeable. To ensure environmental flexibility no part of the fabric was designed to last for more than ten years, while specific environments would last only from a few hours to a few days.

Price did not produce elaborate artist's impressions of the scheme, but detailed designs for the framework and service equipment. Nevertheless, Banham could not resist conjuring up images of its appearance:

'. . . Day by day this giant neo-Futurist machine will stir and reshuffle its movable parts — walls and floors, ramps and walks, steerable escalators, seating and roofing, stages and movie screens, lighting and sound systems — sometimes bursting at the seams with multiple activities, sometimes with only a small part walled in, but with the public poking about the exposed walks and stairs, pressing buttons to make things happen themselves.'[32]

Banham's reference to Futurism places the 'Fun Palace' within the tradition of a radical use of technology that led from Futurism to Fuller and *architecture autre*. The Fun Palace was, indeed, best described not as a building but as a 'facility', 'service' or even 'Giant Space Mobile'. This altered the architect's role from that of a form-giver to one of a provider of opportunities for experience and change.

One element in particular of the 'Fun Palace' scheme made it fully Pop: the Fun Palace was the ideal environment for *Homo ludens*. Price believed that 'Leisure facilities must be used by society as an active social-sensing tool, not merely a static predictable service.'[33] This belief that the future would be one of technologically sophisticated leisure was still prevalent in the mid 1960s and part of the Pop dream. The thirteenth Triennale in Milan in 1964 took 'leisure' as its central theme and many architects and designers endorsed the view of the Dutch architect Constant Nieuwenhuys, whose 'New Babylon' project was reported in *Architectural Design* in 1964:

'For the first time in history, mankind will be able to establish an affluent society in which nobody will have to waste his forces, and in which everybody will be able to use his entire energy for the development of his creative capacities. . . . The new *homo ludens* of the future . . . will . . . be the normal type of man. His life will consist in constructing the reality he wants, in creating the world he conceives freely, no longer bothered by the struggle for life.'[34]

Nieuwenhuys' vision increased the 'Fun Palace' to the size of a city.

Cedric Price continued to expound a radical approach to architectural problems. His 1966 'Potteries Thinkbelt' project attempted to provide education as a service for many rather than as a preserve of the few, in which he questioned the concept of education, its role in society and its institutions. Price was scathing of contemporary university architecture and dismissed it in a memorable phrase as '. . . just the Middle Ages with 13-amp power points.'[35] The 'Thinkbelt' project was planned around road, rail and air networks and made much use of mobile and 'variable physical enclosures' such as railway carriages and electronic communication systems. His belief in technology was unshakeable and was encapsulated in the title of a tape/slide lecture about his own work: 'Technology is the answer, but what is the question?'[36]

Fuller and Price both made sizeable contributions to the body and theory of Pop design. Their lateral thinking, radical solutions and commitment to technology linked them to hard-line Functionalism on the one hand and to

[32] Banham 'A Clip-on Architecture' *Design Quarterly* number 63, 1965, p 15.

[33] Price quoted in Burns 1972, p 58.

[34] Nieuwenhuys 'New Babylon' *Architectural Design* June 1964, p 304.

[35] Price quoted in *Clip-kit* nd, p 27.

[36] Pidgeon Audio Visual (PAV 798) 1981.

Futurisms' liberating rejection of cultural baggage on the other. Their work satisfied those who, like Banham, sought an alternative to the mainstream, and their independent attitude won the hearts of the Pop generation.

Archigram

Historically, architecture has been a highly self-conscious activity. Architects are used to verbalising their ideas and conceptualising about their activities. They have always made major contributions to architectural theory and because architecture has traditionally held the role of the mother art to design theory. This was certainly true in the 1920s and 1930s and remained so until the 1950s. Even in the 1960s, when the status of architecture was questioned by Pop, the contribution of architects was still substantial. Fuller, Price and the Smithsons were four architects whose projects and writings helped place Pop in an intellectual and theoretical context. However, none of them could be unreservedly termed Pop architects. But a group of young British architects who called themselves Archigram were uncompromisingly Pop and sought an architecture and theory wholly in accord with the Pop spirit of the age.

The Archigram team comprised Peter Cook, Warren Chalk, Dennis Crompton, David Greene, Ron Herron and Mike Webb. With the exception of Chalk (aged 37) and Herron (34), all were in their late twenties in 1964. At the beginning of the decade they were recent graduates of architectural schools and felt great dissatisfaction at the current level of discussion and state of British architectural practice. Archigram originally referred to the name of a broadsheet the group published to circulate information and provoke thought. The architectural journals of the day concentrated on establishment orthodoxy at the expense of student projects and/or new ideas, and Archigram's intention was to remedy this. The name was derived from '. . . a more urgent and simple item than a journal, like a "telegram" or "Aerogramme", hence "archi(tecture)-gram".'[37]

37 Cook 'Plug-in City' in Cook 1972, p 8.

Archigram 1 appeared in May 1961 and *Archigram 2* in April 1962. The graphic layout was experimental with interweaving text and images. Snaking between illustrations in issue one was the battlecry: 'WE HAVE CHOSEN TO BYPASS THE DECAYING BAUHAUS IMAGE WHICH IS AN INSULT TO FUNCTIONALISM.' The authors announced their priority: 'We want to drag into building some of the poetry of countdown, orbital helmets.' Archigram wanted an architecture that was part of the advanced technology of the space age. Projects by group members, students and friends, appeared in both issues.

Archigram and Expendability

In 1963 the group adopted the same name as the magazine. *Archigram 3*, published in August 1963, revealed a change of emphasis: it was no longer a collection of disparate projects, but a manifesto by a coherent group. The theme of this issue was emblazoned across the cover: 'Expendability: towards throwaway architecture'. All the material in the issue was relevant to this theme, ranging from consumer products to old and new architecture including projects by Buckminster Fuller. Archigram's own work comprised projects for complex buildings or megastructures which had long-term frameworks but expendable shop- or living-units. Peter Cook's 'Montreal Tower' project (commissioned by

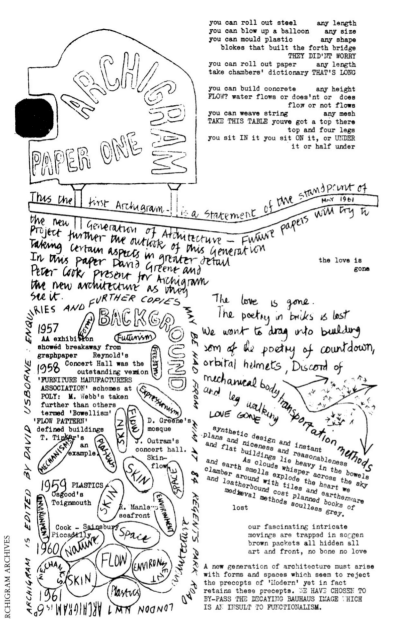

The cover of the first issue of Archigram *whose text was a rallying call to those young architects disenchanted with the contemporary architectural scene. A mood of directness and urgency was conveyed by the graphics.*

Taylor Woodrow), intended as the main feature of the forthcoming 'Expo' in Montreal, was typical and incorporated a central concrete framework on to which temporary units were hung.

In the editorial of *Archigram 3* Peter Cook listed the increasing number of expendabilia that were now socially acceptable — paper tissues, polythene wrappers, ballpoints and others — and commented that at '. . . every level of society and with every level of commodity, the unchanging scene is being replaced by an increase in change of our user-habits and thereby, eventually, our user-habitats.' Cook was delighted by the increasing change, interpreting it as the '. . . product of a sophisticated consumer society, rather than a stagnant (and, in the end, declining) society.' Modernists and cultural critics would have

taken issue with Cook and read 'sophisticated' as an euphemism for 'exploitative'. Cook, however, believed that expendability should be embraced and was disappointed by what he saw as the public's inconsistency:

> 'Why is there an indefinable resistance to planned obsolescence for a kitchen, which in twelve years will be highly inefficient (by the standards of the day) and in twenty years will be intolerable, yet there are no qualms about four years obsolescence for cars.'[38]

[38] Cook: editorial from *Archigram* number 3 in Cook 1972, p 16.

The fashion industry provided the model for expendability: 'After all', Cook proclaimed, 'my wife wears clothes which will be an embarrassment in two years.' The relative price of a kitchen was an obvious reason for not accepting obsolescence, but if the public's attitude changed, which could happen as shown by its attitude to cars, the structure of the market would shift and prices decrease.

> 'Our collective mental blockage occurs between the land of the small-scale consumer products, and the objects which make up our environment. Perhaps it will not be until such things as housing, amenity-place and workplace become recognised as consumer products that can be 'bought off the peg' — with all that this implies in terms of expendability (foremost), industrialisation, up-to-dateness, consumer choice, and basic product-design — that we can begin to make an environment that is really part of a developing human culture.'[39]

[39] ibid, p 16.

Resistance to planned obsolescence in the built environment was linked to the post-war association of non-permanent building with economy and austerity. Architects had fought shy of truth to expendability and disguised technically expendable buildings as 'monuments to the past'. Archigram's message was clear: expendable technology should be a fact of contemporary life — think of a house as a carefully styled consumer product. Cook's basic premise was '. . . the home, the whole city, and the frozen pea pack are all the same. . . .' A collage in *Archigram 3* illustrated the point and included Fuller's Dymaxion car and Wichita house, an LCC temporary house, an all-plastics telephone exchange by British architect Arthur Quarmby, 'Abstracta' system domes, razor blades, 'Daz', 'Puffed Wheat', sliced bread, matches, 'Coca Cola', and other consumer products.

Warren Chalk's 1964 'Capsule Home' project presented the house as a consumer commodity. The Capsule Home was to be mass produced in either plastics or metal, and expendable. Like Fuller's 'standard of living' package and Dymaxion house, services were built-in and made of pre-moulded plastics that could be replaced. Energy would be available from a megastructure into which the capsules were 'plugged'. Chalk's source of inspiration had been the space capsule, and the Capsule Home was to have an equivalent degree of ergonomic exactitude and functional use of space. In accepting eventual technological obsolescence Chalk believed that the consumer's attitude to buying a Capsule Home would be similar to buying a car. However, the degree of customisation of the Capsule Home from the wide-ranging kit of parts would be far greater than was possible for cars. Chalk paralleled the choice: 'You might choose a

Ford bathroom and Vauxhall kitchen, as you rise in the world you can trade in your Hillman living room for a Bentley.'[40]

Chalk considered the main criterion of successful architecture to be the design and presentation of the house as a consumer product. Other criteria were, in order of importance, suitability to mass production, ease of transportation and construction, and obsolescence arising from value for money, a growing family, increased affluence, and the desire for fashion. The Capsule Home was essentially a restating of the Smithsons' 'House of the Future' and 'Appliance House' schemes. What had been controversial in 1956 remained so in 1963–64. Peter Cook recalls how the 'expendability' issue of *Archigram* and the idea of 'architecture as a consumer product' angered the older and mainstream architects.

[40] Chalk quoted in Priscilla Chapman 'The Plug-in City' *Sunday Times Colour Supplement* 20 September 1964, p 33.

Archigram and the City

With the publication of Peter Cook's 1964 project 'Plug-in City' anger turned to outrage. Cook's scheme developed ideas from Cedric Price's 'Fun Palace' and Nieuwenhuys' 'New Babylon'. 'Plug-in City' comprised a main long-term (40-year) framework containing essential services into which units catering for a

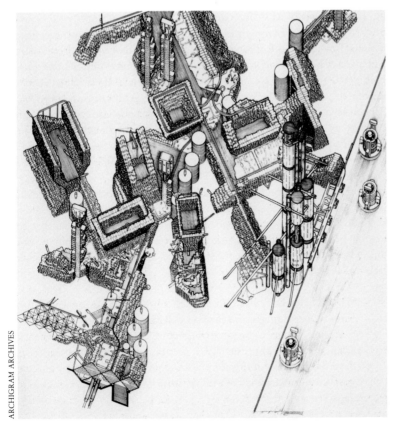

ARCHIGRAM ARCHIVES

Archigram, Plug-in City, 1964. Peter Cook's axonometric drawing conveys the '. . . craggy but directional' and '. . . deliberate varietousness' of Plug-in City.

variety of needs were plugged. These units were served and manoeuvred by cranes operating from a railway at the top of the structure. Each unit was planned for obsolescence; their life-spans varied: car silos 20 years, workplaces 4 years, shopping location 3–6 years, immediate-use sales space in shop 6 months, house units 15 years, bedrooms 5–8 years, and bathroom, kitchen and living room, 3 years. The longer life-span units tended to be at ground level with the shorter life-span units in the upper sections. The framework was based on a system of nine-foot diameter tubes intersecting at 144-feet intervals. One in four of the tubes contained a high-speed lift, the second housed a slower, local lift, the third an escape tube, and the fourth was a goods and service tube. Floors were created — as they were in the 'Fun Palace' — where necessary and suspended from a subsidiary structure. The growth of 'Plug-in City' would not be haphazard or arbitrary, but would be planned and in a linear progression from, for example, London towards, in one direction, Liverpool and, in the other, the Channel and on to Paris. Land at either side of the line of the 'City' would be left unspoiled so the countryside and coast would be much as it was at the time of building.

Cook insisted that the mathematical system should avoid the repetition and '. . . dreariness that is normally associated with regularised systems.'[41] Cook used phrases like 'craggy but directional' and 'mechanistic but scaleable' to describe the appearance of 'Plug-in City', and most of the drawings stressed the '. . . deliberate *varietousness* of each major building outcrop: whatever else it was to be, this city was not going to be a deadly piece of built mathematics.'[42]

In contrast to Modernism's underlying Purism and order inherent in the precision of machinery, Archigram saw technology as a 'visually wild, rich mess.'[43] Their visual sources are easy to recognise because they were often little changed from their normal form: oil refineries, science-fiction imagery, space and under-water hardware, launching towers and Second World War sea forts. Archigram was fully aware of architectural history and drew liberally from Expressionism, Constructivism and Futurism. Archigram's projects resembled Tchernikov's '101 Fantasties' of cityscapes and schemes such as the Vesnin brothers' 1923 'Palace of labour', but 'Plug-in City' was closest to Sant'Elia's '. . . immense, tumultous, lively, noble . . .' Futurist vision.

Archigram had rehearsed ideas about city life in their exhibition 'Living City', held at the ICA in June 1963. This exhibition was a crucial statement if 'Plug-in City' is not to be dismissed as an inhuman and inhumane technological jungle. The stated aim of Living City was to express the vitality of the city rather than concentrate on conventional planning and architectural solutions. Recent examples of post-war planning such as the New Towns of Brasilia and Chandigarh were criticised for their orderliness and monotonous regularity. They lacked the true character of the real city:

'The life-blood of cities runs through all that goes on in them. Some of these things are in themselves bad — vice, corruption of the young, overcrowding, exposure to risks, some are tedious, timewasting, or just banal; but over-riding all these are the positives. . . . The Living City is a unique experience, but the experience is not complete without the dark greys as well as the light.'[44]

[41] Cook 'Plug-in City' op cit, p 36.

[42] ibid, p 36.

[43] Banham 1976, p 17.

[44] Cook 'Our belief in the city as a unique organism underlies the whole project' *Living Arts* number 2, June 1963, p 70.

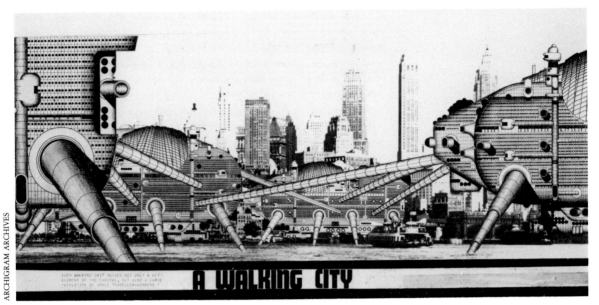

Living City celebrated disorder, fun, chance, consumerism and entertainment. The importance of architectural form was played down:

Archigram's Walking City, 1964: a plug-in city for young Homo movens.

> 'When it is raining in Oxford Street the architecture is no more important than the rain, in fact the weather has probably more to do with the pulsation of the Living City at that given moment. Similarly all moments of time are equally valid in the shared experience. The city lives equally in its past and its future, and in the present where we are.'[45]

45 ibid, p 71.

This recalled the IG's view of the city. In 1959, Alloway had made much the same point: 'Architects can never get and keep control of all the factors in a city which exist in the dimensions of patched-up, expendable, and developing forms.'[46] Archigram called for '. . . an exciting city; one howling with electronics, pulsating with the rumble of great motors, filled with the imagery of science fiction. It accepts the machine on its own terms.'[47] There could be no mistaking Archigram's debt to Sant'Elia's Futurist vision.

46 Alloway 'City Notes' *Architectural Design* January 1959, p 5.

47 Cook 'Our belief in the city . . .' op cit, p 71.

The form of the exhibition was a mixture of miscellaneous items and images with incongruities of scale and meaning. The group argued this was a reflection of how the city was seen by different people in different moods. 'Living City' was a development of the environmental exhibitions organised by the IG in the mid 1950s, the major precursor being 'This is Tomorrow' an exhibition that was still being talked about.

Without knowledge of the Living City exhibition and statements, Plug-in City was liable to be interpreted as a metropolitan Moloch. For the Modern Movement critic Sigfried Giedion, projects by groups like Archigram '. . . come more and more to resemble machines that do not need breathing spaces, and which completely neglect the needs of a human habitat.'[48] Although Archigram refuted this criticism, they illustrated or discussed the *large* scale aspects of Plug-in City and seldom the smaller, personal living units. Nor did the images of Plug-in City show much human activity.

48 Giedion 1941 (1967 edition), p 586.

Three related Archigram projects of 1964 were Warren Chalk's 'Underwater City' and 'Computer City', and Ron Herron's 'Walking City'. Underwater City was a version of Plug-in City modified to a sub-aqua environment and Computer City shared the same concept as Plug-in City except the source material included computers. Walking City caused the most controversy. Its visual impact was immediate: the buildings were on telescopic legs that could be retracted so they could glide like hovercraft across the land or sea until a suitable place to encamp was found. The visual source of Walking City had been the offshore forts in the Thames Estuary, and the concept was derived from hovercrafts and the movable structures at Cape Carnaval (some the equivalent of 40 storeys high) which transported space rockets to their launching pads. Here was the ultimate mobile society, the ideal environment for *Homo movens*. Walking City was presented collaged against a backdrop of the waterfront at Manhattan or crossing the Atlantic Ocean. Archigram was its most visually inventive: the group was hailed as 'a gang of wild-eyed poets'.[49]

[49] Peter Blake in Cook 1972, p 7.

'Amazing Archigram . . .'

The thinking behind these projects was in *Archigram 4* published in May 1964. The full title was 'Amazing Archigram 4 Zoom Issue' and its consistent theme was the relation of fiction, especially science fiction, to architectural fact. The issue took the form of a comic with pages of collaged space-comic imagery. Archigram's visually eclectic approach to sources placed together 1920s architecture, contemporary space and deep-sea technology, projects by the groups and a central pop-up scene of 'Entertainment Tower' projects. The text, although set out as normal, contained think balloons coming from stock comic-characters. A charming female civilian of earth in the year 5000 described Archigram's superimposed caption as:

> 'A bold intuitive gesture that eludes rationalisation the strip cartoon kick provides a visual jump off point . . . a mental zoom boost . . . enables us to push aside architectural waste-matter so that reality may emerge.'

Archigram made use of science-fiction imagery for a number of reasons. First, as Cook stated in the editorial, it was part of a '. . . search for ways out from the stagnation of the architectural scene . . .' Second, unlike conventional cities, the aesthetic of the science-fiction city integrated the 'fast moving object' with the built environment. Third, it connected Archigram to the development of avant-garde architecture which could be traced back to '. . . those dim, neurotic, enthusiastic days of the Ring, *Der Sturm*, and the Futurist Manifesto — the architectural weirdies of the time feeding the infant Modern Movement.' (Archigram thought they could 'feed' contemporary architecture in the same way.) Finally, and most significantly, the attachment to science-fiction imagery signified a Romantic, Futurist attitude to technological change. Whereas Sant'Elia had looked towards cars, railway stations and power stations for inspiration, Archigram used the 1960s equivalents: '. . . the capsule, the rocket, the bathyscope, the Zidpark, the handy-pak.'

Archigram always acknowledged the historical precursors of their attitudes. Cook was equally aware of Archigram's immediate predecessors:

'I don't think something like "Plug-in City" could have existed without the Smithsons, or without Paolozzi, the Russian Constructivists or without weird structures having been done by funny Dutchmen in the 1950s like Nieuwenhuys. We were actually younger, more able to take advantage of it, but they had done the spadework.'[50]

[50] Cook 'Responses' *Architectural Association Journal* December 1966, p 140.

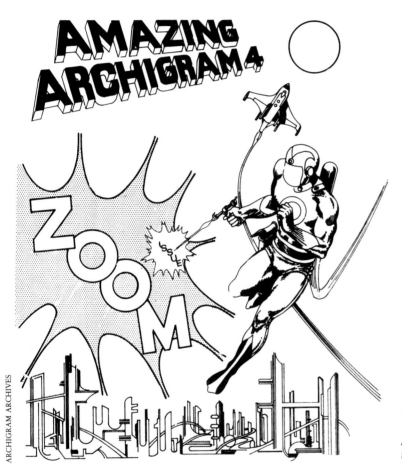

ARCHIGRAM ARCHIVES

The cover of Archigram's Zoom *issue, 1964. Archigram 4 represented an attitude to architecture of living with up-to-date and futuristic technology.*

In this sense Archigram's ideas represented, '. . . a maturity stemming out of the 'fifties.' Cook emphasised the continuity of attitude in the final paragraph of his editorial to *Archigram 4*:

'It is significant that with this material there exists an inspirational bridge, stretching both forty years into the past and perhaps forty years into the future, and perhaps the answer lies neither in heroics nor tragedy, but in a re-emergence of the courage of convictions in architecture.'

By the end of 1964, Archigram had explored the idea of constant change and consequent expendability, and welcomed the idea of a high-technology

Pop society. Furthermore they had produced some of the most powerful Pop images of the decade. Within a few months of the publication of *Archigram 4* the group's work had received major coverage in America, Italy, France, Germany, Holland, Sweden and Finland. Archigram were regularly featured in *Architectural Design*, and a wider readership was made possible by their sympathetic treatment in the colour supplements.

Archigram's Graphic Style

Archigram's work was newsworthy not only for their Pop vision, but their graphic presentation of it. Superman, clipped straight from a comic, hovered over Plug-in City as it appeared in *Archigram 4* but with changed words in the speech balloon. 'It seems I have been over this city for very many miles' said Superman, to which another comic-strip character replied: 'Yes indeed . . . For it stretches over the channel and beyond . . . into Europe.' Archigram's technique of clipping images from disparate sources was basically that of collage which had been used by Pop artists in various ways: by Richard Hamilton to draw appropriate components together, and by Tom Wesselman, James Rosenquist and Claes Oldenburg to create incongruities of scale, context and meaning. Archigram had learnt from the Pop artists that by changing the context of an ordinary object, the viewer's perception of that object was altered.

Banham, discussing their presentation, wrote how Archigram were,

> '. . . voracious consumers of collageable material with which [they] . . . populate and animate their drawings. They raided the illustrations and advertisements in colour magazines and came up, inevitably , with ''leisure people'', because colour magazines in those affluent years contained little else . . . the leisured post-industrial world of the New Utopians.'[51]

51 Banham 1976, p 100.

He refuted the criticism that Archigram's cities were designed only for the young and beautiful as evidenced by their visual style:

> '. . . nothing could more neatly illustrate the dangers of mistaking a piece of British graphic opportunism for an ideological programme. The presence of all these leisure people in Archigram's permissive cities is as much an empirical solution to the problem of finding someone — anyone! — to populate them as it is a theoretical proposal for who *should* populate them.'[52]

52 ibid, pp 100-1.

But recourse to the colour magazines of the day show that more than 'leisure people' were featured, and Archigram could have found other types without much difficulty. As Archigram took pride in their graphic work, it is unlikely that the group would have used images with which they were not satisfied. The incorporation of a specific type of person *did* indicate the particular type of environment Archigram wished to produce: Archigram were designing a Pop environment for the urban young. Members of the group were quite aware of this and Warren Chalk admitted that '. . . you don't have to live in Plug-in City.' Somewhat understatedly he continued, 'Retired people probably won't.'[53] Pop art and collage was the perfect expression of Archigram's vision of the fun-technology society for young *Homo ludens*.

53 Chalk quoted in Chapman 'The Plug-in City' op cit, p 33.

The Influence of Archigram

Archigram were held in high esteem by the young and by architecture students in particular. *Archigram*-inspired magazines flourished briefly in the mid 1960s. *Megascope* was written by Bristol architectural students and lasted for four issues. The first issue (1965) included not only articles on architecture (Cedric Price, plastics, 'Metropolis'), but also articles on men's fashion, typography, and the Beatles. Subsequent issues paid homage to Fuller and Archigram. The first issue of *Clip-Kit*, produced by students of the Architectural Association, was published in early 1966. Initially, the reader bought a folder into which the loose pages of the magazine, which appeared each month, could be 'clipped'. The word 'clip' had as many fashionable associations as 'plug'; 'kit' was derived from the also fashionable 'kit-of-parts'. Theoretically *Clip-Kit* would never be complete but always growing: another idea in good currency. The content of *Clip-Kit* reflected Archigram's pre-occupation with '. . . unprecedented technological advance.' There were articles on technological gadgets, systems, Cedric Price, Mike Webb and a reprint of the Futurist Manifesto of Architecture, which showed how fashionable Sant'Elia had become.

Criticisms of Archigram

Archigram were cast either as heroes or villians, and reactions ranged from uncritical worship to blind condemnation. The main problem raised by Archigram's approach was the level of seriousness with which it should be treated. In November 1965 there was a symposium entitled 'The sociological and other aspects of the Plug-in City', and at the 1966 'International Dialogue on Experimental Architecture' (IDEA) held at Folkestone, Plug-in City was the focus of some sharp criticism. Most concentrated on the unresolved social, political and economic questions. *Arena*, published by the AA, questioned:

> 'The emphasis on might and power is disturbing, especially in the context of inadequate sociological study. The over-development of means of communication at the expense of ideas is reminiscent of Nuremberg rallies.'[54]

[54] Francis Duffy 'Some Notes on Archigram' *Arena* January 1966, p 171.

Criticisms were made of Archigram's lack of interest in existing social and planning organisations, the psychological effect of impermanence, mobility, and obsolescence, and economic funding — all of which were ignored by Archigram in their total commitment to technology. Ostensibly Archigram did not examine the political or organisational implications of technology, a fact which was noted by both mainstream and avant-garde architects alike. The critic Martin Pawley, however, far from accusing Archigram of being politically totalitarian, declared after viewing Herron's Walking City that:

> '. . . whoever proposes to disconnect the building from land, for whatever reasons, is proposing a violation of one of the fundamental principles of all capitalist economies. Archigram is a revolutionary organisation — whether it thinks so or not.'[55]

[55] Pawley 1971, p 113.

Chalk defended Archigram against the accusation that they were 'monsters trying to make houses look like cars', and explained that their interest in industrial technology was as a source of imagery:

'We are conscious that any analogy between say the motor car industry and the building industry is suspect, and a dangerous one, yet it has become necessary to extend ourselves into such disciplines in order to discover an appropriate language pertinent to the present day situation.'[56]

[56] Chalk 'Architecture as Consumer Product' *Architectural Association Journal* March 1966, p 230.

The imagery used was subservient to the open-mindedness behind it, and the current imagery of oil refineries, cars and space would, Chalk maintained, '. . . eventually be digested into a creative system, so that a positive approach will emerge naturally.' Cook was in no doubt that the intention behind Archigram's work was deadly serious: that they were '. . . really trying to question a lot of values and boundaries.'[57] Their strategy was to run with technology in an unpredjudiced state of mind. Cook warned of the danger of reading value judgements into their work. Archigram did not want to be associated with a preconceived set of value judgements or an orderly and logical progression of ideas. As Cook explained:

[57] Cook in an interview with the author 20 May 1977.

'. . . we disintegrate the structure of our work from within — almost as soon as it can be defined. This is consistent with our attitude towards change, and our mistrust of "definitive" architecture.'[58]

[58] Cook 1972, p 2.

And Dennis Crompton described Archigram's belief in and use of the 'flip point', '. . . the point at which the conventional answer becomes a limitation and the solution must be reconsidered in the light of a changed situation.'[59]

[59] Compton 'Architecture and Media: the Flip Point' *The Designer* September 1967, p 7.

Banham, Pop Architecture and Archigram

This sort of attitude endeared itself to Reyner Banham and it was predictable that Banham, champion of the New Brutalists, *provocateur* of the architecture-versus-technology debate, and seeker after an *architecture autre* would be drawn into the debate about Archigram and Pop architecture. Given his Independent Group attitudes and enthusiasm for 'science for kicks' one would have assumed that Banham would welcome the idea of a Pop architecture, but in the early 1960s Banham dismissed it. In an article entitled (with ironic reference to Le Corbusier's 'Towards a New Architecture') 'Towards a pop architecture', published in the *Architectural Review* in July 1962, Banham discussed whether Pop architecture was an inevitability:

'Since it is believed in some circles that any revolution or upheaval in the pure arts must, of some historical necessity, be followed by an equivalent upset in architecture, it is anticipated that the *cordon-sanitaire* between Pop-Art and architecture is about to be breached like a metropolitan green belt, and a Pop architecture emerge about 1966.'[60]

[60] Banham 'Towards a Pop Architecture' *Architectural Review* July 1962, p 42.

Banham rejected the assumption, first because he did not believe there was an inevitable causal connection between art and architecture, and second, '. . . it is not clear how it might benefit architecture.'[61] In view of his subsequent championing of Pop architecture, Banham's second reason is surprising. There was a

[61] ibid, p 44.

certain amount of confusion in the article caused by Banham's imprecise use of the terms 'popular', 'pop', and 'Pop'. From the quotation about cause and effect it would appear that he was looking for a 'Pop' architecture that is the architectural equivalent of Pop Art, but the examples he used are better described as 'popular' architecture (eg the Ideal Home and speculative housing). He discussed Pop as though it was synonymous with 'architecture as package and commodity' which could exist in two ways: either as '. . . a selling point for some desirable standardised product that is too complex or too expensive to be dispensed from slot machines . . .', or, '. . . in itself, a desirable standardised product.' As an example of the first type, Banham cited the Odeon chain of 1930s cinemas, and of the second, well-marketed speculative housing. In this latter sense, he concluded: 'We have had a Pop architecture in Britain, to be precise, ever since SPAN set up shop at Ham Common.'[62] But speculative housing, even of the architecturally superior variety of Ham Common, was closer to the popular appeal of the Ideal Home than to any architectural equivalent of Pop Art.

Banham had acknowledged the implication of expendability in the Smithson's 1956 House of the Future at the time. He reiterated the point during the architecture-versus-technology debate, noting the House's debt to car production and the underlying assumption that '. . . mass produced houses would need as high a rate of obsolescence as any other class of mass-produced goods.' He went on to observe that such a project '. . . is rare, however, because the operational lore of architecture seems not to include the idea of expendability.'[63] In *Motif* in 1962 Banham categorically stated: '. . . there is no Pop architecture to speak of, and never will be in any ultimate sense, because buildings are too damn permanent.'[64] The concept of architecture as an expendable consumer product was, Banham maintained, based on a faulty premise that ignored an essential factor:

'Appliances are made in one place, shipped to another to be sold, and then consumed somewhere else. The bulk of housing . . . is made, sold, and consumed in one and the same place, and that place is a crucial aspect of the product.'[65]

With the brash arrival of Archigram, Banham's thinking shifted back to 'science for kicks', and by 1965 he was clearly enjoying Archigram's '. . . science fiction images of an alternative architecture that would be perfectly possible tomorrow if only the universe (and especially the law of gravity) were organised differently.'[66] However, he seemed to be unsure of how seriously to take the group's work. On the one hand, he saw their work as little more than image-making:

'Archigram is short on theory, long on draughtsmanship and craftsmanship. They're in the image busines and have been blessed with the power to create some of the most compelling images of our time . . . it's all done for a giggle. . . . You accept Archigram at its own valuation or not at all, and there's been nothing much like that since Frank Lloyd Wright, Mies and Corb.'[67]

Elsewhere he pointed out that even if their contributions were:

62 ibid, p 44.

63 Banham 'Stocktaking' op cit, p 96.

64 Banham 'Who is this Pop?' op cit, p 52.

65 Banham in a letter to the author dated 12 August 1980.

66 Banham 'Zoom Wave Hits Architecture' *New Society* 3 March 1966, p 21.

67 Banham in Cook 1972, p 5.

'. . . purely visual and superficial, that would not in itself be contemptible. It does still matter to people what buildings look like. Indeed it matters more than it did. From about 1830 onwards architects designed for their fellow professionals and a blind public. The telly and the proliferation of colour journalism has altered all that by creating a more visually aware sophisticated public.'[68]

[68] Banham 'Zoom Wave Hits Architecture' op cit, p 21.

The importance Banham now attached to visualisation and imagery underlined how he had moved from his stance of 'invisible' technology and 'architecture as service' in the late 1950s and early 1960s to become champion of Pop in the mid 1960s.

Archigram's achievement, according to Banham in 1965, was in creating '. . . the first effective image of the architecture of technology since Buckminster Fuller's Geodesic domes first captivated the world fifteen years ago.'[69] The imagery Fuller created may have been the by-product of his solutions but Archigram's combination of technology and imagery appealed to Banham in the same way as had the Detroit cars of the 1950s. And aesthetic inventions, Banham had argued, were often the advance party and incentive for technological change. Moreover, playing 'science for kicks' the Archigram way implied the sort of open-mindedness Banham argued was necessary in a fast-moving and ever-changing age. Banham expanded on this point in 1967 when discussing Archigram's design method:

[69] Banham 'A Clip-on Architecture' op cit, p 30.

'The essence, and the value . . . is in its running dialogue with current images immediately they appear. It is the *instant* assignments of values, however temporary, to each new image, however puerile or improbable, the moment it swims into the architectural viewscreen, that justifies the fuss we all make over Archigram. . . .'[70]

[70] Banham: review of *Architecture, Action and Plan Architectural Design* August 1967, p 352.

Banham made a fuss about Archigram not only in architectural journals such as *Design Quarterly* but also in non-architectural journals including *New Society*.

Banham as Critic

From 1958 when he started to write a regular column in the *New Statesman* to 1965 and beyond when he wrote for *New Society*, Banham dealt with a wide range of subjects from architecture and art to design and popular culture.[71] In the *New Statesman* for example, he discussed new university architecture, William Morris' reputation, the graphic layout of magazines, the styling of cigarette packs, transistor radios, typewriters, the new small-wheeled Moulton bicycle, vintage cars, contemporary cars, the new 'eating houses', and the foibles of the CoID. Banham further extended his range in *New Society*: besides articles dealing with architecture and art, subjects between 1965 and 1970 included paperback covers, sunglasses, chairs as art, the cult film 'Barbarella' and the cult television puppet programme 'Thunderbirds', household gadgets, the intimacy of the recorded performance, the folk art on Argentinian buses, American drag-racing, customised Minis, and the design approaches behind the Austin Maxi and Ford Capri.

[71] for a selection of writings by Banham, see Banham 1981.

Banham's contribution to Pop was on two levels: that of the development of a theoretical basis for Pop in terms of its technological and cultural relevance to the conditions of the day — articles dealing with the wider theoretical issues tended to appear in professional architectural journals — and, second, informal, yet critical, examination of the ephemeras of Pop culture and design. The latter was a continuation of his interest in popular culture that dated back to the Independent Group days. Banham's sympathetic attitude to his subject matter remained. The IG had argued it was necessary to become involved with the subject matter if critic was to understand its role and meaning. In the 1950s Banham had been captivated by Detroit car styling, but by 1960 the period of the 'insolent chariots' was at the end: 'car styling is a dead Pop-art at present; the minis and the compacts buried an epoch, and cars ceased to be Number One status symbol.'[72] Pop design was not, to the apparent confusion of some critics, synonymous with 'flashy' American cars of the 1950s, which were a manifestation of an approach to design. In the way that individual designs were expendable, so were types of design. Therefore the critic had to have sympathy with the artefacts of popular culture if their meaning was to be understood while they were still relevant. In Banham's view, criticism of Pop culture was significantly different to that of the fine arts and depended

'. . . on an analysis of content, an appreciation of superficial rather than abstract qualities, and on outward orientation that sees the history of the product as an interaction between the sources of the symbol; and the consumer's understanding of them.'[73]

Banham was assuming the role of the interpreter of current (unspoken) meaning, the iconologer who was, in Lawrence Alloway's phrase, 'the knowing consumer', fully aware of the conditions of the society in which he lived.

Banham's style of writing was appropriate to his subject matter: his books and articles on architectural history and criticism were scholarly and serious; his articles on popular culture were often impertinent, witty and provocative. 'The splendour and misery' (he wrote in 1981)

'. . . of writing for dailies, weeklies, or even monthlies, is that one can address current problems currently, and leave posterity to wait for the handbacks and Ph.D. dissertations to appear later . . .

The misery (and splendour) of such writing, when it is exactly on target, is to be incomprehensible by the time the next issue comes out — the splendour comes, if at all, years and years later, when some flip, throw-away, smarty-pants, look-at-me paragraph will prove to distill the essence of an epoch far better than subsequent scholarly studies ever can.'[74]

Banham thoroughly enjoyed his popular culture, yet was also able to see Pop's wider and long-term significance, the implications of which necessitated a restructuring of the hierarchy of design disciplines:

'. . . the foundation stone of the previous intellectual structure of Design Theory has crumbled — there is no longer acceptance of Architecture as the universal analogy of design.'[75]

[72] Banham 'Who is this Pop?' op cit, p 7.

[73] Banham 'A Throwaway Aesthetic' *Industrial Design* March 1960, p 65 (originally published in *Civilta Delle Machine* in November 1955).

[74] Banham 1981, p 7.

[75] Banham 'The End of Insolence' op cit, p 645.

Architectural theory had long provided the model on which the other design disciplines such as interior design and furniture were based. But an age of transience and expendability made architecture, conventionally concerned with permanency, an inappropriate model. Its replacement at the summit of the design disciplines was an inevitability. Banham's ability to understand and respond positively to *both* 'serious' *and* 'trivial' aspects of contemporary culture provided him with insights ordinarily denied to the exclusively 'serious' critic.

Banham and Barthes

A comparison between Banham and Roland Barthes is informative, for there are many apparent similarities. Barthes' *Mythologies*, originally published in France in 1957, contained a number of short essays on popular subjects similar to those of Banham's *New Statesman/New Society* articles: wrestling, soappowder, margarine advertising, striptease, film, toys, and cars. Of the Citroën DS, for example, Barthes wrote:

> 'Until now, the ultimate in cars belonged rather to the bestiary of power . . . it is now more *homely*, more attuned to this sublimation of the utensil, which one also finds in the design of contemporary household equipment. The dashboard looks more like the working surface of a factory. . . . One is obviously turning from an alchemy of speed to a relish in driving.'[76]

[76] Barthes 1972, p 89.

These are the sort of comments that might have been made by Banham in his almost exactly contemporaneous writings about American car styling. The first five paragraphs of Barthes' Citroën article deals in this vein with the meaning of the car's imagery. Barthes' role, like that of Banham, seems to be the interpreter or iconologer who extracts meaning from imagery or form. Barthes' final paragraph is, however, different, and analyses the public's response to the car in the exhibition halls: the car is '. . . in a quarter of an hour mediatized, actualizing through this exorcism the very essence of petit-bourgeois advancement.'[77] What interests Barthes is not the design and styling of the Citroën DS, but the meaning — the mythology — of cars in general in society. Barthes is trying to understand the general and abstract framework (constructed largely of myths) that governs contemporary society, such that particular manifestations of popular culture interest Barthes only because they disclose this underlying framework.

[77] ibid, p 90.

Barthes' structuralist viewpoint is significantly different to Banham's 'post-structuralist' approach. Banham does not start with or seek any abstract framework or general truth. He is interested in design and popular culture because they reveal the attitudes and values of varied individuals and groups. The relation of these two writers to their subject matter underlines this fundamental difference: Banham is emotionally involved with what he writes about; Barthes remains detached from his subject matter. Barthes, who appeals more to detached academics, is less likely to understand fully his subject matter than Banham who, indeed, was highly respected by Pop designers. Barthes was not an important figure in British Pop culture in the 1960s, and *Mythologies* was not translated from the French until 1972. Only then did Barthes (and semiology) become known to wider intellectual circles.

The Cultural Critics and Pop

Banham was the only British critic who consistently championed Pop design in the High Pop years. There were others who were generally sympathetic but who wrote about Pop infrequently. George Melly, who during the 1960s was variously a jazz singer, writer and critic, wrote several well-informed and perceptive articles on facets of Pop culture including fashion and gesture, psychedelic posters, and Pop music lyrics. But Melly's main contribution came in the early 1970s with the publication of his *Revolt Into Style*.

In spite of the massive popularity of Pop music and design, and despite Banham and the Pop critics, the British intellectuals' reaction to popular culture in the 1960s was little changed from that of 1950s. However, interest had increased: the Centre for Contemporary Cultural Studies, under the directorship of Richard Hoggart (until 1973), was founded at Birmingham University in 1964, and in 1966 the Centre for Mass Communication Research at Leicester University and the Centre for Television Research at Leeds University were set up. Following his *Culture and Society*, Raymond Williams published *The Long Revolution* in 1961 and *Communications* in 1962 which attempted to analyse the content and methods of some media. *Discrimination and Popular Culture*, edited by Denys Thompson and published in 1964, included a number of essays by various contributors on aspects of popular culture, and in the same year Stuart Hall and Paddy Whannel's *The Popular Arts*, thought by many to be the best book on the subject, was published.

Hall and Whannel's book continued the thinking of the cultural critics and, in their introduction, the authors duly acknowledged the 'major contribution' of Hoggart and Williams. Hall and Whannel believed there was '. . . a sharp conflict between the work of artists, performers and directors in the new media, which has the intention of popular art behind it, and the typical offering of the media — which is a kind of mass art.'[78] They considered Charlie Chaplin to be a 'popular artist' because he achieved a highly personal style in his work. Conversely, they thought mass art '. . . destroys all trace of individuality and idiosyncrasy . . . and assumes a sort of depersonalised quality, a no-style,' furthermore the 'element of manipulation is correspondingly high'. This did not result in a sympathetic study of the mass media. The cultural critics rejected all the products of the mass media: sophisticated Hollywood films, full-colour magazines and styled, packaged Pop design and music. Banham responded: 'The intense sophistication and professionalism of Pop design is something that many people find hard to take: they would prefer a kind of Hoggartish "spontaneity".'[79] 'Flashy' and 'vulgar', when deprived of coarseness, Banham maintained, need not be derogatory terms for artefacts: 'Flashy a lot of this stuff has to be because its economic life depends on its impact . . .; vulgar it has to be because it is designed for the *vulgus*, the common crowd.' Banham made a crucial point about the social implications of the cultural critics' approach to culture and design: 'If you want Pop design to be tasteful and beautiful instead of flashy and vulgar . . . you must envisage a drastic and illiberal reconstruction of society.' The debate was not just about the appearance and styling of objects, or different aesthetic values, but a social conception of design in society. 'Establishment' bodies including the cultural critics, the CoID, and the Modern Movement generally, believed in the rightness of a selected few to make value judgements that were intended to be the norm for the *vulgus*, even if the *vulgus* (who, by definition, comprised the vast majority) held quite different views.

78 Hall and Whannel 1964, p 68.

79 Banham 'A Flourish of Symbols' *The Observer Review* 17 November 1963, p 21.

80 Banham 'Pop and the Body Critical' *New Statesman* 16 December 1965, p 25.
81 Banham 'A Flourish of Symbols' op cit, p 21.

The Pop prophets believed that the design establishment was a microcosm of the British ruling class against whom Pop was, in Banham's phrase, '. . . the revenge of the elementary school-boys.'[80] Pop represented the rise of the meritocracy who retained a '. . . genuinely common touch.'[81]

Tom Wolfe

An American writer who shared that common touch was Tom Wolfe. Wolfe's impact in the 1960s was confined to his book *The Kandy-Kolored Tangerine-Flake Streamline Baby*, a collection of essays published in Britain in 1966. Many of the essays (like several that appeared in the *Telegraph Magazine* in late 1966) were concerned with 'high society', but the section of the book addressed to 'The New Culture-makers' contained six essays (car customising, Las Vegas signs, 'demolition derbys, the Pop disc-jockey Murray-the-K and Phil Spector) that showed a deep understanding of, and sympathy for, youth cults.

Wolfe's style of writing received much attention. His intention was to capture the excitement and energy of his subject matter: 'People only *write* in careful flowing sentences; they don't think that way and they don't talk that way.'[82] Wolfe described his technique in an interview in 1966:

82 Wolfe quoted in Elaine Dundy 'Wolfe at Our Door' *Vogue* 1 March 1966, p 171.

'I'm trying to restore punctuation to its rightful place. Dots, dashes, exclamation points were dropped out of prose because they "reeked of sentiment". . . . I use expletives to indicate an atmosphere. You can indicate a lot that way.'[83]

83 ibid, p 171.

The final paragraph of the introduction to *The Kandy-Kolored* . . . is an example — albeit an extreme one — of this prose style. In response to a Las Vegas sign-maker's description of his style as 'free-form', Wolfe wrote:

'Free form! Marvellous! No hung-up old art history words for these guys. America's first unconscious avant-garde! The hell with Mondrian, whoever the hell he is. The hell with Moholy-Nagy, if anybody ever heard of him. Artists for the new age, sculptors for the new style and new money of the Yah! lower orders. The new sensibility — *Baby baby where did our love go?* — the new world, submerged so long, invisible, and now arising, slippy, shiny, electric — Super Scuba-man! — out of the vinyl deeps.'[84]

84 Wolfe 1965 (1968 edition), p 14.

Wolfe not only established a style — a combination of creative writing and reportage — that met the IG's criteria for an 'involved aesthetic', but it was also Pop in its own right. Wolfe had no direct influence on the artefacts of Pop design, nor on Pop designers. An influence on Banham's style of writing is conceivable (Banham read and favourably reviewed the youth-cult section of *Kandy-Kolored* . . . in 1965) but Wolfe's significance is his deep understanding of the facets of Pop culture.

Marshall McLuhan

Few writers were brave enough to conjecture about the social, technological and cultural context in which Pop had arisen. A notable exception was the Canadian

academic, Marshall McLuhan. In 1951, McLuhan published *The Mechanical Bride*, an analysis of the multi-layered meanings of American advertisements. It immediately became controversial and was suppressed by suspicious or indignant manufacturers. McLuhan's concern with imagery and meaning paralleled the work of the IG, and the book became 'semi-legendary' among IG members when they discovered it in 1956. In the 1960s McLuhan became associated with a pro mass-media stance but in the 1950s his standpoint had been less enthusiastic. In the preface to *The Mechanical Bride* he wrote that the aim of the contemporary mass media seemed to be:

> 'To get inside [the collective public mind] in order to manipulate exploit [and] control. . . . And to generate heat not light is the intention. To keep everybody in the helpless state engendered by prolonged mental rutting is the effect of many ads and much entertainment alike.'[85]

85 McLuhan 1951, p v.

Although he thought the mass media were destructive, he also acknowledged they were '. . . full . . . also of promises of rich new developments.' It was the latter that McLuhan focused on in later work: *The Gutenberg Galaxy* and *Understanding Media*, published in 1962 and 1964 respectively, made their greatest impact in Britain in 1966–67, when McLuhan's name seldom seemed to be out of the news.

McLuhan shared the IG's view that the mass media were misunderstood: 'Our conventional response to all media . . . is the numb stance of the technological idiot.'[86] This resulted from the use of outmoded criteria: '. . . trying to do today's job with yesterday's tools — with yesterday's concepts.'[87] McLuhan differed from the IG in the degree of importance he attributed to content: in the 1950s both the IG and McLuhan had analysed content in detail, but in the 1960s McLuhan rejected content as secondary and minor. He believed the importance of the mass media lay in their sophisticated technological forms, because these '. . . alter sense ratios and patterns of perception steadily and without any resistance.'[88] In other words, the medium was the message.

86 McLuhan 1964, p 26.
87 McLuhan 1967, p 9.

88 McLuhan 1964, p 27.

McLuhan illustrated this concept by reference to the pre- and post-electric technologies. In the pre-electric or Gutenberg age the dominant medium was print (in Western societies) which was read from left to right in an ordered sequence. McLuhan believed this linearity had shaped the pattern of man's thought and consciousness. Reading was a contemplative, introverted activity that had determined the emotional characteristics of pre-electric man: '. . . by extending the visual power to the uniform organisation of time and space, psychically and socially, conferred the power of detachment and non-involvement.'[89] The bombardment of the contemporary spectator's senses by the electronic media resulted in a consciousness and way of thought that was radically different to the linear thinking of the Gutenberg age. The new mode was essentially non-Western, and McLuhan compared it with the

89 ibid, p 357.

> 'Hebrew and Eastern mode of thought [which] tackles problems and resolutions at the outset of a discussion . . . The entire message is then traced and retraced, again and again, on the rounds of a concentric spiral with seeming redundancy. One can stop anywhere after the first few sentences and have the full

[90] ibid, pp 34-5.

message, if one is prepared to ''dig'' it. . . . [This] redundant form [is] . . . inevitable to the electric age, in which the concentric pattern is imposed by the instant quality, and overlay in depth, of electric speed.'[90]

Thus, the electronic technology provided depth, an important concept to McLuhan which he defined as

'. . . ''in interrelation'' not in isolation. Depth means insight, not point of view, and insight is a kind of mental involvement in process that makes the content of the item quite secondary. . . . Consciousness does not postulate consciousness of anything in particular.'[91]

[91] ibid, pp 300-1.

McLuhan cited the electronic advances of hi-fi and stereo that had facilitated a 'depth' approach to music: '. . . the old categories of ''classical'' and ''popular'' of the ''highbrow'' and ''lowbrow'' no longer obtain.' This confirmed the IG's insights of a decade earlier and provided a further justification for McHale's belief that 'either . . . or' was being replaced by 'both . . . and'.

The advent of the electronic technologies brought about a new consciousness. People throughout the world could be linked together: 'Our extended faculties and senses now constitute a single field of experience which demands that they become collectively conscious.'[92] Not only could events that occurred in one part of the globe be transmitted to another in minutes, but this new consciousness would make '. . . the globe . . . no more than a village.'[93] This was what McLuhan meant by the 'global village', a phrase oft repeated in the late 1960s. McLuhan predicted the consciousness facilitated by the electronic technology would eventually '. . . by-pass languages in favour of a general cosmic consciousness.'[94] Conventional discussions about the content of, for example, television programmes, would miss the point of the 'retribalisation' that McLuhan believed the electronic technology had introduced. Individual consciousness was being superseded by collective consciousness.

[92] McLuhan 1962, p 5.

[93] McLuhan 1964, pp 12-13.

[94] ibid, p 90.

McLuhan used the term the 'electronic technology' to describe all the new mass-media and communications technologies, but he distinguished between them according to their 'temperature'. A hot medium extends only one sense in high definition: photography, for example, is hot because it is purely visual, and the spectator has little to contribute to the image. Whereas a cool medium is not sharply defined and requires a degree of participation from the audience — 'cool jazz', McLuhan suggested, was appropriately named because it was improvisational and free-form. McLuhan thought televison was one of the coolest media: 'The mosaic form of the TV image demands participation and involvement in depth of the whole being, as does the sense of touch.'[95] A person watching television had to participate and be involved in the medium, whereas a radio listener was able to engage in other activities because the degree of participation in a hot medium was much less. McLuhan's critics have pointed out that generally television is not taxing and washes over the viewer. A radio play, conversely, often requires a high degree of involvement and participation on the part of the listener. However, this criticism mistakes interest in the content for the deeper level of participation in the new consciousness. The age

[95] ibid, p 357.

favoured cool media: it was the televisual age. But whereas Banham argued that television increased visual awareness, McLuhan postulated that the effect of a visual medium was aural because the viewer's mind shifted the emphasis to a sense under-deployed by the medium.

Many of McLuhan's ideas are impossible to substantiate, implausible or incorrect. For example:

> 'Since TV, the assembly line has disappeared from industry, staff and line structure have dissolved in management. Gone are the stag line, the receiving line, and the pencil line from the backs of nylons.'[96]

[96] ibid, p 343.

— a claim that is demonstrably untrue. McLuhan's language, such as his use of the word 'depth', is frequently ambiguous and his claims often seem to rely on verbal coincidence rather than causal fact. He makes such generalisations about 'Western man' that they fit few concrete circumstances, and his comments about the 'global village' and the effects of the electronic technologies are mere conjecture. In conventional academic terms McLuhan's books cannot stand critical scrutiny: his claims are unproven and his arguments are not logically developed or followed through. Much of this could be a ploy to 'unfocus' the reader accustomed to criticism that belongs to the pre-eclectric age.

McLuhan's Reputation

Despite the shortcomings of his books, McLuhan was important because he both drew attention to the nature of the mass media and questioned assumptions that previously had been taken for granted. His 'probes' (as he called them) into the mass media made the cultural critics' pre-occupation with content seem anachronistic, petty and narrow minded. With the knowledge of McLuhan's ideas, an intellectual could turn on peak-hour television not only without a guilty conscience but with the reassurance that he was helping to create a global village through a shared consciousness.

McLuhan was a controversial figure and was duly hailed as a genius or branded as a charlatan. With the re-publication of his books and his visit to Britain, his impact in 1967 was massive but — like a true product of Pop — with small sustaining power and his reputation crumbled in the early 1970s. His contribution to Pop culture was, in general terms, his radical thinking about the mass media which opened up the cultural debate and, in particular, his support for youth for whom he reserved especial praise: 'Youth instinctively understands the present environment — the electric drama. This is the reason for the great alienation between generations.'[97] Accustomed to being chided by the cultural critics and the older generations, youth found in McLuhan someone who not only understood them, but who praised their preferences and justified their attitudes. Even the transistor radio, the *bête noire* of the older generations, was praised by McLuhan: it was a cool device which enabled a global village of the young. Youth's understanding of McLuhan may not have been academic, but they took his aphorisms to heart. As one 19-year-old said:

[97] McLuhan 1967, p 9.

> 'It's the visual age. Read your Marshall McLuhan? The media [sic]

is the message. My clothes are my message: they say this man's the greatest, the most geared-up, the most with it. They say — birds come and get screwed by this man. . . .'

No wonder that McLuhan became one of the spiritual leaders to the Pop generation.

The Prophets and Technological Optimism

With the exception of Tom Wolfe whose perspective did not extend beyond that of the social commentator, the prophets of Pop design — Marshall McLuhan, Reyner Banham, John McHale, Archigram and, indirectly, Buckminster Fuller and Cedric Price — shared a belief that technology was changing the world and our perception of it, and even our consciousness. All were technological optimists whose enthusiasm for high technology was unconditional: Man was in control of technology and determined his own destiny: 'The future of the individual', John McHale confidently proclaimed, 'is based . . . on whatever expectation of the future he acquires.'[98] All you had to do was wish and technology would provide the solution. In the late 1950s, Buckminster Fuller had predicted that:

'. . . within a few years we will be able to go in the morning, to any part of the earth by public conveyance, do a day's work, and reach home again in the evening. . . . We will be realistically and legally in a one-town world for the first time in history.'[99]

And even in as respected a work as *Theory and Design in the First Machine Age*, Reyner Banham's optimism for technology burst through:

'Our accession to almost unlimited supplies of energy is balanced against the possibilities of making our planet uninhabitable, but this again is balanced, as we stand at the threshold of space, by the growing possibility of quitting our island earth and letting down roots elsewhere.'[100]

Technology was cast as a modern-day noble savage: it was, announced Banham '. . . morally, socially and politically neutral.'[101] But to separate technological use from control, or media use from control, is artificial and, ultimately, politically naïve. This attitude to technology is symptomatic of the Pop movement and the age in which it occurred. As the environmental lobby of the late 1960s grew into the anti-high technology movement of the 1970s, the unbridled enthusiasm of the prophets of Pop for technology belonged to a bygone age.

[98] McHale '2000 + ' op cit, p 65.

[99] Fuller 'The Comprehensive Man' 1959 in Meller 1970, p 335.

[100] Banham 1960, p 9.

[101] Banham 'Towards a Pop Architecture' op cit, p 42.

TURNING POINTS

7

Labour had been carried to power in 1964 on a wave of optimism for a modern, classless and efficient Britain. However, their majority of only four seats did not allow the government to institute their promised reforms with confidence and another election was called 18 months later. The future that Labour represented was still bright and they were returned to office with a decisive majority of 97 — their highest poll since 1951.

Reform and Disillusionment

The mood of the country was for social reform and many libertarian advances were made under the Labour administration of 1966–70. The death penalty, which had been suspended in 1964, was abolished in 1969; homosexuality between consenting adults was legalised in 1967; and abortion and divorce were made easier to obtain in 1967 and 1969 respectively. Between 1964 and 1967 the Arts Council's budget was trebled, and in 1968 the Theatres Bill brought an end to stage censorship: the permissive society seemed to have arrived. Social injustices were also attacked: legislation on fairer pay was a move towards equal pay for women; race relations acts attempted to eliminate racial discrimination; and much was done on the housing problem — well-intentioned but, in retrospect, horribly misguided — to alleviate the chronic housing shortage.

But the Labour government's record for social reform was not matched by an equivalent expertise in economic policy or industrial relations. Wilson's aim had been to unite the country in prosperity with a strategy of fast economic growth, but Labour had given little thought to the policies that would produce the desired growth, and their approach soon seemed inadequate. Deflation, public-spendings cuts, eventual devaluation and a wage freeze did not reassure the public about the government's economic policies. Indeed wage demands, strikes and inflation outstripped economic growth. The optimism and confidence of the early 'sixties had all but evaporated by the end of the economically crippling seamen's strike in the summer of 1966. Wilson had promised a new Britain but, when yesterday's industrial relations problems caught up with the economic calamities of the present, disillusionment set in. By the end of 1966 Labour's honeymoon with the electorate was over.

Design Rethinking

This loss of faith stimulated a questioning and rethinking that went beyond the political sphere. The repercussions of the Pop explosion were beginning to be assessed in design. So were other ways of thinking. The systematic approach, spearheaded by Bruce Archer and J Christopher Jones, continued to attract recruits and eventually contributed to the design debate. In 1966, Jones wrote two articles in *Design* entitled 'Design Methods Compared' in which he pointed out that there was no single correct approach to design, but that it depended on the:

[1] Jones 'Design Methods Compared' *Design* August 1966, p 35.

'. . . rational choice by the designer of a strategy or sequence which he had good reason to believe is the best available method of posing and answering the questions that are relevant to his problem.'[1]

So liberal a use of the word 'rational' suggests that even Pop could have been the correct method under certain circumstances, but from the rest of the article (and a subsequent one on strategies) it became clear that the methods under discussion were systematic and analytical. In spite of the closure of the Hochschule für Gestaltung in 1968, the design methods movement gathered momentum at the end of the decade with the publication of Jones' *Design Methods* — a detailed, rational and logical approach which attempted to either do without, or reduce to the minimum, questions of intuition or taste in the design process. In 1967 J E Blake reminded readers of *Design* that, as yet, systematic methods could not be successfully applied to questions of aesthetics.[2]

[2] Blake 'Can We Measure Appearance?' *Design* January 1967, p 11.

Capital goods, consumer goods, and the CoID

Both Jones and Archer had scientific backgrounds and their theory of design reflected an engineering bias. The systematic design methodology is clearly better suited to the precise and measurable demands of engineering products than to the more subjective characteristics of personal design. A breakthrough in design theory was made in 1966 when the CoID recognised these two fundamentally different types of design and introduced Design Centre Awards for capital and engineering products in a separate category from those for consumer goods. In the new category the CoID judges promised greater emphasis would be made of working order and mechanical efficiency. Questions of taste and 'good design' would assume a relatively minor role.

The CoID awards for engineering goods reflected a division between science- and art-based design that had always existed, but which had been ignored in much of Modernist theory. 'Design' had been an umbrella term, whose imprecise use had led to generalisations which may have been applicable to one end of the spectrum of design products, but not to the other.

The CoID's support for the consumer associations had never been whole-hearted, and it became less enthusiastic in the later 1960s. While they acknowledged the contributions of the BSI and the Consumer Council towards public awareness of efficiency and ergonomic performance, the CoID continued to complain that matters of appearance were being ignored — they still believed in 1967 (as in 1949 when the first issue of *Design* was published) that an object should function well *and* have what Gordon Russell described as a 'pleasing appearance' but which really referred to the correct style. Indirectly the CoID was forced to admit that 'good form' was not necessarily an outcome of functional efficiency and that 'good design' referred not only to how well something worked, but also if it *looked* functional. There were editorial criticisms in *Design* in 1967 that the consumer associations' concern with value for money on the one hand and the study of ergonomics on the other were becoming more and more divorced from the Council's own approach to design. The consumer associations, according to the CoID, seemed blind to the look of things, showed '. . . signs of in-breeding and exclusiveness . . .'[3], and were using ergonomics as an end rather than a means. Friction between the two bodies tended to

[3] Editor 'A Cuckoo in the Design Nest?' *Design* September 1967, p 19.

decrease as the two bodies followed separate paths: the consumer associations became more involved in canvassing for the Trades Descriptions Act, passed in 1968, and the CoID returned to matters of aesthetico-moral 'good design'.

The CoID and Pop

The dilemma that faced the CoID had resulted from the emergence of High Pop. The CoID had a choice: either to accept or reject Pop. If the Council rejected Pop, it ran the risk of isolating itself from public taste; if it accepted Pop, this undermined the values it had preached since its inception and left if open to accusations of jumping on the latest bandwagon.

Those of the Bauhaus/Braun tradition regarded Pop as a temporary aberration. One critic complained that good taste, '. . . like an unused muscle, has atrophied.'[4] Another blamed the loss of standards on Reyner Banham and the prophets of Pop:

[4] Patricia Conway 'Taste in the Marketplace' *Industrial Design* May 1966, p 33.

> 'If architects (and designers) are to resign their judgement to what the ignorant mass of the public thinks as pretty, let the sick take over and run the hospitals. We are educated in order to know more and be able to judge better.'[5]

[5] Hugh Johnson letter published in *Architectural Review* July 1967, p 6.

There were, however, others who felt that design had positively benefitted from Pop. J E Blake pointed out that, 'The one thing that swinging London has done for design is to release it from an authoritarian and, to many eyes, a sterile aesthetic.'[6] And Christopher Cornford applauded Pop's '. . . full-blooded gaiety and wit with . . . [its] strongly popular and unsnobbish flavour'[7], and he maintained that Pop had fulfilled psychological needs that Modernism had ignored:

[6] Blake 'Function and the Aesthetic Free For All' *Design* September 1966, p 27.

[7] Cornford 'Fashion and Function' *Design* July 1967, p 5.

> 'Both fashion and style are concerned with the expression of values and aspirations, and it is reasonable that we should demand this kind of expression, in addition to physical efficiency.'[8]

[8] ibid, p 5.

The debate continued in *Design* magazine which published two analyses of the implications of Pop: by Paul Reilly in 1967 and by Corin Hughes-Stanton in 1968. Reilly's article was entitled 'The Challenge of Pop', in which he listed the common objections to the Bauhaus-derived Modern Movement. The value of Pop as an antidote was acknowledged, but Reilly went further and perspicaciously noted:

> 'We are shifting perhaps from attachment to permanent, universal values to acceptance that a design may be valid at a given time for a given purpose to a given group of people in a given set of circumstances, but that outside these limits it may not be valid at all. . . . All that this means is that a product must be good of its kind for the set of circumstances for which it has been designed.'[9]

[9] Reilly 'The Challenge of Pop' *Architectural Review* October 1967, p 256.

Here Reilly seemed to have fully understood the challenge of Pop: that a hierarchical single design structure based on universial and changeless values was being replaced by values that were relative to time, place, group and circum-

[10] ibid, p 257.

[11] ibid, p 256.

[12] ibid, p 257.

[13] ibid, p 257.

[14] Hughes-Stanton 'What Comes After Carnaby Street?' *Design* February 1968, p 42.

[15] ibid, p 43.

[16] ibid, p 43.

stance. For, according to Reilly, '. . . though form may have followed function in the good old days, in this electric age they are neck and neck.'[10] However, when Reilly turned from theory to application, doubts were raised. The general impression of goods on display at the Design Centre, Reilly noted, '. . . is of colour and pattern, even gaiety and festivity.'[11] Could it be that the CoID saw Pop only in terms of surface appearance and ignored its essential attribute of appropriateness? Was Pop just a cosmetic brightener, a harmless bit of fun?

Reilly's attitude also comes into question in the closing paragraphs of his article which take on Modernist overtones: 'And so we come back almost to moral judgements. The need is again for discipline, for function, for common-sense in the midst of nonsense.'[12] This sounded like the stance of the CoID in the early 1950s. Reilly concluded: 'Evidence of conviction is what design centres must look for today . . . only then shall we sift the contributors from the charlatans when confronted with the challenge of Pop.'[13] The criteria that distinguished the 'contributors' from the 'charlatans' were left dissatisfyingly vague.

Pop and 'Post-Modernism'

Corin Hughes-Stanton asked 'What Comes After Carnaby Street?' He distinguished between the manifestations of Pop — the Carnaby Street style of Union Jacks and tat — and the attitude behind it. The first he correctly analysed as expendable and certain to disappear, but the second he supposed would remain: 'There is nothing to suggest that the design attitude it represents has exhausted itself or is out of sympathy with the social, economic, or mental ambience with which it is associated.'[14] Hughes-Stanton's emphasis on attitude rather than style was important, and he realised that the implications of Pop were far more significant than its appearance since it could lead to a new design theory which, interestingly, he called 'Post-Modernism' — a term he admitted to borrowing from Nikolaus Pevsner who had used it to describe the neo-Expressionist architecture of Le Corbusier and others who, from the mid 1950s, had been flouting Modernist conventions of *sachlichkeit*. However, in applying the term in a different way, Hughes-Stanton had given it a significantly changed meaning:

'As an attitude [Post-Modernism] . . . is closer to people and to what they want: it is prepared to meet all their legitimate needs without moralising about what those needs should be. Its roots are thus deeper bedded in society than those of the Modern School.'[15]

Post Modernism was more flexible and inclusive than Modernism:

'. . . the new movement has been a tremendous liberating force which has carried design out into the open. Indeed, in looking back, it may well be that the puritanically "functional" period in design, and not Post-Modern, was the mainstream interlude, however, necessary and worthwhile.'[16]

Hughes-Stanton was not merely arguing about appearance, but was questioning the theortical basis of design. The aim should be to combine fun

and function and acknowledge '. . . the equal importance of ergonomics and psychological fulfilment and it is not part of [Post-Modernism's] philosophy to suppress one at the cost of the other.'[17] This would mean that the arts, design and engineering would become increasingly interrelated and dependent upon one another.

[17] ibid, p 43.

The Status of the Modern Movement

In 1968 an exhibition of de Stijl's work at the Camden Arts Centre and a Bauhaus exhibition at the Royal Academy increased the public's awareness of 'first machine age' design. For the converted the exhibitions provided an opportunity to display their dedication, but for the doubters they provided a chance to air their criticisms further. In three radio talks Reyner Banham, Peter Lloyd Jones and Joseph Rykwert attacked the Bauhaus and, by extension, the Modern Movement. Banham and Lloyd Jones concentrated on the misconceptions of the basic design course, and Banham extended this to its influence on contemporary art school teaching. Rykwert highlighted the mystical side of the Bauhaus as personified by Johannes Itten, and further dispelled Modernism's claim to be logical and rational. The Modern Movement was also frequently attacked for its élitist attitude to the common people. In his address to the 1967 Aspen design conference in Colorado, Reyner Banham examined the Modern Movement's belief that design was:

> '. . . part of the great progressive do-gooder complex of ideas based upon the proposition that the majority is always wrong, that the public must be led, cajoled, sticked and carroted onward and upward.'[18]

[18] Banham 'All that Glitters is Not Stainless' *Architectural Design* August 1967, p 352.

Banham coined the term 'design-worry' to describe this tradition which could be traced back through Gropius and Le Corbusier to William Morris, Ruskin and Pugin. The dismissal of popular taste in design and concentration on minority 'educated' values came in for some predictably sharp criticism.

It seems ironic that, at a time when Modernism was coming in for so much criticism from so many quarters, there were more reproductions of Bauhaus products available than ever before, which were selling in ever greater numbers. The reasons are not difficult to find: in the age of television and the colour supplements, consumers were becoming more visually aware and design conscious. People had more money to spend on design, and Modernist design in particular was receiving a lot of exposure. However, it was the Modernist style, and not the principles behind it, that appealed to this design-conscious public. After the frenzy and excitement of High Pop, it was no longer possible to hold a simple belief in Modernism. But Pop itself was changing. There was a shift in sensibility that would eventually lead to its demise.

The Changing Attitudes of Youth

By 1967, affluence had become a fact of life for most of the young in the West, but they were also becoming more socially and politically aware. In America protest against the escalating war in Vietnam became vociferous, and there were mass burnings of draft papers. Minority pressure groups campaigning against

social injustices began to turn to militant activism. But in Britain youthful protest was not directed through conventional political channels, but vague 'consciousness-raising' induced by drugs, in the belief that if you could change the prevailing mode of consciouness, you could change the world.

Drug Culture and the Hippies

Convictions for drug-taking offences rose sharply throughout the 1960s. Between 1963 and 1966 amphetamine abuse was widespread among the Mods and marijuana offences increased fourfold. Convictions for all drugs more than doubled between 1966 and 1967; by 1970, there had been a sevenfold increase in the 1966 level. Major Pop personalities, including some of The Rolling Stones and The Beatles, were convicted and the reform of drug laws became a topical issue.

The use of hallucinatory or so-called psychedelic drugs, such as lysergic acid diethylamide (LSD) or 'acid', which brought about a surreal and often synaesthetic effect, became widespread in America and Britain in 1966 and 1967, respectively. Many young people were taking the advice of Timothy Leary, the 'high priest' of hallucinogenic drugs, to 'turn on, tune in, drop out'. Leary preached the virtues of the LSD experience: 'The LSD trip is a spiritual ecstasy. The LSD trip is a religious pilgrimage. Psychedelic experience is the way to groove to the music of God's great song.' LSD was intoned as no less than the sacrament of a new religion. Beneath the pseudo-mystical tones the intention was clear: change the prevailing mode of consciousness and you change the world.

Those who subscribed to Leary's advice — hippies — had their own lifestyle; they believed in a Rousseauesque philosophy that man is born free but becomes strait-jacketed by the conventions of society, by consumerism, big business and high technology. Hallucinogenic drugs were their talisman to a nirvana of love and peace. During their quest for the ultimate, hippies were happy to live off the fruits of an affluent society; technology they believed should be a provider and a servant, not a master. Conventional middle-class values of thrift and deferred gratification were turned on their head. In the words of Richard Neville, founder of the Underground magazine Oz, 'The pot of gold at the end of the rainbow comes first, later one decides whether the rainbow is worth having for its own sake.'[19]

One committed hippy recalled how they '. . . truly believed that a revolution could be brought about by colour, sounds and imagery. For a few short months, it really seemed that something joyous and powerful was loose in the land.' This naïve optimism was voiced by the British folk-turned-psychedelic singer, Donovan, who gently stated: 'The uglies have had control of us too long — Youth is going to cut through and make everything different.'

Psychedelic Music

The music of late 1966 and 1967 expressed the new philosophy: Scott Mackenzie's 'San Francisco' told of 'gentle people with flowers in their hair' and was one of the best-selling singles of 1967; the previous number one had been The Beatles' 'All You Need Is Love', which became the unofficial anthem of the movement. Music also expressed the psychedelic effects of drugs either as

[19] Neville 1970, p 74.

experience in itself which conjured up the sensations of, or as an accompaniment to, the trip. Singles were unsuitable for this purpose being only three and a half minutes long, and the LP was favoured by bands such as Jefferson Airplane, The Grateful Dead and The Mothers of Invention in America and Pink Floyd and The Soft Machine in Britain. Individual numbers could last for 20–30 minutes and involved much improvisation, free-form composition and technical invention — including electronic feedback and distortion.

The 'turning on' of The Beatles to hallucinogenic drugs in 1966 resulted in references to drugs in their records, such as the 'Revolver' LP, as well as psychedelic musical experimentations ('Strawberry Fields'). The LP released at the height of their involvement with drugs, in June 1967, was, for many, the greatest of their achievements: 'Sgt Pepper's Lonely Hearts Club Band'. This was constructed as a song cycle and incorporated a wide range of influences — Indian music, *musique concrete* and George Formby. One song — 'Lucy in the Sky with Diamonds' ('LSD') — included hallucinogenic visions of 'tangerine trees', 'marmalade skies', 'cellophane flowers', 'newspaper taxis' and 'plasticine porters'; another — 'A Day in the Life' — was a moody evocation of the psychedelic experience. The cover of 'Sgt Pepper' also received wide acclaim. It was a photomontage by Peter Blake of a number of personalities (the significance of inclusion has been debated) representing the Lonely Hearts Club Band. The Beatles themselves, wearing gaudy pseudo-military uniforms, stood at the front.

[20] Koger quoted in Maureen Green 'The Fool's Paradise' *Observer Magazine* 3 December 1967, p 47.

The Fool

Clothing by The Fool, 1967. The Fool's philosophy was expressed by one of their members: 'When they used to open shops it was just after the bread of people, not after turning them on. We want to turn them on. Our ideas are based on love.'

THE OBSERVER

Many of The Beatles' clothes at this time were designed by The Fool — Simon Posthuma, Marijke Koger, Josje Leeger and Barrie Finch — a group of designers who wore clothes similar to those they designed for The Beatles. At one interview Finch wore a blue silk Rajah-collared trouser suit with brightly coloured collages on the chest, Posthuma had on dark red knee-high boots with Turkish pants and a full-sleeved blouse of patterned silk with a jewelled chain over it, Koger wore a blue-patterned headscarf, a flared red and orange mini skirt, multi-coloured blouse, a green brocade jerkin and a silk coat with long wide sleeves, and Leeger wore red tights and sandals, a Gipsy-style orange skirt and an Indian silk blouse with a patterned bodice and embroidered neckband and collar. All of them were committed to visual eclecticism because they believed the world was shrinking:

'All the people of the earth are forced to come together now and this expresses itself even in fashion. Our ideas come from every country — India, China, Russia, Turkey and from the sixteenth to the twenty-first centuries. There's a bit of everything.'[20]

No doubt McLuhan would have approved of such an idea.

The Fool's main criterion of selection was visual and based on pattern, colour and texture. Utilitarian concerns were of little importance. Because they did not mass produce their designs The Fool's output was small, in great demand by celebrities and, therefore, relatively expensive. Like William Morris, The Fool did not seek exclusiveness, but distrusted mass production which they felt was dehumanising and a symptom of a society in love with technology.

Also in the Arts and Crafts tradition of moral worthiness, The Fool believed that one should make one's own clothes and wares. Unlike the Arts and Crafts designers, however, The Fool were of the opinion that aesthetic criteria were personal; making one's own clothes was more important than the garments' appearance. Even people who bought their clothes should not be passive consumers: '. . . gradually they will add extra things . . . and they will learn to be more creative. That's how it should be, for them to do something too.'[21] This attitude was part of the hippies' ideal of a more personal, small community-orientated society based on handicrafts, peace, love and low technology. Designing clothes was seen by The Fool as 'missionary work' and a symbol of their *Weltanschauung*.

[21] ibid, p 45.

Hippy Clothing and Style

A similar zeal lay behind the hippy-inspired practice of embroidering colourful designs onto denim jeans. The designs were derived from a variety of sources ranging from Christian symbolism, American mythology, Art Nouveau, Rousseau (J J and Le Douanier) to Tolkien. The aim was the expression and communication of a state of mind. One hippy spoke of the desire to '. . . externalise inner states so that they may be read by others able to understand the language, attracting companions of the brotherhood.'[22] Fashion was both personal expression and a form of non-verbal communication. The hippy embroiderers believed that the celebration of individuality and painstaking work was more important than the end product. They hoped their designs would be creative enough, their anti-technology back-to-nature spirit strong enough to produce their own versions of the native costumes of Afghanistan or Guatemala. This would help '. . . to liberate art from the hallowed halls of museums and galleries and living rooms of the advantaged.'[23]

[22] quoted in Jacopetti 1974, p 12.

[23] ibid, p 5.

To those outside the sub-group who did not understand their lifestyle, the hippies' clothing seemed arbitrary and bizarre. Their choice of clothing was certainly eclectic and the kit of parts was potentially limitless. Accepted symbols of opulence were worn with items which had connotations of poverty; rich garments were likely to be soiled, dirty or unkempt. They consistently undermined any class notion of dress. Individual items were taken out of their symbolic context and bore little and sometimes no relation to utilitarian requirements: sheepskin coats, heavy cloaks and ankle-length cardigans might be worn on a hot day, feet were sometimes left bare on rainy days, cheesecloth tops might be worn on cold days. All was part of a 'colourful unseating of conventional wisdom' which cannot be explained by mere contentiousness. Conventional rules of social expression were overturned and replaced by a high degree of anarchy — anything *could* be worn with anything else. There were preferences for certain looks and images (there is always a degree of conformity to unwritten rules in the manifestations of any sub-group), but the garments selected were essentially the result of personal choice, which was sometimes based on drug experiences. As one hippy said: 'Drugs are fantastically important. The part they play in people's dress sense turns them on to colour.' Many hippy clothes were second-hand and bought at jumble sales, 'flea-markets' or the Portobello Road. In 1967 the *Tailor and Cutter* commented on the 'boom' in second-hand clothes, which displeased the fashion manufacturers. Hippy dress was a wearer's fashion. One fashion writer commented that, however

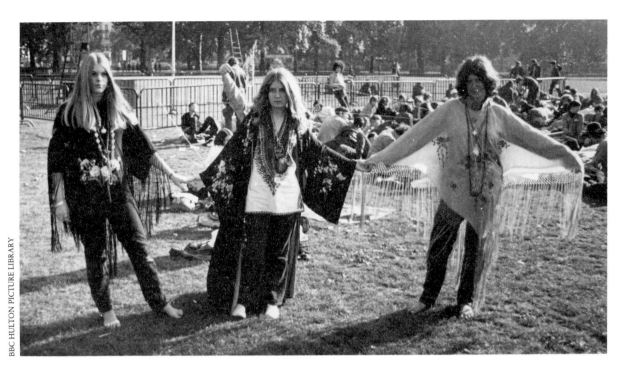

bizarre hippies' appearances, '. . . the total look they achieve is something they have contrived themselves, not something wished on them by commerical man-ufacturers or designers.'[24] Furthermore, the hippy's 'total look' was more open-ended than any of Quant's had been.

The hippy was interested in a total body image. As important as clothes were hairstyle and body expression. The hippy's unruly long hair was an asser-tion of freedom, a symbol of rebellion against conformity and an act in support of natural processes and Rousseauesque primitivism. It brought much insult, ridicule and even injury, but it was seen as a form of identification with under-privileged groups: the 'equivalent of the black man's skin'. Conventional cosmetics, which were equated with conformity to social and sexual norms, were rejected in favour of either naturalness or outlandish and exotic body painting. Flowers and butterflies appeared on the faces, arms and chests of both sexes, and Peacock feathers might be applied around the eyes. For the weekend hippy into commercially orientated 'flower-power', small colourful transfers and paints that could be removed were available.

The hippy's look was a reaction against male and female stereotypes. The hippy face was more feminine than masculine; Theodore Roszak alluded to the male hippy's 'feminine softness' which, he calculated, was '. . . . a deliberate effort on the part of the young to undercut the crude and compulsive he-manliness of American political life.'[25] According to Angela Carter, the hippy face '. . . had a bee-sting underlip, enormous eyes and a lot of disordered hair. It saw itself as a wild, sweet, gypsyish, vulnerable face.'[26] This look was typified by Mick Jagger and Carly Simon and became a stereotype itself.

Body movements and gestures gave the impression that the hippy was badly co-ordinated. This was an acquired way of moving to avoid what the hippies thought was the slick confidence that ease of movement betrayed. Con-versation is a code and not a direct representation of reality and, for the hippy,

Hippy clothing, 1969. Rampant eclecticism and a '. . . colourful unseating of conventional wisdom.'

[24] Meriel McCooey 'Roots of Fashion' *Sunday Times Colour Supplement* 23 February 1967, p 30.

[25] Roszak 1969, p 74.

[26] Angela Carter 'The Wound in the Face' *New Society* 24 April 1975, p 214.

the form of language was more important than the content. There were even accepted ways of acting out the effect of drugs which ranged from the sleepy and slightly out-of-focus to the disordered and disconcerting. Reality for the hippy took place in the mind expanded by drugs, but the body was deemed '. . . a useful carrier for its picture show'[27], the external manifestation of an internal reality.

[27] Willis 1978, p 96.

The Psychedelic Style

In the minds of the media and the public, the term 'psychedelic' fitted the gaudy clashing colours and the amoeba-like all-over patterns that were associated with hippies in 1967. Psychedelia was everywhere: clothes, posters, objects, interiors and even building exteriors. George Harrison of The Beatles and his wife Patti Boyd lived a psychedelic lifestyle in a psychedelic environment. *Vogue* described their house as:

> '. . . transfigured with swirls of colour, flowers, and doodles. Alive with pattern, the house is illuminated like an ancient manuscript by the hands of friends who have come. . . . Before the painted house stands the painted car . . . with its glistening black windows and intricate lacing of Tantric symbols and Sanskrit writing'.[28]

[28] Georgina Howell 'Pattie Harrison and the Painted House' *Vogue* 15 March 1968, p 124.

This description highlights two salient characteristics of the psychedelia style: its all-overness, and the do-it-yourself aspect. Most hippy flats or 'pads' attempted the same spirit but with more modest means, and rooms were cluttered with a diverse and often surreal collection of items.

The Underground

Hippies thought themselves part of a wider community — the Underground — which was bound together by a shared dislike of conventional society. The suitably amorphous Underground in Britain had been coming together since 1965 around the 'Indica' bookshop. It produced several newspapers which catered for hippy and other radical minority audiences.[29] Both the bookshop and its manager were closely connected with the first of these newspapers, the *International Times*. *IT* (as it was renamed after a court case) was first published in October 1966, but was not especially visually sophisticated in its graphic presentation. *Oz* was anything but visually conservative and immediately established a reputation for ingenuity of graphic presentation.

[29] see Nuttall 1970; Neville 1971; and Richard Boston 'Notes From the Underground' *New Society* 16 March 1967, p 394.

Oz Magazine

Launched in January 1967 with a print run of approximately 15 000 copies, *Oz* got its name for three reasons: the Australian background of its founder and editor, Richard Neville; the association with 'The Wizard of Oz' (a hippy-approved fantasy); and, in true Dada spirit, it was easy to remember but essentially meaningless. Neville wanted to produce a visually exciting magazine that he himself would like to read, carrying satire, controversial interviews and Underground news. Offset lithography allied to IBM typesetting had made

cheap colour production possible, and soon the print run for each issue of *Oz* reached 30,000, 4000 more than *The Spectator*.

The text was often ponderous, pseudo-intellectual and nonsensical — it was truly a magazine of the Post-Gutenberg, electronic age — but the visuals included hallucinatory typography, double and triple superimpositions, images out of focus, collage layouts, diagonal text, pages that had to be turned around as they were read and pages that had to be cut up and re-arranged to form a coherent image, all of which were amidst resplendent colours of gold, turquoise, cyan, sienna, saffron, heliotrope and magenta. Rainbow-inking — whereby two or more different coloured inks are poured at each end of the printing frame to produced a colour fade as they spread — was a popular device, as was the printing of words in a colour similar to that used for the background, for example pink words on a red page. The use of black on white was rare. Lettering was highly decorated, sometimes to the point of illegibility, and letters were bent, stretched, pulled and transformed from simple components of communication to elements in the overall psychedelic vision. Such graphic

Graphics from Oz *magazine, 1968. Some believed that the compositional and typographical impenetrability was a way of discouraging the over-30s from reading the magazine.*

[30] included in Apollonio 1973, pp 95-106.

[31] Neville 1971, p 153.

[32] ibid, p 135.

[33] Farren 1976, p 11.

[34] Lewis 1972, p 80.

design could only be fully appreciated by those who had 'tripped'.

Oz subverted the established principles of graphic design to produce a sensation that recalled Futurist graphic design. In the 1913 manifesto 'Destruction of Syntax-Imagination without strings — Words in Freedom', F T Marinetti had declared that

> 'On the same page . . . we will use *three of four colours of ink*, or even twenty different typefaces if necessary. For example: italics for a series of swift sensations, bold faces for the violent onomatopoeias, and so on, with this typographical revolution and this multi-coloured variety in the letters I mean to redouble the expressive force of words.'[30]

The visual sensationalism and the merging of form and content linked psychedelic and Futurist graphic design.

Neville was conscious enough of art and graphic design history to acknowledge '. . . the graphic freedoms pioneered by Dadaist periodicals'[31] but he believed that *Oz* exceeded any previous anti-rationalist design. Pop's characteristic eclecticism was evident in *Oz*'s visuals. Neville maintained that '. . . the whole world can be plundered for decoration — from food labels, oriental comic books, Tibetan scrolls and *Encyclopaedia Britannica*. Copyright is ignored.'[32] The whole history of art was there for the taking. He was indifferent to the accusation of plagiarism: 'Terms like derivative or plagiarism had no meaning in an atmosphere where art wasn't considered to be private property.'[33] The end justified the means, which was to reproduce, or find an equivalent to, the synaesthetic qualities of the hallucinogenic experience. In the view of Peter Lewis:

> 'The best of the artwork can be so compelling that it forces the reader to concentrate on particular ideas and images for an extended period of time. It can be mind-blowing. Temporarily ''the price of admittance in your mind''.'[34]

Hapshash And The Coloured Coat, The Incredible String Band, 1967. The graphic artists saw their posters as 'a stepping stone to mass visual awareness': a glimpse of an arcadian (but sexist) future.

3D EYE

The work of Mike McInnerney, who designed the first issue of *IT*, was influenced by Surrealism. He represented incongruous or impossible scenes in a realistic way. McInnerney's cover for *IT* number 60 showed a Coca-Cola bottle against a pane of glass through which a cloudy sky was visible. The pane was shattered and a piece of the daylight sky — recalling Magritte — was also shattered to reveal the night sky beyond. John Hurford's work for *Gandalf's Garden* was a conglomeration of images inspired by Symbolism, psychedelic visions, Tolkein and Hieronymus Bosch. Two of the most prolific Underground artists, Martin Sharp and Michael English, were best known for their posters, although their illustrative work was frequently published in *Oz* and *IT*.

Psychedelic Posters

Oz often contained a centre-spread illustration that could be hung on the wall as a poster. Neville valued this device highly and claimed: 'Underground publishers were the first to realise that if the paper is printed by a visual process, then it should be conceived of as a painting . . . when did you last frame a page

from *The Times?*[35] Psychedelic graphic design was at its strongest in posters. The psychedelic poster arose simultaneously with the Underground Press at the time of the Aubrey Beardsley exhibition in the summer of 1966. This exhibition was important both as a stylistic influence and as an occasion which brought people together. A poster revival had been underway since 1964. As a result of teenage affluence and the increase in student numbers the market for posters had expanded. Previously poster art had been very popular in the 1890s when Art Nouveau was at its peak, and in the 1930s when under the guidance of Frank Pick, designers of the calibre of McKnight Kauffer, Frank Newbould, Edward Wadsworth, and Graham Sutherland were commissioned to design for the (other) Underground. The new psychedelic poster style was typified by Michael English's work in which images from every conceivable source were plundered: Beardsley, Mucha, the Pre-Raphaelites, Tolkein, Bosch, William Blake, Dulac, comic books, Disney, science-fiction illustration, ancient treatises on alchemy, the engravings of Red Indians, Magritte, Pop and Op art. The source material was used without regard to original context or copyright, and styles were mixed incongruously.

Early in 1967 English formed a partnership with Nigel Weymouth called 'Hapshash and the Coloured Coat'. Their output of psychedelic posters was prolific. Bright 'dayglo' colours, bold design and graphic ingenuity exemplified Hapshash's work. Layout was less a case of carefully composing and balancing positive against negative areas than of filling space in a cumulative way by adding detail to detail. Conventional rules of composition and typography were wilfully ignored.

Martin Sharp, a co-patriate of Neville's, had been responsible for designing the early issues of *Oz*. His illustrations were psychedelic visions of Surrealist and abstract landscapes where figures were metamorphosing into plants, flowers and amoeba-like growths, both terrifying and poetic. In his *UFO* poster, the silver background becomes a void in which all manner of biomorphic forms have been momentarily frozen in their frenzy. In his *Dylan* poster, a shimmering mixture of gold and dayglo red, Sharp transformed Dylan's curly hair into overlapping circles with concentric rings in which quotations from Dylan's songs appeared. Sharp's *Jimi Hendrix* had Futurist power with the singer 'exploding' in vivid green, red and yellow into the abstract space around him. The expressive force of the image achieved a visual equivalent to the music of Hendrix.

In an intelligent article published late in 1967, George Melly applauded Sharp's *Hendrix* poster for its richness of imagination and prophesied that '. . . if such a deliberately transitory art-form as the psychedelic poster can produce a work of permanent interest, this could well turn out to be it.'[36] It is doubtful, as Melly implied, that the traditional values of art are of any relevance in judging psychedelic posters — or Pop design generally — because the Pop designers were not looking for timeless solutions. Indeed by the criteria of traditional art, psychedelic posters are poor: their formal components are seldom resolved, composition is loose and draughtsmanship is absent. Other rules are broken: there is often no congruity between the symbols and the main content, and the primary function of the poster to convey information was frequently neglected as the information became lost within the design. Nevertheless, Melly's praise of the *Hendrix* poster is justified because Sharp designed a work with an expressive force that captured the spirit of the music and its performance.

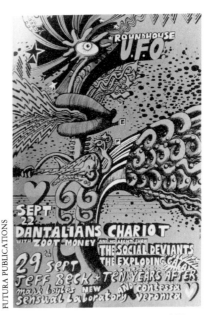

Martin Sharp, *UFO at the Roundhouse*, 1967. Sharp's posters came close to conveying the experience — both terrifying and poetic — of psychedelic drugs.

[35] Neville 1971, p 153.

[36] George Melly 'Poster Power' *Observer Magazine* 3 December 1967, p 17.

Martin Sharp, *Jimi Hendrix*, 1967. Sharp's image was the visual equivalent of Hendrix's music, listened to under the influence of drugs.

171

Posters have normally advertised an event, a product or a venue, and have only acquired the status of art some time after their primary function was over. Not so the psychedelic poster. Information about specific concerts and performances was sometimes conveyed by the posters but their real meaning was communicated non-verbally and visually. Psychedelic posters were not supposed to be isolated in a gallery nor be contemplated with the reverence reserved for accredited *objets d'art*, but were on the streets for all to see. The designers genuinely believed that their posters could help to change the world by giving society a vision of heaven on earth brought about by a changed consciousness. Psychedelic posters communicated, not by any literal message, but intuitively and visually using expressive forms, colours and shapes. The medium was the message which was always the same: 'Turn on, tune in, drop out.' Weymouth declared: 'The poster is only a stepping stone towards mass visual awareness.'[37] For English and all Underground designers, the posters were '. . . part of a whole thing to freak out London, have it all colours and turn on the world.'[38] Psychedelic posters were pure Pop: immediate, specific to a group, cheap (they sold for between 25p and £1), and expendable in both stylistic and physical terms.

[37] Weymouth quoted in 'Posters: Big Business or Art?' *Telegraph Magazine* 10 April 1968, pp 32-4.

[38] English in conversation with the author 19 May 1977.

Psychedelic Record Covers

The psychedelic style began to appear on record cover designs by the end of 1967. Hapshash and the Coloured Coat produced their own LP in red vinyl with a cover that was a potpourri of psychedelic images — rising suns, Tibetan priests, Victorian picture-book shepherdesses, flying saucers, mythical beasts — with lettering that was almost illegible. Martin Sharp designed two record covers for the rock group, Cream: 'Disraeli Gears' (November 1967) was a montage of his characteristic graphic style with retouched photographs, in clashing dayglo reds, greens and yellows; 'Wheels of Fire' (August 1968) had a reflective silver cover with a drawing of one of his abstract landscapes. Other well known LPs with psychedelic covers that appeared in 1967–68 were: 'Their Satanic Majesties Request' (December 1967) by The Rolling Stones — Michael Cooper designed a three-dimensional picture of the group in full psychedelic regalia against a landscape from a far-off planet; 'Axis Bold as Love' (December 1967) by Jimi Hendrix — David King and Roger Law used a Buddhist-style painting for their cover design; 'A Saucerful of Secrets' (July 1968) by Pink Floyd with an atmospheric photographic montage by Hipgnosis; 'The Crazy World of Arthur Brown' (July 1968), which had a photograph by David King showing a moment from one of Brown's psychedelic happenings; and The Moody Blues' 'In Search of a Lost Chord' (August 1968), with a Symbolist-inspired cover by Philip Travers.

Mural Painting

The Fool turned their versatile talents to music in 1968 and designed the cover, wrote, arranged and recorded their own LP. Much of The Fool's time in late 1967 and 1968 was taken up with the designs for the interiors and an exterior mural for the 'Apple Corps'. Apple was a chaotic but well-intentioned organisation set up by The Beatles in April 1968 to act, more or less, as an alternative Arts Council and encourage or finance diverse and often bizarre musical, artistic

or theatrical schemes. The Fool designed the interior with its '. . . image of nature, like a paradise with plants and animals painted on the walls. The floor will be imitation grass and the staircase like an arab tent.'[39] The exterior mural, painted at the end of 1967, was a *tour de force* of psychedelic and mystical imagery, which was not appreciated by local residents who petitioned to have it removed because it was considered to lower the tone of the otherwise respectable area. Other psychedelic or Pop murals had more success. Most were in commercial areas like Carnaby Street and featured swirling abstract psychedelic patterns. The front of the 'Granny Takes a Trip' boutique in Kings Road was a

[39] Green 'The Fool's Paradise' op cit p 47.

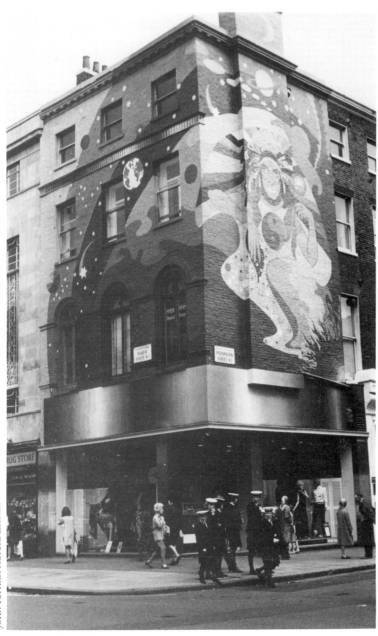

JOHN TOPHAM PICTURE LIBRARY

The Fool, Apple building, 1967. Psychedelia comes — fleetingly — to W1.

frequently changing display of Pop imagery: at various times there was a large simplified painting of Mae West's head (by Nigel Weymouth and Michael Mayhew), a Red Indian warrior (by Weymouth and Michael English), and a real American car of the 1950s. 'Hung on You' had a mural by Michael English in the style of a Lichtenstein comic-strip painting. Binder, Edwards and Vaughan also executed Pop or psychedelic murals and their work appeared on the 'Lord John' boutique, 'Dandie Fashions' and '81 Parkway'. A Modernist architectural critic predictably complained that the psychedelic murals '. . . made a mockery of what is known as modern architecture and good design. For those who set their standards of taste by principles, there is no sense in it.' However, for the Pop designers, murals were just another way of 'turning on the world'.

The Demise of Psychedelia

The psychedelic style epitomised the immediate impact and small sustaining power of Pop. Its end was inevitable, and by January 1968 *Design* was asking: 'Are we suffering from psychedelic fatigue?' — psychedelia was described as the Parkinson's disease of the retina.[40] Although the style may have died with 1967, psychedelia continued in the multi-media, multi-sensory environmental happenings of the late 1960s.

[40] Margaret Duckett 'Are We Suffering From Psychedelic Fatigue?' *Design* January 1968, p 21.

Environmental Happenings

Nigel Weymouth and Michael English, Granny Takes a Trip, 1967. The Red Indian facade decoration became one of the tourist attractions of the King's Road.

Artistic experiences that unite the senses have been attempted since at least the late 19th century. At Bayreuth, Wagner had sought an integration of music, words and action in a *gesamtkunstwerk*, and the revolutionary Russian theatre, under the guidance of Alexander Tairov, had tried to integrate ballet, opera, circus, music hall and drama. Happenings in the 1950s and 1960s had been attempts to break away from artistic conventions and achieve a fusion of art and life, but on a hedonistic level the Pop happenings of the late 1960s were the most complete.

In 1964, Ken Kesey, author of *One Flew Over the Cuckoo's Nest* (1962), and a group of friends calling themselves the Merry Pranksters travelled across America in a 1939 Harvester bus equipped with sophisticated audio and film equipment. Virtually their whole journey took place under hallucinogenic drugs. Kesey than organised two dozen 'Acid Tests' — psychedelic spectaculars — in which LSD was added to sugar cubes, drinks or cake. A multi-media group called USCO manipulated coloured lights, tape recorders, slide projectors and sound machines. The amplified sounds included heartbeats, screams, laughs and breathing and they were accompanied by films and slides of micro-organisms, planets in collision, soldiers in battle, women giving birth, and other images that had emotional and psychological power. Objects were altered and distorted, and the logic of normal perception was destroyed. Their aim was to make everything

'. . . more or less integrated, and aimed at the psyche, the emotions, the central nervous system. . . . The considered intention . . . is to decondition the mind, break through the categories of thought, undercut the constances of perception, so a psychedelic awareness can come into being.'[41]

[41] quoted in Masters and Houston 1968, p 84.

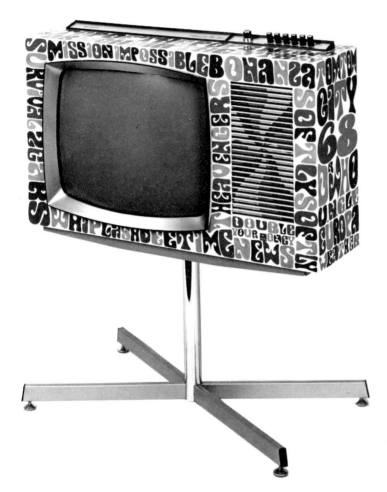

Murphy television set, 1968. Brightly coloured psychedelic lettering was sometimes applied to otherwise-ordinary High Street goods in order to make them appear more up to date. The Murphy television set is an extreme example of this tendency.

A new form of music called 'acid rock', played by The Greatful Dead and Jefferson Airplane, was created for the tests. The participants became overwhelmed by the multi-media and multi-sensory activities, especially if they had taken hallucinogenic drugs. The combination of their hallucinatory visions and the frenzied activity of the Tests created an experience, albeit transitory and formless, of heightened sensuousness. In January 1966 after LSD was prohibited in California, Kesey organised a further 'Acid Test', which was billed as a 'Trips Festival', that lasted for three days. Its commercial success led to a new era in Pop dance halls: Andy Warhol opened the 'Balloon Farm' a club that featured a group called The Velvet Underground; and the 'Electric Circus' in New York combined all the elements of the psychedelic experience. These were followed by Bill Graham's more commerically orientated weekly 'festivals' at the Fillmore Auditorium.

The UFO

Total environmental Pop happenings first occurred in Britain at the end of 1966 when news of the 'Acid Tests' and 'Trips Festivals' reached the Underground. The most celebrated Pop club based on the American 'Acid Test' prototype was the 'UFO' in Tottenham Court Road, London, which opened in December

1966. The letters UFO were ambiguous and had different meanings for different people: 'Unidentified Flying Object', 'Underground' or 'Unlimited Freak Out'; even 'Underground Film Organisation'. UFO sessions went on through the night and, according to one of the regulars, one could go there to '. . . listen, dance, blow bubbles, eat, sleep, trip, make love or just wander around digging people.' The music was usually provided by Soft Machine or Pink Floyd. Soft Machine played a fusion of modern jazz and electronic rock, and Pink Floyd, described as London's premier psychedelic band, played music that was long and complex but eminently suitable for 'tripping to'. Key changes, breaks in rhythm, meandering solos and random noise comprised the aural counterpart of the psychedelic experience. Pink Floyd evolved their own light-show, created by Joe Gannon, taken over by Peter Wynne Williams and eventually run by Mark Boyle, a lecturer at the Hornsey College of Art. Boyle's interest

STUDIO VISTA

Light show at the UFO, 1967. The light show was an integral part of the hippies' psychedelic environmental happening.

in the lightshow had grown from his activity in happenings and evironments — in 1966, he had for example, organised a *Son et lumière for bodily fluids* in which a number of liquids extracted from his body were used as materials for projection. Boyle made the slides at the UFO shows, and incorporated a number of improvisational techniques. Coloured dyes were mixed on a plate of water with the result, rather like ink from a fountain pen in water, projected by an epidiascope. Slides were made from a mixture of coloured water and oil which, because of their different densities and the heat of the projection bulbs, slowly separated. These images, in addition to old cartoon films, were cast over areas of the club including the group, the audience and a dance troupe

named the 'Exploding Galaxy'. The total effect intensified and heightened by hallucinatory drugs was, in the catchphrase of the day, 'mind-blowing'. The UFO flourished for only a short time and, in October 1967, problems caused by financial mismanagement and drug convictions forced the club to close. It was re-opened as the 'Electric Garden' and subsequently became the 'Middle Earth' at which point it was rejected by the Underground as too commercial.

There was also a series of one-off events that attracted Underground support: 'Psychodelphia versus Ian Smith' (December 1966), the 'Biggest Party Ever', the 'Million-Volt-Light and Sound Raves' (January and February 1967) and the 'Fourteen Hour Technicolour Dream' held at the Alexandra Palace in June 1967 which is remembered as one of the highpoints of psychedelic environmental happenings.

The Underground happening required several items of technological hardware: overhead projectors, amplifiers, stroboscopes, tape decks, cinema projectors, and spotlights. Like Boyle's oil-and-water slides, they had great improvisational potential. Because the effect was all important, the hardware tended to be concealed — 'design as service' — but where the technology was visible it was usually as a tangled mass of leads. The Pop technical operators, like the Futurists and Archigram, viewed technology as a wild, rich mess. Clutter and disorder were preferred to neatly styled packages of the discreet CoID-approved variety.

The aim of total sensory bombardment was to fuse inner and outer reality, and mind and body. Neville believed that:

'The most memorable experiences underground are when you connect to the music, to the light show, happening and movie simultaneously, while being stoned and fucking all at the same time — swathed in stereo headphones of course.'[42]

42 Neville 1971, p 53.

The happening was a state of flux that broke down the barriers between individual elements. The end was not the creation of artistic form but the achievement, according to hippy writer, Mick Farren, of '. . . consciousness. The feeling was to research, not into what could be done *by* the intellect, but what could be done *to* the head.'[43] Experience, however fleeting, was valued over form or lasting artistic accomplishment.

43 Farren 1972, pp 51-2.

Psychedelia: Conclusion

Psychedelia was both transitory and transitional. It marked a turning point in the evolution of the Pop sensibility. The graphic style was wholly Pop: cheap, full of impact, immediate, appropriate to a particular group and expendable. It was the visual equivalent of hallucinogenic drugs evoking not only a lifestyle but the mood of the time. Whereas Constructivist graphic design had been limited to a few forms, expressive only of machine standardisation and repetition, psychedelic graphics had overturned pure form and re-emphasised the importance of expression, association and meaning. Psychedelic fashions and murals tried to 'turn on the world' by liberating colour and decoration from restrictions of good taste and sobriety.

The psychedelic state of mind was the obverse of the Modernist's. It was open to chemically, mystically, or intuitively induced ways of attempting to

change consciousness. Sensation and experience were important; concepts based on factual knowledge were not. The Modernists' confidence in the Western intellectual tradition which had given rise to scientific rationalism was rejected as narrow-minded and ethno-centric. Like the Independent Group and the prophets of Pop, hippies were willing to suspend moral judgements as a strategy to keep their minds open to new experiences. But, whereas the prophets of Pop wanted to run with technology and journey to the stars, hippies wanted to explore inner space on the voyage of discovery to their personal nirvanas. Hippies have been accused of being middle-class drop-outs and self-indulgent parasites who mistook their own navels for the universe, but their values and attitudes brought — for better or for worse — a lasting change to Pop.

In fashion, for example, the hippy's emphasis on personal expression and participation replaced High Pop's emphasis on up-to-dateness and immediacy. But of major importance in its implications for Pop was the hippies' attitude to expendability and technology. Although their anti-materialist outlook enabled them to discard and recycle simple objects and clothes without conscience, hippies were passionately opposed to the exploitation of natural or rare resources, the increasing use of synthetic and non-biodegradable materials, and an economic system of planned obsolescence. They believed the uncontrolled use of precious resources to be a social crime and a symptom of a consumptive society. Hippies found social and environmental pollution obscene and they wished for harmony with nature and an ecologically sound planet. High technology and expendability, so much an integral part of Pop, were now despised.

The Politicalisation of Design

One particular incident in 1967 was seminal in its effect on hippies. It also contributed to the public's changing attitude towards environmental pollution and, ultimately, technology. A huge oil tanker, the *Torrey Canyon*, ran aground, stuck fast and ruptured her side on a reef off Cornwall known as the Seven Stones. Within a few days the first of the ship's 120 000 tons of crude oil began to be washed up on the coasts of Britain's south-west peninsula. There had been no similar accident of this magnitude before and the cost in terms of pollution and bird life was frighteningly high. For many hippies this incident changed their perspective from that of self and their own Underground to the whole 'planet earth'. They began to see the importance of and the necessity for social responsibility.

So too did designers. In 1967, *Design* urged designers to examine the wider issues and study the environmental effects of products:[44] pollution, conservation, and the destruction of the countryside should all be of concern to the designer. Socially responsible thinking gathered momentum. In 1968 the editor was of the opinion '. . . it would seem the right time for a major rethink of what people really want'[45], and the following year in a statement entitled 'Design in its context', the editor argued it was a 'crucial' time to look at the wider environment.[46] In 1969 Reilly of the CoID wrote of the need for a '. . . thorough reappraisal of attitudes to design across the whole span of British industry'[47]. And *Architectural Design* and the *Architectural Review* published regular features called, respectively, 'Alternative Futures' and 'Manplan', which both began in 1969.

[44] J Christopher Jones 'Trying to Design the Future' *Design* September 1967, pp 35-9.

[45] Editor 'Designing for Satisfaction' *Design* March 1968, p 19.

[46] Editor 'Design in its Context' *Design* January 1969, p 15.

[47] Paul Reilly 'Design for Survival' *New Statesman* 5 September 1969, p 303.

The tone of this post-1966 period was captured by Michael Middleton in an article called 'The Wider Issues at Stake'. Middleton wrote of '. . . a movement of public opinion, a developing concern, which is one of the genuinely hopeful events of the decade.' He continued with an explanation that:

'What is hopeful is that the wider public is now beginning to grasp the scale, the complexity, the interlocking nature of such problems. What is at stake is nothing less than the quality of life itself — not in a century's time, but twenty, ten, two years' time.'[48]

[48] Middleton 'The Wider Issues at Stake' *The Designer* February 1970 p 1.

The concerns to which Middleton referred included the *Torrey Canyon* oil slick, the Aberfan disaster, traffic congestion in city and town centres, speculative property development, and air and water pollution.

A forceful environmental lobby was growing. A proposed third London airport was (at the time) successfully opposed on environmental and ecological grounds. Within a couple of years the concerns of a minority of radicals and hippies had become major issues for the professional classses. The International Council for the Society of Industrial Designers (ICSID) took as the theme of its sixth conference, held in London in the summer of 1969, 'Design, Society and the Future'. Much of the debate centred on the role and status of technology in society, and excerpts from four papers published in *Design* were under the title 'Technology: good servant or errant monster?' As the editor of *Design* pointed out:

'If we are to avoid mistakes similar to those of the first industrial revolution, then we have to make sure that modern technology is geared to take us where we want to go, and not just where the next steps happen to place us.'[49]

[49] Editor 'A Choice of Tomorrow' *Design* May 1969, p 25.

The connection between bigger and better was questioned and a reaction against advanced technology was under way. Planners and designers had to change their thinking from quantification to the quality of life. A shift was taking place from the industrial to the 'post-industrial' society. According to one planner at the ICSID conference:

'The problem is to redirect our energies and all the technology which is at our service toward renewed human ends — ends which are not given, as was survival amid scarcity, but are now in need of being invented.'[50]

[50] Hasan Ozbekham quoted in 'Technology: Good Servant or Errant Monster?' *Design* October 1969, p 56.

An advanced chemical plant might mean the production of wealth, but it would also mean the pollution of the water and air around it. Priorities and values had to be determined and this, in turn, required political decisions. Designers were becoming politicised as they realised that design was part of the social, economic and political system of a country.

Concomitant with the politicisation of design was a loss of faith in professional architects and designers. The collapse of the Ronan Point tower block in London in 1968 drew attention to the widespread unpopularity of high-rise buildings and the inadequate level of research and testing on the majority of

POP DESIGN

pre-fabricated systems of building. Architects suddenly found that they were being held responsible for the social unhappiness associated with high-rise housing and they lost the confidence of the public. Professionals — whether architects, planners, doctors or politicians — who had been accustomed to being held in high regard, were suddenly mistrusted and even distrusted by an increasingly critical and vocal public.

Youth and Activism

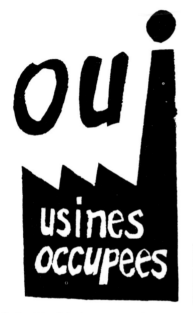

Atelier Populaire, Oui usines occupees *(Yes to occupied factories), 1968. The Atelier politicised the poster in order to 'turn on the world' to the political struggle.*

[51] Sorbonne students quoted in Roszak 1969, p 22.

[52] *Atelier Populaire* 1969 np.

1968 was an eventful and seminal year: Russia invaded Czechoslovakia; Martin Luther King and Robert Kennedy were assassinated; student leader Rudi Deutsch narrowly survived an assassination attempt; President Johnson resigned and Richard Nixon became President. Civil disorder and race riots were widespread and student protest was fierce. Youth turned on, tuned in, and woke up to politics. The idealistic dreams of the 1967 'summer of love' were shattered in 1968 when love frequently turned to hate. Those hippies who, according to one of their number, had been '. . . hit on the head by a policeman' renamed themselves 'yippies' and took to violence. In America there was fierce youth support for the anti-Vietnam war movement which was beginning to change public opinion about America's involvement in that war.

But the most politically radical action that year occurred in France where, for a few bloody and violent days in May, it seemed as though the government would be overthrown. Students attempted to motivate workers to revolt with a promise that:

'The revolution which is beginning will call in question not only capitalist society but industrial society. The consumer's society must perish of a violent death. . . . We are inventing a new and original world. Imagination is seizing power.'[51]

Art students responded by forming the *Atelier Populaire* which produced a constant flow of street posters and street theatre events, puppet shows and happenings. The aim of the *Atelier* was unambiguous:

'Let us form in our cultural and political action the rearguard of the workers' struggle against the repressive system of bourgeois culture. Let us redouble our attempts to find both in action and through our contact with the masses the methods of struggle best suited to each situation. Let us increase the number of *Ateliers Populaires* so as to provide the conditions necessary for the emergence of a people's culture and an information network at the service of our workers.'[52]

The posters produced by the *Atelier* were usually simple one-colour prints, expressionist in conception that were pasted up on hoardings, fences and walls as a daily press release giving information, inciting the populus to riot, criticising the government, and motivating the workers to act against the injustices they suffered. Although the *Atelier*'s posters and the psychedelic posters of the previous summer may have appeared to be substantially different, there were four significant similarities. First, the instigators of both types of

SOMOGY, PARIS

180

poster wanted, in their own way, to 'turn on the world' to their different causes. Second, both believed that style fundamentally shaped the message. Third, both attached secondary importance to formal concerns. Finally, both were forms of do-if-yourself activism — the posters could be produced cheaply without sophisticated technical skills. The didactic role of the poster was firmly established in the late 1960s as small groups produced their own posters for all manner of political, ecological, social or spiritual causes.

The question that distinguished the radicals from the reformers in the post-1967 period was whether the shift to the post-industrial society and revision of goals could be accomplished *within* the old political system or whether it was necessary to bypass and even destroy conventional political channels. Those who had status and position — the professionals — wanted to reform the system from within. Groups as radical as the *Atelier Populaire* saw no alternative but to overthrow the system.

The *Atelier Populaire* viewed art and design as tools of the revolution. The designer was a revolutionary whose responsibility was not to a capitalist paymaster and bourgeois society but to the people. His job was not to pander to falsely created desires but to communicate ideologically pure information and help solve real needs and problems. Like their predecessors in Russia in 1917, the designers of the *Atelier Populaire* could claim to be useful and worthy members of the revolution.

Association of Members of Hornsey College of Art (AMHCA), Don't let the bastards grind you down, *1968. The Hornsey students (and some staff) took their lead from the Paris students and used the poster as a means of communicating ideology, opinions and beliefs.*

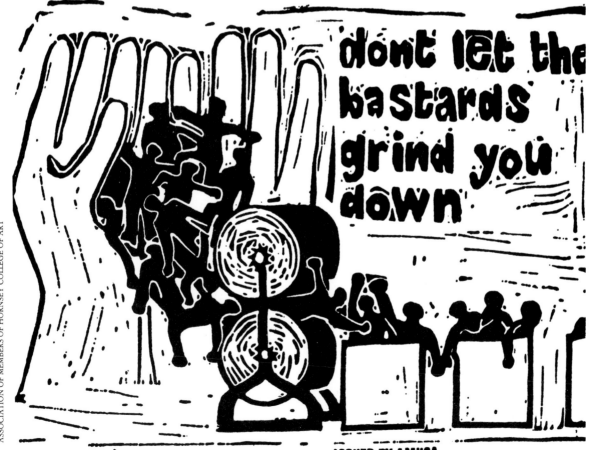

ASSOCIATION OF MEMBERS OF HORNSEY COLLEGE OF ART

In Britain, the young who had voted Labour in 1964 and 1966 in the belief that society would be transformed, had become at first disillusioned and then angry. The Labour administration was branded a Tory government run by Labour politicians. As the political system had maintained the status quo, radical politics and direct action were necessary. The main confrontation occurred in October 1968 at the anti-Vietnam march outside the American Embassy in Grosvenor Square; but throughout the summer it had seemed as if Britain would have its own version of the Paris riots. There were 'sit-ins' at the London School of Economics and several art colleges including Hornsey, Guildford and Birmingham. From the end of May to early July, Hornsey students took over their college and, like the *Atelier Populaire*, produced posters, murals, statements and documents. The fundamental question the students asked was: 'What and who is education for?' Conventional education was likened to a conveyer belt, and there was a demand for a rethinking of educational aims and priorities. The students argued that academic entrance requirements and compulsory examinations should be eliminated, distinctions between vocational and non-vocational courses should be dispelled, and a network of courses should replace the existing linear organisation. 'Document 3' emphasised the wider educational and social implications of the demands:

> 'One must recognise that in setting up a new educational structure at Hornsey one is creating the work model for a fundamental re-organisation of the educational system, and thus, in effect, the value and priority system of our present society.'[53]

[53] Hornsey 1969, p 48.

Anarchy, radicalism and 'agitprop' were words heard continually throughout 1968. In 1967 a peaceful revolution brought about by drugs and consciousness-raising had seemed possible: by 1968 a violent revolution in Europe seemed not only possible but, for a few weeks, likely.

Summary

It is rare that a genuine change in sensibility can be as accurately pinpointed as the change that occurred between 1966 and 1968. In 1966 technology was worshipped, expendability was a social grace and Pop was High. By 1968 technology was evil, expendability was a social crime and, as a vital and dynamic force, Pop was over. Political participation and technological control mattered more to radical youth in 1968 than fashionability and fun.

LATE AND POST POP

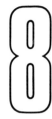

Between 1968 and 1972 Pop fragmented to the extent that it ceased to exist. The prospect of a unified and classless Britain under Labour had begun to fade in 1966: expectations of change had given way to hope and, by 1968, hope had turned to despair. When Labour were voted out of office, it was not because the Conservatives inspired widespread optimism — they had fared badly in the opinion polls up to the eve of the election — but because the electorate had lost faith in Labour and looked towards Edward Heath to bring back a semblance of order and pride to the strike-torn, mismanaged and unhappy nation.

The Fragmentation of Youth Culture

1968 had marked the beginning of the end of the period of consensus. Radical youth turned away from conventional politics towards direct action and confrontational politics. On the Paris streets in May 1968 one of the oft-heard slogans had been 'Demand the impossible'. The bitter pill the would-be revolutionaries had been forced to swallow was that demanding the impossible could result in the achievement of nothing. The drug-induced consciousness-raising revolution of 1967 and the direct political action of 1968 had both been attempts to change the whole world. After 1968 youth lowered its sights. If the world could not be changed by radical politics or consciousness-raising, then at least individuals, groups and small communities could fight for something more tangible. The youth movement of 1967 and 1968 broke up into small groups pursuing separate causes with singleminded passion and determination. Youth was still ideological, but they had learned to be practical idealists.

During the late 1960s the number of rights groups grew, oppressed minorities were mobilised and the underprivileged were championed. Black groups began to assert themselves, women's lib developed into feminism, and homosexuals formed active pressure groups. Peace movements, some under the influence of John Lennon and Yoko Ono's 'bed-ins', gained in confidence and size, religious sects multiplied, and alternative lifestyles were lived-out in places as disparate as basement flats in Notting Hill and remote communities in Wales. 'Shelter' — 'the national campaign for the homeless' founded in 1966 — exerted pressure on local authorities to rehouse families. Some took their fate in their own hands and squatted.

The issues that had caused riots in 1968 frequently resurfaced. The fight for a better environment — whether in terms of waste, pollution or noise — had originally united both reformers and radicals, but in the late 1960s it became an ideological battleground. Professional designers and planners had become committed members of the increasingly powerful environmentalist lobby, but the radicals argued that concern for the environment was the new opium of the people and distracted attention from the real issues. In the middle of a debate about professional design at the annual major design conference at Aspen, Colorado in 1970, the French group gave vent to their radical ideas:

[1] Statement by the 'French Group' in Banham 1974, p 208.

'The group believes that too many matters, and essential ones, have not been voiced here as regards the social and political status of design, as regards the ideological functions and the mythology of environment.'[1]

They described Aspen as the 'Disneyland of design' and called for a dozen resolutions on topics ranging from the abandonment of design for profit, to motions on Vietnam and abortion. Designers had to confront the political, social and economic systems in which they worked and this was not achieved by discussing 'the environment' as if it was an apolitical design problem. The spirit of May 1968 lived on.

In Britain similar ideological issues were raised by the 'ARSE' group (Architectural Radicals, Students and Educators) who started publishing their own magazine in 1969. Their slogan was 'We shall build for society by building a new society first' and they encouraged direct action such as taking over empty office blocks and squatting.

Small pressure groups were a key factor in the avant-garde arts from self-build architecture to self-help community arts programmes. 'Arts Labs' — the first of which was opened in 1967 — flourished in major cities, and by 1969 it was calculated there were 150 in existence. The labs encouraged multi- and inter-media experimentation in art, music, dance, theatre and film, to maintain, as one proponent believed, the '. . . rejection of western materialist values which underpinned the hippy revolt of 1967.'

There was a 'free' or 'anti-university' movement. According to its prospectus, the London Free School provided:

'A free-wheeling succession of open-ended situations. Ongoing vibrations highly relevant. Exploration of Inner Space, deconditioning of human robot, significance of psycho-chemicals, and the transformation of Western European Man. Source material: Artaud, Zimmer, Gurdjieff, W. Reich, K. Marx, Gnostic, Sufi, and Tantric texts, autobiographical accounts of madness and ecstatic states of consciousness — Pop art and twentieth century prose.'

The School's subject matter is a revealing list of the alternative culture heroes of the day.

The Underground continued, although during the late 1960s and early 1970s it was less active. The psychedelic newspapers were replaced by magazines such as *Time Out* which was intended to facilitate self-help and activism. By 1972 the original Underground publications had been made redundant by the plethora of community-based or minority-directed papers and magazines.

Pop Music in the Late Pop Years

Although commercial interests took over many of the hippies' ventures, the hippy ideology was maintained in music. There was a growth of independent record labels (such as John Peel's 'Dandelion' label) which did not emphasize commercial success, and the cult of 'doing your own thing' which valued artistic sincerity and personal self-discovery. Each of The Beatles began to pursue indi-

vidual musical goals and their collective dominance declined. Nevertheless, with six number one singles between 1967 and 1969 and four number one LPs between 1967 and 1970, The Beatles' selling power was little diminished.

Pop music, like youth culture, fragmented and became more hetero-geneous in the late 1960s. There was straightforward commercialism (The Monkees), middle-of-the-road ballads (Engelbert Humperdinck), Pop-poetry (Pete Brown), electrified folk/poetry (Incredible String Band), and an elec-tronic rhythm'n'blues-based improvisation (Cream). With the experimenta-tion of the 'progressive' groups such as Cream, Led Zeppelin and the Nice, Pop music became an earnest activity which could be discussed in terms of 'pendia-tonic clusters' and 'flat-submediant key-switches'. At one end of the range Pop music aspired to the status of art; at the other it merged with popular music and became light entertainment that could be broadcast on Radio 2. Even Radio 1 (the BBC's Light, Third and Home stations had been superseded by Radios 1, 2, 3 and 4 in September 1967) was quite acceptable to many adults which indicates how Pop was no longer the unifying force *against* adult values it had been throughout the Early and High Pop years.

The change in Pop music was symptomatic of the wider changes in out-look taking place among the young. This transformation of the Pop sensibility did not wipe out Pop immediately; the changes were localised. Late and Post Pop are best described as a spectrum: during Late Pop there were the occasional explosions of a High Pop spirit; between Late and Post Pop, because of the changing sensibility, there was sometimes a genuine and creative synthesis of old and new; during Post Pop, ideas and designs that oppose Pop's attitudes and values appeared. Progression in this period was neither uniform nor consis-tent, but the direction of progression was unquestionable.

In this chapter I shall follow the divergent routes Pop took by focussing on some of the different areas Pop influenced: in the first part I shall deal with furniture, interior and environmental design, and, in the second, fashion and graphics.

Late Pop Furniture

There had been much activity in Pop furniture design in 1967 and 1968. Several designers had introduced new ideas for disposable paper furniture, but, as the enthusiasm for an ever-changing way of life waned, the role of paper furniture changed. David Bartlett, the designer of the 'Tab' chair, acknowledged that disposable furniture was not going to herald a radical change of lifestyle but would be accepted and suitable for particular functions. He formed David Bart-lett Design Ltd and brought out a paper bookcase and a paper nursery range which included young children's tables and chairs, a toy bin/table, and a 'Wendy House' 54 inches high. Bartlett explained why he designed for a limited market:

> 'I have never thought that the whole furniture-buying public was
> open to cheap disposable furniture. But there are gaps which just
> cry out for it and, gradually we are plugging those gaps.'[2]

2 Bartlett quoted in anon 'Men Who Influence By Design' *Ideal Home* February 1969, p 32.

The Reed Paper Group made corrugated fibreboard desks and chairs for Buckinghamshire County Council who intended to use them in their nursery

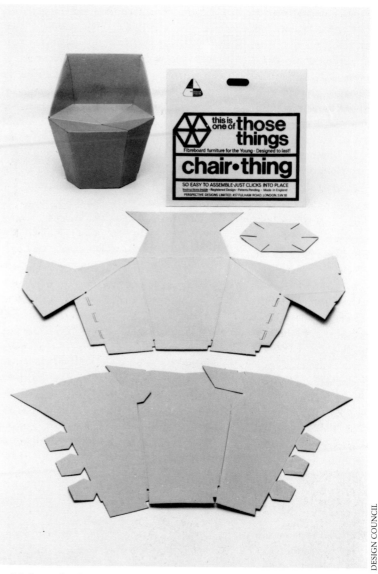

Peter Murdoch, Those Things chair, 1967. A
further development of his 1964 chair, Those
Things won a CoID award in 1968.

DESIGN COUNCIL

and infant schools as an economic measure. Polycell marketed this furniture
under the name of 'Child's Play'. In 1967 the chair was priced at 12/6d
(62½p), the desk was 19/6d (97½p), the table was £1, and the toy chest was
21/6d (£1.08p). Each item was sold flat in a large carrier bag. The range came in
blue or red and had a life expectancy of about a year. Peter Murdoch designed a
similar range comprising a chair, stool, and table — 'Those Things' — which
were blue, turquoise, pink, or orange, sold for £1 each and won a CoID design
award in 1968.

Disposable Pop paper furniture could never have secured a mass market
and would always have been limited to the young and fashion conscious. As one
critic put it:

'People who will buy paper chairs for their bed-sits, seaside flats or
playrooms, will never be weaned from the almost obsessive

emotional need for "real" furniture in their more established environments.'[3]

[3] José Manser 'Furniture: Mainstream or Throwaway?' *Design* January 1968, p 30.

Furniture was too closely associated with the psychological requirements of status and security for disposable furniture to be bought widely. Seduced by the concept of 'Homo ludens', designers had been too optimistic in hoping that technology and fashion could cause an immediate and fundamental change in Man's psychology.

'Fun' Furniture

Some Pop furniture designers turned to sculpture. Jon Wealleans and Jon Wright designed and made what they described as '. . . fun furniture for children and adults'[4]: a soft PVC seat in the shape of a giant set of false teeth, a set of seats resembling a large jigsaw puzzle, made in foam and upholstered in lilac, silver or fake fur, and a 4 ft × 3 ft soft telephone which could be used as a chair when the receiver was removed. The two main shops selling fun furniture were 'Mr Freedom' and 'Luckies'. Also available at these outlets were a 'giant bumper gum shoe seat', a small sofa made from eight, 5 ft long foam-rubber 'cigarettes' covered in cream PVC with brown filters, large 'Liquorice Allsort' cushions, and a shiny fibreglass, hand-shaped chair. Visually these pieces were pure Pop, but as they were one-offs or limited editions they were very expensive: the false teeth chair cost £160. One piece of fun furniture intended for mass production until technical difficulties prevented its manufacture was Roger Dean's 'Teddy Bear' chair. Dean maintained that people did not buy their furniture for reasons of ergonomics or utility but for emotional ones. The arms of the Teddy Bear could be wrapped around the sitter to provide comfort and reassurance at the end of a hard day. Objects which were as much sculpture as

[4] quoted in Valerie Wade 'Big Deal' *Sunday Times Magazine* 28 February 1971, p 32.

Roger Dean, Teddy Bear chair, mid 1960s (left). The sitter could take refuge in the arms of the Teddy Bear at the end of the day.

Fun furniture by Jon Wealleans, early 1970s (below). Surrealism and Claes Oldenburg are combined with a desire for childlike fun.

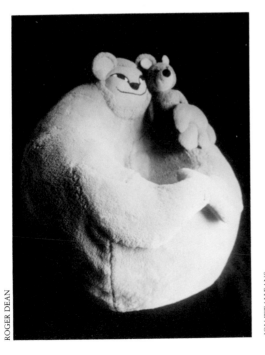

ROGER DEAN

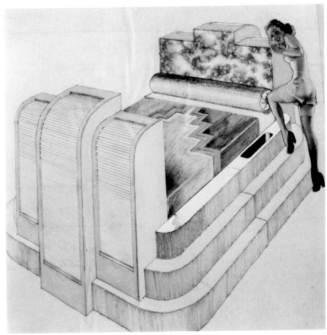

JON WEALLEANS

furniture were made at the end of the 1960s and early 1970s. In 1969 the painter Allen Jones made a table, seat and coatstand in the shapes of fetishistically clad women. A one-off chair was the cartoonist Gerald Scarfe's 'Chair Man Mao chair' (1971), a three-dimensional caricature of Mao Tse Tung which 'grew' from an upholstered armchair. This 'furniture' commanded fine art prices.

The inspiration for 'fun furniture' came from three main sources: the Surrealist tradition of the unexpected and the shocking — in the 1930s Salvador Dali had made seats in the shape of Mae West's lips and her out-stretched hands; the Pop Art of Claes Oldenberg who changed both the scale and the material of common, everyday objects; and children's furniture which was often multi-purpose and designed to stimulate imaginative play.

The simplicity and obviousness of 'fun furniture' should not obscure its implications. The admission of childlike needs and urges was a radical departure from the conventional belief that an adult is serious. These conventional and radical attitudes were typical in the different approaches to design of the Bauhaus and the Pop designers: one was formal and serious, the other informal and playful. But as *Homo ludens* declined at the end of the 1960s, 'fun furniture' soon started to look trite and self-indulgent.

Micro-environments

Interesting developments were taking place in interior and architectural design. A number of designers remained committed to a belief in high technology and the 'technological fix', which they developed through the concept of the fully integrated micro-environment using technological hardware and the imagery of the space race. Micro-environments were usually a plastic shell housing a comprehensive range of technological goods required for living in a leisure society: cooker, refrigerator, record-player, radio, tape player, television, video, film, slide-projector and mood-lighting system. Italian designers, including the Archigram-influenced Archizoom and Superstudio groups, developed a long-

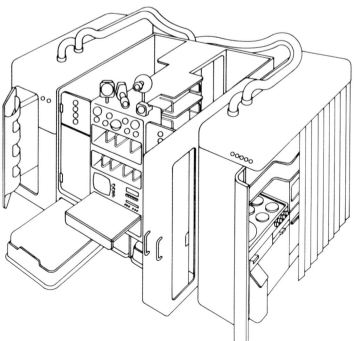

Joe Colombo, House Environment, early 1970s.
The sophisticated, fully-integrated but tight-fit micro
environment.

lasting interest in the sophisticated micro-environment. Although the fourth 'Eurodomus' in 1972 contained many micro-environments, the highpoint of the movement was at the exhibition 'Italy: The New Domestic Landscape', held at the Museum of Modern Art in New York in the summer of 1972. This featured environments by Joe Colombo, Ettore Sottsass, Mario Bellini, Alberto Rosselli and Gae Aulenti. Japanese designers motivated by the acute shortage of dwelling space also exploited micro-environments. Kisho Kurokawa's fully serviced capsule homes shown at 'Expo 70' and capsule tower apartments in Tokyo attracted enormous attention and were among the first of many such environments in Japan.

The intrinsic problem with micro-environments stemmed from the physical size. Responsiveness and participation — which had become increasingly important aspects of Pop in 1966 and 1967 — were severely limited by the tight-fit design solution (reminiscent of space capsules). Moreover, the imagery of micro-environments seemed anachronistic in the late 1960s.

By contrast an idea with far greater potential was that of the loose-fit and responsive environment in which software was emphasised and hardware played down or even concealed. The major influences on many of the designers who explored this idea were the psychedelic environments and happenings created at clubs such as the UFO.

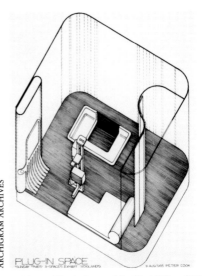

ARCHIGRAM ARCHIVES

Archigram, Plug-in Space at the Plug'n'Clip exhibit, 1965. Archigram were beginning to shift from the imagery of hardware to the effects of software.

Archigram and the Responsive Environment

The new mood of imaginative involvement generated much thought and affected such designers as Archigram who were also showing a greater concern with flexibility, responsiveness and participation. Their 'Plug'n'Clip' project exhibited at the Oscar Woolands shop in late 1965 had been a significant development in this area. Archigram argued for a rethink of the interior environment. 'Plug'n'Clip' was a departure from hardware as an end in itself to hardware as a means of environmental control and as a facilitator of choice. Although the exhibit contained a media trolley carrying sophisticated electronic gadgetry, its significance lay in what it did rather than how it looked. Like the equipment at an Underground happening, the trolley included apparatus for projecting coloured slides and moving light sequences over the complete wall space of the interior:

> 'We can reproduce the images of yesterday by photograph or film, and the slide show has taken the place of the family album. It is only an extension of all these to conceive of a living room that could stimulate by colour, sound, or projected images, any atmosphere one required simply by throwing a switch.'[5]

Technological advances might have made the rethink possible, but the technologically orientated society made it necessary. Peter Cook felt that the designer had a duty keep pace with

> '. . . children who have been brought up on space travel and bright colours, washable plastics and throwaway handkerchiefs [who] will not only be ready to accept this way of living in their homes, they will demand its inherent standards.'[6]

[5] Cook 'What of the Future?' in Ella Moody (ed) *Decorative Art and Modern Interiors* London, Studio Vista, 1966, p 6.

[6] ibid, p 6.

Could it be that those children had now become hippies?

In the years following 1965 Archigram became increasingly preoccupied with responsiveness and participation. Cook summarised the group's aim in the editorial of *Archigram 8* (1968):

> 'All effort is responding to something. An active architecture — and this is really what we are about — attempts to sharpen to the maximum its powers of response and ability to respond to as many reasonable potentials as possible. If only we could get to an architecture that really responded to human wish as it occurred then we would be getting somewhere.'[7]

[7] Reprinted in Cook 1972, p 74.

Archigram had attempted this with their 'Control and Choice' project of 1966–67. As Cook announced:

> 'The determination of your environment need no longer be left in the hands of the designer of the building: it can be turned over to you yourself. You turn the switches and choose the conditions to sustain you at that point in time. The "building" is reduced to the role of carcass — or less.'[8]

[8] Cook 1972, p 68.

Archigram were aiming at a total environment '. . . the hardware, software and ephemera . . . all intermixed (and interdependent at any one time)': an environment that would activate all the senses and be responsive to individual demands. Archigram and psychedelia shared the idea of 'design as service', and both asserted the priority of content over form that Cedric Price had sought in his 'Fun Palace' scheme.

Archigram, Control and Choice, 1966. The illustration attempts to communicate the idea of constant change and metamorphosis determined by the occupiers of the house.

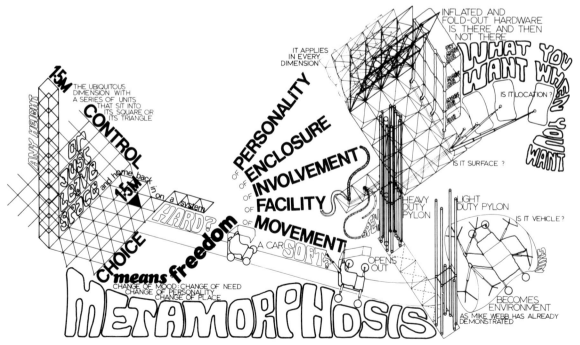

ARCHIGRAM ARCHIVES

Cook found that making visualisations of his ideas presented a major problem. Archigram's usual Pop graphic style, with its emphasis on technological objects, bright colours and selected 'goodies', was inadequate to convey a metamorphosing environment. Cook conceded that '. . . it becomes almost impossible to draw. It becomes necessary to try to summarize a time–space–atmosphere sequence that might never take up a finite configuration.'[9] Cedric Price, whose influence on Archigram was now stronger than ever, had faced these problems at the beginning of the decade and solved them by means of written notes and occasional sketches. This strategy did not suit Archigram with their preference for sophisticated graphics, and Cook used a mixture of images and words for 'Control and Choice'. Key words on the diagrams included 'freedom', 'involvement', 'movement', 'choice', and 'metamorphosis'. A model was made, and a further diagram showed a selection of hardware and structure. The diagrams were intended as '. . . a momentary frozen summary of parts that can be drawn.'[10] Soon after the project Cook was admitting that the printed page was no longer adequate and, appropriately in the age of McLuhan, the output of *Archigram* magazines declined. Only two were produced between the beginning of 1967 and the end of 1970. Archigram's experiments into the use of multi-media had made the printed magazine largely redundant.

Archigram applied some of the 'Control and Choice' ideas to their house for the year 1990, 'Living 1990', commissioned in 1967 by the *Weekend Telegraph* and on display at Harrods. Walls, ceilings and floors could be adjusted according to need, and the surface of the floor could be made hard enough to dance on or soft enough to sit on. The seating could be propelled like a hovercraft and used for travelling within the house. The internal arrangement of the house could vary considerably over 24-hour period. The priority now — similar to the hippies' 'trips festivals' — was mood, atmosphere and experience. Archigram was moving towards the 'soft environment' in which hardware could be invisible.

For those who, like Cook himself, remembered the provincial drabness of the 1950s, advanced technology had been a novelty to be celebrated. The new generation for whom advanced technology was part of their everyday life required a different design approach. The *imagery* of technological hardware was no longer necessary: technology could be concealed as long as the environment was responsive and exciting.

Experiments in Living

The influence of Archigram and psychedelia on architectural students and young designers was clearly discernible. The 'Experiments in Living' exhibition at Maples furniture store in late 1970 included a number of unorthodox design solutions and responsive interiors: there was a 'Pot Pit' which was based on a space capsule and continual visual change was provided by a projector; a custom-built domed black space called a 'Bubble Bed' in which one could impose one's personality by visual and aural means; and a 'Trip Box' that could be altered according to the inhabitant's wishes. The box's designer claimed: 'It will help to fill increasing leisure hours. The Englishman's castle is no longer his home; it is a fun palace.'[11] We were, apparently, still on the brink of the new leisure society.

9 ibid, p 68.

10 ibid, p 68.

11 Alex MacIntyre quoted in Margaret Duckett 'Please Turn On the Wallpaper' *Telegraph Magazine* 2 October 1970, p 38.

The central area of 'Experiments in Living' was called the 'Mind Field'. Circular screens on which moving visuals were projected enclosed free-form furniture, mostly by the brothers Martyn and Roger Dean. Martyn Dean's 'Retreat Pod' was a small but comprehensive integrated interior. The windowless, thin, rigid polyurethane shell resembled a giant ant's head. The pod fitted snugly around one person and the interior had hundreds of tiny orange neon bulbs which could be turned on to give bright illumination, or dimmed for a soothing atmosphere. The interior was also installed with a battery of electronic gadgets including speakers, amplifiers, television, videotape, tape recorders and hi-fi. A television camera enabled the inhabitant to see what was going on outside the pod and, to reduce the fear of claustrophobia, the door had no catches and stayed shut by its own weight. To allay anxieties of suffocation a visual feature was made of the ventilation system which, externally, resembled an ant's 'feelers'.

The Deans believed that interior design and furniture should function primarily at an emotional and psychological level. The home, like the primitive cave, should provide physical *and* emotional security. Thus the 'Retreat Pod', was

'. . . sound and light proof and has a soft fur interior to minimise touch, it disconnects you, and that's a state in which you are most receptive to propaganda, or self-determined indoctrination via tape recorders, projectors, light effects, and so on. You could take your mind from a state of near sensory deprivation right through to sensory chaos.'[12]

[12] Dean quoted in Margaret Duckett 'Leave Your Prejudices at the Door' *Telegraph Magazine* 25 September 1970, p 47.

[13] quoted in Peter Pass 'Mind Expander, Bubbler and Pneumo-Wiesen' *Form* (Germany) September 1969, p 17.

The potential misuses of the Pod — including brainwashing — did not seem to bother the designers who presumed it would be used to help induce states of self-awareness and self-fulfilment.

The Austrian Haus-Rucker Co created consciousness-inducing environments such as the 'Mind-Expander', a miniature PVC dome/large helmet for two which contained visual and aural stimulation, 'Flyhead', a total environmental helmet for one, and 'Yellow Heart' which had an inner and outer PVC skin that moved to the rhythm of a heartbeat. Haus-Rucker Co's work in the late 1960s and early 1970s illustrated the gulf between Pop interiors and conventional interior design. Without knowledge of synaesthesia and hallucinatory drugs, Haus-Rucker Co's prophecy that 'the future as we see it, is bright yellow. Like vanilla ice-cream — refreshing, nice smelling and appetising. A vanilla future'[13] would have seemed gibberish. A critic nonetheless might have added that vanilla ice-cream may be refreshing, but it is also nutritionally insubstantial.

These environments were, as Martyn Dean admitted, a substitute for drugs: a non-chemical way of heightening the user's state of consciousness. External (superficial) reality was excluded so that the 'deeper' reality inside the inhabitant's head could be explored. 'Retreat Pods' were the ultimate in personal 'design as service'. The acid-test of these environments was the quality of the experience they facilitated. Designers — and entrepreneurs — soon became aware that the experience had commercial potential. A group, called Envirolab, of ex-Architectural Association students helped to design a mirror dome for the Pepsi Pavilion at the 1970 Expo in Osaka. Constructed in alumi-

Martyn Dean, Retreat Pod, 1970: a fully-integrated micro-environment which was supposed to provide physical and psychological security.

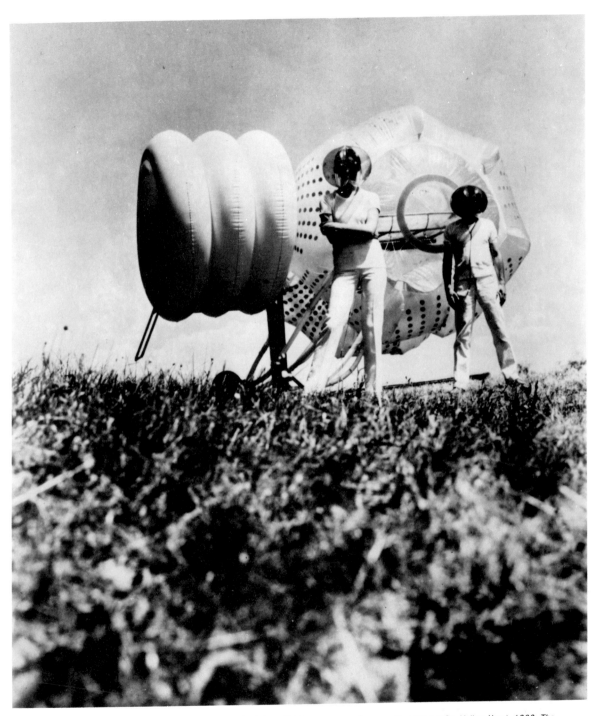

Haus-Rucker Co, Yellow Heart, 1968. The environment as a machine for tripping in.

nised nylon, it had a diameter of 30 metres, a height of 18 metres and an enclosed space that was activated by light and sound. Projected images could cover the entire wall surface, and the accompanying sound helped to distort the space, challenge perceptual values, and produce an atmosphere.

The Eventstructure Research Group (ERG), based in London and Amsterdam, made use of integrated interiors to stimulate people and enliven

the environment. 'Airground' was a large air-supported PVC dome with a semi-inflated billowing cushion floor which was shown at the Brighton Festival in 1968, and 'Waterwalk', used at the same festival in 1970, was a 5 metre high enclosure which floated on the water and could be walked through. The work of ERG and the similar SIME (Simultaneous Multi-Media Entertainment) group was a synthesis of art, happenings, environmental design and therapy — a logical conclusion to the late Pop development of the responsive environment.

Without the experience of hallucinogenic drugs and their synaesthetic side-effects, much of the experimentation in environmental and interior design would have been confined to the development of conventional ideas. Many designers acknowledged that psychedelia had given them insights into sensory perception and environmental experience that were not possible through normal design procedures.

The Interior Landscape

Closely related to the idea of the responsive environment was the trend towards the interior landscape. This led to a reaction against the technological progressivism of Pop and a technological or mechanistic appearance was avoided. Again it was Archigram who were at the vanguard of this trend. In their 'Plug'n'Clip' project Archigram questioned the basic conventions of interior organisation:

[14] Cook 'What of the Future?' op cit, p 6.

Roger Dean, Upstairs at Ronnie Scott's Jazz Club, 1968. Dean's interior illustrates the trend to a softer, more organic-looking interior landscape.

Bernard Holdaway, Tomotom Rolls, 1971. The rolls were the standard unit that could be grouped to provide a furniture landscape for any shape of interior.

'If we seriously begin to use the three dimensions that space really consists of we can interpret this until the floor can be anything: a hard, flat washdown surface; a rolling, lounging, contemplative surface; a surface to be laid upon . . . and even dug into . . . Various ideas have been devised for the whole house to be a series of floor levels into which you sit and store things, so that furniture as such is completely eliminated.'[14]

The group proposed inflatable walls and moveable screens on ceiling railways that could be operated electronically. Furniture was replaced by self-shaping

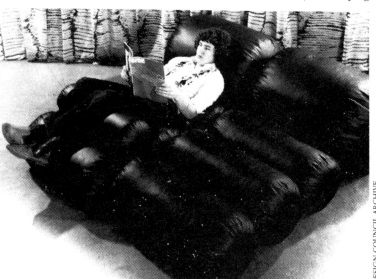

DESIGN COUNCIL ARCHIVE

DESIGN COUNCIL ARCHIVE

pneumatic seating, and the floor was described as a 'magic carpet', hard enough for walking on but soft enough for sitting or lying on.

The interior landscape also had commercial potential. One of the first schemes to be constructed was Roger Dean's 1968 design for the 'Upstairs' club at Ronnie Scott's Jazz Club in London. The small size of the room meant that conventional seating would have cluttered the interior. Dean designed organic-looking, high-density polythene foam shapes in two- or three-tier structures soft enough to provide comfortable seating, yet resilient enough to withstand being walked on or clambered over. The shapes, which seemed to grow out of the floor and undulate like a landscape, were both successful and popular.

Dean's design was for a specific interior. Other designers developed a system or kit-of-parts approach in order that their designs could be applied to any interior. Ambrose Lloyd was successful with both his award-winning Dunlo-pillo foam seating unit (1970) and his 'Cushioned landscape' which visitors to the 1971 Electric Theatre exhibition at the ICA could lounge on. Hull Traders (the manufacturers of Bernard Holdaway's 'Tomotom' paper furniture range) produced 'Tomotom Rolls', polyether-filled tubes in nine-, 15- and 26-inch diameters, 27 inches long, which could be grouped together to form virtually any layout.

De-'furniturised' Furniture

In the era of the interior landscape, conventional free-standing furniture was in danger of looking at home only in a museum. Reyner Banham developed this point in a witty and challenging article published in *New Society*. In it he considered 'Chairs as Art' and the way in which

'. . . previously unselfconscious and virtually invisible domestic items suddenly become great, monumental objects which demand attention, dusting and illustration in colour supplements.'[15]

[15] Banham 'Chairs as Art' *New Society* 20 April 1967, p 566.

Banham called this process 'furniturisation' and examined the preoccupation with form and cultural symbol over performance and human service. As enthusiastic about technology as ever, Banham prophesied that technology '. . . would probably bring furniture to an end, or at least render it invisible . . .' were designers not so obsessed with self-aggrandisement through the creation of objects aspiring to the status of art-works.[16] Banham called for a 'design as service' approach to seating: if designers questioned the function of chairs they would realise that chairs were used not only for sitting on but for a multitude of uses:

[16] ibid, p 566.

'. . . propping doors open or (in French farce) shut. They are used by cats, dogs and small children for sleeping on; by adults as shoe-rests for polishing or lace-tying; as stands for Karrikots and baby baths; as saw horses; as work benches for domestic trades as diverse as pea-shelling and wool winding; and as clothes hangers . . . as stepladders for fruit picking, hedge clipping, changing lamp bulbs and dusting cornices. And, above all, they are used as storage shelves for the masses of illustrated print that decorate our lives.'[17]

[17] ibid, p 568.

With undeniable logic Banham pointed out how:

> 'This failure to make provision for any of the functions of a chair except the least important one, being sat on, shows all too clearly how cultural habit prevails over technology. If rational inquiry were to prevail, it would show that chairs are simply detached units of a commonwealth of horizontal surface on which any number of objects, including the human fundament, can be parked.'[18]

Banham's provocative approach was not Functionalist but behaviourist, the former had never taken account of primary *and* secondary functions. Our cultural habits of thought, Banham continued, had led us to identify every function with a free-standing object to satisfy it. This 'infantile malady of design'[19] could be redressed by the provision of horizontal surfaces ranging from soft to hard. Even though the interior landscape was the most sensible functional solution, it was unlikely to be taken up on a wide scale because, he jibed, the occupant would be '. . . barely recognisable as a member of the decent, self-respecting human race'[20], and might even be branded a hippy! However flippant this remark it made the pertinent point that a particular style of design is almost invariably associated with a lifestyle or particular group.

Informal horizontal surfaces became fashionable at the end of the decade, and Max Clendinning forecast that 'Followed to its extreme, furniture would be a series of versatile, interchangeable, multi-purpose cushions.'[21] The furniture on display at European trade shows in 1968 had a common theme which José Manser described as

> '. . . a blatant invitation to relaxation and ease . . . From Italy, France, Scandinavia and Great Britain, the news is the same: chairs are to be lain in rather than sat upon, preferably *en masse*, but almost certainly *à deux*, and the lower the user's centre of gravity the better.'[22]

The message was clear: furniture was becoming less 'furniturised' and decidedly less Modernist in spirit. The new furniture, Manser concluded, '. . . defies earnestness and inspires gaiety'.[23]

Roger Dean was one of the designers at the forefront of this development. Four years before his 'Teddy Bear' chair and while he was still at art school, Roger Dean had designed the 'Sea Urchin' chair. In conscious opposition to the conventional method of designing a chair — analysing function which supposedly suggested a form — Dean said he '. . . started with a vague notion of a chair one could do anything with: one could sit in it in any position, and approach it from any direction.'[24] The 12-section polyurethane foam interior shaped a four-foot diameter dome to the sitter's posture by depression. The remainder of the foam formed a support for legs and arms. It could be either a recliner if approached from a high angle, or an upright chair if from a low one. When the 'Sea Urchin' appeared in the 'Prototype Furniture' exhibition at the Design Centre in 1967 the *Architects' Journal* commented that 'The service it provides is not so much support as symbiosis.'[25] Hille showed interest and undertook to produce the chair but were defeated by technical difficulties with the moulded foam.

[18] ibid, p 568.

[19] ibid, p 567.

[20] ibid, p 568.

[21] Clendinning quoted in anon 'Men Who Influence By Design' op cit, p 29.

[22] Manser 'Free-Form Furniture' *Design* December 1968, p 28.

[23] ibid, p 28.

[24] Dean 1975, p 13.

[25] anon 'Prototype Furniture' *Architects' Journal* 18 January 1967, p 215.

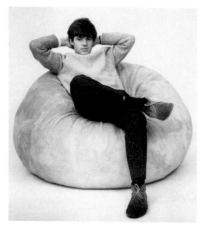

Roger Dean, Sea Urchin chair, 1967. A comparison with Stam's S33 chair (page 22) underlines the fact that Pop's attitudes, values and aesthetics were the reverse of those of Modernism.

DESIGN COUNCIL

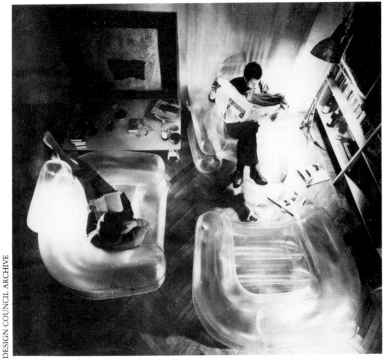

DESIGN COUNCIL ARCHIVE

Scolari, Lomazzi, D'Urbino and De Pas, Blow Chair, 1967. The Blow Chair, although one of the first and most successful inflatables, was conventional in form.

Of similar shape and associations to Dean's chair were 'sag-bags' or 'bean-bags'. These contained as many as 12 million plastic granules or polystyrene beads which adjusted to the shape of the body. The first, and one of the most stylish, was the 'Sacco' which weighed less than six kilos and was available in eight colours. It was designed by the Italian design team of Gatti, Paolini and Teodoro and sold for £33, but derivatives were widely available and relatively cheap. Despite their cheapness, 'sag-bags' were not bought by low-income groups in the late 1960s and early 1970s. One critic pointed out that these groups had been successfully conditioned by advertising and the media to feel that sag-bags were not 'proper' chairs. Because of their associations with fun and relaxation, sag-bags appealed to a specific market: the young and Pop.

There was also a craze among the young for large cushions which were covered in a variety of ways: elaborately decorated in cotton or quilted satin; with simple bold colours; or in a combination of patterns. They were widely available and stocked by shops such as Habitat. The popularity of these cushions was due to their association with informality and youthfulness, their cheapness, because they could be designed and made at home — 'sew-it-yourself-cushions' as one magazine feature advised.

Inflatable Furniture

A development of the Late Pop years in keeping with experimentation in furniture design was inflatable furniture. Inflatable furniture exhibited the characteristics of expendability, use of synthetic materials and associations with the space race. It was also suited to the Late Pop demands for flexibility, responsive-

ness and the soft environment. Furniture could be inflated when guests called and deflated and packed away when they had left, making better use of space. There had been isolated experiments in inflatable furniture in the 1950s and early 1960s. In 1962 Verner Panton had suggested transparent inflatable furniture because it adapted to different physiques and looked light and airy. In 1964 both Cedric Price and Arthur Quarmby had developed prototypes, but little more was produced until 1967 when furniture by the French architects, Aubert, Jungman and Stinco, and the Italian designers, Scolari, Lomazzi, d'Urbino and de Pas (who became well-known for their 'Blow' chair), became widely available. Quasar Khanh's inflatable furniture range, including chairs and a sofa, was also manufactured in transparent or coloured PVC shapes linked by metal rings. The shapes could be filled with air or with coloured gas or water. A firm called Ultra-lite imported Khanh's inflatables into Britain. The armchair initially sold for £28 but eventually cost £21 15/- (£21.75) when it was made in Britain under licence. By August 1968 Ultra-lite were producing 300 items a week. Khanh's other projects included an inflatable room, a transparent car, and an ambitious attempt to connect the PVC sofa to the heating system.

Shortly after Khanh introduced his range of furniture, Paul Woods designed a sofa (£16) and chair (£9) for Incadinc, a company that specialised in inflatable products. Woods' furniture was transparent, tinted blue or pink, or coloured red, white or blue. The chair was composed of several inflatable tubes or 'build-ups' secured by nylon nuts and bolts. It had a less boxy appearance than the Khanh chair. Additional tubes could be bolted on to change the shape

An inflatable at the Isle of Wight pop festival, 1970. The unsophisticated technology and do-it-yourself potential of low-pressure inflatables brought them into the centre of youth culture in the late 1960s.

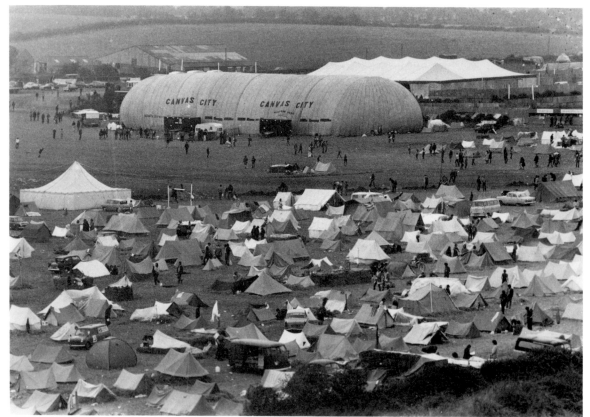

of the furniture and the whole floor could become an inflatable area. Incadinc also produced an inflatable 'Air Chair' (sometimes called the 'Pumpadinc') made from polished PVC laminates in see-through purple, red, dark blue and white. The 'Air Chair' was a circular bowl, 24 inches high at the back, 18 inches at the front and 38 inches in diameter. It sold for £6 19/6d (£6.97½p), the same price as a blue-tinted translucent chair made by Pakamac. A matching stool was £3 19/6d (£3.97½p). By the summer of 1968 'Habitat' were selling an imported inflatable chair in red, white, yellow or blue for £3 15/- (£3.75), and a firm called 'X-Lon' were making 'inflatable pop cushions'.

The fragility of inflatable furniture was often exaggerated. If items were kept away from intense heat, sharp objects and hot cigarette ends, they could survive the rigours of everyday living. A puncture could be repaired with a PVC patch and glue, usually provided with the furniture. A more common fault that continually taxed designers and manufacturers was the rupturing of the seams.

One reason for the popularity of PVC furniture with the young was its relative cheapness, as Margaret Duckett indicated in 1968 when reviewing the available PVC furniture:

'The boom in blow-up PVC furniture this year has made its mark mainly as a cheap way to substitute orthodox upholstery with free air. An inflatable sofa for £20 cuts the average price of a conventional sofa by at least £40 to £50.'[26]

26 Duckett 'Sitting On Air' *Telegraph Magazine* 23 August 1968, p 29.

Inflatable furniture was also novel and fashionable, although the shapes of many of the items were traditional. Khanh's design was little more than an air-filled copy of a three piece suit and Duckett, without irony, approved that they '. . . blend well with Georgian proportions'. *Design* thought many of the shapes were traditional and unadventurous because inflatable furniture was at an early stage of development and until the novelty wore off there would be little improvement. But inflatables never lost their Pop connotations of youthfulness and fashionableness: one advert for a vinyl inflatable chair referred to its 'space-age comfort'; the break with the conventions of permanency and sturdiness kept inflatables firmly within the Pop orbit — genuine examples of Late Pop products.

Inflatables and the Late Pop Sensibility

A major exhibition of inflatable structures held at the *Musée d'Art Moderne* in Paris in early 1968 demonstrated that inflatable furniture was part of a far wider movement which included large-scale structures and exhibition halls, temporary hospitals, supports for broken limbs, water barrages and boats, as well as the more common examples of mattresses, beach balls and disposable novelties. Although pneumatic structures dated back to the First World War, the difference in the 1960s, wrote Reyner Banham in 1968, was the

'. . . confluence between changing taste and advances in plastic technology. The taste that has been turned off by the regular rectangular format of official modern architecture . . . is turned right on by the apparent do-it-yourself potentialities of low pressure inflatable technology.'[27]

27 Banham 'Monumental Windbags' *New Society* 18 April 1968, p 569.

Low-pressure inflatables were easy to manufacture and maintain, they remained inflated by the sheer volume of air rather than its pressure. A change in pressure in a high-pressure inflatable could be drastic, whereas the opening and closing of a 'door' in a low-pressure inflatable was not a problem because only a small volume of air was lost. Low-pressure inflatables offered far more potential in terms of low technology: a domestic vacuum cleaner, with its suction process reversed, was the only hardware necessary to keep the structure inflated.

Inflatables appealed to the architectural avant garde because, according to *Architectural Design*:

> 'The potential of pneumatics as instant variable volume packages capable of providing high control and response to demands, could realise the concept of nomadic existence as elements within a kit of other high amenity systems . . . jet packs, hoverdeck air-floor, cybernet, energy sponge, power-pack, exosteleton . . . and cheese spread. Hard and soft utilities for the developing nomad.'[28]

[28] anon 'Pnue World' *Architectural Design* June 1968, p 271.

Inflatables held the promise of an *architecture autre* for the 21st century. Archigram had made use of inflatables in their projects since 1964, and by 1966 they were proposing inflatable walls, furniture, and floors. In his 1968 'Suitaloon' project, Mike Webb proposed spacesuit-like clothing that could be inflated into a small enclosure which, when connected to a buggy, could roam around the back garden or the globe. The potential of inflatables seemed infinite and Archigram's enthusiasm was contagious. The student magazine *Clip-Kit* recommended inflatables to all architects and designers interested in new ideas because, 'Blow-ups are flexible, light and cheap — they are happening and are fast moving from the tentmaker and futurist's vocabulary into the architect's.' Architectural Association students produced an inflatable camper's pack measuring $2'3'' \times 2' \times 1'$ which included a plastic dome, a pressurised water tank, ventilation, heating, cooling, washing, cookery and waste-disposal services, an inflatable floor and cleaning equipment.

The inflatable's lack of tautness gave a characteristic responsiveness, of which Banham wrote:

> '. . . a state of active homeostasis, trimming, adjusting and taking up strains, [it] is malfunctioning if it *doesn't* squirm and creak. As an adjustable and largely self-regulating membrane it is more truly like the skin of a living creature than the metaphorical "skin" of, say, a glass-walled office block.'[29]

[29] Banham 'Monumental Windbags' op cit, p 570.

Banham's description is significant for three reasons: it extended the meaning and scope of responsiveness which was so important in the Late-Pop period; it is indicative of the low technology emphasis of the late 1960s; and it is symptomatic of the growing interest in the zoomorphic or organic.

Some of the claims made for pneumatic structures were, inflated out of all proportion. Arthur Quarmby, an architect respected for his open-minded approach to new ideas and materials and author of a major book on plastics, made a virtually impossible claim:

> 'I believe that pneumatics are the most important discovery ever made in architecture, that they can free the constraints which have

bounded it since history began and that they can in consequence play an immeasurable part in the development of our society.'[30]

[30] Quarmby 1974, p 114.

Nevertheless the absorption of inflatables into the mainstream of architectural vocabulary was hastened by the range and sophistication of pneumatic structures on show at 'Expo 67' in Montreal and 'Expo 70' in Osaka. In the mid to late 1970s, success with technical and material problems and a receding energy crisis enabled the rapid development of high-pressure pneumatic structures, and low-pressure inflatables became the property of travelling groups like ERG and rural hippies. However, in the late 1960s inflatables answered the quest for a responsive, adaptable, soft, do-it-yourself and, if necessary, expendable environment. Low-pressure inflatables, both actually and symbolically, could be unadulterated Pop.

Two projects encapsulate the pre-occupations in interior and environmental design of the Late-Pop period. 'Barbarella' (France/Italy 1967), Roger Vadim's film of the cult science-fiction comic strip, captured the mood of late 1960s experimental interior design. Jane Fonda starred as Barbarella, the beautiful 40th-century astronaut whose adventures took her through strange landscapes and brought her into contact with even stranger peoples. The interior of Barbarella's rocket was a series of surfaces hard enough to walk on, soft enough to lie on and uniformly covered in fur except for her inflatable transparent plastic bed. The hardware was concealed. Barbarella journeyed to the wicked city of Sogo which was constructed of pneumatic domes and soft interiors. In one scene Barbarella is captured and tortured in an 'Excessive Machine' which is supposed to kill the victim with pleasure (a machine which obviously belonged in a fun palace). Throughout the film the hardware invariably breaks down and software triumphs. Banham described Barbarella as the '. . . first post-hardware SF movie of any consequence',[31] and comparisons were made with Stanley Kubrick's '2001:A Space Odyssey' (GB 1968), a film in the science-fiction hardware tradition. '2001' was seen by some designers as a warning of how the environment would look if Modernists were left in charge.

[31] Banham 'Triumph of Software' *New Society* 31 October 1968, p 629.

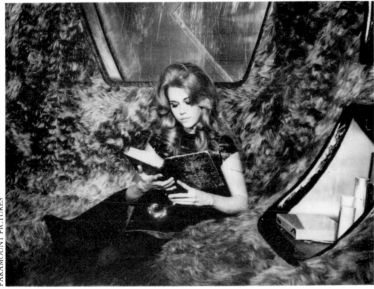

PARAMOUNT PICTURES

Jane Fonda as Barbarella, 1967. Barbarella's rocket interior was a fur-lined interior landscape, the reverse of normal science-fiction conventions.

Archigram and Instant Cities

Archigram's major project at the end of the 1960s brought together a number of their ideas including their exhibition experiments, the responsive environment and metamorphosis. The 'Instant City' was, in Cook's words,

> '. . . an assembly of instantly mounted enclosures, together with electronic sound, and display equipment that could be used to tour major provincial towns, and thereby inject into them a high intensity boost that would be sustained by the slow development of a national communications and information network that would advertise and relay further events and entertainments.'[32]

Some members of the Archigram team had been born and/or had lived part of their lives in provincial towns (Cook in Southend and Crompton in Blackpool, for example), and admitted to a feeling of '. . . being left out of things.' The 'Instant City' would rectify this.

The essential kit of hardware comprised audio-visual display systems, projection television, trailered units, pneumatic and lightweighted structures and entertainment facilities, exhibits, gantries and electric lights. However, as facilities would be tailor-made for the location '. . . there is no perfect set of components'. But as Archigram's desire was for '. . . a replacement to architecture that (for once) responds environmentally to the individual', the town and its people would be more important than the hardware.

> 'Events, displays and education programmes are partly supplied by the local community and partly by the "City" agency. In addition major use is made of local fringe elements: fares, festivals, markets, societies, with trailers, stalls, displays and personnel accumulating often on an ad hoc basis. The event of the Instant City might be a bringing together of events that would otherwise occur separately in the district.'[33]

Archigram illustrated an 'Instant City' visit to a typical English town and made studies of particular locations including Bournemouth and St Helens by gathering information about facilities such as clubs, local radio and universities in the area. A later version of the project used airships as giant 'skyhooks' to drop servicing elements, tents and other paraphernalia. The airship could also be seen as a 'megastructure of the skies'.

As well as providing a vehicle for Archigram's ideas, Cook acknowledged 'Instant City' to be a response to those Underground and 'alternative culture' events that

> '. . . have been going on under our nose: Hyde Park, Woodstock EVR, street theatre, control by tenants, rehabilitation rather than rebuilding, the Airship as an opportunity lost, simpler scaffolding, boredom with light shows, people sitting under flags, telex, Emerson making Bach and Dylan part of the same counterpoint. . . .'[34]

Outdoor Pop festivals were a phenomenon of the late 1960s. The most famous was the 'three days of peace and love' that attracted nearly half a million people

[32] Cook, Herron and Crompton 'Instant City' *Architectural Design* May 1969, p 277.

[33] Cook 1972, p 89.

[34] Cook and Herron 'Instant City' *Architectural Design* November 1970, p 567.

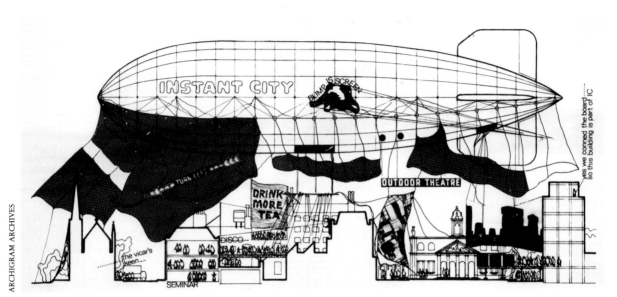

ARCHIGRAM ARCHIVES

to Woodstock in America in August 1969. In the same year in Britain, a quarter of a million people came to the Hyde Park open air concert, and an estimated 150 000 people attended the Isle of Wight pop festival, which was dubbed by the organiser the 'Electronic Inflatable City'. The following summer Cedric Price was commissioned to design facilities for 'Phun City', a site four miles from Worthing for a three-day festival.

However, the physical facilities of these outdoor Pop festivals were woefully inadequate when compared with Archigram's sophisticated ideas. It was social and not environmental factors that accounted for the success of the Pop festivals. The stage and performance areas may have looked like part of Archigram's vision, but the overall appearance of the tents, shelters and stalls resembled a shanty town which was not a perfect place to live. Nonetheless, the idea of unpopulated green fields becoming a community in a matter of days, and then returning to green (or muddy) fields in a similar amount of time gave Archigram confidence in the basic premise of the 'Instant City'. The 'Instant City' was Archigram's last project to retain the appearance and imagery of Pop.

Archigram's immediate influence could be seen in the recreational centres and 'fun palaces' where the 'fun' content of the group's work was acceptable and commercially viable. In Tokyo, Minory Mutakami's 'Summerland' completed in 1967, made use of advanced technology and visual gimmicks — a wave machine, water sprays, tropical palms, artificial breezes and intentionally temporary decoration — to provide a fantasy environment. In Britain, projects for Whitley Bay, Margate and Girvan followed the 'Summerland' example. The Whitley Bay 'pyramid' was described by the designers, Gillinson Barnett and partners, as a 'living internal landscape' which would include wrecks, rocks and shoals of fish as well as a wave machine. The design of Keith Albarn's 'Dreamland' fun-house at Margate had been influenced by Archigram's interest in audience participation, and his 'Fifth Dimension' fun palace, built at Girvan in 1969, was also inspired by their work '. . . with patterns of light, colour and sound; walls are lined with exotic "feelies" and floors have a habit of changing, suddenly and without warning, from hard concrete to soft sponge.'[35]

Archigram Instant City, 1969. Archigram viewed Instant City as '. . . a replacement to architecture that (for once) responds environmentally to the individual . . .'.

[35] Alastair Best 'Funny Business at the Seaside' *Design* November 1969, p 58.

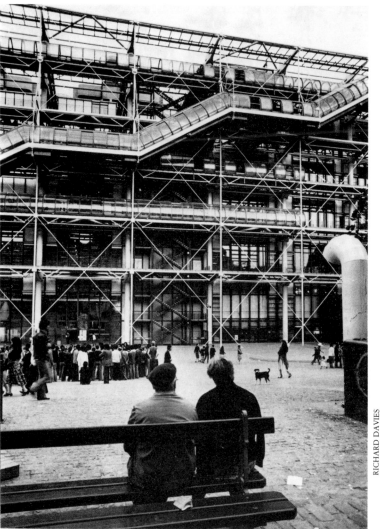

RICHARD DAVIES

Piano and Rogers, Pompidou Centre, 1971-7. The Centre is a popular and successful building which conceptually and visually is indebted to the work of Cedric Price and Archigram.

Pop Buildings and Pop Cities

But there is one building in particular that stands out as a perfect example of Pop architecture. In 1971 Renzo Piano and Richard Rogers won the competition for the Paris Pompidou Centre. The brief was for a cultural centre comprising a museum of modern art, a reference library, a centre of industrial design, a centre for music and acoustic research, and service facilities. The architects' proposal was modified and eventually completed in January 1977. The Pompidou Centre is a visual extravaganza of external coloured service ducts, equally brightly coloured service machinery and transparent tubular pedestrian escalators. The floors are permanently fixed but the internal walls are designed as changeable partitions to allow spaces to be altered according to need. It recalls images of Cedric Price's 'Fun Palace' and Archigram's 'Plug-in City', and Rogers has referred to the Centre as a 'fun palace', an environment for *Homo ludens*. The Centre's popularity would seem to contradict the claim that Pop architecture is necessarily inhumane and alienating.

If 'real' Pop architecture was possible, why not a Pop city? In 1968 Pop architects and designers realised that such a city may already exist: Las Vegas was the Pop *ville trouvée*. Tom Wolfe had been the first to draw attention to Las Vegas as worthy of the consideration of architects in his celebrated essay included in *The Kandy-Kolored Tangerine Flake Streamline Baby*. The author pointed out that Las Vegas and Versailles were the only two architecturally uniform cities in Western history: Versailles because it had been planned by a despot, and Las Vegas because it was

> '. . . the only town in the world whose skyline is made up neither of buildings, like New York, nor of trees . . . but signs. One can look at Las Vegas from a mile away on Route 91 and see no buildings, no trees, only signs. But such signs!'[36]

36 Wolfe 1965, p 18.

Wolfe described a typical Las Vegas sign:

> 'Each letter of BUICK is on a baroque rocket . . . the lights work in a series . . . In phase 2 the rockets light up orange and yellow. . . . They shoot off red jet flames. . . . They take off to the left. . . . A terrific rush of light shoots up the main stem there, the big parabola. . . . It explodes in the crazed atomic nucleus at the top. . . . The sign is 105 feet tall, 11 storeys up in the air, in other words . . . It's insane! It's marvellous!'[37]

37 Wolfe 'The New Life Out There' *Telegraph Magazine* 16 May 1969, p 8.

Las Vegas was an example of an environment that did not rely on architectural hardware but on large signs and electricity. Reyner Banham argued that Las Vegas was relevant because it provided an example

> '. . . of how far environmental technology can be drawn beyond the confines of architectural practice by designers who (for worse or better) are not inhibited by the traditions of architectonic culture, training and taste.'[38]

38 Banham 1969, pp 269-70.

With the publication in 1972 of Robert Venturi's *Learning from Las Vegas*, the interest in Las Vegas changed from a concern with environmental technology to architectural semiotics: 'Las Vegas . . . as a phenomena [sic] of architectural communication.'[39]

39 Venturi 1972, p 1.

The origins of the interest in the semiology of architecture and design can be traced back both to the information theory course run by Tomas Maldonado at the Hochschule für Gestaltung in Ulm between 1957 and 1960, and Roland Barthes' writings in 1956 and 1957. The 1970 publication of Charles Jencks and George Baird's *Meaning in Architecture* signified that the first stage of architectural Post-Modernism — a stage which had grown out of Pop — was underway.

When he had been writing about Las Vegas signs, Tom Wolfe had pinpointed a further characteristic of the American environment appropriate to the Pop sensibility. He described how the signs were built not

> '. . . to catch the eye of the art world but of people driving by in cars. . . . It's as simple as that. . . . A very liberating thing, the car.

40 Wolfe 'The New Life Out There' op cit, p 9.

. . . Millions of Americans roaring down the strips and boulevards and strips and freeways in 327 horsepower family car dreamboat fantasy creations.'[40]

This Futurist imagery emphasised the changing and dynamic mobile environment rather than static form. Both Alloway, in 1959, and Price, in 1962, had praised Los Angeles for its anti-monumental character. And this city reached the peak of its influence on Pop architects and critics in 1968 with a series of four radio broadcasts by Reyner Banham and a worshipful article by Warren Chalk in *Architectural Design*, in which Los Angeles was described as '. . . an ephemeral experience of low key or non-architectural situations that have to be seen to be believed, lived in to be understood.'[41]

41 Chalk 'Up the Down Ramp' *Architectural Design* September 1969, p 404.

The extent to which the ideas of the architectural avant garde were filtering into the mainstream can be gauged by the concept and plan for Milton Keynes New Town, designated in 1967. Lord Llewelyn Davies, the chief planner, described the plan as 'a modified Los Angeles system.'[42] The car was actively welcomed as providing 'freedom of choice and opportunity' and the six goals of the plan were described in the following order:

42 Llewelyn-Davies quoted in Reyner Banham 'The Open City and its Enemies' *The Listener* 23 September 1976, p 359.

1 opportunity and freedom of choice
2 easy movement and access, and good communications
3 balance and variety
4 an attractive city
5 public awareness and participation
6 efficient and imaginative use of resources.[43]

43 Milton Keynes Development Corporation *The Plan for Milton Keynes* volume 1, 1970, p xi.

The priority of these goals and the vocabulary used indicate a more liberal outlook than any previous New Town had enjoyed, and one that would have been unthinkable before the 1960s Pop and 'architecture as service' movements.

Beyond Pop Architecture

But, by the time their ideas were absorbed into the mainstream, Pop's practitioners had either moved on or been rejected as reactionary by the radical and politicised young. In the case of Archigram, rejection and new developments coincided. In 1969, a writer in *Architectural Design* equated:

'The downward trend of the human spiritual condition with the advancement of technology. . . . System builders, throw-away utopians and plug-in idealisers will continue the trend to a worsening environment until man has to resort to artificial stimulants. . . . Is Archigram's Plug-in city in fact Drug-in city?'[44]

44 Peter Hodgkinson 'Drug-in City' *Architectural Design* November 1969, p 586.

Throughout the period when it was heavily criticised, Archigram retained their belief in high-technology solutions. Chalk spoke for the whole group when he acknowledged the contemporary concern with ecological problems, but he warned that if '. . . we are to prevent eco-catastrophe it can only be done by more sophisticated environmental systems, not by dropping out. Nor the hippie-type philosophy.'[45] The young were not convinced and no longer looked towards Archigram for a lead.

45 Chalk 'Touch Not' in Cook 1972, p 138.

But by 1970 Archigram had left behind the imagery of Pop. It was only in retrospect that Cook realised the full implications of Archigram's later projects

> '. . . it was fashionable to introduce a project as an "anti-building", or a "non-building", or a "conglomeration of environmental elements". What was missed at the time was its discussion as a piece of *conceptual* architecture: as a discussion of values and sequences totally *detached* from three-dimensional implications.'[46]

[46] Cook 'The Electric Decade' in Gowan 1975, p 142.

Pop art had been replaced by conceptual art at the end of the decade, a situation that was paralleled in avant-garde experimental architecture. In 1970 *Design Quarterly* devoted a special double issue to 'conceptual architecture.' In his notes towards its definition, editor Peter Eisenman argued that conceptual architecture — although it defied precise definition — was fundamentally different from Pop, which was always in some way related to youthfulness and fun. Pop was over and, as if to confirm the point, Archigram broke up in 1973.

Conceptual architecture was an esoteric offshoot of Pop and of limited interest to the radical young. Of far wider importance and lasting significance was the growth of the 'responsible' attitude to design, which was outlined in the writings and characterised in the designs of Victor Papanek. Papanek argued that designers should establish their priorities and use their abilities to design for underdeveloped areas, the handicapped, the disabled and the disadvantaged. The prevailing situation in design was analogous to 90% of doctors choosing to work in cosmetic surgery, which could be seen as an abuse of resources and talent. Papanek's *Design for the Real World*, first published in America in 1971, became the Bible of the responsible design movement. Students who only four years ago were designing plug-in cities now concentrated their efforts on responsible environments, such as portable hospitals and emergency housing for Third World countries. Design as service was re-interpreted as design as social service. Fuller and Price were discovered by a new generation of students.

Advanced technology was now rejected by the radicals as a symptom of a capitalist society and a cause of exploitation and suffering. In 1967 the hippies 'returned to nature', and the *Torrey Canyon* disaster resulted in a sharp rise of interest in ecological issues. The leader in the *New Scientist* in August 1969 proclaimed that 'Ecology is in', the *Ecologist* warned of industrial and social catastrophes unless action was taken on their *Blueprint for Survival*, and conferences on the Human Environment concluded there was *Only One Earth*. Recycling and secondary use was put forward by the Friends of the Earth as a strategy for the future. Houses could be made from waste, and bottles could be designed to be used as house-bricks instead of being destroyed.

A London-based group called the 'Street Farmers', invented what they called 'guerilla architecture' — a mixture of activism and ecological thinking — and built a 'Street Farm House' which tested out principles of energy conservation and recycling. Hippy 'do-it-yourself' communities, principally Drop City and Libre in the United States, received much attention and praise. These communities eschewed traditional forms of architecture because they were compartmentalised, '. . . blocking man from man, man from the

universe, man from himself.' Echoing Frank Lloyd Wright, the hippies wanted their homes '. . . to spring from the soil like trees.' The preferred forms were Fuller-inspired, not only for structural and constructional reasons, but because 'To live in a dome is — psychologically — to be in closer harmony with natural structures.'[47] As if to underline their rejection of contemporary society, the homes were constructed from the debris and obsolescent technology of the consumer society they rejected.

Student magazines and architectural journals reported and illustrated the temporary shelters of the world's underprivileged or outcast groups. The immediacy, flexibility, adaptability and degree of direct involvement in making such shelters appealed to Western architectural activists. The *barriada* movement in Peru attracted special attention, but there were warnings against this elevation of the squatter or itinerant to the heights of a noble savage.

The radicals felt they needed access to means and tools, and the publication of books such as the *Whole Earth Catalog* which ran to numerous editions in the 1970s partly supplied the answer to this need. These books and manuals gave information on the how, why and wherefore of do-it-yourself construction. *Domebooks* and *Survival Scrapbooks* on shelter and food were published soon after. In the 1970s technology became radical, soft, alternative or appropriate, and small was beautiful. The age of Pop had passed.

47 Bill Voyd 'Funk Architecture' in Oliver 1969, p 158.

Late Pop Fashion

In the more immediate and fast-changing areas of fashion and graphics, the decline of Pop was more abrupt. The multi-coloured kaleidoscope appearance and disappearance of forms, patterns and colours in clothing continued in 1967 and 1968. Fashion magazines referred to Pop fashion as a '. . . do-it-yourself business, with no dictatorship by fashion tyrants', they announced that '. . . individuality predominates, experiment is the pulse', and described the mood as one of 'rampant individualism'. The *Tailor and Cutter*, bemoaned the loss of seasonal fashion developments that Pop had overthrown, 'Currently the world of fashion is one of utter confusion . . . there is every kind of look.'

Shops such as 'Granny Takes A Trip' ('. . . run by bizarre eccentrics for bizarre eccentrics') catered for this individualism and provided a varied selection of both new and second-hand clothes including 1920s charleston dresses, Victorian bustles, Boer-war helmets, African fezes, Arab head-dresses, Chicago gangster suits, military uniforms, mini skirts, Op shirts, gold-rimmed sunglasses, floral ties, velveteen breeches, yellow suede jackets and pink PVC dresses. Customers included The Rolling Stones and The Beatles, and the market was sufficiently large to create an upsurge of this type of shop in Carnaby Street. The amount of money spent on clothes was staggering. In 1967 one member of a pop group boasted that 80% of his weekly income was spent on clothes: 'No I'm not exaggerating. We artists get out clothes tax free, which is right since they build our image.' A major Pop group such as The Who were reported to spend £150 a week each on clothes which meant that shop owners like John Stephen, who was well established in Carnaby Street, were able to expand rapidly. Stephen opened 15 shops elsewhere in Britain, 21 in Europe and 24 in America. Even the female Pop fan was estimated to spend between £6 and £7 of her average weekly wage of £10–15 on clothes and accessories.

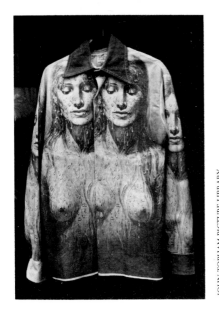

Shirt from I was Lord Kitchener's Valet, 1968. An example of a garment that seems to have been influenced by the paintings of Tretchikoff.

JOHN TOPHAM PICTURE LIBRARY

Pop fashions of 1967 and 1968 were exotic, flamboyant, decorative and colourful. 'Bright colours', declared one magazine, 'express the spontaneity of today.' Visual sources as diverse as Wyndham Lewis' Vorticist paintings, African prints, Oriental, Mexican and Red Indian textiles, canal-boat decoration, and Eastern European gypsy and peasant clothes were used. The influence of hippy clothing spread, resulting in bolder combinations of colours and shapes. Hippy clothes, mass produced and toned down for high-street boutiques, acquired conventional features that made them more respectable: suits were made with crude stylised floral patterns; and there were flowered shirts with matching ties.

The Beatles' pseudo-military clothes on the cover of 'Sgt Pepper' started a craze for authentic regimental uniforms and clothes, and during 1967 a shop specialising in old regimental uniforms called 'I was Lord Kitchener's Valet' opened in Portobello Road. The appeal of uniforms was due not only to their colour, decoration and extravagant detail, but also to their campness. The essence of camp, as outlined by Susan Sontag in 1964[48], is its love of the unnatural, of theatricality, of artifice and exaggeration. Pop, with its dislike of seriousness, horror of heroic statements and love of debunking was a natural home for camp. On television, the increasingly camp humour of 'The Avengers' made it a cult programme and was outdone only by the 'Batman' series of 1966–67. The older generation did not understand camp, and the wearing of uniforms was considered to be an insult to Queen and Country. A similar reaction occurred when Pete Townshend of The Who wore a jacket made from a Union Jack. Most of the critics missed the point of the fashion for regimental uniforms: the *Tailor and Cutter* thought it must be a psychological outlet for national service, and the *Observer* magazine wondered if there was a sinister subconscious side to dressing up to kill.

In women's fashion, the mini rose to new heights in 1967 and became known as the 'micro' — a length that was little more than a gesture towards the idea of a skirt. If there were any doubts over the implication of the micro, Mary Quant dispelled them:

'The erogenous zone of our present fashion period is the crutch. This is a very balanced generation and clothes are designed to lead the eye naturally to the crutch. The way girls model clothes, the way they sit, sprawl or stand is all doing the same thing. She is standing there defiantly with her legs apart saying "I'm very sexy, I enjoy sex, I feel provocative, but, you are going to have a job to get me." Modern clothes . . . indicate that women are in charge of their sexual lives.'[49]

The micro was clearly a socio-sexual statement but, like other supposed signs of liberation before it, double-edged.

From 1967 to 1969 there were annual autumn predictions that the mini would not survive the winter, but such utilitarian attitudes towards fashion overlooked the more important functions of clothing. The maxi became fashionable at the end of the decade but it did not eclipse the mini. To cope with winter temperatures the mini skirt was worn under a maxi coat; other solutions to exposure (of both kinds) were trousers worn under mini skirts, the mini made into culottes which kept the line and appearance of the skirt, and 'hot pants' — brief shorts which were introduced by Quant in 1969.

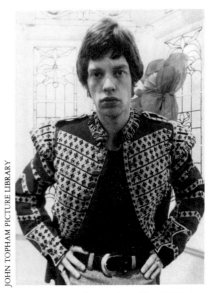

JOHN TOPHAM PICTURE LIBRARY

Mick Jagger in military-style clothing, 1967. As well as its ability to shock, pseudo-military clothing was prized for its bright colour and extravagant detail.

[48] Susan Sontag 'Notes on Camp' *The Partisan Review* 1964, pp 514-30.

[49] Quant quoted in Drusilla Beyfus 'Undressing in Public' *Telegraph Magazine* 8 August 1969, p 21.

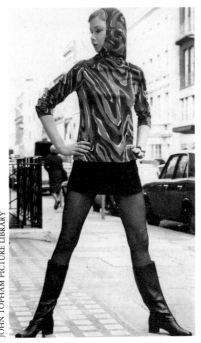

JOHN TOPHAM PICTURE LIBRARY

The micro skirt: the mini at the furthest point of its evolutionary process.

A shop assistant wearing a chiffon wrap-over see-through top in the Lady Jane boutique in Carnaby Street, 1968. The vogue for see-through tops was hailed as either a sign of liberation or a symptom of exploitation.

BBC HULTON PICTURE LIBRARY

Another significant fashion was the see-through top which received much media attention in 1968 and 1969. Interpretations of the see-through, like interpretation of the topless, tended to polarise: it was seen as a gesture of liberation by some, or as a fashion to please men by others. In an article in 1968, Dr Catherine Storr discussed the implications of the fashion, and predicted that the women who wore see-through tops would be those with 'small, firm breasts, the virginal, the under-developed . . . the women who because of their youth or their physical build don't need the support of a bra.'[50] This would, she regretted, reinforce men's ideas of female stereotypes. Germaine Greer urged women of all ages, shapes and sizes to wear see-through fashions or go bra-less in order to wean men from their notions of 'pin-up' perfection. Feminists were beginning to question the underlying rules of the game. Storr suggested several reasons why the see-through look came into fashion when it did: it was a sexual gesture; a reaction to unisex; an 'impulse to strip emotionally, to bare our psyches'; and finally it was part of a return to nature.

Underwear design throughout the 1960s was a reaction to the restricting and unnatural shapes of the earlier decades. In 1965 Rudi Gernreich, the inventor of the topless swimsuit, brought out the 'no-bra' which did not have wire and so was breast- rather than bra-shaped. The aim of the new underwear was to be invisible and accomodate 'ease and free movement'.

From 1966 to the end of the decade there was a trend for what Angela Carter described as 'Rousseauesque naturalism' and the image of naturalness.[51] Mary Quant began to manufacture cosmetics that gave a 'natural look'. Quant's 'Skinsaver', the 'ultimate natural cosmetic', consisted of a moisturising cream and a box of vitamin pills. Artificial was being rejected for natural. Exposure of the body was now to do more with being natural than erotic. And a fashion for softer, more romantic materials, such as chiffon, replaced obviously synthetic materials, such as PVC.

The End of Pop Fashion

[50] Storr 'The Logic of See-Through' *Nova* April 1968, p 65.

[51] Carter 'The Wound in the Face' *New Society* 24 April 1975, p 214.

By 1969 *Vogue* was proclaiming: 'In fashion, the revolution is over. A new quiet reigns.' And the *Tailor and Cutter* rejoiced in the fact that: 'It can be assumed with some certainty that the phenomenon of Carnaby Street, in its original context, is ended — at least as a noticeable social force.'

At the end of the decade not only Pop fashion but the very idea of fashion itself was rejected. Some pronounced it wrong (or perhaps it was only unfashionable) to be interested in superficial things like clothes. One fashion writer commented that even permissive people want to be serious '. . . but their clothes get in the way. We've had 10 years of frivolity, and now it's time to move on to something new.' Some fashion designers pronounced themselves to be jaded with fashion. Mary Quant thought that 'anti-fashion' came into being as part of the '. . . general self-criticism, depression, anti-materialism and guilt' that characterised the end of the 1960s and early 1970s.[52]

[52] Quant quoted in Peacock 1977 foreword.

'Anti-fashion'

'Anti-fashion' was especially popular with student groups who donned blue-denim jeans and plain or self-coloured T-shirts. This unofficial uniform was, as one committed wearer -cplained, '. . . a deliberate rejection of the neon colours

and artificial, plastic-coated look of the affluent society.' To the socially and politically conscious, the clothes signified egalitarianism and solidarity with the working class underprivileged. The symbolism of denim jeans derived from their origins. Prospecting miners in the Gold Rush of 1849 used denim to make tents until (the other) Levi Strauss used the material to make long-lasting trousers. Denim was also associated with cowboys and their romanticised root-less life. It was worn extensively by manual workers and, because it was cheap, by underprivileged groups. Denim trousers started to become fashionable when worn by the hard-living character played by Marlon Brando in two influential films, 'The Men' (US 1950) and 'A Streetcar Named Desire' (US 1952). These associations contributed to the popularity of denim jeans with youth groups. Their street credibility increased when they were worn by 'politically conscious' folk singers such as Bob Dylan and Donovan, in 1964 and 1965. By 1965 denim was being described as the 'factory fabric which has got itself a fashion tag'. Not only unisex jeans, but suits and skirts were manufactured in denim, and the craze for Wild West fashions in 1965 helped spread the material's popularity. Pop groups such as Status Quo, who had worn psychedelic clothes in 1967, made denim their hallmark by the turn of the decade. The other half of the 'anti-fashion' uniform, the T-shirt, had similar humble associations and origins. It had started as a vest or work shirt but had become fashionable when Brando sported his T-shirt in 'A Streetcar Named Desire'.

'Anti-fashion' went up-market and appeared as Tom Wolfe's 'Funky Chic'.[53] Jeans were tailored, named after famous designers and became high fashion. 'Anti-fashion' was also adopted by the skinheads in 1969. Skinheads were working class and they toughened the 'anti-fashion' image until it was hard and brutal. Their hair was either chopped off or shaved down to stubble. Shirts were skin-tight and gave the impression that they were too small. Trousers, held up by braces, came down only as far as the ankle. Army-surplus lace-up boots with reinforced toes were used offensively. The original skin-heads' life of violence was a cynical reaction to the hippies' nebulous ideas of love, peace and classlessness. The skinheads' image was not created without visual discrimination: particular makes of clothing — 'Crombie' overcoats, 'Ben Sherman' or 'Jaytex' shirts, 'Levi' jeans, 'Sta-Prest' trousers, and 'Doctor Marten' boots — were favoured for the 'right' look of ugliness.

Although 'anti-fashion' was partly a reaction to Pop fashion, with the exceptions of the 'funky chic' and skinhead ends of the spectrum, it displayed several of Pop's characteristics: it was popular, low cost, mass produced, aimed at youth, and could occasionally be sexy. However, it did lack one of the most important characteristics — a sense of humour.

The skinhead's image — an unequivocal statement of disaffection and violence — was associated with visual ugliness and social brutality.

[53] see Wolfe 1976 (1977 edition), pp 174-90.

The Sloganised T-shirt — A Pop Remnant

There was one type of T-shirt which could unreservedly qualify as Pop fashion: the sloganised T-shirt. They had been available throughout the 1960s and were printed with decorative designs including flags and targets. T-shirts sporting the names of well-known products, such as 'Coca-Cola', celebrities like Monroe and Che Guevara or Pop groups were popular, low cost, mass produced and fashion-able. In 1966, the year of the football World Cup final in London, T-shirt sales boomed: the official England mascot, 'World Cup Willie', was seen throughout the summer on numerous chests. Other popular images were

At times the sloganised T-shirt replaced the 'old school tie' as the sartorial standard-bearer of identity and membership.

London place names such as 'Carnaby Street' and 'Trafalgar Square' reproduced as *trompe l'oeil* name plaques. In 1967 hippies took to T-shirts, using esoteric images to communicate membership of their Underground.

Sloganed T-shirts could be worn like temporary tattoos proclaiming the latest idol or craze, whether serious or for fun. But their messages could be taken on two levels. There was the literal message of 'Long Live Che' for instance, but the wearer was likely to contradict this the next day by wearing an 'I love America' T-shirt. The more important message was the implicit one of 'fashion is fun'. Whereas the 'anti-fashion' T-shirt lacked Pop's up-to-dateness, the sloganed T-shirt could be witty, gimmicky — and sometimes sexy — as well as popular, expendable, low cost and mass produced. However, unlike most Pop fashions, it could be worn by people of all ages.

Late Pop Graphic Design

In graphic design, the LP cover became the most creative outlet for the Pop style. The Beatles' 'Sgt Pepper's Lonely Hearts Club Band' (June 1967) was a landmark in cover design. It was one of the first 'gatefold' designs, a format that opens up like a book cover thereby doubling the amount of space the graphic designer has at his disposal. An unusual addition was a card sheet in a pocket in the cover containing printed badges, a false moustache, a picture card, sergeant's stripes, and a stand-up photograph of The Beatles decked out as Sgt Pepper's band. The graphics of the cover were a mixture of Victorian camp and Pop art, fully consistent with the style of its designer, Peter Blake — with a little help from his then wife, Jann Haworth — and with it a further link between Pop Art and Pop graphic design was forged.

Pop art, Symbolism and Surrealism were three clearly discernible trends in record cover design in the late 1960s. Andy Warhol's cover for the 'Velvet Underground' LP (1967) displayed multiple images of lips and a Coca-Cola bottle. For another LP cover by the same group, Warhol designed a poorly

printed yellow banana which, on some copies of the record, could be peeled off to reveal an equally poorly printed pink banana. The cover of the 1969 Pete Brown and the Battered Ornament LP, 'A Meal You Can Shake Hands With in the Dark', designed by Underground artist Mal Dean, was influenced by comic-strip. A Pop style was occasionally used for non-Pop LPs: a George Formby compilation called 'I'm the Ukelele Man' had a Warhol-inspired cover of 20 garishly coloured, mini-portraits of Formby.

Some record covers continued the Symbolist influence which had been strong in psychedelic design. The most famous was Bob Seidemann's 'Blind Faith' (1969) which showed a close-up of a topless pubescent girl with Pre-Raphaelite hair, holding a silver aircraft-like model and standing in a luscious green field. Seidemann explained his design:

> 'The virgin with no responsibility is in front of the tree of life, and the spaceship is the fruit of the tree of knowledge. What I had in mind was that the release of the record would coincide with the landing on the moon. As man steps into the galaxy, I wanted inno-cence to carry my spaceship.'[54]

The Blind Faith cover was photographic (although figure and background were taken separately and then made into a montage), and anticipated a growing use of photography in the 1970s.

In the 1970s Hipgnosis became the foremost record cover designers. Hipgnosis' work was technically sophisticated and the impact of their sleeves was immediate and impressive. Their early designs showed a strong Surrealist inspiration, such as Storm Thorgerson's design for the 'Toe Fat' — an image of four nude bodies, which each had an enlarged big toe for a head. Another cele-brated cover was the design for Pink Floyd's 'Atom Heart Mother' (1970) — an unretouched colour photograph of a cow in a field. The unexpectedness of this image and its complete lack of relevancy to the music or lyrics, gave the cover a truly surreal character.

The cover for Pink Floyd's 'Atom Heart Mother', 1970. The cover's absolute ordinariness gave it an authentically surreal character.

[54] Siedemann quoted in Hipgnosis and Dean 1977, p 14.

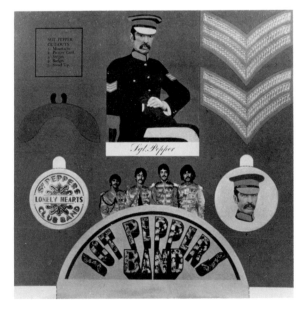

Peter Blake and Jan Howarth, cover and card sheet for the Beatles' Sgt Pepper's Lonely Hearts Club Band, 1967. The card sheet, included inside the cover, is a good example of Pop Victoriana graphic design.

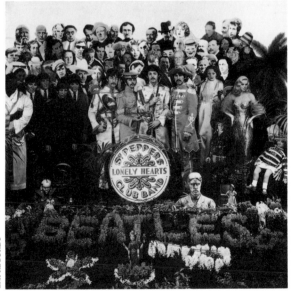

Two more Beatles' covers in 1968 and 1969 are worthy of mention. Following the 'Sgt Pepper' cover, the enigmatic 'Double White Album' (December 1968) had a plain white cover except for an embossed number (implying a limited edition) in white. The design, by Richard Hamilton, emphasised the function of a cover as packaging and continued Hamilton's interest in that area. The cover for 'Abbey Road' (October 1969) was a photograph by Iain Macmillan showing The Beatles on a zebra-crossing walking one behind the other but in step. Although not intended as such, the cover was interpreted as indicating the direction of The Beatles' uncertain future. The design did, intentionally or not, convey a slightly unreal atmosphere.

There were two reasons why the LP cover became an important medium for creative ideas in the late 1960s. Foremost was the economic importance of the LP: while the sales of singles slightly decreased and then stabilised at nearly 47 million in 1970, the number of LPs doubled between 1967 and 1970 to 65 million, overtaking singles sales for the first time in 1968. And covers helped to sell records. The second reason was related to the prevailing mood of self-determination. Pop groups were having a greater say in their musical output and insisted on commissioning graphic designers whose work was in keeping with their music, which is not surprising when one considers that many of them went to art school including John Lennon, Keith Richard, Ray Davies, Pete Townshend, Eric Clapton, Jimmy Page and David Bowie.

Pop graphic design was not confined to record covers but it was more

The Beatles' 'Yellow Submarine', 1968. Edelmann's artwork is typical of the soft and rubbery style of Pop graphics which became popular in the late 1960s.

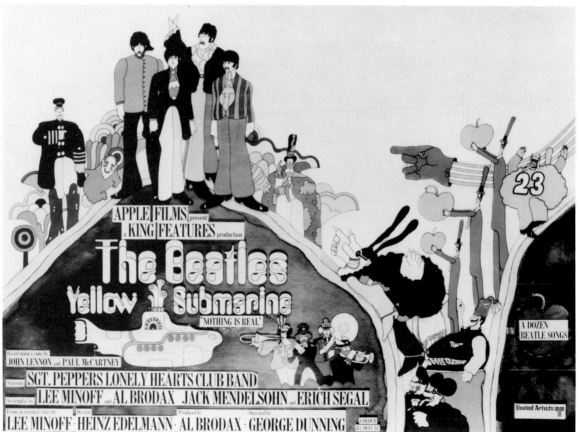

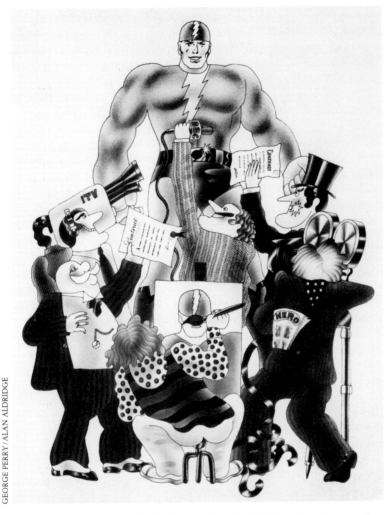

GEORGE PERRY/ALAN ALDRIDGE

Alan Aldridge, illustration from The Penguin Book of Comics, *1971. Aldridge was a highly successful illustrator in the late 1960s and early 1970s, and even became — albeit for a short while — art director of Penguin Books.*

often than not connected with Pop music. The full-length animation film 'Yellow Submarine' (GB 1968), which featured the music of The Beatles, was in part an Apple Corps production. It starred characters based on the Sgt Pepper image and followed their fortunes as they voyaged through the 'Sea of Holes' and 'Pepperland', and were pitted against 'The Snapping Turtle Turks', the 'Blue Meanies' and the 'Apple Bonkers'. The artwork was under the direction of Heinz Edelmann who brought together Surrealist figures with mouths on their cheeks, clenched fists which flew menacingly through the air, psychedelic clothes, Victorian photographs and prints, an Op art 'Sea of Holes' through which the submarine disappeared, and concrete poetry with words which were objects that had to be negotiated which squeezed characters out of the animation frame. The medium of animated film was appropriate for Pop because it allowed fantasy, fast change and special colour effects. 'Yellow Submarine' was full of hallucinatory images, although it appeared slightly dated by the time of its release.

One further Beatles' project interesting for its anthology of Pop graphic style was *The Beatles Illustrated Lyrics* published in 1969. It was edited by Alan

Aldridge and included the work of 45 British and American illustrators and photographers. Aldridge began work as a graphic designer in 1963 when he was 20 years old, and by 1965 his work was appearing regularly in colour supplements and fashion magazines. His rubbery and colourful style was a mixture of Mabel Lucy Attwell, Donald McGill and H M Bateman and his work of the mid to late 1960s is typical Pop.

The End of Pop Graphic Design

Mainstream graphic designers had only experimented with Pop. That there had been some loosening up was undeniable — even *The Times* had occasionally succumbed to Pop typography and borders for a feature article. But as Pop and the Underground disintegrated, Constructivist graphic design reasserted itself. By the 1970s Pop was dismissed as a bit of fun. Professional graphic designers could now return to the '. . . steadfast . . . dependable utilitarian logic of Swiss design.'[55]

[55] Carol Stevens 'Swiss Design is Alive and Well . . .' *Print* January/February 1971, p 37.

Nostalgia, Revivalism and Kitsch

DESIGN COUNCIL/PHIL SAYER

The Kensington High Street interior of Biba, 1969, where the hypnotic atmosphere of High Pop was replaced by the elegance and nostalgia of revivalism.

[56] Angela Carter 'Fin de Siècle' *New Society* 17 August 1972, p 355.

Surreal LP covers, colourful clothes and T-shirts with slogans helped to keep Pop alive. But in the late 1960s the changing mood of society made it appear increasingly anachronistic. No longer was it easy to believe that technology and all its products were good. People lost their faith in progress and sought reassurance in images of a romanticised past. Nostalgia as an industry was born in the Late Pop years.

The change from progressive to nostalgic could be detected in Pop itself. There was a vogue for 1920s and 1930s clothes, and although 1920/30s revivalism had been popular throughout the decade, in 1966 and 1967 it came to the forefront, fuelled by the box-office success of the film 'Bonnie and Clyde' (US 1967). In 1968, one fashion editor noted that the 1930s look had 'seeped into everything'. In 1970 the midi, which looked back to the 1920s and 1930s became fashionable. 1940s revivalism soon followed and, in 1972, to complete the circle, there was a revival of Teddy Boy clothing. Even Biba, which moved into new and larger premises in Kensington High Street in 1969, was housed in a 1930s atmosphere of satin and ostrich feathers. This was in contrast to the Biba of 1967 where cheap, fashionable, expendable clothes were sold amidst pounding Pop music. The past was being used as a state of mind: a haven from the uncertainty and bustle of High Pop.

The maternity smock of 1972, a fashion of false pregnancy, underlined the magnitude of the shift. Maternity emphasised gender differentiation, and this resurgence of role-defined clothing was interpreted as a yearning for security. Smocks were often produced in materials with Victorian nursery designs, described by one commentator as having 'the sickly sweet flavour of nostalgia'.[56] As revivalism became more nostalgic, fashion became pastiche to make up for a lack of new creative ideas. There was a nostalgia for attitudes too. According to the *Observer* magazine in 1971, 'Now stores are beginning to realise women basically *want* to be told what to wear.' If true, this signified a return to the autocratic attitudes redolent of the 'fifties.

Revivalism and nostalgia became manifest in graphic design. A 1920s and 1930s revival, spurred by the 1966 *Les Années Vingt Cinq* exhibition in

Paris, overtook Pop at the ephemeral end of the spectrum. In record cover design, nostalgia had started with the release of 'A Collection of Beatles Oldies' in December 1966. The cover was designed by David Christian and depicted The Beatles in scenes from the 1930s. The Who's LP 'Tommy' (1969) resembled an Art Deco montage; the Hipgnosis cover for Audience's 'Lunch' (1972) was a photograph reproduced from a 1930s knitting pattern; soft-focus photography, which resembled a still from a Hollywood love story, was used for David Bowie's 'Hunky Dory' (1971). A revival of 1950s graphic design was a force in record cover design in the early 1970s: Hipgnosis photographed a couple dressed in 1950s clothing amidst a contemporary setting for the cover of an LP by Fumble (1972); a Philip King painting of Monroe (in triplicate) was used as the cover of Mott the Hoople's 'Rock and Roll Queen' (1972); and 1950s Detroit cars were used regularly from 1972.

Although the psychedelic artist *and* the early 1970s graphic designer used the art and design of other periods, there was a major difference between them. The Pop designer stole from numerous sources and combined them in a collage that was undeniably of the present. The result frequently captured if not the spirit then at least the mood of the time. This made the work transient but was proof of its success. The graphic designer of the 1970s drew heavily on specific periods or styles of graphic history, and was more sophisticated and detached towards the design. Previous styles were used as if in quotation marks.

By 1968, the loosely defined Art Deco had become the collecting rage and interior designers were scouring junk shops for blue-glass coffee tables and radiograms patterned with marquetry and electric streaks, and junk shops with objects from the 1920s suddenly became antique shops. Art Deco came out of the closet, and was re-integrated as a valuable member of society. The first popular book on the subject, Bevis Hillier's *Art Deco*, was published in 1968.

The trend in boutique interior design moved towards a 'folksy' and nostalgic feel, manifested in 1920s idyllic landscapes with blue skies, puffy clouds and lush green undulating hills. Consumer spending had also contracted and the owners of boutiques with diminishing profits could no longer risk large sums of money on fashionable interior designs. A new 'Pop-styled' restaurant called 'Mr Feed'em', opened in 1971 by the owners of 'fun furniture' retailers 'Mr Freedom', seemed to be more kitsch than Pop with waiters dressed in boiler suits, waitresses in hamburger-painted mini skirts and 1940s head scarves, plastic flies in the soup, cakes in the form of a pair of jeans, and napkins depicting Mae West as the Statue of Liberty.

Kitsch became fashionable in the late 1960s. The traditional cottage teapot, the 1930s electric heater in the shape of a yacht, and the *Mona Lisa* reproduced on a teatowel have all been categorised as kitsch. In 1951 Gordon Russell defined kitsch as 'the sham art of commercialised romance'[57], but by the 1960s its most common meaning was 'in bad taste'. *Bad* taste presupposes the existence of *good* taste; those who dismiss kitsch as the maudlin art of the masses tend to believe in the existence of a transcendent 'good taste'. Both kitsch and Pop were bizarre, irrational and flamboyant, but this celebration of kitsch — as in Zandra Rhodes and Alex McIntyre's late 1960s flat interior where everything was self-consciously cheap and plastic — had the effect of re-establishing the notion of 'good taste'. The change in sensibility, of which revivalism and nostalgia were a part, had contributed to the popularity of kitsch.

[57] Russell 'Kitsch' *Design* December 1951, p 4.

Summary

Kitsch, revivalism and nostalgia were all symptoms of an age which had lost faith in its own abilities and which sought easy refuge in pre-packaged solutions and a mythical past. Similarly, at its worst the alternative technology movement promoted images of pre-industrial villages in a rural nation where William Morris would have felt at ease. The early 1970s were pessimistic and conservative. The change from fashionable fun to revivalism of distant ages and from high technology to low ecology signified that society had lost its belief in the notion of progress. It was, therefore, no coincidence that the boom industry of the decade was nostalgia. Pop had seemed right at the time but that time had passed. Pop's significance, however, transcended its time and lies in the major and continuing questions it raises about design and its relation to people and society.

CONCLUSION

The Achievements of Pop

Pop grew from the confluence of several social and economic trends that had been underway in Britain since the mid 1950s: full employment, consumerism, private affluence, social mobility, a loosening of the class structure, a changing social outlook, and teenage affluence and rebelliousness. The Pop movement was a flowering of creative talent and an expression of youthful confidence in an age of bold — if often naïve — optimism. Janey Ironside, professor of fashion at the Royal College of Art, spoke of the '. . . tremendous feeling of youth, excitement and freedom' of the High Pop years[1] and Peter Cook of Archigram considered that 'the key word one comes back to is optimism. There was tremendous optimism.'[2] Many people genuinely believed that Pop was the beginning of a new consciousness, that the Pop generation were '. . . pioneers of a new movement, a new relationship with the world and the universe';[3] and Reyner Banham described what he perceived as the '. . . transition from a culture based on aristocratic taste to one based on free-form self-fulfillment . . .'.[4] The idea of *progress* was an idea in good currency, and the imagery of progress — especially the hardware of space travel — dominated the media.

At its most extreme Pop was a rejection of everything traditional or belonging to the 'wine culture' (as opposed to the 'coke culture'). But Pop was not just a reaction to established standards. While it was important to youth that Pop design was not liked by their elders, it was equally important that it was their own. Pop mattered to youth who participated with different degrees of awareness and activity in the design process: it ranged from the keeping up with the latest fashions, through the careful selection of secondhand clothes, to the active designing and making of artefacts and environments. Youth enjoyed their design in a way which would have been impossible had it been handed-down by a group of designers emotionally detached and separate.

Pop fulfilled youth's desires for impact, immediacy, imagination, colour, variety and action. At its best and in the words of George Melly, Pop worked '. . . like a laser beam. It penetrates the moment like a burning point of light, leaving both past and future in total darkness.'[5]

The disposable paper mini-dress by Dispo, the paper chair by Peter Murdoch, and the psychedelic poster by Michael English epitomise Pop design. The mini dress was colourful, young and sexy; the chair was bright, decorative and novel; and the poster was bold, imaginative and self-indulgent. All three artefacts appealed directly to youth as a group because each expressed and reflected youth's lifestyle. The mini-dress fulfilled the need for both personal and social expression; the chair was part of a desire for fashionable furniture and furnishings in keeping with the age of the mini-dress; and the poster satisfied the requirement for visual impact. All were fashionable items valued only as long as they were up to date. Obsolescence is the inevitable outcome of fashionable design and Pop was marked by a kaleidoscopic appearance and disappearance of forms, styles, images, patterns and colours. Small sustaining power was

[1] Janey Ironside on 'Ten Years After' BBC Radio 4, 16 September 1975.

[2] Cook in conversation with the author, 20 May 1977.

[3] English in conversation with the author, 19 May 1977.

[4] Banham 'Towards a Million Volt Light and Sound Culture' *Architectural Review* May 1967, p 333.

[5] Melly 1970, p 205.

acceptable — even desirable — as long as there had been an initial impact.

As early as the 1950s, Reyner Banham had realised that expendability was the crucial element in Pop that set it apart from all conventional canons of culture. Both Banham and other members of the Independent Group — principally Richard Hamilton, Lawrence Alloway and John McHale — had analysed American mass media of the 1950s to formulate relevant criteria with which they could understand and evaluate popular culture. Although the vehicles of expression — the content and the style of popular culture — changed, the Independent Group identified characteristics that were constant and could be applied to Pop design in the 1960s. Hamilton's 1957 definition of the chief characteristics of American 1950s popular culture as '. . . popular, expendable, low-cost, mass-produced, young, witty, sexy, gimmicky, glamorous [and] Big Business . . .'[6] was applicable to the mini-dress, the paper chair and the psychedelic poster. If the word 'glamorous' seems more reminiscent of the Hollywood film stars of the 1950s, then 'flamboyant', 'extravagant' or perhaps 'stylish' could take its place without any dilution of Hamilton's definition. 'Big Business' is open to different interpretations, but neither Hamilton nor the present author see it as an inevitably corruptive and exploitative influence conspiring against the welfare and better judgements of the consumer.

Pop's wit and humour were almost as subversive of traditional values as expendability. Modernist designers and critics had been earnest and high-minded. They took their self-imposed responsibility for educating the public and raising the level of their taste very seriously. Pop's wit, humour and sense of enjoyment undermined this approach. Humour, from satire through camp and kitsch to black humour, was used as a weapon.

Pop was a means of non-verbal communication: one member of the Underground asserted that '. . . our culture, our art, the music, newspapers, books, posters, our clothing, our homes, the way we walk and talk, the way our hair grows . . . it's all one message — and the message is FREEDOM.'[7] For Pop youth generally the message was 'I am free. I am youthful. I am fashionable'. Pop's success came about not only because it was a *style* of design that appealed to a particular group, but because it embodied an *attitude*. Pop was a language.

[6] Hamilton: letter to the Smithsons dated 16 January 1957 in Hamilton 1983, p 28.

[7] John Sinclair quoted in Neville 1971, p 56.

Consumerism and Pop

Pop is an expression of the change in the role of design that accompanied the shift towards a consumerist society in post-war Britain. The term 'consumerist society' is subtly but significantly different to 'consumer society'. The latter is roughly synonymous with capitalist society and has been in existence for some centuries: the consumerist society is an advanced stage of the consumer society in which private affluence *on a mass scale* is the dominant force in the market-place. The consumerist society arrived in Britain symbolically in 1951, and materially in the mid to late 1950s. America was the nation with the first and wealthiest consumerist society. And nothing better illustrates the essence of consumerist design than the 'insolent chariots' of the 1950s: the big brash cars that, through styling features and symbols, asserted America's power and confidence in the days of the Cold War and cheap energy. A gleaming new car may have been a sign of financial success, but the make and model announced the owner's position on the social ladder.

In the pre-consumerist Europe of the 'first machine age', progressive designers preached that form should follow primary function, and that fitness for utilitarian purpose was the first principle of good design. In those heroic days, with the high-minded commitment of designers to collectivism and democratic internationalism, and when good design was going to be the birth-right of everyman, good working order — or at least the appearance of good working order — had not only to be achieved but visually emphasised.

The Modernist critic J M Richards had written in 1935 that the characteristics of Modern design were standardisation, simplicity and impersonality: characteristics that referred back to mechanical efficiency and machine production. However, these characteristics hardly expressed an individual's hopes, desires and aspirations in the post-war world. Consumerist society shifted the balance in design from primary to tertiary function: from design principally concerned with solutions to utilitarian needs, to design emphasising an object's emotional, psychological and social role. Whereas Modernist design in the 'first machine age' had sought to unify people, consumerist design of the 'second machine age' sought (and seeks) to differentiate groups. Pop in being relevant only to a particular group at a particular time and place in an age of affluence, was typical of consumerist design and was its first popular and mass movement.

Reyner Banham differentiated between the 'first' and 'second' machine ages in technological terms: the first was the age of power from the mains and the reduction of machines to human scale; the second was the age of domestic electronics and synthetic chemistry.[8] It is tempting to interpret the fundamental difference as an opposition between collectivist ideals and consumerist fantasies. However this interpretation would be erroneous. The Modernist design described by Richards and others constituted only a small part of design in the 'first machine age'. More typical are the electric heaters and wirelesses — the fashionable and sought-after consumer products — that became increasingly available among the middle classes. The 'first machine age' was undoubtedly a consumer age, different in quantitative, not qualitative, terms from the second. But those quantitative differences were substantial and led to the changes in outlook, habit and taste that were keenly debated by members of the Independent Group.

[8] Banham 1960, p 10.

Criticisms of Pop

Because of the explosion of young talent and the sense of optimism, there is a danger of the Pop years being remembered as a Golden Age. For all its achievements in overturning British cultural drabness and parochial thinking, Pop culture had major faults which were either ignored or glossed over.

The belief, for example, that the 1960s was a time of classlessness is largely mythical. The myth arose because of political rhetoric and a change in taste and habits. In the early 1950s the young had no identifiable taste of their own, but reflected the taste of their parents which tended to be a reliable indicator of social class.

With the economic and social changes, and the Americanisation of society through films, magazines and rock'n'roll music, and the increasing consumerist tendencies of British society, the taste of the young began to change in the mid to late 1950s. By the High Pop years with the development of youth as a consumer group, taste was determined more by age than by class background.

For example, a young girl of the upper class was now more likely to buy a cheap mini from 'Biba' and learn her dances from 'Ready! Steady! Go!', than she was to shop at Burberry's, attend court balls and uphold the Queen's English. For a time it became fashionable to appear working class.

To the majority, however, Pop appeared classless and indeed its appeal cut across divides of class, but these divides were never broken down. The same was true of society at large. Harold Wilson exploited the mood of optimism and the desire for a new Britain by emphasising a classless society in his pre- and post-1964 election speeches. The country began to tell itself it was becoming classless. And although the old class divisions may have lessened, the class structure remained intact to re-surface in the mid 1970s when the age of consensus gave way to the emergence of the New Right. Taste determined by age reverted to taste as a reflection of class.

Appearance was often confused with substance in the 1960s. Some critics argued that Pop had resulted in a major education of visual awareness. Mario Amaya, for example, believed that the '. . . conscious awareness of style in the 'sixties, the preoccupation with the way things look has come to mean that more people are more aware than ever before of their visual environment.'[9] This represented, he continued, '. . . an upgrading of taste, a keener awareness of the things around us as they infiltrate our lives and our art.' Opponents of Pop countered that this obsession with the outward appearance of things was, if not perverted, at least unbalanced. In its epitaph to the decade, *Design* dismissed Pop as

> '. . . a slide culture. Even nuclear explosions, it has been discovered, make superb photographs. It is almost as though things are not fully real until they are made into slides, or double page pictures in the colour magazines.'[10]

Design's view was that Pop had resulted in a superficial visual awareness that made amoral and apolitical judgements on appearances. This criticism could be little more than a reborn puritanism, but it was true that Pop had aestheticised daily life to the extent that fashionability and visual appearance became all important. Was there in fact any real reason why cutlery *should* swing like The Supremes? Did music and fashion provide the best models on which to base a design theory?

Commenting on Banham's contributions to a collection of *New Society* articles, Peter Conrad accused him of

> '. . . an aesthete's indifference to politics. Ravished by appearances, enchanted by form and scournful of function, the aesthete has an interest in preserving things as they are.'[11]

It follows that the aesthete is a reactionary. Conrad is right in general, but wrong in particular. Any, let alone close, attention to Banham's articles would reveal he is far from worshipping form for its own sake. He consistently related the design of artefacts and objects to the user-group and made criticisms accordingly. However, Conrad's accusation of indifference to politics can be levelled at much Pop design and many Pop designers. How long could Archigram have continued to argue that politics was outside their terms of reference?

[9] Amaya 'The Style of the Sixties' *The Spectator* 14 July 1967, p 54.

[10] anon 'New Authority, New Scope and a Change of Purpose' *Design* January 1970, p 100.

[11] Conrad 'The Scientists of Camp' *Times Literary Supplement* 21 October 1977, p 1237.

From the Independent Group and McLuhan to Fuller, Price and Archigram the commitment to and optimism for high technology was unconditional. The prophets of Pop were 'technological superhumanists' as Martin Pawley termed them[12], and represented what one critic described as '. . . the extreme of technological blindness'.[13] From Mies to Banham, technology was invoked as neutral. This, coupled with the optimism for advanced technology, links the 1960s with the 1920s in an overall 'machine age'. The majority of the 'first machine age' designers may have imposed a classical aesthetic *on* the products of technology, whereas the 'second machine age' designers, like the Futurists before them, sought a wild and rich aesthetic *of* technology but both were undeniably committed to the machine, advanced technology and the notion of progress. The two 'machine ages' were the reverse and obverse of the same coin, which the alternative technology lobby discarded as outmoded currency. This aspect of Pop can be interpreted as the last outpouring of the Modern Movement.

In their insatiable quest for progress, the prophets of Pop had chosen to disregard questions of technological control. In the 1970s technology became a political issue and there was a reaction against advanced technology in the form of 'soft' or 'alternative' technologies. This neo-Utopianism may have represented an overdramatic backlash, but we have been forced to acknowledge the later view that '. . . a society's technology can never be isolated from its power structure, and technology can thus never be considered politically neutral'.[14]

There were other related criticisms. Pop's lack of concern for conservation of materials and disregard of environmental pollution were commented on in the late 1960s when the ecological lobby was growing in strength and confidence. Expendability, it was argued, was morally irresponsible in an age of conservation. Not only were Pop artefacts expendable but they were often tawdry, 'cheap and nasty', and functionally poor. It is true that many Pop artefacts were inadequately designed and poorly manufactured. They were being made, like most popular design, for mass consumption in a highly competitive marketplace, and not for a small group of connoisseurs. Carnaby Street tat was not intended to last for eternity. It was immediate, impactful and, of course, expendable, so quality of manufacture mattered little. Similarly, working order was seldom a major issue when compared with relevant or fashionable imagery or symbolism. Ugliness or beauty and efficiency or inefficiency can be had in any combination, and a Pop style did not *necessarily* signify a disregard for working efficiency — in spite of what many seemed to think.

Pop was usually sexist. The mini-skirted dolly-bird kitted out at 'Biba' and the Pre-Raphaelite look-alike of the psychedelic posters were both portrayed as young, attractive and desirable. The position of young women in society in the Pop years was, however, transitional. From being the silent and motionless appendages to men and machines in the 1950s, young women in the 1960s acquired a freedom facilitated by their relative financial independence and the oral contraceptive pill both of which gave them confidence to express, assert and enjoy themselves. Most importantly, women perceived themselves as independent. Although those early perceptions were naïve and conditioned by male expectations, they were the beginning of a consciousness and rethinking of women's role, position and aspirations within society that gave rise to feminism. Pop took place in a pre-feminist and sexist age but Pop itself was not *intrinsically* sexist.

[12] Pawley 1971, p 113.

[13] McEwan 1974, p 23.

[14] David Dickson quoted in Nigel Cross *Design and Technology* T262 unit 9, Open University, Milton Keynes p 58.

The Legacy of Pop

The legacy of Pop is *not* stylistic. Pop may have some appeal for the sentimental who reminisce about their mis-spent youth but the conditions that created Pop have long since changed. The expendability of Pop ought now to be respected as once it was enjoyed. Nor is its legacy a calculated opposition to ergonomics in favour of a preoccupation with the latest fashionable trend. The anti-rational pyrotechnics or ornamentalist designers such as Memphis may reveal an occasional stylistic debt to Pop just as their visual extremism, cavalier attitude to finish and indifference to functional considerations are traits that were often visible in Pop's not infrequent moments of unbridled flamboyance.

Part of Pop's legacy is its lasting effect on taste and sensibility. Colour and decoration are more widely tolerated, and synthetic materials such as plastics are no longer snobbishly rejected out of hand. The need for qualities such as wit and invention in design is appreciated, and this has helped to open up relatively overlooked areas of art and design (such as child art, primitive art and Art Deco) to both designers *and* sections of the population. George Melly adjudged that Pop '. . . has affected all our sensibilities and to the good. We are more open, less stuffy, less intellectually snobbly, more loving because of Pop.'[15] And Peter Lloyd Jones believed that the shift in sensibility caused by Pop was 'profound'.[16] Pop encouraged stylistic diversity and eclecticism and this climate of tolerance and open-ness resulted in a visual kaleidoscope of permissiveness.

Pop also changed the social climate of design. After Pop, designers no longer enjoyed the self-appointed moral authority of their Modernist predecessors. People were no longer willing to be dictated to by a professional élite, they no longer accepted that their taste was uneducated and inferior.

Pop signalled a rejection of Modernism's design procedures and methodologies. In 1970 *Design* criticised Pop because it

'. . . meant an end to any kind of philosophical base for action. Pop is instinctive and sybaritic (broadly speaking), and that does not make for great advances in cultural thought.'[17]

Many Pop designers believed that the age of *Homo ludens* had arrived and that an instinctive or intuitive way was the best way of responding to the new 'sybaritic' conditions. This, they argued, *did* make for advances in cultural thought: it was better to respond emotionally and analyse that response later, than analyse first and then see if one approved of or liked that design. In pre-Pop (viz Gutenberg) times, cultural thought had progressed in a logical and linear way whereas in the Pop (electronic) age it advanced in a concentric, intuitive way. Archigram wanted their projects (like McLuhan wanted his books) to be thought of as 'probes' and 'ideas in progress': it is better to travel than to arrive.

Modernists believed there was one correct design method. To solve a design problem, the Modernist would ideally discard preconceptions about possible solutions and work through a series of questions and answers which led to a form — the design solution. The Pop designers believed this was mistaken and that so-called irrational design procedures often produced the best results. In the past, fantasy and fiction had helped to shape fact, and they believed this would continue to be the case. Banham justified irrational procedures:

[15] Melly 1970, p 229.

[16] Lloyd-Jones 'The Pop Art of Living' *The Listener* 11 August 1977, p 170.

[17] anon 'New Authority, New Scope and a Change of Purpose' op cit p 106.

'Whatever one may think about rational design procedures, it is clear that for most of the profession . . . most of the time, actual design solutions are contained within a stock of forms already in circulation. Therefore, an operation like Archigram which either invents forms off the top of its head, or drags in forms from other branches of design, increases the range of possible architectural solutions by enlarging the vocabularly of forms.'[18]

[18] Banham in a letter to the author dated 12 August 1980.

It is a claim few practising architects and designers would dispute. In rejecting Modernism, Pop was rejecting a way of thinking and value system that, ultimately, upheld scientific rationalism.

Pop exposed the symbolic and expressive poverty of Modernist form. Modernism emphasised primary and pure Phileban forms because it was object based rather than consumer based. The machine, and not people, determined the products: 'The machine has rejected ornament. . .' declared Herbert Read in 1934 — a statement that implies the machine, not the designer, was making the decision. But the machine is a tool, a means to an end determined by people. Its products are shaped by external forces, not by internal laws. Modernist form was determined by production while consumption was ignored: it was reductivist and non-referential. Working order dictated forms. 'Economy of form' and 'truth to materials' may be useful guidelines to the designer: they can lead to an understanding of which shapes are most easily manufactured, and they may bring an aesthetic satisfaction, but they are unlikely to result in products which are liked and valued by the majority of consumers.

If forms are to have 'meaning' for various groups they need to be referential. Referential forms are determined by taking into account such external factors as meaning (an object's role within a group) and expressive, associational or symbolic forms, ornament or decoration. Primary (or abstract) forms become less important than secondary (or humanistic) ones. In this way design based on popular taste becomes a language with publicly accepted codes and conventions. Modernist objects will still be produced, but they will be chosen for their limited meanings and associations, not because they are significant or morally superior. Modernism becomes another style option.

Pop was never intended as a universal style, nor as a solution to social problems. It was relevant only for a particular group (the young), in a particular time (1960s) and place (urbanised society). Other groups had different desires and needs which would be catered for in different ways. In 1967 Paul Reilly understood the implications of this for design theory:

'We are shifting perhaps from attachment to permanent, universal values to acceptance that a design may be valid at a given time for a given purpose to a given group of people in a given set of circumstances, but that outside these limits it may not be valid at all.'[19]

[19] Reilly 'The Challenge of Pop' *Architectural Review* October 1967, p 256.

This represented a major shift — and advance — from Modernist design theory which claimed universality in relation to both people and types of product. A theory that purported to be valid to all groups of people could not satisfy the differing needs, desires and values of the varied groups that exist in a democratic, pluralistic and affluent society. Nor did Modernism distinguish

between two significantly different types of goods: capital and consumer. There is no reason why the exacting products of engineering should be treated in the same way methodologically as souvenirs or personal items. Capital and consumer goods fulfil different *types* of requirements.

Good design ceases to be equated with Platonic truth and must be radically redefined. As Hamilton said in 1960, designers have to accept '. . . the convenience of different values for different groups and different occasions.'[20] The intellectuals of Pop moved theory away from aesthetics to a sociological interpretation of art and design. Design theory should be concerned with groups and their demands. Only the 'plurality of hierarchies', a concept generated by the Independent Group, can deal with these varied and sometimes contradictory demands.

The different sets of values held by different groups may be expressed by different styles of design which can co-exist and be equally good or bad as the case may be. We need to remember, however, groups are dynamic, and their needs and tastes develop and change. Also each individual is a member of more than one group and therefore has different needs at different times. Just as one requires a range of clothes for types of occasion and to express membership of particular groups, one needs a range of design styles appropriate to varying demands and lifestyles. After Pop, to speak of 'good design' without qualifying the terms of reference or type of product is meaningless.

Critics such as Pevsner rejected Pop as debased, and moralised against '. . . the craving of the public for the surprising and fantastic.'[21] But why should people not desire such characteristics? People's attitudes to their surroundings and objects are not detached and rational and are coloured by sentiment, memory and emotion. People have a need — and Pop provided for it in the 1960s — for surprise, imagination, variety, colour, fun, and delight in extravagance. This need is emotional and psychological, and it is a need which designers should not ignore. It accounts for — and justifies — fashion and other 'irrational' urges.

Pop and Design History

Acceptance of 'irrational' needs has an important implication for the history of design. Historians such as Pevsner, Read, Richards, Giedion and Mumford dismiss design that does not conform to the logic and order of the Rationalist tradition. Art Nouveau is one such example which the Rationalists see as a *cul de sac* that was of value only as a transitional stage between 19th century historicism and 20th century progressivism. 1930s streamlining is dimissed as vulgar and a perversion of principles.

A history of design that emphasises either expressive or symbolic form and visual imagination can be traced back from Pop, through American car styling of the 1950s, streamlining of the 1930s, Art Deco of the 1920s and Expressionism (including Futurism) of the 1910s, to Art Nouveau and High Victorian designers such as William Burges. The modern roots lie in the Picturesque with its qualities of surprise, imagination and delight; and beyond that Rococo and Mannerism. It is a history that needs to be written to complement Modernist histories.

The Rationalist and 'irrationalist' traditions should co-exist, neither is more correct or better than the other. Pevsner, in dismissing what he described

[20] Hamilton in National Union of Teachers Report 1960, p 136.

[21] Pevsner 1960, p 217.

as another Expressionist 'interlude' in the mid to late 1950s, was prejudiced and, ultimately, wrong. Nor is it true that Rationalism has a social conscience whereas 'irrationalism' does not. As Banham pointed out in 1967, this attitude is to read a style of design as though it betrays the moral worthiness of the designer:

> 'Art Nouveau equals decadence, Expressionism equals selfishness, white walls and flat roof equals care for functional performance . . . chromium bright-work equals commercial swindle; and so forth.'[22]

[22] Banham 'All That Glitters is Not Stainless' *Architectural Design* August 1967, p 351.

The Independent Group preached 'both . . . and' rather than 'either . . . or': both Rationalist and 'irrationalist' approaches to design are valid ones. One can predominate at any one time, although it is mistaken to reduce their occurrence to action/reaction in a cyclical manner. They are likely to exist side by side, as did the Arts and Crafts and Art Nouveau, Modernism, Art Deco and streamlining, and the systematic design methodologists and Pop.

In our scientifically based society, 'rationalism' and 'irrationalism' are loaded words; the former is considered a quality, the latter a failing. Rationalist has become an accepted term to describe the scientific and structural tradition in architecture and design, but a less emotive term than 'irrationalist' is needed to describe the alternative tradition. In spite of the possible confusion, I favour 'Expressionist' because it can be interpreted in several ways. A number of things can be expressed: the condition of the soul; a point of view; the function of an object; the role and meaning of an object; or the mood of the time. This range seems to include all the types of design in the 'irrationalist' tradition.

Pop and Design Theory

Rationalism and Expressionism are theoretical constructs which cannot exist in a pure form: each always contains a lesser or greater degree of the other. On the line which joins the two poles, there is a point at which elements of Rationalism and Expressionism are combined in equal proportion. Such a synthesis of Modernism and Pop was sought by Corin Hughes-Stanton in *Design* in 1968. Hughes-Stanton argued in favour of '. . . the equal importance of ergonomics and psychological fulfillment' in design.[23] This was to lead to a new era of Post-Modern design. The Modernist principle of good working order would be combined with the Pop attitude to popular taste and visual enjoyment. The article by Hughes-Stanton was a positive contribution to the design theory of consumer items.

[23] Hughes-Stanton 'What Comes After Carnaby Street?' *Design* February 1968, p 43.

Hughes-Stanton was not the first to use the term Post-Modernist in an architectural context. Pevsner used the term in 1966 to describe the Neo-Expressionist architecture of Le Corbusier and Wright, and other usages date back as far as 1949.[24] From 1975, Charles Jencks had used the term frequently to describe what he saw as a movement in architecture that emphasised meaning in architectural form. But Hughes-Stanton's use of the term and that of Jencks are significantly different. While Hughes-Stanton's (largely unnoticed) Post-Modernism used the best of Modernist principle and Pop approach, Jencks' Post-Modernism tended to ignore popular taste in favour of esoteric iconography. The Post-Modernism of Charles Jencks was often little more than a

[24] see Jencks 1977 (revised edition 1978, p 8); and Banham 'The Writing on the Walls' *Times Literary Supplement* 17 November 1978, p 1337.

sophisticated party-game: identify the sources or combine two or more incongruous parts into an incongruous whole. Hughes-Stanton's Post-Modernism was seldom put into practice in the 1970s. For most manufacturers, a combination of Modernism and Pop meant little more than the introduction of a bright colour onto an otherwise unchanged Modernist form.

A further impetus for Post-Modernism has arisen from the 'black box dilemma' and the inability of Modernist theory to deal with the microprocessor which can drastically reduce the size and form of an object's working parts. Because form no longer primarily results from the working parts, the designer has to concern himself with visual language. An understanding of visual language may be helped by the study of semiology. The rise of semiology in the 1970s was historically understandable (like Pop it shared a dissatisfaction with Modernism's abstract aesthetics) but it tended to be of only peripheral use to the practising designer. Writers have preferred to concentrate on the theoretical issues of semiology at the expense of its applications.

Semiology is only one tool the designer can call on in his understanding of what people buy and why: motivational research, psychology and marketing techniques are other tools; or designers can, like Pop designers, trust their intuitive judgements. The designer's method is important only in so far as it produces good (viz appropriate) results. What is certain is that the Post-Modern designer has to be concerned with visual language and be a 'specialist in the look of things' as Hamilton predicted in 1960.[25] The term 'stylist' which has long been a term of scorn in Britain has to be re-evaluated. The debate about Post-Modernism continues, although Post-Modernism seems to have degenerated into Ornamentalism. In spite of its relative open-mindedness, Post-Modernism could become codified into a semi-official design orthodoxy. This would contradict one of the most important implications of Pop: the toleration of a plurality of hierarchies.

The rejection of Modernism and the adoption of Post-Modernism or a plurality of hierarchies raises the question of design and morality. Modernists elevated their design tenets to a position of moral importance. To print an illusionistic pattern on a two-dimensional surface was a cause not principally of aesthetic dissatisfaction but of moral indignation. With the rejection of Modernist principles and the adoption of the concept of appropriateness, moral questions during the design process become meaningless. Moral issues in design are of different order and should precede the design process. These issues concern the personal and political conscience. Should the designer be concerned with expensive, luxury items? Should (as Papanek believes) design be for the disadvantaged or disabled? Should scarce commodities be used up? Should the designer be party to a shoddy product? Should obsolescence be built in? Should the design be executed with fashion in mind? These issues, and the criteria of *relatively* 'good' design, should be debated publicly because in any democratic society it is desirable that the majority of the population understand the nature of their society. To affirm the words of Richard Hamilton: 'An ideal culture, in my terms, is one in which awareness of its condition is universal.'[26] This was manifested in design by Lawrence Alloway's concept of 'the knowing consumer'.[27]

Of course there are no simple answers to these moral dilemmas and a designer's ideals will be compromised by the need to earn a living. In an ideal society designers would work only on those projects with which they are morally

[25] Hamilton 'Persuading Image' *Architectural Design* February 1960, p 28.

[26] Hamilton in National Union of Teachers Report 1960 p 136.

[27] Alloway 'Artists as Consumers' *Image* number 3 1961, p 18.

happy. The moral dilemma resolved (or accepted), the designer could then, untroubled by aesthetico-moral 'principles', set about designing the best (ie most appropriate) design that the technical and financial circumstances would allow.

In a democratic and pluralistic society, the quality of a design can only be evaluated by reference to the user-group and cultural context. Good design is neither universal nor eternal, but is that which satisfies the needs (material) and desires (emotional) of an individual or group at a particular time in a particular place. Design is a part of a way of life and must have a sound social footing.

It is ironic that it was a Modernist designer, Moholy-Nagy, who provided a justification and a fitting slogan for the type of design of which Pop was such a good example. In a paragraph heading in his *The New Vision* of 1939, he declared:

'Not the product, but man, is the end in view.'[28]

[28] Moholy-Nagy *The New Vision* 1939, p 14.

Every designer should heed this advice.

BIBLIOGRAPHY

ADAMS *Art of the Sixties* London, Phaidon, 1978.

ADDISON Paul *Now the War is Over* London, Cape/BBC, 1985.

AITKEN Jonathan *The Young Meteors* London, Secker and Warburg, 1967.

ALDRIDGE Alan (ed) *The Beatles Illustrated Lyrics* (1972 edition) New York, Dell, 1969.

—— (ed) *The Beatles Illustrated Lyrics* volume 2 (1980 edition), London, Futura, 1971.

ALLOWAY Lawrence *American Pop Art* New York, Collier, 1974.

—— *Network: Art and the Complex Present* Michigan, UMI Research Press, 1984.

AMAYA Mario *Pop as Art* London, Studio Vista, 1965.

APOLLONIO Umbro *Futurist Manifestos* London, Thames and Hudson, 1973.

ARCHER L, Bruce *Systematic Method For Designers* London, Royal College of Art, 1965.

ARMSTRONG-JONES Anthony *Personal View* London, Weidenfeld and Nicolson, 1979.

ARTS COUNCIL *New Painting 61–64* exhibition catalogue, London, Arts Council, 1964.

ATELIER POPULAIRE *Posters From the Revolution* London, Dobson, 1969.

BAILEY David *Bailey's Box of Pin Ups* London, Weidenfeld and Nicolson, 1965.

—— *Goodbye Baby and Amen* London, Condé Nast, 1969.

BANHAM Mary and HILLIER Bevis (eds) *A Tonic to the Nation* London, Thames and Hudson, 1976.

BANHAM Reyner *The Architecture of the Well-Tempered Environment* London, Architectural Press, 1969.

—— (ed) *The Aspen Papers* London, Pall Mall, 1974.

—— *Design By Choice* London, Academy, 1981.

—— *Guide to Modern Architecture* London, Architectural Press, 1962.

—— *Los Angeles: The Architecture of Four Ecologies* London, Penguin, 1971.

—— *Magastructure: Urban Futures of the Recent Past* London, Thames and Hudson, 1976.

—— *The New Brutalism* London, Architectural Press, 1966.

—— *Theory and Design in the First Machine Age* London, Architectural Press, 1960.

BARKER Paul (ed) *Arts In Society* London, Fontana, 1977.

BARNES Richard *Mods* London, Eel Pie, 1979.

BARNICOAT John *A Concise History of Posters* London, Thames and Hudson, 1972.

BARRETT Cyril *Optical Art* London, Studio Vista, 1971.

BARTHES Roland *Elements of Semiology* (1967 edition), London, Jonathan Cape, 1964.

—— *Mythologies* (1973 edition) London, Granada, 1957.

BAYLEY Stephen *In Good Shape* London, Design Council, 1979.

BAYNES Ken and Kate *Gordon Russell* London, Design Council, 1980.

—— *Industrial Design and the Community* London, Lund Humphries, 1967.

BEAGLE Peter *American Denim* New York, Abrams, 1975.

BENNETT-ENGLAND Rodney *Dress Optional* London, Peter Owen, 1967.

BENTHALL Jonathan and POLHEMUS Ted (eds) *The Body as a Medium of Expression* London, Penguin, 1975.

BENTON Tim, BENTON Charlotte and SHARP Dennis (eds) *Form and Function* London, Crosby Lockwood Staples, 1975.

BERGONZI Bernard *Innovations* London, Macmillan, 1968.

BERNARD Barbara *Fashion in the 60s* London, Academy, 1978.

BIGSBY C W E (ed) *Approaches to Popular Culture* London, Edward Arnold, 1976.

—— *Superculture* London, Paul Elek, 1975.

BLAKE John and Avril *The Practical Idealists* London, Lund Humphries, 1969.

BLAKE Peter *Peter Blake* London, Tate Gallery, 1983.

BOGDANOR Vession and SKIDELSKY Robert (eds) *The Age of Affluence* London, Macmillan, 1970.

BOOKER Christopher *The Neophiliacs* London, Collins, 1969.

BOURGES Herve *The Student Revolt* London, Jonathan Cape, 1968.

BRAND Stewart (ed) *The Last Whole Earth Catalog* (1975 edition), London, Penguin, 1971.

BURNS Jim *Arthropods* London, Academy, 1972.

COLLINS Peter *Changing Ideals in Modern Architecture* London, Faber and Faber, 1965.

COMPTON Michael *Pop Art* London, Hamlyn, 1970.

CONRADS Ulrich (ed) *Programs and Manifestos on 20th Century Architecture* Mass., MIT, 1970.

—— and SPERLICH Hans *Fantastic Architecture* London, Architectural Press, 1963.

COOK Peter (ed) *Archigram* Studio Vista, 1972.

—— *Architecture: Action and Plan* London, Studio Vista, 1967.

—— *Experimental Architecture* London, Studio Vista, 1970.

COUTTS-SMITH Kenneth *The Dream of Icarus* London, Hutchinson, 1976.

CRISPOLTI Enrico *Peter Phillips* Milan, Idea Books, 1977.

CROSS Nigel (ed) *Design Participation* London, Academy, 1972.

——, ELLIOTT David and ROY Robin (eds) *Man-made Futures* Milton Keynes, The Open University, 1974.

DEAN Roger, *Views* Limpsfield, Dragon's World, 1975.

DICKSON David *Alternative Technology* London, Fontana, 1974.

DORFLES Gillo *Kitsch: The World of Bad Taste* London, Studio Vista, 1969.

ECOLOGIST The *A Blueprint for Survival* London, Penguin, 1972.

ENGLISH Michael *3D Eye* Limpsfield, Dragon's World, 1979.

ERRIGO Angie and LEANING Steve (eds) *The Illustrated History of the Rock Album Cover* London, Octopus, 1979.

EWING Elizabeth *History of 20th Century Fashion* London, Batsford, 1974.

FARR Michael *Design in British Industry* London, Cambridge University Press, 1955.

FARREN Mick (ed) *Get on Down* London, Futura and Dempsey, 1976.

—— *Watch Out Kids* London, Open Gate, 1972.

FAULKNER Tom (ed) *Design 1900–1960* Newcastle, The Polytechnic, 1976.

FINCH Christopher *Image as language* London, Penguin, 1969.

—— *Pop Art* London, Studio Vista, 1968.

FRAMPTON Kenneth *Modern Architecture: A Critical History* London, Thames and Hudson, 1980.

FRITH Simon *The Sociology of Rock* London, Constable, 1978.

FULLER R Buckminster *The Dymaxion World of Buckminster Fuller* New York, Anchor, 1973.

GARNER Philippe *The Contemporary Decorative Arts* London, Phaidon, 1980.

GEDDES Norman Bel *Horizons* New York, Dover, 1932.

GIEDION Sigfried *Space, Time and Architecture* (5th edition, 1971), London, Oxford University Press, 1941.

GEFFRYE MUSEUM *Utility Furniture and Fashion* exhibition catalogue, London, ILEA, 1974.

GILLIATT Mary *English Style* London, Bodley Head, 1967.

GOWAN James (ed) *A Continuing Experiment* London, Architectural Press, 1975.

GRAY Nicolette *Nineteenth Century Ornamented Typefaces* London, Faber and Faber, 1976.

GREER Germaine *The Female Eunuch* London, Paladin, 1971.

GROPIUS Walter *The New Architecture and the Bauhaus* London, Faber and Faber, 1935.

GUGGENHEIM MUSEUM *Richard Hamilton* exhibition catalogue, New York, Guggenheim Museum, 1973.

HALL Stuart and WHANNEL Paddy *The Popular Arts* London, Hutchinson, 1964.

HALL-DUNCAN Nancy *A History of Fashion Photography* New York, Alpine Books, 1979.

HAMBURG KUNSTVEREIN *Pop Art in England* exhibition catalogue, Hamburg, 1976.

HAMILTON Richard (ed) *Collected Words* London, Thames and Hudson, 1983.

HEBDIGE Dick *Subculture: The Meaning of Style* London, Methuen, 1979.

HENRI Adrian *Environments and Happenings* London, Thames and Hudson, 1974.

HERZOG Thomas *Pneumatic Structures* London, Crosby Lockwood Staples, 1977.

HESKETT John *Industrial Design* London, Thames and Hudson, 1980.

HILLIER Bevis *Art Deco* London, Studio Vista, 1968.

—— *Austerity Binge* London, Studio Vista, 1975.

—— *Posters* London, Weidenfeld and Nicolson, 1969.

HIPGNOSIS (eds) *Album Cover Album* Limpsfield, Dragon's World, 1977.

HITCHCOCK Henry Russell and JOHNSON Philip *The International Style* New York, W W Norton and Co., 1932.

HOGGART Richard *The Uses of Literacy* Chatto and Windus, 1957.

HORNSEY STAFF AND STUDENTS *The Hornsey Affair* London, Penguin, 1969.

HOWELL Georgina *In Vogue* (1978 edition), London, Penguin, 1975.

INSTITUTE OF CONTEMPORARY ARTS *Man Machine and Motion* exhibition catalogue, London, ICA, 1955.

—— *Parallel of Life and Art* exhibition catalogue, London, ICA, 1953.

JACKSON Anthony *The Politics of Architecture* London, Architectural Press, 1970.

JACOPETTI Alexandra *Native Funk and Flash* New York, Scrimshaw Press, 1974.

JENCKS Charles *The Language of Post-Modern Architecture* London, Academy 1977.

—— *Modern Movements in Architecture* London, Penguin, 1973.

—— and BAIRD George (eds) *Meaning in Architecture* London, Barrie and Jenkins, 1970.

JOHNSON Lesley *The Cultural Critics* London, Routledge and Kegan Paul, 1979.

JONES Barbara *Black Eyes and Lemonade* exhibition catalogue, London, Whitechapel Art Gallery, 1951.

—— *The Unsophisticated Arts* London, Architectural Press, 1951.

JONES J Christopher *Design Methods* London, John Wiley, 1970.

KATZ Sylvia *Plastics* London, Studio Vista, 1978.

KEEN Graham and LA RUE Michel (eds) *Underground Graphics* London, Academy, 1970.

KIRKPATRICK Diane *Eduardo Paolozzi* London, Studio, Vista, 1970.

KONIG René *The Restless Image* London, George Allen and Unwin, 1973.

KRIVINE Jack *Juke Box Saturday Night* London, New English Library, 1977.

LAMBERT Margaret and MARX Enid *English Popular and Traditional Art* London, Collins, 1946.

—— and —— *English Popular Art* London, Batsford, 1951.

LANDAU Royston *New Directions in British Architecture* London, Studio Vista, 1968.

LAVER James *A Concise History of Costume* London, Thames and Hudson, 1969.

LEARY Timothy *The Politics of Ecstasy* London, Paladin, 1970.

LE CORBUSIER *The City of Tomorrow* (1971 reprint) London, Architectural Press, 1929.

—— *Towards a New Architecture* (1970 reprint) London, Architectural Press, 1927.

LEVIN Bernard *The Pendulum Years* London, Jonathan Cape, 1970.

LEWIS Peter *The Fifties* London, William Heinemann, 1978.

LEWIS Roger *Outlaws of America* London, Heinrich Hannau, 1972.

LIPPARD Lucy (ed) *Pop Art* (3rd edition, 1970) London, Thames and Hudson, 1976.

LOEWY Raymond *Industrial Design* London, Faber and Faber, 1979.

MacCARTHY Fiona *A History of British Design 1830–1970* London, George Allen and Unwin, 1979.

MacEWEN Malcolm *Crisis in Architecture* London, RIBA Publication, 1974.

McKIE David and COOK Chris (eds) *The Decade of Disillusionment* London, Macmillan, 1972.

McHALE John *The Expendable Ikon* exhibition catalogue, Buffalo, Allbright-Knox Art Gallery, 1984.

MacINNES Colin *England, Half English* London, MacGibbon & Kee, 1961.

McLUHAN Marshall *The Gutenberg Galaxy* London, Routledge and Kegan Paul, 1962.

—— *The Mechanical Bride* (1967 reprint) London, Routledge and Kegan Paul, 1951.

—— *Understanding Media* (1973 edition) London, Abacus, 1964.

MARWICK Arthur *Britain in our Century* London, Thames and Hudson, 1984.

MASTERS Robert E L and HOUSTON Jean *Psychedelic Art* New York, Grove Press, 1968.

MEIKLE Jeffrey *Twentieth Century Limited: Industrial Design in America, 1925–1939* Philadelphia, Temple, 1979.

MELLER James (ed) *The Buckminster Fuller Reader* (1972 edition) London, Penguin, 1970.

MELLY George *Revolt Into Style* (1972 edition) London, Penguin, 1970.

MOHOLY-NAGY Laszlo *The New Vision* London, Faber and Faber, 1939.

MUMFORD Lewis *Art and Technics* (1966 edition) New York, Columbia Press, 1952.

MURGATROYD Keith *Modern Graphics* London, Studio Vista, 1969.

MUSEUM OF MODERN ART *Italy: The New Domestic Landscape* exhibition catalogue, New York, MoMA, 1972.

—— *Modern Architecture in England* exhibition catalogue, New York, MoMA, 1937.

NATIONAL UNION OF TEACHERS (NUT) Popular Culture and Personal Responsibility (verbatim report of October 1960 conference) London, NUT, 1960.

NEVILLE Richard *Playpower* London, Jonathan Cape, 1970.

NEWELL Malcolm *Mood and Atmosphere in Restaurants* London, Barrie and Rockliff, 1965.

NUTTALL Jeff *Bomb Culture* London, Paladin, 1970.

OLIVER Paul (ed) *Shelter and Society* London, Barrie and Jenkins, 1969.

OZENFANT Amédée *Foundations of Modern Art* New York, Dover, 1952.

PAOLOZZI Eduardo *Paolozzi* exhibition catalogue, London, The Art Council, 1976.

PAPANEK Victor *Design For the Real World* London, Paladin, 1974.

PAWLEY Martin *Architecture Versus Housing* London, Studio Vista, 1971.

—— *Garbage Housing* London, Architectural Press, 1975.

PEHNT Wolfgang *Expressionist Architecture* London, Thames and Hudson, 1973.

PEVSNER Nikolaus *An Enquiry Into Industrial Art in England* London, Cambridge University Press, 1937.

—— *Pioneers of Modern Design* London, Penguin, 1960.

—— *Pioneers of the Modern Movement* Faber and Faber, 1936.

—— and RICHARDS J M *The Anti-Rationalists* London, Architectural Press, 1973.

PHILLIPS Barty *Conran and the Habitat Story* London, Weidenfeld and Nicolson, 1984.

POLHEMUS Ted *Fashion and Anti-Fashion* London, Thames and Hudson, 1978.

PRICE Cedric *Works II* London, Architectural Association, 1984.

PULOS Arthur *American Design Ethic* Mass., MIT, 1983.

QUANT Mary *Quant by Quant* London, Cassell and Co., 1966.

QUARMBY Arthur *The Plastics Architect* London, Pall Mall, 1974.

RABBIT Peter *Drop City* New York, Olympia Press, 1971.

READ Herbert *Art and Industry* London, Faber and Faber, 1934.

RICHARDS J M *The Castles on the Ground* London, Architectural Press, 1946.

—— *An Introduction to Modern Architecture* London, Penguin, 1940.

RILEY Bridget *Bridget Riley* exhibition catalogue, London, Arts Council, 1973.

'ROLLING STONE' *The Sixties* New York, Rolling Stone, 1977.

ROOSE-EVANS James *Experimental Theatre* London, Studio Vista, 1970.

ROSENBERG Bernard and WHITE David Manning (eds) *Mass Culture* New York, The Free Press, 1957.

ROSZAK Theodore *The Making of a Counter Culture* London, Faber, 1969.

RUSSELL John and GABLIK Suzi (eds) *Pop Art Redefined* London, Thames and Hudson, 1969.

RYAN Peter *The Invasion of the Moon 1957-70* London, Penguin, 1971.

RYBCZYNSKI Witold *Paper Heroes* Dorchester (USA), Prism, 1981.

SALTER Tom *Carnaby Street* London, M&J Hobbs, nd.

SANDFORD Jeremy and LAW Roger *Synthetic Fun* London, Penguin, 1967.

SHARP Dennis *Modern Architecture and Expressionism* London, Longmans, 1966.

—— (ed) *The Rationalists* London, Architectural Press, 1978.

SMITHSON Alison and Peter *The Shift* London, Academy, 1982.

—— *Without Rhetoric — An Architectural Aesthetic* London, Latimer, 1973.

SPENCER Herbert *Pioneers of Modern Typography* London, Lund Humphries, 1969.

STUTTGART The Institute for Foreign Cultural Relations *Bauhaus* Stuttgart 1975.

TATE GALLERY *Eduardo Paolozzi* exhibition catalogue, London, Tate Gallery, 1971.

—— *Richard Hamilton* exhibition catalogue, London, Tate Gallery, 1970.

THISTLEWOOD David *A Continuing Process* exhibition catalogue, London, ICA, 1981.

THOMPSON Denys (ed) *Discrimination and Popular Culture* London, Penguin, 1964.

TOFFLER Alvin *Future Shock* London, Bodley Head, 1970.

TWIGGY *Twiggy* London, Hart-Davis, MacGibbon, 1975.

VEBLEN Thorstein *The Theory of the Leisure Class* (1961 reprint) New York, The Modern Library, 1899.

VENTURI Robert *Complexity and Contradiction in Architecture* New York, MoMA, 1974.

—— *Learning From Las Vegas* Mass., MIT, 1972.

VICTORIA AND ALBERT MUSEUM *The Way We Live Now* exhibition catalogue, London, V&A, 1979.

VOSTELL Wolf and HIGGINS Dick *Fantastic Architecture* New York, Something Else Press, nd.

WARD Barbara and DUBOS René *Only One Earth* London, Penguin, 1972.

WARNER Alan and JENKINSON Philip *Celluloid Rock* London, Lorrimer, 1974.

WATKIN David *Morality and Architecture* London, Oxford University Press, 1977.

WHEEN Francis *The Sixties* London, Century/Channel 4, 1982.

WHITECHAPEL ART GALLERY *Modern Chairs 1918-1970* exhibition catalogue, London, Whitechapel, 1970.

—— *The New Generation: 1964* exhibition catalogue, London, Whitechapel, 1964.

—— *The New Generation: 1965* exhibition catalogue, London, Whitechapel, 1965.

—— *New Generation 1968: Interim* exhibition catalogue, London, Whitechapel, 1968.

—— *This Is Tomorrow* exhibition catalogue, London, Whitechapel, 1956.

WILLIAMS Raymond *Communications* London, Penguin, 1962.

—— *Culture and Society: 1780-1950* London, Chatto and Windus, 1958.

—— *The Long Revolution* London, Chatto and Windus, 1961.

WILLIS Paul *Profane Culture* London, Routledge and Kegan Paul, 1978.

WINGLER Hans *Bauhaus* Mass., MIT, 1969.

WOLFE Tom *The Electric Kool-Aid Acid Test* New York, Bantam, 1968.

—— *The Kandy-Kolored Tangerine-Flake Streamline Baby* London, Mayflower, 1965.

—— *Mauve Gloves and Madmen*, Clutter and Vine New York, Bantam, 1976.

—— (ed) *The New Journalism* London, Picador, 1975.

YANKER Gary *Prop Art* London, Studio Vista, 1972.

YOUNG Jean and LANG Michael *Woodstock Festival Remembered* New York, Ballantine Books, 1979.

INDEX